Crusoe's
Footprints

Crusoe's Footprints

Cultural Studies in Britain and America

Patrick Brantlinger

ROUTLEDGE New York London

To my L680 and V611 students.

Published in 1990 by

Routledge
An imprint of Routledge, Chapman and Hall, Inc.
29 West 35th Street
New York, NY 10001

Published in Great Britain by

Routledge
11 New Fetter Lane
London EC4P 4EE

Library of Congress Cataloging-in-Publication Data

Brantlinger, Patrick, 1941–
 Crusoe's footprints : cultural studies in Britain and America /
Patrick Brantlinger.
 p. cm.
 Includes bibliographical references.
 ISBN 0-415-90146-4. — ISBN 0-415-90284-3 (pbk.)
 1. Culture—Study and teaching—United States. 2. Culture—Study
and teaching—Great Britain. I. Title.
HM101.B72 1990
306'.07'041—dc20 89-24284

British Library cataloguing in publication also available.

As for cannibals, I am not persuaded, despite Cruso's fears, that there are cannibals in those oceans. You may with right reply that, as we do not expect to see sharks dancing in the waves, so we should not expect to see cannibals dancing on the strand; that cannibals belong to the night as sharks belong to the depths. All I say is: What I saw, I wrote. I saw no cannibals; and if they came after nightfall and fled before the dawn, they left no footprint behind.

Susan Barton in J. M. Coetzee's *Foe*.

Contents

Preface

The short version of this book is that "cultural studies" has emerged from the current crises and contradictions of the humanities and social science disciplines not as a tightly coherent, unified movement with a fixed agenda, but as a loosely coherent group of tendencies, issues, and questions. The outcome partly of the theory and canon wars of the 1960s and 1970s, cultural studies does not reflect a single "field," theory, or methodology, but makes use of several—Marxism, feminism, deconstruction, psychoanalysis, ethnography. Using these and other tools, cultural studies analyzes what the late Raymond Williams liked to call "our common life together"—which may also mean, our *lack* of a "common life together" and those social/cultural forces which create surplus difference, division, alienation.

Perhaps more than anyone else's, Williams's influence is evident in cultural studies. He taught us especially that intellectual work cannot and should not stop at the borders of single texts, single historical problems or controversies, or single disciplines. For such work to matter, the connections of texts and histories with our own lives and experiences must be recognized and become part of what we analyze. Williams's works—*Culture and Society, The Long Revolution, The Country and the City, Modern Tragedy, Marxism and Literature*—are among the major resources of cultural studies. Yet the writings and ideas of many others, often influencing Williams himself, are equally central: the names of Althusser, Barthes, Derrida, Foucault, and Gramsci play through these pages, as do also those of Richard Hoggart, Stuart Hall, and E. P. Thompson.

Although I mention some of the key institutional developments associated with cultural studies—for example, the Birmingham Centre for Contemporary Cultural Studies—I have not written an institutional history. In Britain, programs called "cultural studies" have sprung up in many places, particularly the new universities and polytechnics, and there is now a Cultural Studies Association with annual meetings and somewhere over one-hundred members. In the U.S. and Canada, programs labeled "cultural studies" or some near equivalent now also exist at many universities. The History of Consciousness Program at the University of

California at Santa Cruz represents an older version, while new programs at such places as Pittsburgh, Syracuse, Illinois, and Wisconsin-Milwaukee seem to spring up almost monthly. The same is true of the numerous journals which publish "culturalist" and "New Historicist" work: *Critical Inquiry, Cultural Critique, Cultural Studies, Diacritics, Discourse, Economy and Society, Feminist Studies, Media, Culture and Society, New German Critique, Representations, Signs, Social Text, Works and Days*—these are just the few titles that occur to me at the moment.

The full story of institutional developments, however, will have to wait for another teller. My focus has been instead on main issues, questions, themes, approaches. I have tried to write an introductory account of these issues, describing and summarizing a wide range of work—an account aimed especially at advanced humanities and social science students and faculty. The *specific* audience I had in mind while writing were the graduate students in various "fields" who have taken my and James Naremore's L680 Literary Theory courses at Indiana University. When Jim and I looked this year for texts that would lay out the map of cultural studies in a clear, fairly comprehensive way, we didn't find any (though Terry Eagleton's *Literary Theory* helps). I discovered David Punter's *Introduction to Contemporary Cultural Studies* in the midst of writing this book, and it offers some useful points of comparison and contrast with my account. Perhaps most usefully, it contains several essays that deal with problems and methods of teaching cultural studies courses. I also discovered Anthony Easthope's *British Post-Structuralism* while writing my survey: it, too, usefully describes a number of issues and tendencies I deal with here, as well as some that I don't deal with.

I'm grateful to our L680 students for numerous ideas and insights. This sort of survey is like a discursive collage, with numerous voices "ventriloquized" into my own text through citation. While I can directly cite the authors of other books and articles, however, I can't directly cite our students' ideas. Yet their voices are "dialogically" part of my voice, and that is true as well of the voices of many of my colleagues at Indiana and elsewhere. I benefited greatly from Jim Naremore's excellent teaching in his L680 course and from our out-of-class discussions. I also benefited from the help and ideas of Chris Anderson, Matei Calinescu, Brian Caraher, John Eakin, Kathryn Flannery, Susan Gubar, Ken Johnston, Gene Kintgen, Barbara Klinger, Chris Lohmann, Lew Miller, Tom Prasch, Dave Thelen, Steve Watt, and Tim Wiles. The participants in our yearlong Theory and Interpretation of Mass Culture lecture series also taught me a great deal. John Fiske and Michael Denning gave superb lectures and visited my L680 class to discuss their work and ours in useful ways. The other participants—Devon Hodges, Lynn Joyrich, Robert Ray, and Peter Wollen (along with Chris Anderson, Barb Klinger, and Steve Watt from Indiana University)—all opened new perspectives for us. And I'm grateful as well to my friends at the University

of Florida who read and discussed with me parts of *Cultural Studies* last March: James Twitchell, Greg Ulmer, Jack Zipes, and others. Besides these, I want to thank Mary Burgan, Bill Germano, Tony Shipps, Bill Thesing, Martha Vicinus, Alan Wald, and Martha Woodmansee, as well as the participants in the main session on cultural studies at MLA last December: Catherine Gallagher, Richard Johnson, Richard Ohmann, Janice Radway, and Gayatri Spivak.

While working on *Cultural Studies,* I read several manuscripts of forthcoming books that I should also cite as influencing what I've had to say. The most recent of these is Steve Watt's *The Popular Theatres of Joyce and O'Casey,* which analyzes the intricate dialectic between supposedly "high" and supposedly "low" or "popular" cultural forms in turn-of-the-century fiction and drama. Earlier I read—and highly recommended for publication—Regenia Gagnier's *Subjectivities* and Alan Sinfield's *Making Literature,* both of which (though perhaps with different titles) will be recognized as major contributions to another of the central themes of cultural studies: the social construction of "subjectivities."

And I'm especially grateful to Ellen Anderson Brantlinger for all her ideas, help, and patience.

1

The Humanities
(and a Lot More)
in Crisis

Nightmare Island

"It happened one day about noon going towards my boat, I was exceedingly surprized with the print of a man's naked foot on the shore, which was very plain to be seen in the sand" (Defoe 162). So Robinson Crusoe tells us; his discovery is the start of nearly two years of living in terror, panic-stricken that his isolation will end with the advent of cannibals or, what he imagines would be just as bad, devils. Yet at first he nearly convinces himself not to be afraid, because "this foot might be the print of my own foot, when I came on shore from my boat" (165). This thought cheers him for a while, until he considers both that he had not come ashore at that spot and that the footprint is too large to be his own. So commence the years spent in "dread and terror of falling into the hands of savages and cannibals" (170).

Commenting on the episode, Michel de Certeau writes:

> The conquering bourgeois is transformed into a man "beside himself," made wild himself by this (wild) clue that reveals nothing. He is almost driven out of his mind. He dreams, and has nightmares. He loses his confidence in a world governed by the Great Clockmaker. His arguments abandon him. Driven out of the productive asceticism that took the place of meaning for him, he lives through diabolical day after day, obsessed by the cannibalistic desire to devour the unknown intruder or by the fear of being devoured himself. (de Certeau, *Practice* 154)

Crusoe, who has so often served economists—from Adam Smith through Marx and beyond—as the model of bourgeois rationality and productivity, might just as easily have served as the model of bourgeois irrationality and repression. Despite the fact that the "cannibals" eventually do break into his isolation, for two years Crusoe is haunted by his footprint—not his, of course, literally, but haunted by his own mental image of the footprint, pressed into his thoughts like

1

the original footprint into the sand. He possesses it; it possesses him. It becomes the inescapable image of the Other—of all the others—whom he in his isolation has left behind, discovering (it seems) through self-sufficiency that he can very well live alone.

Of course all this changes when "the Other" arrives. At first, the "cannibals," from whom he rescues "Friday." With his guns, the element of surprise, and now Friday as his amanuensis, he is more than a match for "the other" cannibals. Later on he confronts his European "rescuers." He thus escapes the fate he most feared after seeing the footprint—that is, of being devoured by the savages. But he also discovers in one savage—Friday—the opposite of savagery: despite cannibalistic inclinations from which Crusoe must wean him, Friday proves to be incredibly docile and grateful: "for never man had a more faithful, loving, sincere servant, than Friday was to me; without passions, sullenness, or designs, perfectly obliged and engaged; his very affections were ty'd to me, like those of a child to a father" (211).

What Crusoe cannot master—or get to call him "master"—he sees only as savagery and desert island. Friday, on the other hand, is no more than a dark copy of Crusoe, a shadow-self, prepared always to do his bidding. Crusoe's first intuition is right after all: Friday's footprint—or *the* footprint—was his own; what so terrified Crusoe for two years was his shadow. Crusoe names Friday, teaches him English, and speaks to him mostly in commands, the imperative mode of imperialism. Therefore Crusoe remains just as profoundly isolated *after* he has rescued Friday as before—the isolation implied by mastery, as opposed to equality, solidarity, the recognition of self in the voices and gestures of others. Perhaps the footprint after all was only hallucination, mirage, the result of too much sun, too much isolation. And perhaps the cannibals and Friday, too, are only phantoms, the shadows of an objectless fear and a desire for mastery that Crusoe himself fails to understand. No doubt they are "real," in the same sense that the footprint was "real": but they might as well just be the images projected on sand, sky, and water by Crusoe's fear and desire. Just as Crusoe is unable, in some ultimate sense, to decipher the clue of the footprint by matching it to a living reality, a living person, so he is unable to say or learn anything at all about the "cannibals." Even Friday is his creature, who speaks only the words "Master" Crusoe gives him to speak, more parrot than man. Crusoe never learns to speak Friday's language. Crusoe's language speaks for both.

Perhaps there was a real foot corresponding to the footprint Crusoe discovers; perhaps there were real cannibals corresponding to the images and shadows of cannibals he dreads, fights, and either kills or drives away. But he knows only the images; he finds in the island and in his experience only that which he wishes or dreads to find. The discovery of the footprint doesn't end his isolation; it only underscores it. Even his rescue of Friday doesn't end, but only increases his isolation in a different form—the "master" now of his selfless/unselfed servant.

Crusoe's solipsism can be read as a parable of all the forms of imperialism and political divisiveness that have divided people through history into masters and servants, the dominant and the dominated. No doubt the moral Defoe intended stresses mastery—including self-mastery—as the primary value. But it seems just as possible to see in Crusoe's mastery—of the island, of the cannibals, of Friday, of fate—a kind of madness, the antithesis of self-mastery. Crusoe seems almost to will his isolation, and to cling to it even when it is being invaded. He never learns the lesson which, as I shall try to show, is the main one "cultural studies" has to offer: in order to understand ourselves, the discourses of "the Other"—of all the others—is that which we most urgently need to hear.

Disciplining the Disciplines

In both American and European universities since the 1960s, the perception of a crisis in the humanities and social sciences is now common. Between 1968 and 1988, a deluge of decline and fall rhetoric has swept through educational institutions. Perhaps the only aspect of education today which is not in "critical" or perhaps comatose condition is such rhetoric. While Jonathan Kozol has announced that one-third of the adult population of the U.S. is now functionally illiterate, E. D. Hirsch, Jr. has raised the perhaps equally frightening specter of "cultural illiteracy" and Allan Bloom has declared that higher education is "closing the mind" of America. In 1982 Harvard English professor Walter Jackson Bate declared that "the humanities are . . . plunging into their worst state of crisis since the modern university was formed a century ago in the 1880s." Quoting this remark in "To Reclaim a Legacy," his 1984 director's report to the National Endowment of the Humanities, William J. Bennett agreed with Bate in tracing the crisis back to the late 1960s and early 1970s, when occurred, he claimed, "a collective loss of nerve and faith on the part of both faculty and academic administrators [which] was undeniably destructive of the curriculum" (Bennett 16–21).

To Bate's and Bennett's declarations of crisis can be added many others which, like theirs, locate the origins of the current moribund state of the humanities and more generally of education in the radical tendencies of the 1960s. According to the editors of a recent anthology recollecting (favorably) that radical decade, "Trashing the 60s has become a strategic feature of the current struggle for hegemony" (Sayres 8). In Britain, too, the sixties have been "the leading target of Tory demonology," as Simon Frith points out; "for Margaret Thatcher and her colleagues the 60s were when Britain went bad" (Sayres 59). In a speech on May 17, 1988 (reported the following day on National Public Radio), Ronald Reagan blamed the "drug crisis" on "the permissiveness of the 60s." (But at the same time the press was blaming Nancy Reagan for believing in astrology—remember the "Age of Aquarius"?) What does it mean to blame the ills of a society on an

earlier decade, particularly one that ended almost two decades ago? Reverse nostalgia? What is a "crisis" anyway, and how has it happened that universities under the supposedly calm, well-disciplined (star-blessed?) political regimes of Reagan and Thatcher, in the 1980s and not the 1960s, have fallen into such disarray?

According to the now trite and invariably trivializing conservative myth of what happened in the sixties, youthful aggression caused knee-jerk liberalism to cave in to radical demands—ironic in light of the supply/demand metaphors Bennett employs:

> When students demanded a greater role in setting their own educational agendas, we eagerly responded by abandoning course requirements of any kind and with them the intellectual authority to say to students what the outcome of a college education ought to be. With intellectual authority relinquished, we found that we did not need to worry about what was worth knowing, worth defending, worth believing. The curriculum was no longer a statement about what knowledge mattered; instead, it became the product of a political compromise among competing schools and departments overlaid by marketing considerations. (Bennett 19–20).

By examining his notion of "marketing considerations," Bennett might have been forced to acknowledge that, with certain strategic exceptions, the demands of multinational corporations and government rather than the counter-demands of radical students and faculty carried the day. The exceptions were a small number of academic trends and initiatives—in the U.S., Women's and Afro-American Studies programs are the key examples—which took as one of their aims the democratization of the curriculum. Through "political compromise" these achieved marginal status in the higher educational establishment in the late 1960s and early 1970s (in Britain, the development of "cultural studies" programs followed a roughly similar path). But it was not "marketing considerations" that won these programs their current positions in higher education, except in a sense Bennett does not mean: university administrators often only grudgingly agreed to their establishment, worried about bad public relations if they balked.

As Thorstein Veblen long ago pointed out, the modern university is "a business house dealing in merchantable knowledge" (Veblen 85). Although its primary customers are students, if they become uppity or too radical, the university can always expel them. For the most part, students wish to acquire "merchantable knowledge" which they in turn can sell to other business enterprises. And the largest customers for the research services of universities, of course, are corporations and government. Have Women's and Afro-American Studies or have "marketing considerations" precipitated the current crisis in the humanities? Bennett is no critic of capitalism; his answer is therefore unequivocal, as a headline in

The Chronicle of Higher Education for February 17, 1988 makes clear: "Scholars defend their efforts to promote literature by women and blacks, decry attack by Bennett."

Bennett thinks that feminists and Afro-American scholars are "intellectual lightweights." But in the face of the Vietnam War and systemic racism, poverty, sexism, and environmental spoliation at home and abroad, all blithely downplayed or ignored by neoconservatives like Bennett, marketing considerations certainly did produce university curriculums that are now careerist smorgasbords instead of intellectually coherent programs. That outcome was as unsatisfactory to radical students and faculty as to Bennett. Thus, the 1962 *Port Huron Statement,* manifesto of the Students for a Democratic Society (SDS), declared that "our experience in the universities [has not] brought us moral enlightenment."

> Our professors and administrators sacrifice controversy to public relations; their curriculums change more slowly than the living events of the world; their skills and silence are purchased by investors in the arms race; passion is called unscholastic. The questions we might want raised—what is really important? can we live in a different and better way? if we wanted to change society, how would we do it?—are not thought to be questions of a "fruitful, empirical nature," and thus are brushed aside. (SDS 109)

A similar demand for "moral enlightenment" characterized the student movements in western Europe in the sixties, culminating in the events in France of May, 1968. Although these events—and the decade as a whole—did not produce major political revolutions in western Europe or the U.S., there was a worldwide trend toward liberation—the dismantling of the last remnants of the old colonial empires (of which the Vietnam War was only one highly spectacular instance), the civil rights movement, feminism, the various youth "countercultures." Even without political revolutions in the West, the political gains were major ones, and so were the cultural gains. As during similar revolutionary eras in the past— the aftermath of the American and French Revolutions, for instance—creative energies were released in the sixties that are still active. The latest crisis in education is occurring not because students are again mounting the barricades, but because the humanities and social science disciplines are cracking at the seams, unwilling or perhaps unable to take the new, threatening, creative energies into account. Above all, the authority of the academic disciplines has been challenged from several directions. In the 1980s, perhaps the weakest of these challenges has come from student radicalism; yet what Jürgen Habermas wrote about students in the sixties continues to haunt academic memories: "the rising generation has developed a particular sensitivity to the untruth of prevailing legitimations." The young have always expressed "outrage against the double standards of the older generation's morality," Habermas declared. The difference

in student protest from the sixties forward has been the acute awareness of living in a society with the capacity to fulfill "the emancipatory ideals of the eighteenth century"—that is, to create a world of freedom, enlightenment, and prosperity for all—which instead does just the opposite. Despite abundance, "it has not abolished hunger . . . while it has widened the gap between industrial and developing nations, exporting misery and military violence" (Habermas, *Toward* 25).

The *Port Huron Statement* lays bare the dilemma of humanistic liberalism in a society that enshrines it in academic institutions, yet systematically thwarts the realization of its ideals. This blockage between theory and practice *is* the crisis Bate and Bennett deplore. Unless the ideals expressed in great works of literature and art (not to mention religion, which the humanities sometimes claim to have reluctantly superseded) can and do become politically empowered, there seems to be no point in teaching them. Departments of English, for example, could just as easily and even more practically teach great advertisements as great books, if the only purpose is the merely rhetorical one of learning to read and write effectively. In much academic discourse, "esthetic appreciation" is a mystified and mystifying category, used as a cover for innumerable nonesthetic purposes (for instance, publishing scores of "critical" essays on a single "great" novel like *Middlemarch*—the "greatness" or intrinsic esthetic worth justifies the scholarly attention). But in its unexamined forms the notion of esthetic appreciation is usually little more than a disguised or unrecognized utilitarianism: whatever gives pleasure is valuable, *or* whatever leads to scholarly productivity and publishing is valuable, *or* both—as Jeremy Bentham said, if the game of pushpin gives as much pleasure as poetry, then it is just as valuable as poetry.

I am not denying that esthetic concerns should be a primary focus of humanities teaching. On the contrary, in the present over-disciplined and over-technologized condition of the humanities, esthetic concerns have little or no genuine place. Of course esthetic appreciation is central to those theories of the humanities which see them as in some manner "humanizing" or "civilizing" those who study them. But this traditional line of reasoning has been frequently called into question, not least by the events of the twentieth century which have belied the very idea of the progress of civilization. Against such increasingly untenable theories, I will argue that a more reasonable line of defense for both the humanities and the social sciences is presently offered by the idea of cultural and historical representation— although, if this idea is taken seriously, it will lead beyond the narrow and narrowing limits of the academic disciplines as now established, in the direction of cultural studies. Further, as Herbert Marcuse argued in *The Aesthetic Dimension* and elsewhere, for esthetic values to take their proper place in education and in society at large would entail a revolutionary transformation that, of course, is simply unthinkable for the neoconservative and liberal defenders of the traditional humanities and the status quo.

The crisis in education only reflects the larger crises of American and European world-hegemony. Upheaval in the humanities and social sciences must and will continue so long as the U.S. and other powerful, industrialized nations continue exporting "misery and military violence." If the humanities offer the profoundest expression of our society's ideals, then social crisis must necessarily be reflected in academic work. As Terry Eagleton remarks, the humanities are a "body of discourses" about the "most imperishable values"; they are "pitched into continual crisis" by the negation of those values in actuality. Crisis is thus the "permanent and structural" condition of the humanities; the cure cannot come completely from within the schools and universities. Moreover, "it is part of [the humanities'] chronic bemusement . . . never to know whether they are central or peripheral, grudgingly tolerated parasites or indispensable ideological apparatuses" (Eagleton, "Foreword"). Within the university's hierarchy of disciplines, humanists are likely to feel more peripheral than central. Tradition gives the humanities an importance that current funding and research priorities belie. At giant public "multiversities" like the Big Ten schools, humanities courses are taken by many students only as requirements—a sort of force-feeding in writing skills, history, great books, and appropriate "values" before they select the chutes labeled "pre-professional"—pre-med, pre-law, and so forth. About half of the freshmen entering my university (Indiana) say they want to major in business (although the School of Business admits only a portion of these). Clearly, one doesn't need to blame the radical sixties for the current marginalization and sense of irrelevance that pervades the humanities today.

If crisis is the permanent condition of the humanities, moreover, that is also true of the social sciences. A fairly typical declaration appeared in the first issue (1972) of the British journal *Economy and Society:* "All the social sciences are in a state of crisis." Such pronouncements usually lead to calls for "a 'critical' sociology or 'critical' theory and . . . for 'relevant' as well as interdisciplinary research," though the editors hasten to add that "these new interests . . . have tended to be unsupported by serious scholarship and have consequently too often degenerated into blind dogmatism, confused eclecticism or mere polemic." More recently, with the "Critical Theory" of the Frankfurt Institute as backdrop, Brian Fay writes that "for a social theory to be critical and practical as well as scientifically explanatory," several conditions must be met. The first of these is "that there be a crisis in a social system" (Fay 30). The purpose of "critical social science" may be to help that social system resolve its crisis, but it may also be to precipitate crisis in order to bring about progressive social change. In any event, for both Fay and the editors of *Economy and Society,* critical social science is conceived as a form of active, hopefully "relevant" political practice as well as theory. Along with other critical social scientists, they agree with Marx's eleventh thesis on Feuerbach: "The philosophers have only *interpreted* the world . . . the point,

however, is to *change* it." But how to change it if students prefer courses in computer science or broadcasting to ones in "critical" sociology?

The perception of crisis in academic work even extends to the natural sciences. The politicization of at least some natural scientists over such issues as nuclear energy, acid rain, and world hunger points to the same sense of crisis—the same contradiction between theory and practice—or in other words the same belief that knowledge *must* be put to better use than the continued production of "misery and military violence." "As far as I know, nobody has ever founded a university *against* reason," declared Jacques Derrida in a 1981 lecture at Cornell. "So we may reasonably suppose that the University's reason for being has always been reason itself, and some essential connection of reason to being" ("Principle of Reason" 7). But, he went on to argue, reason must be kept pure from any worldly contamination of being—hence, the distinction between "disinterested" and "oriented" or applied research. This distinction, however, is ultimately arbitrary or "groundless"—rests on an "abyss," Derrida claimed—so then, in what sense is the university more reasonable than the society and world it represents?

Assuming that the university *is* in some sense more reasonable than society, then it must come into conflict with society—crisis will be its inevitable condition of existence. And internal crisis, within the university, must also be the inevitable result when the rationality which is its reason for being comes into conflict with careerism, marketing considerations, the arbitrary limits of disciplines, and research "oriented" toward the production of "misery and military violence." In relation to the humanities, the failure to achieve, through what Schiller called the "aesthetic education" of humanity, more than superficial results is evident in those episodes (years, decades, centuries?) of barbarism erupting in the midst of civilization that characterize modern history. George Steiner's *In Bluebeard's Castle* (1971) took as a central fact about the modern condition that the wolves of "political bestiality" have on more than one occasion cloaked themselves in the sheepskins of high culture, including university diplomas. Steiner spoke in funereal tones about our entry into "post-culture," the spectral aftermath of a now defunct literary humanism (124). To Steiner's conservative despair, we might compare the Marxist despair of Theodor Adorno, for whom "all post-Auschwitz culture, including its urgent critique, is garbage Not even silence gets us out of the circle" (*Negative* 367). But both Steiner and Adorno sought a criticism, a theory and practice, that would bear the ark of cherished esthetic *and* political values through the catastrophes of modern history.

Against the despair of both the right and the left, Bennett's desire to reclaim the legacy of the humanities seems, to say the least, out of touch, an ideological stance petrified at the level of nineteenth-century individualism, at once Arnoldian and Reaganite. This is especially true because Bennett does not recognize in the humanities the political claims for openness, justice, democracy—liberalism, in short—that other prominent defenders including Arnold found in them. Much

less does Bennett find in the "aesthetic dimension" a reservoir of utopian desire and imagery that might help open paths toward the radical restructuring of society and the realization of a good life for all. Except in the pre- and after-worlds of religion, utopia has always been stillborn or, at best, withered before birth in western thinking (see Kateb). But a utopian understanding of art and literature has been central to radical theory for at least the past century and a half, from Schiller and Blake through John Ruskin and William Morris down to the Frankfurt Institute theorists and the drafters of the *Port Huron Statement* (see Ernst Bloch and also Herbert Marcuse, *The Aesthetic Dimension*). The traditional defenders of the humanities, however, are willing neither to attribute a utopian, politically transformative potential to them, nor to abandon them as if they were so many sinking ships, torpedoed by "misery and military violence" (or perhaps by innate evil, the ultimate axiom of political conservatism).

So humanities teaching sticks mainly to an individualistic rationale: culture works its small miracles, if at all, on private egos, hopefully transforming what Arnold called the "ordinary self" into the "best self" by ones and twos, while abandoning the larger, necessarily political hope of "humanizing" and "enlightening" society in general. In such circumstances, declarations that humanism or the humanities are dead—along with God, "Man," reason, the author, and the referent—seem understandable, if hardly comforting. At their radical margins, the humanities turn into a series of obituaries. Barthes pronounced "the author" dead in 1968; two years earlier, Foucault had written that "man is an invention of recent date. And one perhaps nearing its end" (Foucault, *Order* 387). In West Germany, where charges of complicity between the liberal humanism of the universities and the rise of the Third Reich have sharpened the lines of conflict, the "institution" of literary criticism is, according to Peter Hohendahl, "in a permanent state of crisis." In the late sixties, German literary radicals "coined the slogan Literature is Dead": "Past and present literature, and in fact any conventional discussion of literary issues, had seemingly lost its meaning. Whatever individuals felt about the value of specific literary works, there was no consensus that could serve as a basis for the general discussion" (Hohendahl 44, 39).

For conservative defenders of the humanities such as Bate and Bennett, declarations of the deaths of literature, or the author, or the referent are a chief part of the problem, not a solution to anything. But of course Bate and Bennett themselves are talking about the decline and fall of the humanities, just as George Steiner's themes are the deaths of tragedy and high culture under modern conditions of democratization and mass society. So the rhetoric of crisis is shared by both radicals and conservatives (Herron 131–35). Nevertheless, one very tempting (conservative) explanation for the crisis in the humanities has been that radicals of the death-of-literature type have invaded the universities, taken over academic conferences, and usurped the pages of journals. These "radicals," however, are

only doing their jobs, and often doing them very well, much to the chagrin of the conservatives (see Mooney). Yet the arrogance of theory is now a (theoretical) commonplace. Steiner is not alone in thinking that "never has there been a more hectic prodigality of specialized erudition Never have the metalanguages of the custodians [of culture] flourished more, or with more arrogant jargon, around the silence of live meaning" (Steiner 106). The myth of the sixties is thus often given still another twist, according to which the humanities have been subverted from within by new theories of language, epistemology, and cultural politics. In their more extreme forms, these theories question the very possibility of intellectual authority (even while claiming it themselves, as Derrida does in his lecture on universities, or Barthes in his authoritative annunciation of the death of the author).

Bruce Robbins remarks that "the least generous interpretation of theory . . . is that yes, it came out of the 60s, but it squandered the energies of the 60s in merely academic, merely theoretical infighting" (17). By both its opponents and its advocates, theory is often linked to the New Left and counterculture rebellions of that decade, in part because many current academics (like myself) were students then. Several of the main figures in the literary theory boom came to intellectual maturity in the sixties—Barthes, Foucault, Derrida, Habermas—so the equation seems complete. All radical intellectuals, moreover, have been caught in the impasse of the counterrevolution that followed the eventful days of 1968 in the U.S., France, and elsewhere. Though the New Left and student rebellions of the sixties did not produce political revolutions in Europe or North America, they mirrored revolutions in the Third World, and they were at least symptomatic of a larger cultural revolution (see Jameson in Sayres, 178–209). The apparently "absent revolution" has once more presented itself as a major influence on intellectual, if not exactly on socio-economic, history (Kent 437). But the absence of the revolution is today illusory; it is taking place elsewhere, in the Third World, but also here, all around us (the cannibals have already set foot on the island; they are us). We can always pretend that it isn't happening. But the world is undergoing *radical* change whether we recognize it or not; the academic disciplines can either read the footprints in the sand, or refuse to read them, but they are there.

The conservative myth that "theory"—structuralism, deconstruction, Marxism, feminism, psychoanalysis, and so on—has *caused* the crisis in the humanities needs to be turned around: theory is a response to crisis, not its cause. The main cause of the crisis is instead directly related to those same "marketing considerations" Bennett both invokes and fails to analyze. Further, cultural studies, wherever it has emerged, has been not merely a new sort of interdisciplinary academic practice, but a coalescing movement, a sort of magnet gathering the various theories that now often go under the label "theory" into a problematic and perhaps impossible synthesis. Against the reification of the disciplines, as

these have been increasingly "colonized" by that "instrumental reason" which causes them to imitate the sciences and to account for themselves in terms of "marketing considerations," cultural studies judges the humanities by other standards, and particularly by the standards of "moral" and "esthetic rationality." In saying so, I am adopting some of the terminology and arguments of Habermas's "communicative ethics," about which I will have more to say in the final chapter.

Radical theorizing in the humanities and social sciences in general expresses the gulf between theory and practice, between ideal democracy and the clearly inadequate social arrangements or derangements arrived at through the decay of welfare state liberalism and the Pyrrhic victories of Reaganism/Thatcherism. But against the new forms of radical theory, conservatives construct their own "theoretical" defenses of the status quo, or of some nostalgic past characterized by disciplinary harmony, simplicity, and authority.

In *The Practice of Everyday Life,* de Certeau writes:

> The ministers of knowledge have always assumed that the whole universe was threatened by the very changes that affected their ideologies and their positions. They transmute the misfortune of their theories into theories of misfortune. When they transform their bewilderment into "catastrophes," when they seek to enclose the people in the "panic" of their discourses, are they once more necessarily right? (95–96)

Standing—no matter how bravely—rigidly by disciplinary structures that by their very natures are impermanent, constantly changing (perhaps the only thing constant about them *is* change), the ministers of knowledge often behave like Crusoes defending imaginary islands against equally imaginary cannibals. Meanwhile they fail to see the real, multiplying footprints in the sand, even though most of these are their own, or those of their predecessors: the *liberal* arts, the humanities and social sciences, *must be* "liberal"—even "liberating"—or else degenerate into mere hypocrisy and obfuscation. Within the context of humanities and social science teaching, I will argue, cultural studies is today the most rational response to the disciplinary blindness of all the Crusoes who have surrounded us, taken over our islands, invaded our most private thoughts. These Crusoes are ourselves; so are the Fridays.

Beyond the Text:
Literary Theory and/as the Crisis

In literary fields, structuralism, deconstruction, psychoanalysis, feminism, and Marxism re-read and "decenter" familiar texts and strive to revamp "the canon" and hence the curriculum in radical ways. Perhaps these theoretical approaches to the text are expressions of the thwarted aspirations of the sixties; perhaps

instead they are "oriented," careerist responses to "marketing considerations." Or perhaps they are authentic and progressive movements of knowledge, results of supposedly "disinterested" research and analysis. Finally and, I think, most likely, perhaps these three possible causes of the current valorization of theory in literary studies—"theorrhea," as J. G. Merquior calls it—are not alternatives, but political, economic, cultural imperatives that have operated simultaneously. "Post-structuralism has been the seat of theorrhea in the humanities—ambitious 'theory' as a pretext for sloppy thinking and little analysis, fraught with anathemas against modern civilization" (Merquior 253). That is, of course, the most negative view of theory; what Merquior fails to acknowledge is that "ambitious 'theory' " raises serious questions which, even if it fails to answer them, cannot be answered by retreating to traditional positions and practices. Whatever the case, "theorrhea" does indeed seek to subvert intellectual authority of the reactionary sort invoked by Bennett, *and also* of the "disinterested," supposedly rational sort both invoked and deconstructed by Derrida. To quote John Donne, "new philosophy calls all in doubt" in many academic fields; while the new philosophers often rejoice, their conservative colleagues bemoan the apparent anarchy into which their chosen realms of culture have plunged. But is crisis necessarily the terrible thing its critics make it out to be?

A critic—even a literary critic—is perforce a crisis manager. In *Blindness and Insight,* Paul de Man asserted that "the notion of crisis and that of criticism are very closely linked, so much so that one could state that all true criticism occurs in the mode of crisis. To speak of a crisis of criticism is then, to some degree, redundant" (de Man 8). The redundancy carries over to all the humanities and social sciences, to all forms of the critical exercise of reason. The Greek root-word for "crisis," *krinein,* meant to separate, and the first definition given in my dictionary reads: "the turning point in the course of a disease, when it becomes clear whether the patient will recover or die." Supposing the patient to be the humanities or even society at large, isn't it possible that the crisis will prove a welcome one if it leads to recovery, to beneficial change? And is criticism (*Kritik,* literary theory, etc.) which separates the good from the bad, the true from the false, the healthy from the diseased, the cause of crisis or its potential cure? "In Chinese," writes Bill Livant, "the character which means *Crisis* is a combination of the characters which mean *Danger* and *Opportunity*" (Livant 35).

On these points de Man is unhelpful: "The rhetoric of crisis states its own truth in the mode of error. It is itself radically blind to the light it emits" (de Man 16)— a dictum which encompasses de Man's own rhetoric of crisis and, perhaps, the project of literary deconstruction in general. Stalling at the level of rhetorical analysis, deconstruction has often refused to go "beyond the text" to forge even the most cautious social or political commitments (this is especially true of the American version of deconstruction, but is perhaps less so of Derrida—see Norris, and my comments on Habermas and Derrida in the final chapter). But of

course both the willingness and the unwillingness to go beyond the text are political stances or have political consequences. De Man was unwilling, as is evident in the rest of his argument about crisis, which has more to say about Mallarmé and free verse than about criticism in relation to history or society (one especially silly version of crisis tells us: these referents can no longer be found anywhere, even in libraries). In any event, if crisis is inherent to the humanities, that is true not just because the highest humanistic values are contradicted by social reality, but also because theory, at least in some of its guises, fails to take into account the institutional, social, political forces that shape culture. That hasn't prevented it, however, from seeming to be driven by a deconstructive impulse, at once totalizing and nihilistic, that claims to "subvert" the "foundations" of culture, knowledge, and perhaps (in its more ambitious versions) society. To what extent is theorrhea a mere ideological reflection of social forces, "marketing considerations"? To what extent does it insightfully outrun, predict, illuminate those forces? And to what extent is it the creature of a purely *willful* "will to knowledge" that is ultimately "groundless" or without "foundation"?

In *Prophets of Extremity,* Allan Megill notes that "crisis" is one of the key ideas of several of the major figures in the current literary theory boom— Nietzsche, Heidegger, Foucault, Derrida—as it is also in Marx and Marxism (both as economic crisis and as revolution). According to Megill, the modern notion of "cultural crisis" derived in the first instance from "the collapse of the 'God of the philosophers' and of the 'God of the Bible' " that can be traced back to Kant's first critique and the historical criticism of the Bible by Feuerbach, Strauss, and others. The crisis is thus "the loss of the transcendent dimension, prompted by . . . *Kritik* as a pervasive power," which in turn leads to "modern man's [sic] homelessness in the world" and to "the loss of authoritative standards of the good, the true, and the beautiful to which reason has access" (xii-xiii). Bound up with *Kritik* as a corrosive cultural force, moreover, is that pervasive historicism which relativizes all values. Both are forms of the very "principle of reason" that Derrida rightly contends is also the main principle of the university. The exercise of reason, of *Kritik,* produces crisis by challenging false authority (perhaps ultimately all authority), and *this is the primary function of the university.* When reason turns upon itself—when reason subverts reason, as apparently in deconstruction—then crisis itself is, so to speak, in crisis (but if the outcome is purely theoretical, there is nothing after all for the ministers of knowledge to worry about). For Megill, a deepening of the crisis—or rather a second, more profound crisis—can be seen in the late nineteenth century starting with Nietzsche's challenge to historicism. Nietzsche announces not only the death of God but also of "the faith in progress that was the widely diffused, vulgarized form of historicism" (xiii). And finally, even more "critically," Nietzsche announces the death of the rational basis of knowledge. The tradition of deconstructive theory from Nietzsche to Derrida appears to undermine both *Kritik* and histori-

cism, leaving humanity not only without faith but also without method—nothing but endless, ever-delusive desire.

Work in literary fields has been a hot spot for registering crisis if only because, once the divine authority of the Book was called into question, what replaced it was the obviously questionable human authority of books in general. "The Bible has become a bookstore," the bookstore has become a library, and today "the library is burning" (Foucault, *Language* 106, 92). During the nineteenth century, something like John Stuart Mill's "marketplace" of ideas came gradually into existence (see *On Liberty*). The simultaneous development of academic literary criticism can be understood as an attempt to fix or stabilize the authority of secular books whose value in that marketplace is inherently unstable. "Canon formation" ensued as a major academic enterprise (the theological metaphor suggests the nostalgic or reactionary basis of traditional literary criticism). But canons, even by the most conservative accounts (T. S. Eliot's "Tradition and the Individual Talent," for example) change with each addition of a new classic (although, how can there be a *new* classic?).

Hence, the pathos of Arnold's project, in *Literature and Dogma* and elsewhere, to devise a flexible, literary religion, and conversely to devise a literary canon that would be stable enough to substitute for religion. This has been the main program of literary criticism ever since Arnold, through T. S. Eliot, F. R. Leavis, the New Critics, and Northrop Frye, down to the less-than-radical Yale deconstructors (now partly disseminated to diverse places). And the electronic mass media have of course also undermined the authority of secular books. The educational model derived from the earliest European universities—allegorical exegesis by a professor/priest of a revered biblical text, with the Book itself sometimes chained to the lectern—has either evolved or devolved (depending on your politics, religion, or both) in the U.S. into the intellectual free-for-all of the Modern Language Association's thousand-and-one sessions (through which even a King Shahriyar could not stay awake—but perhaps there is safety in both numbers and turmoil). From the Enlightenment forward, the secular canon of great literary works—"culture" in Arnold's and perhaps Bennett's sense—has gradually displaced religious authority. Esthetic quality and artistic inspiration now stand in for divine revelation and grace, as Arnold contended in "The Study of Poetry." But, in contrast to dogma, culture is at best, as Jakob Burckhardt observed, a "wavering authority" (qtd. in Goodheart, *Culture* 17). And literary criticism, now institutionalized as an academic "discipline" in departments of comparative literature, English, and other languages, aspires to be the new theology, capstone of the academic disciplines, although many of its practitioners now acknowledge that it is in reality a version of cultural politics. It has inherited the dual, ambiguous task both of exercising the wavering authority of culture and of continuously criticizing and thus subverting that authority. Once again, perpetual crisis has been the result of this instability.

Instability is also about the only quality that is "intrinsic" to "literature" itself. A late nineteenth-century invention, the "English literature" curriculum rests on the assumption that literary forms of discourse can be clearly distinguished from other forms. The New Criticism in North America and Leavisite *Scrutiny* criticism in Britain asserted the categorical separateness of literature; the function of criticism became defining and maintaining its formal properties, genres, boundaries (see Graff, *Professing*). But, as Mary Louise Pratt contends, "the belief that literature is linguistically autonomous, that is, possessed of intrinsic linguistic properties, which distinguish it from all other kinds of discourse," is false (Pratt xii). Literary language operates by the same rules as ordinary language. Quite apart from issues of cultural politics, the application of linguistics to literature leads to the breakdown of the disciplinary boundaries erected by professional (that is, academic) critics to keep it separate from all other forms of discourse. But literature is also a leaky category because it is an ensemble—despite Northrop Frye, not a system—of representations of the world at large, including all other forms of discourse that are supposedly nonliterary. Literature is, in other words, inevitably "heteroglot," to borrow Bakhtin's terms; its definitions tend always to move in the direction of the definitions of "literacy," which themselves tend to blur into "orality"; its properties are the properties of discourse in general.

In most versions of current literary theory, the authority of the theorist or critic directly challenges that of literature, or of the works of culture she analyzes or deconstructs. No longer can one expect an academic literary critic or scholar to defend the cultural authority of literature as a separate, transcendent discourse— or for that matter, to defend the authority of criticism or scholarship. She is just as likely to deny that reading literature is an unambiguously meaningful activity, or that the wavering authority of culture is benign rather than malignant, liberating rather than authoritarian. Marxist critics view works of literature as ideological, feminists view many of them (and the canon of classics in general) as patriarchal, and those influenced by psychoanalysis—Freudian, Jungian, Lacanian, reader-response theory—view them as equivalent to dreams, symptoms, or delusions, the creatures of unconscious desire. Perhaps worst of all from the standpoint of conservative defenders of the humanities, deconstructionists treat all texts whatsoever as vanishing acts, inserting their own frequently brilliant texts into the gaps and absences left by the writings they purport to read.

All these versions of literary theory, even deconstruction, move boldly beyond the text (the text, that is, in the traditional, formalist, New Critical sense) in ways that René Wellek and Austin Warren once famously denounced in *The Theory of Literature* as "extrinsic." Deconstruction in some of its avatars may be a continuation of New Critical formalism, but Derrida and other practitioners of it take the entire philosophical—not just literary—tradition as their field. And Marxist and feminist theories are obviously forms of political, not just literary, discourse, while psychoanalytic approaches open onto larger, beyond- or perhaps post-

literary questions about creativity, interpretation, and the social construction of "subjects" or "subjectivities." These passages beyond the text or even beyond literature by supposedly literary critics are clear challenges to traditional ways of understanding the humanities disciplines. They are also all movements in the direction of a cultural politics that aims to overcome the disabling fragmentation of knowledge within the disciplinary structure of the university, and in some cases also to overcome the fragmentation and alienation in the larger society which that structure mirrors. In these ways most versions of literary theory point in the direction of a unified, inter- or anti-disciplinary theory and practice that, for lack of a better name, is now often called cultural studies.

The subversion first of religious authority and then of the authority of *Kritik* or the Enlightenment faith in reason and science are themes underlying much recent theorizing about a sweeping, fundamental shift in the cultural organization or "paradigm" of western civilization. The heralds of "postmodernism" often claim to know that we have moved beyond the "philosophy of the subject" to new forms of knowing. The "dialectic of enlightenment," the "twilight of individualism," the "death of the subject" or of reason—these themes obviously also announce the present crisis, at once academic and grandly historical. Catherine Belsey makes the point clearly in relation to literary theory:

> Post-Saussurean work on language has challenged the whole concept of realism; Roland Barthes has specifically proclaimed the death of the author; and Jacques Lacan, Louis Althusser and Jacques Derrida have all from various positions questioned the humanist assumption that subjectivity, the individual mind or inner being, is the source of meaning and of action. In this context the notion of a text which tells a (or the) truth, as perceived by an individual subject (the author), whose insights are the source of the text's single and authoritative meaning, is not only untenable but literally unthinkable, because the framework which supported it . . . no longer stands. (Belsey 3)

Because cultural studies has been defined, by Richard Johnson and others, as the investigation of how our individual "subjectivities" are socially constructed (Johnson 45, 62), it will be necessary to consider whether and how such an investigation also contributes to the demise of "the philosophy of the subject" (or, in Jacques Derrida's terms, to the demise of western metaphysics). Is cultural studies another humanism? Or is it, like Foucauldian poststructuralism and Althusserian Marxism, an anti-humanism? My own answer is mixed: cultural studies is anti-individualist or anti-subjectivist because it locates the sources of meaning not in individual reason or subjectivity, but in social relations, communication, cultural politics. The stress on culture implies the social construction of meanings, *but it also implies* the existence of forms of political or communal reason transcending individual subjectivity. Yet this transcendence is materialist, not idealist:

perhaps the best short definition of cultural studies besides Johnson's is Raymond Williams's of "cultural materialism": "the analysis of all forms of signification, including quite centrally writing, within the actual means and conditions of their production" (*Writing* 210).

The deconstructionist problematic of reason undermining reason is, of course, not solved by Williams's definition. Reason (and therefore some version of Kantian critique, though a "postindividualist" one) remains central to cultural studies, in a way perhaps similar to psychoanalysis. Freud can be said to have helped cause the "death of the subject" by revealing the internal conflicts, fragmentation, and irrationality of the individual. But he did not therefore abandon reason or the perspective of the "knowing subject": that remained crucial— indeed, all the more crucial given the problem of achieving self-understanding by a basically irrational self. And despite its focus on the (singular) self, psychoanalysis turns introspection into dialogue between analyst and patient and treats self-formation as a social process, at least within the family. This is why Habermas, in *Knowledge and Human Interests* and elsewhere, takes psychoanalysis as one model for "communicative reason," the name he gives to all forms of authentic knowledge. With its emphasis on achieving social reason, cultural studies remains humanistic, though it may also prove to be, as Johnson suggests, a "post-post-structuralist" movement (69). Perhaps cultural studies and not a self-defeating or self-deconstructing poststructuralism will be the characteristic form of postmodern radical intellectual work—after or (much more likely) during the crisis.

Discovering the Footprints of the "Cultural Text" in the U.S.

In a recent deconstruction of deconstruction (itself a highly fashionable sub-genre of current literary theory), Robert Scholes remarks: "The powerful appeal that Derridean thought has had for American literary critics has its emotional roots in a cultural reflex of sympathy for the outlaw." This outlawry offers, Scholes thinks, a "profound attraction" to a new freedom, an "exhilirating escape from stifling rules and responsibilities" especially attractive to "the generation whose sensibilities were shaped by the sixties" (including Scholes). "Political radicalism may thus be drained off or sublimated into a textual radicalism that can happily theorize its own disconnection from unpleasant realities" (Scholes, "Deconstruction" 284–5). Similarly, Gerald Graff laments the widespread illusion among younger American academics (and the same holds true for their British counterparts) that highly specialized, in-house expressions of presumably radical ideas are somehow equivalent to political acts, with power to influence the real (that is, the nonacademic) world. "In the last decade, virtually every phase of American literature has been reinterpreted in political terms" (Graff, "American

Criticism" 109). The same is true of all literature. A "more-radical-than-thou" competitiveness masks the actual powerlessness of many soi-disant radicals; political rhetoric (of a theoretical sort) gets louder without any real politics going on. While it is obviously not a good idea to throw a bomb into a university administration building, both Scholes and Graff suggest that the appeal of literary deconstruction—to name just one supposedly "radical" literary theory—is the therapeutic one of throwing imaginary bombs into revered literary texts (and hence, into the humanities as a whole): "It does people good to feel radical and go around deconstructing things" (Scholes, "Deconstruction" 285).

There is enough truth in Graff's and Scholes's amusing accounts to make it difficult to find anything like a radical politics in most literary theory, especially deconstruction. They both know, moreover, that the ultimate irony is that deconstructionist theory has been put to highly conservative use, at least in American literary criticism. It has been a way for Paul de Man, Geoffrey Hartman, J. Hillis Miller, and other eminent deconstructors to reclaim the legacy at least of formalist criticism, if not exactly of the "intellectual authority" and "great tradition" that Bennett defends. "Saving the text," to quote one of Hartman's titles, and not sabotaging it has been the goal. The recent revelation of de Man's collaborationist writings during the Nazi occupation of Belgium makes it even more difficult to claim a connection between deconstruction and some version of radical politics (see Derrida, "Paul de Man's War"). According to Frank Lentricchia (writing well before the revelations about de Man's 1940–42 journalism):

> American post-structuralist literary criticism tends to be an activity of textual privitization, the critic's doomed attempt to retreat from a social landscape of fragmentation and alienation. Criticism becomes, in this perspective, something like an ultimate mode of interior decoration whose chief value lies in its power to trigger our pleasure and whose chief measure of success lies in its capacity to keep pleasure going in a potentially infinite variety of ways. (*After* 186)

But debunking the conservative tendencies of deconstruction is not much different from debunking its would-be radicalism or outlawry. In neither case are the claims of theory much diminished; instead, both moves point to the need to theorize about the relations between knowledge, politics, and society—indeed, both moves are versions of such theorizing, though not complete ones. The logical difficulty in Scholes and Graff is that an attack on the pseudo-politics of literary theory is itself a form of political critique. How can such an attack avoid being also pseudo? Perhaps by making more sweeping political claims? Whatever the answer, Graff's discussion of academic pseudo-politics points beyond the university to larger social issues:

> Marx's account of the fetishism of commodities very much looks forward to twentieth-century consumerism, in which traditional alignments between class

and ideology have been so radically overturned that would-be subversive ideas and imagery have themselves become fashionable commodities. Revolutionary ideas are picked up lightly, worn for a season, and disposed of when next season's models come in. The very profusion and confusion of ideas simultaneously competing for attention ensures that many, if not all, viewpoints will be tolerated while few have much impact. Only direct attacks on private control of production and on economic inequality appear resistant to easy "co-optation." (Graff, "American Criticism" 94)

Marcuse said much the same thing in the sixties when he spoke of the co-optation of radical ideas and countercultural trends by the "one-dimensional society." In fairness to Graff, though he complains about academic pseudopolitics, he knows that he cannot not make political judgments himself: he too understands that culture (including literature) is inherently political, so the question becomes, In what sort of politics should (and can) academic literary critics engage?

Most analyses of the current crisis in the humanities at some point turn to marketing considerations, if not always, as in Graff, to commodity fetishism. To cite one more example, in *The Crisis in Criticism* (1984), William Cain deplores "our damaged state." He has little to say about radical students, but he is nevertheless certain that marketing considerations have been a cause of the crisis—he worries about the "commodification of criticism" and the "proliferation of pseudo-projects" in English departments. Cain berates his colleagues for their "constant movement away from the center, as commentaries upon commentaries multiply" (xiii). What once seemed the well-defined category of literature has been swallowed up by an omnivorous textuality and an equally omnivorous historicism. Instead of talking about the classic texts, critics now talk about each other and about new, apparently nonliterary theories. Rather than discourse about discourse, now we are getting discourse about discourse about discourse. But Cain himself is adding to this third-hand sort of discourse: the texts he analyzes are by E. D. Hirsch, J. Hillis Miller, Stanley Fish, and so on—writers surely not central to anybody's canon of literary classics. Like Graff, in short, Cain does the thing to which he objects.

The proliferation of "pseudo-projects" that Cain both deplores and participates in suggests the paradox that theorrhea is at once the crisis and that which parasitically thrives on crisis. Among the pseudo-projects Cain counts "the elaborate and glowing expositions of Derrida, the earnest if misguided attempts to make literary study 'Marxist'. . . , the jargon-filled inquiries into the densest meditations of Lacan" (xiii). But just how much damage have these projects caused, given Cain's opinion that they are pseudo? On the one hand, Cain offers the view that new theories are breaking the disciplinary boundaries of a previously self-contained, rational field of study. On the other, he offers the exactly contrary view: "The boom in literary theory has . . . altered the curriculum only in marginal

ways. Our discipline remains fundamentally intact. . . . Deconstruction helps to supplement techniques of close reading; Derrida, Barthes, Foucault, and others are added to the list of figures examined in 'theory and criticism' courses; a few inter-disciplinary programs have emerged—this is about all we can point to." So the signs of the times pointing to crisis also point to boom (or, theorrhea is both crisis and boom) *and* to business as usual: "The basic shape of English studies is unchanged" (xii).

I don't deny that this is an accurate description of the impact of theory⁻ on most English departments in the U.S. and elsewhere. But it is more than a little inconsistent for Cain, like Graff and Scholes, to speak of deconstruction as "a hot commodity" now "in demand," and to add that "it attracts . . . many critics because it gives the thrill of political talk without the problems and responsibilities that any actual politics would bring" (*Philosophical* 15). The inconsistency is especially apparent when Cain makes his own pitch for a new sort of criticism that would move beyond the text at least to the "micropolitical" level of the analysis of institutions, for "the institution largely controls and orders us, and not the other way around" (15). But what next? Cain does not believe academic disciplines need any radical reshaping. Although his conclusion sounds "risky," its actual political tendency is vague: "We will always be interpreters of texts, but to renew our discipline . . . we ought not to confine our attention to the text alone. Instead we should attempt, I believe, to realize larger, if more demanding and risky ambitions" (15).

This sounds like the sort of rhetoric university administrators indulge in during commencement ceremonies. What would it mean to go beyond the text in Cain's terms? What are the "risky ambitions" he wishes to realize? Having criticized the pseudo-politics of their colleagues, what do Scholes and Graff recommend in the way of a genuine political practice for literary critics and humanists? As does Lentricchia in *After the New Criticism,* Cain invokes Foucault, whose analyses of institutions, disciplines, and discursive practices seem to call for radical resistance to patterns of cultural domination (*Crisis* 256–7). But Cain's definition of literary criticism as in itself an institution allows him to evade the more radical—that is, political—implications of Foucault's work, and to return to literary criticism almost as usual, albeit with a greater emphasis upon historical contextualization and the political themes in the texts he analyzes. Yet how can such contextualization resolve the "crisis in criticism" Cain diagnoses?

Despite his ironic comments about other people's pseudo-politics, Graff's solution in *Professing Literature* and elsewhere is more definitely political than Cain's. Graff is willing to imagine the restructuring of academic departments and disciplines. And he understands that merely adding contexts to texts as what literary scholars ought to study would indeed leave "the basic shape of English studies . . . unchanged." For Graff, radical (literary) theory has its uses: "Current radical critiques of academic literary studies have effectively exposed the preten-

sions of 'unproblematic' appeals to literature itself, and my analysis often echoes them." He cites Eagleton and Foucault as two critics of institutions as well as of texts with whom he at least partially agrees, and adds: "Like certain deconstructionists, I am concerned with the way idealizations such as 'humanism' have functioned rhetorically to mask the conflicts that constituted them" (*Professing* 11). But once the unmasking of literary and humanist pretensions has occurred, what should the next step be?

The concluding section of *Professing Literature* is called "Teaching the Cultural Text," and here Graff echoes Scholes's *Textual Power,* as well as what he takes to be the main message of literary theory in general: "Current literary theory constitutes a sustained effort to overcome the disabling opposition between texts and their cultural contexts. . . . If there is any point of agreement among deconstructionists, structuralists, reader-response critics, pragmatists, phenomenologists, speech-act theorists, and theoretically minded humanists, it is on the principle that texts are not, after all, autonomous and self-contained, that the meaning of any text in itself depends for its comprehension on other texts and textualized frames of reference" (256). Likewise, Scholes writes that interpretation always involves connecting a text with what lies beyond that text—with "a larger cultural text, which is the matrix or master code that the literary text both depends upon and modifies. In order to teach the interpretation of a literary text, we must be prepared to teach the cultural text as well" (*Textual* 33). And if that is so, then something like cultural studies becomes necessary to show us how to teach the cultural text.

In "The University and the Prevention of Culture," Graff voices his dissatisfaction with the academic division of labor that has blunted social criticism in part by keeping "professors isolated and thus incapable of coming into conflict" even among themselves, and in part by isolating them also from the public (Graff and Gibbons, 70). One aim of cultural studies should thus be the counterdisciplinary one of breaking down intellectual barriers to culture and forging new patterns of intellectual and political critique both within and outside the university. A renewed cultural criticism ought to look beyond the isolated text to the creation of oppositional forms that are simultaneously academic and public, literary and political. Culture in this context means both literature and politics, or the recognition that the two are inseparable. And it is in the British cultural studies movement that Graff finds an approximate model for what he wants. Specifically invoking cultural studies as "conceived and practiced by Raymond Williams" and in some British universities, Graff calls this "a more inclusive model" for work in the humanities than any now offered by the traditional disciplines, and declares: "The starting point should be the recognition that the broad consensus which underlay traditional liberal education no longer exists, and that reestablishing coherence is now necessarily a matter of dramatizing exemplary conflicts and controversies rather than expounding the received great books, ideas and traditions" (80).

Reinventing Cultural Criticism

For literary humanists, the move toward cultural studies perhaps begins with the realization that reading the isolated "classic" or "great book" is not possible without also reading the larger "cultural text" into which it fits. But just what is this cultural text? Who writes it? How can it be read? Where is it located? Is it something like a gigantic library (conveniently located on a college campus), containing all the other texts ever written? This would suggest not much more than an expanded version of the literary canon or tradition, and Scholes and Graff mean more than that. I agree fully with their central perception: no text contains meanings the way an apple contains seeds; meanings are generated in communicative relations; the understanding of a text always depends on what lies beyond it, on contexts, including "the reader." But it's also the case, as Graff points out, that the idea of "contextualizing" is by itself no solution to the crisis in the humanities. For one thing, if deconstruction has made it problematic even to define a text, then that must be even more true of "context." And "to speak of literature and context is already to risk separating the two" (Sinfield 3). According to Derrida's famous dictum, "there is nothing outside the text" (*Of Grammatology* 158), which seems either to transform reality into a gargantuan book, or else to dismiss reality in favor of an ordinary book. But assuming (commonsensically) that there *is* something beyond single texts (other texts, at least), and that we can call this something "contexts," then how do we go about studying it? Is the appropriate context for understanding, say, *Middlemarch,* the Victorian past in which George Eliot wrote it, the pre-Victorian past in which the story takes place, or the present in which we read it? Or is it all of these, together with the history of its reception from Eliot's time to our own (in which case, imagine a variorum *Middlemarch,* containing all the variant readings)?

Calls for more and better contextualization in literary studies are certainly one symptom if not a cure for the current crisis in the humanities. Sometimes these calls seek little more than a return to old-fashioned historical scholarship. There is nothing wrong with this: despite attacks by deconstructionists and others on history, empiricism, reference, and seemingly plodding kinds of research, history will always be an absolutely essential activity. But calls for more contextualization also often lead, as with Graff, to ideas of interdisciplinary or counterdisciplinary ventures for which "cultural studies" is now a common but perhaps fuzzy umbrella term. And "contextualization" usually also means politicization, with its accompanying thought that all forms of cultural work are ideological or at least not "value-free."

Partly the trend toward cultural studies—whether in the U.S. and Canada or in Britain—springs from a rejuvenated Marxist literary theory, paradoxically more flourishing in the neoconservative eighties than it was in the radical sixties. But Marxist theory flourishes partly because it is the one tradition in which the

relations between literature and society have been vigorously and continuously thought. When Fredric Jameson, the most influential Marxist literary critic in the U.S., writes that "the political interpretation of literary texts [is] not . . . some supplementary method" to other kinds of criticism, but is instead "the absolute horizon of all reading and all interpretation" (*Political Unconscious* 17), he is only expressing what all literary critics and humanists have known or suspected all along. The generation of meanings between author and text, text and reader, reader and author is inescapably social (therefore political, therefore ideological). And therefore also the most valuable literary criticism will illuminate not just the "esthetic" or "formal" properties of texts, but—inseparable from those properties—their "politics."

Echoing Jameson, John Brenkman writes that "the most valuable literary criticism contributes to social criticism" (vii). And in *The Political Responsibility of the Critic,* Jim Merod writes that criticism needs to break out of its disciplinary isolation and its exclusive focus on the literary properties of texts to a wider political practice: "criticism . . . can oppose . . . cultural domination by intellectual practices that obscure social reality and thereby advance capitalist hierarchies and the power of the state. Criticism can expose its own affiliations with the institutional and ideological organization of public space and use its considerable social leverage to promote the political solidarity of demoted cultures and disfranchised people" (3). That, at least, is the hope behind a lot of the supposedly pseudo—that is, powerless—radicalism of literary theory today. Jameson, Brenkman, and Merod all voice the familiar calls for political relevance and radical social change common to Marxist and New Left literary criticism. At the same time, they also voice the now quite widespread desire for a new cultural politics that will help bridge the gap between theory and practice not only in the humanities but in society at large. They thus join with feminists, Afro-American and Ethnic Studies scholars, Foucauldians, deconstructive and hermeneutic "radicals," discourse theorists, and "critical" social scientists in seeking ways to make operative the humanistic and democratic values often expressed in literature and the arts and seemingly housed (incarcerated?) in the disciplinary institutions of higher education.

For some, "cultural studies" signifies a hopefully liberating practice that would, as a first step, unlock what the traditional disciplines now imprison. Thus, in a recent issue of *Works and Days,* Evan Watkins and the other contributors express the wish to develop a new "counterdisciplinary" and "counter-hegemonic" practice within the university that would focus on all forms of ideology and cultural representation or misrepresentation. They want to "transform . . . literary criticism into a more politically self-conscious cultural criticism" (Watkins 7). Alan Trachtenberg writes in his contribution: "Rather than sharing a subject matter with literary criticism, cultural criticism can be said to de-reify that subject matter, bursting through disciplinary boundaries in order to recover the text both as social

experience and as social knowledge" (37). Trachtenberg considers his form of intellectual work to be "critical cultural history" (see his *The Incorporation of America* for an example) and to aim ultimately at more than just the creation of "a vanguard oppositional consciousness" (but it isn't clear from his contribution just what this "more" would consist of).

Henry Giroux and three co-authors express similar ideas in "The Need for Cultural Studies," which appeared in 1985 in *Dalhousie Review*. They argue that the traditional disciplines are arbitrary and hermetically sealed both from each other and from the larger society. Perhaps more controversially, they also argue that merely "interdisciplinary" programs—"American or Canadian Studies, Womens Studies, Black Studies, etc."—have been failures. What is wanted is "a counter-disciplinary praxis" that will put the fragmentary, over-specialized or over-disciplined pieces of "culture" together, and that will help to construct an "oppositional public sphere" of "resisting intellectuals." This "counter-disciplinary praxis" they name, following the British example, "Cultural Studies." But feminists and Afro-Americanists usually think of their work as "counter-disciplinary" and "oppositional." If their forms of teaching, research, and politics have "failed," that may be less a function of what they say and do than of the ways academic "disciplining" marginalizes them and muffles their voices. In any event, they too, like Giroux and his co-authors, seek practices both in and beyond the classroom that will be socially critical and liberating. All of the individuals and groups I have mentioned would, I think, agree with Edward Said's comment in *The World, the Text, and the Critic:* "Were I to use one word consistently along with *criticism* . . . it would be *oppositional.*" And the object of "oppositional criticism" is not the literary text, but all forms of cultural representation and domination (Said's *Orientalism* is a key example of such criticism), and "its social goals are noncoercive knowledge produced in the interests of human freedom" (*World* 29).

As Richard Johnson suggests, these tendencies toward cultural studies as oppositional criticism, focused beyond the narrowly literary on the cultural or social text, have some claim to be postmodernist forms of intellectual work. Jonathan Arac, Paul Bové, and several other contributors to *Postmodernism and Politics* make the same point. In his introduction to this anthology, Arac writes:

> The crucial contemporary agenda is elaborating the relations that join the nexus of classroom, discipline, and profession to such political areas as . . . gender, race, and class, as well as nation. . . . The current movement from "literary" to "cultural" studies, from "literary criticism" to "criticism," shows this direction Postmodern critics . . . can carry on a significant political activity by relating the concerns once enclosed within "literature" to a broader cultural sphere that is itself related to . . . the larger concerns of the state and economy. (Arac xxx)

Arac thus joins the many recent literary theorists who advocate a shift away from merely literary to cultural studies (among others, see Herron, Sprinker, Ryan, and the anthologies edited by Nelson and Grossberg and by Angus and Jhally). But postmodernism here, as in other ways, may mean a casting back to older, perhaps pre-modernist cultural forms. At times, the advocacy of cultural studies seems to express not much more than the desire to make intellectual work politically "relevant" (that sixties keyword) by renewing a quite familiar type of cultural criticism. In *The Function of Criticism,* Eagleton argues that the movement to reconnect literary with political and social criticism involves the restoration of criticism to its traditional (eighteenth-century!) patterns and uses. In *The Failure of Criticism,* Eugene Goodheart mourns the passing of explicitly Arnoldian, humanistic kinds of discourse that treated literature as necessarily connected to the health of the social organism and the progress of civilization (though Eagleton argues, rightly I think, that literary and social criticism were already becoming separated, specialized genres and disciplines by Arnold's time). And in *Lionel Trilling and the Fate of Cultural Criticism,* Mark Krupnick also calls for the resurrection of an older type of cultural criticism. After listing a dozen varieties of criticism, ranging from phenomenology and semiotics to "Derridean-Marxist-feminist" approaches, Krupnick declares: "What is in short supply is a kind of writing that once was the dominant tendency in American literary studies: cultural criticism" (1). But all of the criticisms Krupnick lists at least aim to be forms of cultural criticism. Even deconstructionists—perhaps especially deconstructionists—despite their insistence that "there is nothing outside the text," constantly make large pronouncements about the social reality beyond the text (including sometimes, perversely, the assertion that such a reality is inaccessible, like the High Court in Kafka's *The Trial*).

Perhaps the least sympathetic interpretation of the deconstructive questioning of "representation" or "reference" is that it makes it impossible to escape from the isolated literary text (or even less sympathetically, makes it impossible to say anything at all). But surely there is a difference between a *single* text and that *general* textuality which is synonymous with culture. "The prison-house of language" contains infinitely more room than the prison house of, say, "Ode on a Grecian Urn." No doubt the text in Derrida's remark, as he himself has claimed, also means the larger cultural text to which Scholes and Graff direct our attention (see Derrida, "But, beyond," and also Norris 54–55). Certainly the apparent assault by deconstruction on all forms of representation can be construed not as an assault at all, but as a dramatic—perhaps melodramatic—assertion of the inescapability of representation, of culture. Arac for one seeks to claim Derrida and deconstruction for postmodernist cultural studies when he writes that "Derrida simply does not attack representation; even where he may be quoted to this effect, he has more to say on the matter" (xxiv-xxv). Arac cites Derrida's *Speech and Phenomena* as arguing that the recognition of representation is the antithesis of "the metaphysical fantasy of

pure presence." Arac points out that Derrida uses the key term "trace" "to elucidate the 're' of representation as part of the most fundamental structure of repetition," one even more "primordial" than the seeming givenness or immediacy of being. "Representation is an inescapable aspect of the human condition; in this sense, indeed, there is no hors-de-texte" (xxv). And in this sense, too, deconstruction, like structuralism before it, has not so much made it impossible to escape from a narrow focus on individual poems and novels as it has made it impossible *not* to focus on the question of representation or culture in general. Thus one effect of both structuralism and deconstruction has been similar to the influence of Marxist and feminist theories in shifting literary criticism in the direction of cultural studies, if by such studies we mean—to quote Williams again—"the analysis of all forms of signification, including quite centrally writing, within the actual means and conditions of their production."

What other reasonable meaning can possibly be attached to the dictum that "there is nothing outside the text" except that there is no escape from culture, from our destiny in social and political representation and self-fashioning? Yet the political thrust of deconstruction has remained vague, contradictory, or under-developed. As Michael Ryan declares, deconstruction's lack of a social theory "is not an extrinsic or accidental oversight but an intrinsic fault, because decon-struction points toward the possibility and necessity of such theory without ever providing one. Deconstruction describes the logical or structural necessity of turning such metaphysical principles as consciousness, ideal meaning, presence, and nature inside out and into a 'social text' " (Ryan 35). Ryan's theme is precisely how to give deconstruction its appropriate social theory, and this he finds in Marxism. Indeed, examples of this paradoxical union of seeming opposites—Marxism with deconstruction—can be found in many recent attempts to forge an expanded literary criticism that would also be cultural or social criticism, and perhaps a form of political intervention in the larger society as well. But for many radical theorists in the eighties (no longer the sixties), the key question is not whether anything can be gained by yoking together Marxism and deconstruction, or any other set of seemingly incompatible theories. The question is instead, What are the social forces that have prevented the general democratization and humanization of society? What indeed has thrown the humanities "into their worst state of crisis since the modern university was formed," and how can we move beyond that crisis to "recovery"? With the question, at least, both radical theorists and neoconservatives like William Bennett agree.

American Studies as Cautionary Example

Calls to reinvent or resurrect an older cultural criticism suggest that there may be many precedents for cultural studies. Furthermore, the claim by Henry Giroux and his colleagues that various forms of interdisciplinary work—Women's, Afro-

American, Canadian, and American Studies—have failed to produce the genuinely "counter-disciplinary praxis" they identify with cultural studies deserves scrutiny. But Women's and Afro-American Studies have of course been oppositional, in some ways counterdisciplinary, and more successful than Giroux recognizes (I will say more about those "fields" in the chapter on class, gender, and race). I agree, however, that American Studies "should be regarded as a cautionary example to those who would try to establish Cultural Studies as an interdisciplinary enterprise within the academy" (Giroux et al. 476).

The American Studies movement was in part a response to the disciplinary bureaucratization and fragmentation of higher education in this century. Because many of its leaders were literary scholars, it was also a response to the New Criticism, with its insistence on the autonomy and formal structure of poems and artworks (see Henry Nash Smith in Kwiat and Turpie 9). The desire to unite the various humanities and social science disciplines in a single program and the desire to see American culture as an evolving totality went hand in hand. Because the typical combination of disciplines emphasized history and literature, the results often looked not much different from a quite traditional literary history format, focused on the U.S. But the aim was different, at least in its initial political agenda. Yet this aim was, as Giroux and his colleagues note, far less oppositional or critical than nationalist and celebratory—an academic cultural chauvinism.

Such a nationalistic purpose emerges clearly from Tremaine McDowell's account of the establishment of the American Studies program at the University of Minnesota, starting in 1945. McDowell describes this program as one of the first and also, "at the moment [1948], the most extensive in the country" (70). The basic theme of the beginning course, "American Life," was "the unity within diversity, the diversity within unity which characterize life in the United States." If this sounds suspiciously like theological language about the trinity, that is generally true of the American rhetoric of unifying the plural and harmonizing differences. McDowell recognizes, however, that another name for diversity is conflict: "Under unfavorable circumstances its diversity sharpens into violence; where differences are reconciled the life of the nation is deepened and enriched" (72). So the "life" is that of the nation rather than of its individual pieces (regions, states, classes, races, citizens, etc.), and the paramount value is unity rather than potentially violent differences. At the same time, McDowell argues, American Studies promises to reconcile the different disciplines (too far apart, too specialized) and also "the tenses"—past, present, and future. And he contends that "nowhere in the liberal arts is there a better hope than in American Studies for bridging the unnatural gulf which separates the campus from the world outside" (32). Thus, wherever there is division in "American life," the American Studies movement aims to bring the opposed sides together: the ultimate goal is social harmony.

McDowell simultaneously sings the praises of American Studies (good also for students who desire meaningful, interesting employment after graduation) and of "American life," frequently quoting Whitman to underscore his patriotic/democratic/liberal message. Other early accounts of the American Studies movement are similarly patriotic and upbeat. Except for the idea that the traditional disciplines need to be supplemented with an interdisciplinary approach that offers a holistic vision of "life" in the U.S., there is little in these accounts that could be called critical, oppositional, or radical. Even the charge that the traditional disciplines are too confining is little more than an academic commonplace—the founders of American Studies were far removed from the sort of demand for a "counter-disciplinary praxis" made by Giroux and his coauthors. Here is how McDowell describes the relation between American Studies and the traditional disciplines:

> It should now be clear that our long-established courses . . . in the social sciences (dealing chiefly with the present) and those in the humanities (dealing predominantly with the past) can profitably be supplemented *but in no sense supplanted by* . . . new courses which synthesize past and present as do American Studies. Essential in any such undertaking are the two academic disciplines in which the past is most important, history and literature. But if a program is to unite the tenses completely, it cannot safely be centered in . . . these departments. . . . Neither, for the opposite reason, can it be centered in the social sciences. Rather it must strike a balance between all the relevant humanities and . . . social sciences. (10; my italics)

Once more, "balance" or a unity which minimizes conflict is McDowell's liberal goal. He closes his call for interdisciplinary unity, harmonizing the tenses, by quoting Whitman: " 'I accept Time absolutely.' "

Not all the early accounts of the American Studies movement are quite so rosy as McDowell's, but it is nevertheless the case that, if one had to choose half of *e pluribus unum* for its motto, that half would be *unum*. The desire to see "American life" steadily and see it whole was generally a liberal and patriotic one. At the same time, that desire led to an emphasis on a number of holistic terms to describe the (hopefully) unified and unifying subject matter of the new field. Besides "American life," "culture" was an obvious choice. As the editors of *American Quarterly* announced in their first issue in 1949, the American Studies movement aimed to "give a sense of direction to studies in the culture" of the U.S. And in an early essay in the same journal, Richard Sykes defined the movement as promoting "the study of American culture. Culture is the key concept, the unifying concept . . . [American Studies] is a . . . branch of cultural anthropology" (254). According to H. Stuart Hughes, "by the late 1950s, a number of historians were at last ready to endorse the view that the widest and

most fruitful definition of their trade was as 'retrospective cultural anthropology' "
(Hughes 24).

Other holistic (and, unless qualified, implicitly unifying) terms also emerged.
In *The Search for a Method in American Studies,* Cecil F. Tate declared the new
interdisciplinary field to be characterized by "holism and myth" (7). To define
holism, he also turned to anthropology, quoting Robert Redfield's explanation of
how "a culture or a personality" can be grasped " 'by an effort of comprehension
which is not analytic, which insists on a view of the whole as a whole' " (11).
And the stress on culture as well as on seeing things whole leads Tate to espouse
a form of social organicism: culture, he says, is "a functioning independent
structure like an organism, exhibiting many of the characteristics of human
personality and life" (13). The old, usually conservative idea of society as
organism reinforces the "life" of the nation as the main subject of American
Studies. Faintly echoing Hegelianism, it also points to progressive evolution as
the narrative pattern or teleology of this main subject. And whatever seems to
give that "life" characteristic expression—notably, literature and the arts—is
accorded privileged status. These emphases in turn echo the early nineteenth
century search for an American literary identity—the U.S. version of what Jerome
McGann has called "the romantic ideology," reinforcing notions of high culture,
the unity of the text, and the heroics of great authors.

Such were the guiding principles of the "myth and symbol" school of American
Studies. As Tate points out, by "myth" the early practitioners of American
Studies—Roy Harvey Pearce, Henry Nash Smith, R. W. B. Lewis, and others—
meant any widely diffused idea or theme expressive of the "life" or "mind" of
the nation—again, close to some anthropological definitions of myth and culture.
Of course "myth" often refers to irrational forms of social delusion (its most
common meaning in a secular age), and in this way it tends to merge with the
concept of ideology. But whereas "myth" has frequently retained a religious
connotation, "ideology" commonly refers to secular political beliefs. The stress
on myth thus involves a political ambiguity not shared by ideology. That is,
"myth" can be used in demystifying critiques of social illusions, virtually as a
synonym for "ideology"—this is how, for example, Roland Barthes uses it in
Mythologies. Or in an older, less critical and more conservative inflection, "myth"
can be used neutrally—even reverently or patriotically—to refer to essential,
characteristic cultural forms (though ones which, no doubt, the wise scholar can
see through or beyond). Tate cites Ernst Cassirer's definition of myth as " 'the
primary cognitive form under which all reality is viewed' " by any society. By
such a definition, "myth" is thus both universalized and deprived of its critical
edge as illusion or false consciousness—it is instead *the* fundamental form of all
knowing, all consciousness.

The ambiguity of "myth" is, however, a problem partially shared by every term
aiming to capture a social totality. "Culture," "ideology," "history," "society" all

involve similarly totalizing—and critically disabling—connotations. Assuming that you consider it politically useful and/or scientifically necessary to criticize an entire society or culture, from what standpoint can you do so? If you belong to that society or culture, what tools will allow you to achieve a perspective external to or transcending its limits? This question has been central to the tradition of the *Geisteswissenschaften* or "human sciences" from at least the time of Wilhelm Dilthey forward. But no such epistemological difficulty troubled most of the early practitioners of American Studies, in part because they weren't interested in transcending those limits—that is, they did not conceive of their work as oppositional criticism. "Myth" was less a term of demystification than of celebration; it did little more than measure the elitist distance between academic and "popular" forms of American culture. The individualism of Thoreau's *Walden* or of Whitman's "Song of Myself" could be interpreted both as myth and as a central, acceptable tenet of American liberalism, one of the building blocks of freedom (supposedly this political terminology is also "objective" or "value-free," or at least the values it expresses were felt to be the correct ones, needing no elaborate defense).

But once liberalism was challenged—especially when, along with the humanities and social sciences, it fell into crisis in the 1960s—the old terms no longer worked automatically. The myth and symbol school did offer a more historical, more "contextualized" view of American literature and culture than the New Criticism could provide. As Graff points out, "Though sweeping assertions about loss of innocence and the machine and the garden can become examination cliches just as cheaply arrived at as any close readings of isolated works, some cliches are more productive than others, particularly when the alternative to a simplistic overview is usually no overview at all" (*Professing* 224). But its presentation of various American myths—"the virgin land," "the American Adam," and so forth—was far removed from the sort of oppositional criticism Said, for example, recommends and practices.

This is not to say that American Studies variants on the theme of nation-building went unchallenged, especially in the sixties. Perhaps F. O. Matthiessen is the most frequently cited figure who was both pioneer of the American Studies movement and radical social critic. A Marxist or Marx-influenced tradition in American literary criticism is also evident in the work of Granville Hicks, Edmund Wilson, Kenneth Burke, Irving Howe, and others (see Wald). And work in history and the social sciences was often oppositional in the sense Said means. I am thinking, for instance, of C. Wright Mills's *The Power Elite* (1956), Paul Goodman's *Growing up Absurd* (1960), William Appleman Williams's *Tragedy of American Diplomacy* (1962), and the line of labor and slavery historians stretching from Philip Foner and Herbert Aptheker to Herbert Gutman and Eugene Genovese.

For the most part, however, such oppositional writing was not a product of

American Studies programs in the universities. But at least three factors gradually altered the early, generally patriotic emphasis of the American Studies movement. One is what happened in the sixties, especially the anti-Vietnam War, civil rights, and women's liberation movements (the last two, at least, still, *pace* William Bennett, unfinished business). Obviously liberalism, patriotism, and humanism of even the most heavily qualified, theorized, academic sort suffered hard blows during the sixties. The second is the rise to academic prominence of literary theory and its offshoots (though again, it has been easier for many academics to scapegoat theory as a cause of crisis than to come to terms with its unsettling questions). And the third is the accelerated "disciplining" of higher education since the sixties, perhaps the main academic response to "marketing considerations." While many recent practitioners of American Studies have been politically more radical than the founders of the movement, bureaucratic marginalization within the university has affected most American Studies programs along with everything else. The chief reason why American Studies has not amounted *either* to the unifying force McDowell predicted *or* to "oppositional criticism" Graff locates in a "dynamics of 'patterned isolation' " whereby any challenging or controversial thesis gets simultaneously rubberstamped and marginalized.

> This is a pattern that has welcomed innovations, but so isolated them that their effect on the [academic] institution as a totality is largely nullified. American literature and culture studies were merely *added* to the existing departments and fields, which did not have to adapt to them, quarrel with them, or recognize their existence to any sustained degree. Their influence has finally been assimilated, but quietly and in uncontroversial fashion. (*Professing* 225)

Graff adds a few more twists of the knife by noting that "a similar marginality overtook other postwar programs organized around cultural history, such as the Committee on Social Thought at the University of Chicago, the Modern Thought Program at Stanford, and the History of Consciousness Program at Santa Cruz." (To these I can add the Victorian Studies program at Indiana University, which I have directed since 1980.) All of these programs at least initially "generated excitement and produced unusually good students, but 'the reorganization of knowledge' implicit in their approaches has yet to become central in the university" (225). Disciplines, as Michel Foucault argues, are techniques of marginalization and exclusion (see, for instance, Foucault, *Discipline* 170–94); therefore "interdisciplinary" programs within the university—perhaps especially those attempting to unify knowledges into some coherent theory or pattern—are themselves subordinated and isolated by dominant discourses just as are class, racial, religous, and sexual "minorities."

The Victorian Studies journal and program, founded in 1957 with the American Studies model partly in mind, has always been "interdisciplinary." For its found-

ers, the aim was "to capture something of the life" of Victorian Britain, and also to overcome the "dangerously narrowing . . . departmental isolation" of academic disciplines. In a 1964 editorial in *VS,* Michael Wolff wrote that the results might be "anti-disciplinary," perhaps a kind of academic truancy, but contended that they might instead be "meta-disciplinary" and "the hope of those who would like . . . in some Darwinian way [to] evolve a new discipline by natural selection among the old." He then declared: "Perhaps it will turn out that . . . the new discipline is cultural history rediscovered" (59). Wolff and his colleagues intended *VS* to be "oppositional," at least in relation to the traditional disciplines, and their academic radicalism carried over to active support of the civil rights, women's, and anti-Vietnam War efforts of the sixties. The connecting themes between the Victorian past and the American present—industrialization, urbanization, democratization, imperialism—were and remain powerful ones. But Victorian Studies never became more than an academic specialty among many other special-ties, a field in which academic specialists specialize and, in a sense, choose marginalization as a way of life.

What Graff concludes about American Studies is thus also true about similar programs throughout higher education in the U.S. Interdisciplinary cultural his-tory has failed to become a centralizing force in the humanities, while an often "attenuated New Criticism of explication for explication's sake" has waxed important in part because it challenged no one and threatened to transgress no disciplinary boundaries. "This explains why criticism had no sooner triumphed in the university after [World War II] than it began to be routinized"—that is, routinized as *literary* criticism, and not clearly as cultural or social criticism (*Professing* 225). But perhaps a similar fate awaits new ventures in cultural studies today.

Graff shares his marginalization thesis with a number of recent practitioners of American Studies. In the anthology of essays edited by Sacvan Bercovitch and Myra Jehlen, *Ideology and Classic American Literature,* the general emphasis is on replacing the less critical term "myth" with the more critical, supposedly demystifying term "ideology." Various pioneers of the American Studies move-ment—Henry Nash Smith, Leo Marx, and others—confess that they were naive to use "myth" and have now been convinced that "ideology" is a better term. Smith's depiction of the exploration and settling of the West in *Virgin Land,* for example, now appears to him too innocent about violence—to native Americans, of course, and to slaves, Mexicans, and others, but also to the land, nature, animals. Thus Smith now believes he neglected the "tragic dimensions of the Westward Movement," in part because these dimensions have been ideologically occluded or mystified by, among others, the early practitioners of American Studies. Citing this and other examples, Bercovitch points to a new "ideological awareness among Americanists" ("Problem" 637). And Jehlen writes that the American Studies movement is now characterized by two developments: "The

first is an increasing recognition that the political categories of race, gender, and class enter into the formal making of American literature such that they underlie not only its themes, not only its characters and events, but its very language. The ideological dimension of literary works has emerged, therefore, as integral to their entire composition." This leads her to the question of "ideological criticism," as opposed to the older "myth and symbol" school of American Studies. The second development has been "the education of American critics in European theories of culture including a complex tradition of ideological theory" (Jehlen 1–3). Thus American Studies is today shifting ground from literary criticism and a patriotic, traditional, wanly Hegelian form of cultural history to kinds of work that try to be oppositional in Said's sense, though whether such work will also be politically effective—in reforming "American life" or just in reforming the curriculum—remains to be seen.

2

Cultural Studies in Britain

Beginnings

The crisis in the humanities in the U.S. and Canada has its parallel in Britain. In "Crisis in English Studies," a lecture delivered at Cambridge University in March, 1981, Raymond Williams applied Thomas Kuhn's definition of a scientific "paradigm" to literary criticism and scholarship, and noted that the orthodox paradigm was in a state of crisis: "as Kuhn argued . . . paradigms are never simply abandoned. Rather they accumulate anomalies until there is an eventual breaking point" (*Writing* 192). More recently, in *Futures for English*, Colin MacCabe contends that the only approach to literary studies in the university which makes sense any longer is through a recognition that "*broken* English" is all we now have in common (3–14; my italics).

The anomalies that have broken English or thrown the orthodox paradigm of literary scholarship into crisis Williams identified as Marxism, structuralism, deconstruction, and other versions of literary and cultural theory. Any wholesale rejection of these, he argued, would be reactionary and futile. Instead, literary scholars at Cambridge, as in every other university, must "ask a hard question: can radically different work still be carried on under a single heading or department when there is not just diversity of approach but . . . fundamental differences about the object of knowledge. . . ? Or must there be some wider reorganization of the received divisions of the humanities . . . into newly defined and collaborative arrangements?" (211). Williams didn't answer this "hard question" directly though Cambridge was then in the process of answering it by refusing to keep MacCabe on the faculty). But throughout his career Williams like MacCabe displayed a "wider" vision that challenged the "received divisions" of academic thought, and the key to that wider vision for Williams was the idea of culture.

In the introduction to another recent anthology of essays which, like *Futures for English*, considers possible ways of refocusing the study and teaching of English, Peter Widdowson writes:

> The "crisis" in English [as an academic field] is no longer a debate between criticisms as to which "approach" is best. Nor is it directly, yet, a question of English Departments being closed down along with other economically unproductive (and ideologically unsound) areas—although in Thatcherite Britain that is all too real a possibility. Rather it is a question, posed from within, as to what English *is*, where it has got to, whether it has a future, whether it *should* have a future as a discrete discipline, and if it does, in what ways it might be reconstituted. (7)

One interpretation of crisis might stress the reaction of the Thatcher regime against educational initiatives begun in the sixties: witness the recent decision to abolish tenure in British universities, part of the more general "attack on higher education" in Britain since 1981 (Kogan and Kogan). According to John Sutherland, since the late 1960s "the British university has undergone a boom-bust cycle" much more traumatic and extreme than anything experienced in North America (Sutherland 133). The most recent cuts may indeed be evidence for Terry Eagleton's view that "the institutions of British higher education simply cannot contain, or sustain, oppositional criticism" (Sutherland 140), though it should be added that, while more expansive, more flexible, and better funded, American higher education also has its limits and enemies.

The Thatcherite account, like William Bennett's in the U.S., blames the crisis on the very initiatives that began the expansion or boom part of the cycle, and more generally on the political and cultural unrest of the sixties. But then there are still other accounts, some written in the sixties, that trace the crisis back even farther, to more fundamental or wide-reaching causes. As early as 1964, in the introduction to an anthology called *Crisis in the Humanities,* historian J. H. Plumb wrote: "the rising tide of scientific and industrial societies, combined with the battering of two World Wars, has shattered the confidence of humanists in their capacity to lead or to instruct. Uncertain of their social function [they] have taken refuge in two desperate courses—both suicidal. Either they blindly cling to their traditional attitudes and pretend that their function is what it was and that all will be well so long as change is repelled, or they retreat into their own private professional world and deny any social function to their subject." In either case, Plumb thought, the result was a "retreat into social triviality" (7–8).

At the moment when Plumb and his colleagues were criticizing the "suicidal" tendencies of the humanities, new practices were emerging that sought to reverse those tendencies. One of these new practices was the historicist, interdisciplinary, and perhaps counterdisciplinary kind of work now commonly called cultural studies. Developing out of the "left-Leavisism" of Williams and Richard Hoggart, the tradition of Marxist historiography associated with Christopher Hill, Eric Hobsbawm, and E. P. Thompson, and the New Left and revived feminism of the sixties, the cultural studies movement in Britain has undertaken forms of teaching

and research that aim both to transcend (or counteract) the established academic disciplines and to serve as progressive political interventions in the larger society. While the practitioners of cultural studies in Britain today sometimes see their work as an answer to the crisis announced by Williams, MacCabe, Widdowson, and (much earlier) Plumb, academic and social conservatives of course charge them with being part of the problem rather than solution.

Cultural studies is a central topic in Widdowson's anthology, particularly in Michael Green's useful account of the origins and work of the Centre for Contemporary Cultural Studies at the University of Birmingham. Green notes that cultural studies has found "only an uneasy lodgement" in British higher education, in part because its relation to the traditional disciplines is one of critique rather than of replication or even comfortable merger in interdisciplinary kinds of work. "Cultural studies has thus not become a new form of 'discipline' " (Green in Widdowson 84). Further, efforts to give the movement theoretical unity through semiotics, structuralist Marxism, cultural materialism, and so forth are "premature" and perhaps inevitably contradictory. This is partly because so much of its work has been collaborative, bringing together people from diverse disciplines and theoretical orientations. Still, Green supposes, even "premature" attempts to theorize cultural studies may be better than treating the new field as a synonym for communications or as "just a 'cover' for a revised and qualified marxism" (84).

Like other accounts of the British cultural studies movement, Green's starts with a group of seminal texts which together in the late 1950s and early sixties represented a "break" both from the traditional academic disciplines and from an orthodox or "economistic" Marxism. "Culture" itself is a term that illustrates the dual nature of this break. On the one hand, for those in literary fields, culture is by any definition a beyond-the-text, if by text is understood a work of literature taken in isolation from history and society—that is, pried loose from its contexts. On the other, the stress on culture—"culturalism," as it is sometimes called— involves a rejection or at least revision of the old base/superstructure paradigm in Marxist theory as well as of the more sharply "causal" and reductive features of other literary and social theories such as psychoanalysis and structuralism.

The cultural studies trend has been away from formalist literary criticism, history, and the isolated social science disciplines toward forms of "ethnographic" analysis. As MacCabe declares in "Broken English," "In many ways the importance of the mid-1960s was . . . the anthropological 'turn' whereby our own culture became an object of study like any other, privileged only by historical accident and not by some immanent qualities. A book like Barthes' *Mythologies* [is] exemplary in this respect" (*Futures* 3). *Mythologies* (1957), moreover, appeared virtually simultaneously with Williams's *Culture and Society* (1958) and with the other founding texts of the British cultural studies movement: Richard Hoggart's *The Uses of Literacy* (1957), Williams's *The Long Revolution* (1961),

and E. P. Thompson's *Making of the English Working Class* (1963). Barthes's focus was on the mass cultural phenomena that make up so much of—perhaps the entirety of—modern social experience. Similarly, in accord with Williams's dictum that "culture is ordinary," the focus of British cultural studies has been on "everyday life" or the structures and practices within and through which modern society constructs and circulates meanings and values. Perhaps reflecting both French and British influences, in *The Practice of Everyday Life* de Certeau traces his own stress on the quotidian back also to Wittgenstein's insistence that *all* language-use is rooted in "ordinary" language-use. In a sentence that might sum up the British cultural studies movement de Certeau declares: "The critical return of the ordinary, as Wittgenstein understands it, must destroy all the varieties of rhetorical brilliance associated with powers that hierarchize and with nonsense that enjoys authority" (13). Some of the "powers" and "nonsense" de Certeau has in mind are connected with the traditional academic disciplines; the turn to "ordinary" culture—and to the idea that "culture is ordinary"—bears with it the promise of a democratic, counterdisciplinary practice of the sort called for by Henry Giroux and his colleagues.

While cultural studies has been influenced by a wide range of literary and social theories, as Green indicates it has not settled into a theoretical orthodoxy or systemization (despite a temporary Althusserian enchantment in the mid-1970s). For some, one virtue of the idea of culture, freighted with a long history of semantic conflict, is its very resistance to theoretical closure and perhaps even to clear definition. "There is no solution to this polysemy," writes Richard Johnson, current director of the Birmingham Centre; "it is a rationalist illusion to think we can say 'henceforth this term will mean . . .' and expect a whole history of connotations (not to say a whole future) to fall smartly into line. So . . . I fly culture's flag . . . and continue to use the word where imprecision matters" (Johnson 43). And Williams, who more than anyone else has given culture its central place on the contemporary intellectual agenda in both Britain and North America, declared that many times "I've wished that I had never heard of the damned word. I have become more aware of its difficulties, not less, as I have gone on" (*Politics* 154).

Together with the publication of the founding texts, and the establishment of *New Left Review* in 1960 and of the Birmingham Centre in 1963 under Hoggart's direction, the new movement was well underway in Britain by the time of J. H. Plumb's annunciation of crisis. In each of the founding texts, culture is a category that transcends or transgresses various disciplinary and theoretical boundaries: literary criticism for Hoggart and Williams, orthodox political and economic history for Thompson, and a mechanical or economistic Marxism for all three. Williams, Hoggart, and Thompson deal with the formation of social classes and class consciousness by stressing the cultural record as of at least equal importance with economic factors. They also seek to reclaim culture for the working class,

"common people," or "masses" as against anti-democratic and, too often, academic definitions that identify culture exclusively with elitist ideals of education, leisure, and esthetic consumption. And their culturalist focus on social class and history is powerfully personal and at times autobiographical (Hoggart's book in particular can be read as a kind of generalized autobiography or sociological memoir, and Williams's novels, starting with *Border Country* in 1960, are also highly autobiographical). In writing about culture, popular radicalism, and the fate of the working class in modern society, Hoggart, Williams, and Thompson all take their own experience as part of the data: as in current ethnography, they are "participant observers" (see Clifford and Marcus, *Writing*). Their insistence on the connectedness of the personal, the political, and the academic—like the insistence by feminism that "the personal is political"—remains a characteristic of cultural studies today.

I will start with *Culture and Society,* because it, more than any other work, set the agenda for cultural studies in both Britain and America by demonstrating how the multiple concepts signified by the single word "culture" arose in key debates about industrialization and democratization. These debates were not separate from literature and the arts, fenced into the neat disciplinary corrals of economics and sociology, but instead shaped British intellectual and literary history in fundamental ways over the last two hundred years. The question of social class is perhaps less obvious in *Culture and Society* than in its sequel, *The Long Revolution.* Nevertheless, as Williams later declared, the primary, "oppositional" aim of both books was "to counter the appropriation of a long line of thinking about culture to what were by now [the 1950s] decisively reactionary positions" (*Politics* 97). Williams wanted to wrest the concept of culture away from its elitist and disciplinary moorings and put it to democratic use. The chief sort of anti-democratic narrowing during the nineteenth century came through the identification of culture with nonutilitarian and often (to the majority) inaccessible forms of "high" art and literature. Against such an exclusionary appropriation of the very term "culture," Williams mounted a double attack. First, like an anthropologist he defined culture as "ordinary" and universal, a definition that has helped focus cultural studies on the "lived experience" of people producing meanings and values through everyday social interaction. Second, as Williams contended most explicitly in the conclusion to *Culture and Society,* the goal of all serious intellectual work is or ought to be the achievement of "community" or of a democratic "common culture."

Williams's title begs comparison with the Arnoldian and now largely academic idea of high culture expressed in *Culture and Anarchy.* But is its meaning tautological (culture and society are identical) or antithetical (culture *versus* society, just as Arnold had meant, culture versus anarchy)? Williams did not resolve this ambiguity; it was instead embedded in the history he explores. Nevertheless, the tradition Williams most wished to understand and alter did set

culture in opposition to society (not just anarchy) by constructing artistic and literary idealizations divorced from the material realm of work and politics, and yet supposedly capable of sitting in judgment upon that lower or fallen realm. This was the dominant direction for literature from romanticism to modernism—the balloons of "high" culture and of a merely "literary" criticism cut free from the experience of most people—that Williams wanted to reverse (indeed, as he demonstrated in *The Country and the City,* the rift went back much further, through the seventeenth century and beyond). But by revealing the social motivations and determinations underlying high cultural forms like "country house poetry," Williams appears to conflate culture and society into a nonexplanatory tautology, leaving the would-be social critic with no vantage point superior to society from which to criticize it. As Theodor Adorno puts it, "The cultural critic can hardly avoid the imputation that he has the culture which culture lacks" (*Prisms* 19). Williams's underlying assumption, that a democratic idea of culture can be used to criticize other ideas of it, involves an epistemological tangle that he only began to untangle in his later, more theoretical works, starting with his memorial lecture on Lucien Goldmann in 1971. But this is not a major weakness in his early analyses, especially since, as always in intellectual work, the right questions had to be asked before anyone could begin to answer them.

Arnold has been a major influence on modern literary humanism in part because his notion of culture was restricted to literature and the arts, and even more narrowly to the canon of classics as selected through the forms of literary and art criticism that are today a central activity of the humanities. Yet Arnold simultaneously attributed to culture the political function of taming social "anarchy" by teaching both the individual and the "state" how to realize their "best selves" (and thereby also how to follow "right reason and the will of God"). Arnold saw anarchy in terms mainly of social class selfishness and class conflict, and defined culture—that is, liberal education especially in literature and the arts—as the best means to achieve an orderly transition to democracy (which he believed was inevitable, though without much liking it). No matter how professionalized, sanitized, and yet seemingly liberal in intent, however, the Arnoldian conception of culture is itself class-bound, an ideological construction that has carried an increasingly reactionary charge in the twentieth century. Yet there was a liberal generosity in Arnold absent from William Bennett and his Thatcherite doubles, and this Williams acknowledged: "Those who accuse [Arnold] of a policy of 'cultivated inaction' forget not only his arguments but his life. As an Inspector of schools . . . his effort to establish a system of general and humane education was intense and sustained. . . . *Culture and Anarchy* . . . needs to be read alongside the reports, minutes, evidence to commissions and specifically educational essays which made up so large a part of Arnold's working life" (*Culture and Society* 119).

Nevertheless, Arnold wanted both to narrow culture to a conception of "the

best" in literature and the arts and to give it extraordinary powers which it did not have. For Arnold culture was what promised, in the twilight of religion and the decline of aristocracy, to preserve social order against the "ignorant armies" unleashed by industrialization and democratization. But, as Williams declared, "culture as a substitute for religion is a very doubtful quantity" (126). Culture is a social "process," but on Arnold's definition it comes "to resemble an absolute, [though] it has in fact no absolute ground" (127). Literary criticism after Arnold, while gradually becoming an academic discipline, has striven to retain the dual political functions of determining artistic greatness (canon formation) and of teaching the classics in such a way that social order (classroom discipline, at least?) would hopefully win out over anarchy. Needless to say, the first function has proved easier to carry out than the second—canon formation and revision is today the main activity of the thousands of literary scholars who populate MLA and dozens of other conferences in the U.S., Britain, Canada, and elsewhere, whereas it isn't at all clear that the diffusion of classics through the educational system has any effect either on maintaining social order or on humanizing society (these two goals are not necessarily identical). And though the vast majority of people in Britain, Europe, and North America can now (still?) read and write (thanks to the often heroic and always underpaid efforts of elementary—not university—school teachers), the vast majority choose not to read the classics, but recent bestsellers, newspapers, and magazines—when they choose to read anything at all.

In *Culture and Society,* Williams both mapped the British tradition of cultural criticism and became a major participant in it. His own observations in the final section on the contradictions between capitalism and democratic ideals of community marked the 1958 terminus of a line that stretches back to William Cobbett, Edmund Burke, and early responses to the democratic revolutions in America and France and the industrial revolution in Britain. Key figures at the beginning of the tradition were the great romantic writers—Blake, Wordsworth, Coleridge, Shelley—who set the poetic imagination in opposition to an increasingly rationalized, industrialized, and democratized society. "The positive consequence of the idea of art as a superior reality was that it offered an immediate basis for an important criticism of industrialism. The negative consequence was that it tended, as both the situation and the opposition hardened, to isolate art, to specialize the imaginative faculty to this one kind of activity, and thus to weaken the dynamic [political] function which Shelley" and the other Romantics proposed for it (*Culture and Society* 43). The separation—culture *versus* society—entailed an increasingly inward stress on the cultivation of the isolated, individual mind, with the poet—and perhaps the reader—somehow transcending the social realm. Yet struggling within and through this "romantic ideology" (as McGann calls it) were various opposing tendencies, efforts to reverse artistic alienation and to use the idea of culture for social criticism. These efforts Williams analyzed in the

Romantic poets themselves, and also in Carlyle, Dickens, Ruskin, Arnold, George Eliot, Oscar Wilde, William Morris, and a host of other writers down to 1950 (the twentieth-century writers include D. H. Lawrence, R. H. Tawney, T. S. Eliot, I. A. Richards, F. R. Leavis, Christopher Caudwell, and George Orwell). Williams thus helped launch the critique of the romantic/ideological construction of literature and of modern literary criticism now on offer by various brands of literary theory, including deconstruction, feminism, and the New Historicism.

From the late eighteenth century forward, culture has been a term of ideological contention and "polysemy," in whose various conflicting uses Williams traced, as if in etymological miniature, the larger struggles of social groups and classes for power, freedom, and education—that is, for full social and cultural representation. "The organizing principle of this book," Williams wrote in the foreword, "is the discovery that the idea of culture, and the word itself in its general modern uses, came into English thinking in the period which we commonly describe as that of the Industrial Revolution" (ix) and was a response to revolutionary social change. The same is true of many of the other terms Williams analyzed, both in *Culture and Society* and in his later works (most obviously in *Keywords: A Vocabulary of Culture and Society,* published in 1976 and in a revised edition in 1983). For Williams, etymologizing was not just antiquarianism, good only for stuffing dictionaries; done rightly, it revealed the social construction of meanings out of complex, always political struggles and exchanges. Words and language (and therefore meanings and values) are dynamic, not static; forged in the crucible of history, not fixed for all time at the beginning of speech.

As structuralist and deconstructive theory was also beginning to emphasize, culture as representation is our destiny, our (second) nature; whatever threatens to shut down, repress, or distort representation through the assertion of some absolute "presence" threatens also to put an end to both culture and history. In one of his meditations on representation, Derrida argues that "a criticism or a deconstruction of representation would remain feeble, vain, and irrelevant if it were to lead to some rehabilitation of immediacy, of original simplicity, of presence without repetition or delegation. . . . The worst regressions can put themselves at the service of this antirepresentative prejudice" ("Sending" 311). But one difference between Williams's approach and Derrida's to a keyword like culture or representation is that Williams locates the sources of its shifting, conflicting meanings in specific historical changes and political practices. Derrida, on the other hand, locates—or better, dislocates—meanings in specific texts, particularly those of the western philosophical tradition. He, too, often proceeds by a keyword or key-idea approach, but at the abstract level of the metaphysics he deconstructs, a metaphysics which (as Derrida recognizes) tries to look over the heads of most people and to transcend everyday language use, and therefore overlooks the fact that "culture is ordinary."

In *Marxism and Literature* and elsewhere, Williams criticized both structuralism and deconstruction for being anti-historical and for treating language as an endless, airy circulation of signifiers without referents, floating free from actual social practices and conflicts. For linguistic theory, he turned away from the abstract tradition pioneered by Saussure, to the sociolinguistics of the "Bakhtin school" (including, besides Bakhtin, V. N. Volosinov and P. M. Medvedev). In their view, words were fundamentally "multivocal" or "heteroglossic," sites of conflict as much as of agreement, the ever-shifting molecules of cultural politics that could only be analyzed at the level of the specific historical contexts and struggles in which they were continually shaped and reshaped (*Marxism* 35–44; see also Williams's late essay, "The Road from Vitebsk"). For Williams, any keyword becomes a narrative, a history without closure—the dictionary of "lived experience" stays open and all of us are its lexicographers. "The variations of meaning and reference, in the use of culture as a term, must be seen . . . not simply as a disadvantage, which prevents any kind of neat and exclusive definition, but as a genuine complexity, corresponding to real elements in experience" (*Long* 59). Like culture, experience is a crucial idea for Williams; though open to historical reconstruction, neither concept is reducible to theoretical closure or single meanings.

Before the late 1700s, "culture" usually referred to "the 'tending of natural growth', and then, by analogy, [to] a process of human training. But this latter use, which had usually been a culture *of* something, was changed, in the nineteenth century, to *culture* as such, a thing in itself. It came to mean, first, 'a general state or habit of the mind', having close relations with the idea of human perfection. Second, it came to mean 'the general state of intellectual development, in a society as a whole'. Third, it came to mean 'the general body of the arts'. Fourth, later in the century, it came to mean 'a whole way of life, material, intellectual and spiritual' " (xiv). It is this last, inclusive or holistic definition which approaches Williams's contention that "culture is ordinary." It is also the definition nearest to anthropology, emergent as a new social science discipline over the same period that the romantic ideology of literature was developing. Thus, four years after *Culture and Anarchy*, Edward Burnett Tylor published his pioneering anthropological work, *Primitive Culture* (1871), the first sentence of which, still often cited as a standard anthropological definition, reads: "Culture or Civilization, taken in its widest ethnographic sense, is that complex whole which includes knowledge, belief, art, morals, law, custom, and any other capabilities and habits acquired by man as a member of society." Of course the idea of "primitive" culture, seemingly nonjudgmental and universalizing (even "savages" possess culture, and human nature is everywhere the same) was for Tylor rooted in an evolutionary theory of vast differences in levels or stages of social progress, from savagery through barbarism to civilization. While Friday could now be said to have "culture," he was nevertheless still a "cannibal," in

urgent need of reformation. At the bottom or in the middle of the evolving hierarchy of cultural stages were the nonwhite races of the world, while at the pinnacle stood modern Europeans. So although it universalized and at the same time pluralized the idea of culture, nineteenth-century anthropology served as a social Darwinist underwriting of European and white American imperialism, just as bourgeois economics provided "scientific" ideological defense for capitalism at home and abroad (see my *Rule of Darkness,* 184–88).

Tylor's attribution of culture to "primitive" peoples is worth comparing to Williams's attribution of it to the working class. From Tylor's time down to the present, culture in the anthropological tradition has shed its evolutionary trappings, becoming either a relativistic term, or else—going a bit farther—*primitive* culture has been set in critical opposition to a debased, modern, rapacious, capitalist civilization, as in the writings of Claude Lévi-Strauss, Marvin Harris, Stanley Diamond, and others (on "primitive communism" as a utopian category, see Maurice Bloch; on current anthropology as a form of social critique, see Clifford, *Predicament,* Clifford and Marcus, *Writing,* and Marcus and Fischer, *Anthropology as Cultural Critique*). In analogous fashion, Williams discovered in the history of working-class culture not just the contrary of but a potential antidote to bourgeois culture; he thus offered a "reformist" rather than "revolutionary" version of Marx's theme of the proletariat as the bearers of the future. Williams located the main achievements of working-class culture not in poems or artworks, but in "the basic collective idea, and the institutions, manners, habits of thought and intentions which proceed from this. Bourgeois culture, similarly, is the basic individualist idea and the institutions, manners, habits of thought and intentions which proceed from that. In our culture as a whole, there is both a constant interaction between these ways of life and an area which can properly be described as common to or underlying both" (327).

If Williams's analysis of culture in relation to social class appears as at most a qualified Marxism (and in the late 1950s he did not consider himself to be a "Marxist"), it also sharply reverses Arnold's in *Culture and Anarchy.* Arnold offered a primarily literary culture as the antidote to the selfishness or partiality of all three major social classes (Barbarians, Philistines, Populace). Whereas bourgeois individualism (including Arnold's) underlay those narrowing processes that restricted literature and art to the "educated" minority, the working class, Williams contended, had developed a culture that at its best (important qualification!) stressed sharing, solidarity, community, and to some extent also internationalism. Williams concluded *Culture and Society* with the suggestive thought that working-class culture contained the chief values, though in attenuated, repressed, much-maligned forms, to which we must look for the future. At the same time, as much of the culture-and-society tradition showed, bourgeois culture at *its* best involved "service" (Arnold's educational work was an example), not just a rapacious, profit-motive individualism. And even the most conservative theories

of culture had "throughout, been a criticism of . . . the bourgeois idea of society" (328). Thus, the ideal of community often reflected an older, aristocratic, pre-industrial or pre-capitalist but in some ways also perhaps more generous social formation, as expressed in the nostalgic utopias of Romantic and Victorian medievalism (Carlyle, Ruskin, Morris). But it could also mean an egalitarian, democratic (and sometimes, though more rarely, international) society of the future. In conflict with these visions of "community" or of our possible "common life" together, Williams wrote, are "the institutions of cynicism, of denial and of division [which] will perhaps only be thrown down when they are recognized for what they are: the deposits of practical failures to live" (334).

Literacy's Uses and Abuses

Among "the institutions of cynicism," Williams counted the capitalist mass media, or those forms of communication that, instead of tending toward authentic community or a "common life" in which the interests of all individuals would matter, tended instead to produce only illusions of community. These illusions bound "masses" of people together through advertising and the forms of cheap entertainment, for the profit of those who controlled the media and other forms of big business. This was a critique of mass society and commercial corruption familiar from the work of F. R. Leavis, Denys Thompson, and *Scrutiny,* as Williams pointed out. But he rejected Leavis's elitism, or the thesis that, as Leavis wrote in *Mass Civilization and Minority Culture,* "in any period it is upon a very small minority that the discerning appreciation of art and literature depends" (qtd. in *Culture and Society* 253). And he also rejected Leavis's related idea that culture—or at any rate, the only culture that matters—means exclusively "the great tradition" of art and literature. "The concept of a cultivated minority, set over against a 'decreated' mass, tends . . . to a damaging arrogance and scepticism" (363). Besides, "the new means of [mass] communication represent a major technical advance" (300).

Partly against Leavis, Williams declared: "There are no masses; there are only ways of seeing [other] people as masses" (300). Yet the chief ways of seeing other people as masses—commercial, cynical, destructive—were coming through the new forms of mass communication, not through elitist criticism. This was a major theme in *The Long Revolution* and in Williams's later work on the mass media (particularly *Communications,* 1962, and *Television: Technology as Cultural Form,* 1974). It was also a major theme in Hoggart's *The Uses of Literacy.* "Most mass-entertainments are in the end what D. H. Lawrence described as 'anti-life,' " Hoggart declared. "They are full of a corrupt brightness, of improper appeals and moral evasions" (*Uses* 277).

In their shared belief that the commercial mass media were "corrupt," Williams and Hoggart looked back to Leavis's cultural criticism even while they struggled

to distance themselves from it. Williams was writing about his own situation as much as Hoggart's when, in his 1957 review of *The Uses of Literacy,* he delcared:

> The analysis of Sunday newspapers and crime stories and romances is . . . familiar, but, when you have come yourself from their apparent public, when you recognise in yourself the ties that still bind, you cannot be satisfied with the older formula: enlightened minority, degraded mass. You know how bad most "popular culture" is, but you know also that the irruption of the "swinish multitude", which Burke had prophesied would trample down light and learning, is the coming to relative power and relative justice of your own people, whom you could not if you tried desert. (Williams, "Fiction" 425)

Part of what Williams registered here was the autobiographical basis of Hoggart's work, one similar to his own. Both men came from working-class backgrounds, both began their teaching careers in adult education rather than in the universities, and both wanted their writing to help their "own people" achieve something more than just "relative" justice.

The Uses of Literacy can be placed in the long British tradition of "ethnographic" observation of the working class, stretching back to Henry Mayhew's *London Labour and the London Poor,* the "industrial novels" of Dickens, Disraeli, and Elizabeth Gaskell, and Engels's *Condition of the Working Class in England in 1844,* among others. These and similar texts formed a major group within the larger culture-and-society tradition Williams mapped, and were also part of the groundwork of British sociology (see Lepenies and also Gallagher). The act of social observation in this tradition ordinarily extended across class lines in a patronizing direction: a bourgeois or sometimes aristocratic writer would "travel into the poor man's country" and report what he or she saw, just as an explorer or anthropologist would report on, say, travels into "darkest Africa" (see Keating for more examples). But the nineteenth century also witnessed the burgeoning of another tradition in which working men and women wrote about themselves. For a variety of reasons that deserve fuller analysis, this second, often autobiographical tradition of working-class self-representation has largely been ignored, except by social and labor historians (to put it another way, the canonized works of social observation are usually by middle- or upper-class writers; see Gagnier for some of the reasons). In *Culture and Society,* Williams dealt with no writers who could be called working-class until he got to D. H. Lawrence. Yet his own writing shoulders an autobiographical burden that strives to be representative: the political obligation of the working-class intellectual to represent the experience of the entire class by describing one's own.

The same autobiographical, yet representative or collective, emphasis is apparent in *The Uses of Literacy.* Of course by 1957 it was not an unfamiliar pattern for an intellectual both to come from the working class and to write about his or

her "lived experience." But also by 1957 the illusion of the embourgeoisement (or disappearance, or at least quiescence) of the working class was powerful enough to make an account of working-class values striking, especially when accompanied by an assertion of the value of those values.

Hoggart's originality lay less in his writing about the working class from the inside (as a "native," Williams said) than in the way he stood both the social observation and the larger culture-and-society traditions upside down. The "native" suggested that his version of domestic primitive culture was not just interesting, but also in some ways worthy of emulation by the upper classes, who did not always exhibit quite the same moral fiber as the working class. But now this decent working-class culture was threatened by forces from above—forces which could, with just a little stretching of Hoggart's argument, be identified as a higher culture, although the more common name for this higher culture (product of bourgeois enterprise) was "mass culture." Hoggart focused on reading materials (the "literacy" of his title), so that his work of essentially social criticism is also an interesting example of Leavisite literary criticism, but even in 1957 he was aware of the dominance and "corrupting" influence of the electronic mass media, as his later writings about broadcasting show (for examples, see the first volume of *Speaking to Each Other*). In short, here was a variant of the culture-and-society tradition in which an older, more sharing, and more authentic culture was being eroded by the forces of mass production and consumption—but the displaced or damaged culture was not high or elite, as it had been for Leavis; it was proletarian.

If Hoggart makes decent working-class life sound a bit dull and at times too good to be true, that is partly because he renders a few of its less "respectable" features almost invisible. He describes sex, drink, and sport with a Lawrentian frankness; but he barely mentions crime and politics. In the middle-class tradition of social observation, working-class crime was frequently emphasized and often exaggerated, but in *Uses* it is almost nonexistent. Hoggart has a few rather tepid things to say about workers' unfavorable attitudes toward the police, but crime is not a major part of even youthful working-class resistance to the dominant culture. If that was perhaps more nearly true in the 1950s, it isn't today. Further, it seems unlikely that the majority of British workers in this century have been as uninterested in the Labour Party and trade unionism as Hoggart makes them out to be.

Perhaps this lack of political consciousness was partly due to the pacifying effects of the mass media. But the "older order"—the decent, pre-broadcasting working-class culture of his childhood in Leeds—Hoggart depicts as already depoliticized. "Resilience" and resignation—making do with little and expecting no great changes in the future—are the main working-class virtues, along with family and communal sharing (compare Pierre Bourdieu on the French working-class "taste" for the "necessary" in *Distinction*). "As to politics . . . they have a limited realism which tells them that, as far as they can see, 'there's no future'

in it for them. 'Politics never did anybody any good' . . . in general most working-people are non-political and non-metaphysical in their outlook" (*Uses* 86). Meanwhile, the intellectual minority who, like Hoggart, were interested in politics and wanted to change things, were as cut off from influencing the masses as Leavis's discerning few. Hoggart strikes a tragic note: "It seems unlikely at any time, and is certainly not likely in any period which those of us now alive are likely to know, that a majority in any class will have strongly intellectual pursuits" (276). And partly because they lack the appropriate intellectual equipment for exercising critical judgment, the majority of workers are, he feels, unable to bear up against the onslaught of "candy floss," "shiny barbarism," and "sex in shiny packets" that constitutes modern, commercialized mass culture.

In his conclusion to *Uses,* Hoggart worries about a set of ideas central to Williams and also to contemporary cultural studies:

> . . . it may be that a concentration of false lights is unavoidable at this stage of development in a democracy which from year to year becomes more technologically competent and centralised, and yet seeks to remain a free and "open" society. Yet the problem is acute and pressing—how that freedom may be kept as in any sense a meaningful thing whilst the processes of centralisation and technological development continue. This is a particularly intricate challenge because, even if substantial inner freedom were lost, the great new classless class [that is, "the masses"] would be unlikely to know it: its members would still regard themselves as free and be told that they were free. (282)

Cultural studies today continues to explore Hoggart's and Williams's themes of social class, community, and mass communications. But it has sometimes discovered cracks in the monolith of "mass culture" that Hoggart and Williams were far from noticing: younger investigators often find "oppositional" meanings and "practices" in film, rock music, and popular literature, where before there seemed only a uniform "corrupt brightness" and "cynicism." Further, neither *Culture and Society* nor *The Uses of Literacy* touches on a number of related subjects central to cultural studies today—gender and race are the most obvious absences, though the self-consciousness that now often goes under the heading of theory is another. The assimilation and application of various continental theories (semiotics, Althusser's structuralist Marxism, the writings of Antonio Gramsci, Frankfurt Institute Critical Theory, and so forth) has been a major part of the story of cultural studies—one which has tended to cast Hoggart's relatively untheoretical "empiricism" in the shade.

But one of Williams's strengths was his own steady assimilation and testing of new theories. As Terry Eagleton remarks in his memorial to Williams in *New Left Review,* "you had a sense of having struggled through to some theoretical position only to find that Williams had quietly pre-empted you"; after the "wilder

flights of Althusserian or post-structuralist theory" Williams was still there "when some of us younger theorists, sadder and wiser, reemerged from one or two cul-de-sacs to rejoin him where we had left off" ("Resources" 8–9). Although *Culture and Society* has its theoretical moments, *The Long Revolution* is the book in which Williams began to elaborate his own theories of culture; I will therefore treat it in the next section. Here I will turn to E. P. Thompson's "history from below," both because Thompson's work forms an interesting contrast to Hoggart's and because his collision with theory—notably his attack on Althusserian Marxism in *The Poverty of Theory*—focuses the issue of the relations between empiricism and theory in an especially sharp way.

Questions of theory are obviously important in any kind of (necessarily) empirical historical work, though often enough research gets done and histories get written without answering or even asking them. As with literary criticism and American Studies in the U.S., the opposition between a supposedly untheorized empiricism and the theorization of virtually everything seems partly generational. But one difference between the "myth and symbol" originators of American Studies and Williams, Hoggart, and Thompson is the relative invisibility of social class as a problematic in the work of the former and its obvious centrality in the work of the latter. This is not simply a matter of the working-class origins of Hoggart and Williams, and of Thompson's background of middle-class radicalism. Nor is it entirely due to the development in Britain of a more coherent, organized, and politically influential tradition of "labourism" and socialism than in North America. Rather, the relative invisibility of social class as an issue in the U.S. and Canada itself needs to be theorized and contested—a constructed, cultural or ideological absence that has made the "pseudo-politics" of theory seem all the more pseudo in university classrooms and on the panels of MLA. It isn't the case that social class is a major problem in Britain, whereas it is only a minor one in North America; rather, the problem arises in North America because we tend to see no problem.

The majority of Hoggart's decent, law-abiding workers may not have been either very political or very intellectual, but they were nevertheless literate. It was just (Hoggart believed) that the wrong sorts of reading— titillating romances, sensational crime stories, and the like—were being mass-produced and sold to them as a sort of ersatz-culture. In contrast, for Thompson's late eighteenth- and early nineteenth-century workers, though they were not all readers, politics was a consuming passion. And they "made" their own culture to express that passion. The intellectual minority that Hoggart sees as both atypical and disconnected from the majority of the working class, Thompson treats as representative and vitally connected. This was the radical vanguard, whose theories and writings expressed the first powerful critiques of industrial capitalism. And it was through the cultural process of consciousness-forging that, Thompson contends, the work-

ing class as such was forged. The radical intellectuals were, so to speak, the cultural smiths.⁻

Thompson thus reverses the deterministic scheme whereby the emergence of the industrial proletariat is seen as a mere reflex of economic forces. Instead, the *making* of the English working class was, he thinks, a far more active, oppositional, and *cultural* "process" than economistic explanations have allowed. And the chief makers were the writers, revolutionaries, trade unionists, Owenites, and finally Chartists who showed how conscious solidarity with all workers as a class, with its own interests standing over against those of the bourgeoisie and aristocracy, could further the cause of freedom, equality, and justice for all.

> Class happens when some men [sic], as a result of common experiences (inherited or shared), feel and articulate the identity of their interests as between themselves, and as against other men whose interests are different from (and usually opposed to) theirs. The class experience is largely determined by the productive relations into which men are born—or enter involuntarily. Class-consciousness is the way in which these experiences are handled in cultural terms: embodied in traditions, value-systems, ideas, and institutional forms. If the experience appears as determined, class-consciousness does not. (9–10)

The "productive relations" which shaped class experience—what Marxist theory refers to as the economic "base" or "mode of production"—formed an arena of necessity or determinism. But those relations didn't entirely determine the cultural response to the conditions they seemed to fix in place, and this cultural realm was thus one of freedom, or at least that freer dimension of life in which people could fight for more freedom and justice against both economic necessity and social injustice.

But an emphasis on culture with its implications of conscious choice and agency will not by itself banish questions of economic determinism. In his review of *The Long Revolution,* Thompson criticized Williams for treating the complex processes of social history in general as " 'a process of learning and communication.' " Williams took this idea so far, Thompson wrote, that " 'communication' becomes a new reductionism. . . . [Thus] the central problem of society today is not one of power but of communication: we must simply overcome barriers of elites, status-groups, language, and divisive cultural patterns, and expand into a common culture" (Thompson, "Long" 35). But Thompson's own emphasis on culture as historical class- and self-making is open to the same charge of reductionism. Thus, in *Arguments within English Marxism,* Perry Anderson asks: "Has Thompson *demonstrated* that the English working class made itself as much as it was made—not in a false, scientistic sense, but in terms of plausible balance of evidence?" (32) Anderson points out that *Making* does

not provide a clear analysis of the economic lines of force in the Industrial Revolution. Amid a vast amount of evidence about popular and radical movements and attitudes, Thompson provides few "objective coordinates" about class formation. "It comes as something of a shock to realize, at the end of 900 pages, that one has never learnt such an elementary fact as the approximate size of the English working class, or its proportion within the population as a whole, at any date in the history of its 'making' " (Anderson, *Arguments* 33).

Anderson and others (Calhoun, McLennan, Kaye) have leveled a variety of charges against *Making,* though they also insist that it is a major, highly original work of social history. First, it puts culture as a historical force and its relation to other forces squarely on the agenda. Second, it stresses the value of the opinions and experiences of the embryonic working class not just as historical curiosities, but as viable alternatives to the opinions and experiences of the ruling class. Even when those opinions belonged to individuals or groups defeated during the larger processes of class formation and industrialization, they remain, for Thompson, essential parts of the record. In the familiar passage from the preface to *Making,* Thompson writes:

> I am seeking to rescue the poor stockinger, the Luddite cropper, the "obsolete" hand-loom weaver, the "utopian" artisan, and even the deluded follower of Joanna Southcott, from the enormous condescension of posterity. Their crafts and traditions may have been dying. Their hostility to industrialism may have been backward-looking. Their communitarian ideals may have been fantasies. Their insurrectionary conspiracies may have been foolhardy. But they lived through these times of acute social disturbance, and we did not. Their aspirations were valid in terms of their own experience. . . . (12–13)

From his massive research into the experience and opinions of stockingers, weavers, and artisans of all sorts, Thompson concludes that "from 1830 onwards a more clearly defined class consciousness, in the customary Marxist sense, was maturing, in which working people were aware of continuing both old and new battles on their own" (712). The Chartist movement, originating toward the end of the 1830s, was the first nationwide, working-class political party, and therefore the logical terminus of Thompson's account (though the narrative continues in Dorothy Thompson's *The Chartists*).

In Thompson's great biography of William Morris, first published in 1955, the same stress on cultural politics—culture *as* politics—is apparent. Morris played leading roles in the arts and crafts movement and the development of British Marxism, and his creative energy, moral passion, and honesty remain exemplary. His transformation from "romantic" poet and artist to "revolutionary" intellectual is the path which, Thompson believes, the first romantic poets and artists should have traveled. Williams also considered Morris a major figure, in part because

he sought to connect cultural criticism "to an actual and growing social force: that of the organized working class." Williams judged that Morris's Marxism "was the most remarkable attempt that had so far been made to break the general deadlock" between theory and practice in the culture-and-society tradition (*Culture and Society* 148). Thompson says that when he started to read Morris he "was seized" by him; "I thought, why is this man thought to be an old fuddy-duddy? He is right in with us still" (Abelove et al. 13).

Although the first version of the biography was (Thompson now feels) marred by "Stalinist pieties" that he repudiated in 1956 after the crushing of the Hungarian uprising (Abelove et al. 20), what the biographer shares with his subject is not Marxist orthodoxy but the exact opposite—a libertarian or utopian unorthodoxy or even anti-orthodoxy. Morris was, Thompson declares, "the first major English-speaking Marxist." Nevertheless, "to defend the tradition of Morris (as I still do) entailed unqualified resistance to Stalinism. But it did *not* entail opposition to Marxism; rather, it entailed rehabilitating lost categories and a lost vocabulary in the Marxist tradition. But this 'vocabulary,' in Marx, was partly a silence—unarticulated assumptions and unrealized mediations. In [*Making*] I tried to give that silence a voice, and—I hope with increasing theoretical consciousness—this remains a central preoccupation of my historical and political writing" (Abelove et al. 21).

One name for the lost vocabulary Thompson wishes to voice is Marxist humanism. It was partly to combat Stalinism that Thompson waged war in *The Poverty of Theory* against Althusser's "scientific" or "structuralist" Marxism. It was partly also to combat what he saw as the shift of *New Left Review* (which he had helped found in 1960) and British "left" intellectuals generally away from practical political work toward the seductions of theory. And it was partly also to defend (and theorize) his own "empiricist" practice of history. Much simplified, Thompson's argument against Althusser revolves around the antithesis between empiricism and theory. It isn't that Thompson rejects all theory as floating free from the facts or from "experience": but there needs to be a constant "dialogue" between theories and facts, and it is just this "dialogue" or mediation, Thompson believes, that Althusser's authoritarian, supposedly scientific "epistemological stance" cuts off (*Poverty* 32–3). Instead of adjusting itself to the evidence, theory for Althusser (Thompson argues) takes the place of evidence; it thus elevates itself to the status of a new "idealism" or "theology." And a "static structuralism which evicts agency as process" from history is nothing short of "Stalinism reduced to the paradigm of Theory" (182).

Besides the immediate political question of "Stalinism," Thompson believes Althusser to be idealistically divorced from social experience in two related ways. First, like other forms of structuralism, Althusser's is "a system of closure" or intellectual reification (98). It does not distinguish, Thompson argues, "between structured process, which, while subject to determinate pressures, remains open-

ended and only partially-determined, and a structured whole, within which process is encapsulated" (98). Althusser's structuralism emphasizes the "structured whole" or social totality at the expense of "process," "experience," and human "agency." History becomes a vast piece of machinery "without a subject." "We may call it Althusser's orrery, a complex mechanism in which all the bodies in the solar system revolve around the dominant sun" (98). Class struggle is supposedly this "dominant sun" or "the motor of history," and yet Althusser, Thompson thinks, cannot conceptualize it as active struggle or process. Related to the reification of human agency and history in Althusser and all other versions of structuralism, moreover, is a general intellectual arrogance, especially ridiculous and damaging to any theory that claims to be democratically liberating.

> . . . this new *elitism* stands as direct successor in the old lineage: Benthamism, Coleridgean "clerisy", Fabianism, and Leavisism of the more arrogant variety. Once again, the intellectuals—a chosen band of these—have been given the task of enlightening the people. There is no mark more distinctive of Western Marxisms, nor more revealing as to their profoundly anti-democratic premises. Whether Frankfurt School or Althusser, they are marked by their very heavy emphasis upon the ineluctable weight of ideological modes of domination— domination which destroys every space for the initiative or creativity of the mass of the people—a domination from which only the enlightened minority of intelletuals can struggle free. (185)

In short, Althusserianism is arrogant because it is a form of ideological critique which purports to explain how almost everyone is deluded, and deluded in such a "structural," total, or systemic fashion that it isn't clear that demystification remains a possibility—the fading hope of "enlightening" the masses by the perhaps "enlightened minority."

The Poverty of Theory offers a stark contrast between culturalism and structuralism. Yet much of the story of cultural studies concerns the various assimilations of theory—that is, mergers between theory and empiricism—that Thompson seems to oppose. And Althusser is among the theorists who have most influenced cultural studies. There is a sense in which culture for Hoggart, Williams, and Thompson means empiricism or the accumulated data and expressions of "lived experience" in all their irreducible variety, ambiguity, and indeterminacy. And there is also a sense in which all forms of theory which attempt to pin culture down, to reduce the complexity of "lived experience," are "anti-life." But perhaps there are also versions of theory which promote rather than stifle life? In raising this question Williams, I think, proved more flexible and open-minded than either Thompson or many younger theorists who have adhered to Althusserianism or to one variety or another of poststructuralism. Nevertheless, the recent turn in cultural studies away from an emphasis on determining "structures" to indetermi-

nate "practices" is also a return to the emphasis on lived experience in Hoggart, Thompson, and Williams, all of whom would have agreed with de Certeau that "practices" are always in excess of "structures." The relations between determining or at least limiting structures and partially resistant or oppositional practices have been a continuously debated issue for cultural studies, one that will recur frequently in my account.

For reasons Anderson clarifies, in the afterword to *The Poverty of Theory* Thompson backed away from some of his more violent accusations against Althusser, but at the same time defended himself by indicating that he feared the influence of theoretical dogmatism on British thought. Althusser might not be absolutely "Stalinist," but structuralism in general, Thompson believed, involved an idealistic avoidance of both history and politics, a negation of the role of human agency and "experience" in changing social relations. Structuralism thus supported the bourgeois status quo (for Thompson, not so different from "Stalinism" as it at first sounds). It also involved an arrogance toward "ordinary" experience and people that Thompson cannot abide: "people are not so stupid as some structuralist philosophers believe them to be" (qtd. in McLennan 102).

So it is theory in general—not just Althusserian Marxism—that Thompson finds troublesome. This is evident as well in Thompson's various attacks on the theoretical turn taken by *New Left Review* under Anderson's direction and the displacement of the "old New Left" by the "new" one. With Anderson's assumption of the editorship of *NLR* in 1962, "the main lines of the review underwent . . . ruthless modernisation. Old Left steam-engines were swept off the tracks; wayside halts . . . were boarded up; and the lines were electrified for the speedy traffic from the marxistentialist Left Bank" (*Poverty* 245). Thompson, champion of the "old Left," is willing to stand by empiricism, historicism, and a libertarian Marxism partly inspired by William Morris, at the risk of seeming old-fashioned to a younger, theory-conscious or perhaps theory-crazed generation:

> I remain on the ground like one of the last of the great bustards, awaiting the extinction of my species on the diminishing soil of an eroding idiom, craning my neck into the air, flapping my paltry wings. All around me my younger feathered friends are managing mutations; they are turning into eagles, and whirr! with a rush of wind they are off to Paris, to Rome, to California. (*Poverty* 319)

But this is disingenuous on Thompson's part. As in the recent skirmishing "against theory" in *Critical Inquiry* and other U.S. journals, Thompson is theorizing against theory. When Walter Bagehot opined that the political genius of the British people lay in their antitheoretical gift of "dullness," he too was behaving like one of the great bustards. The irony multiplies if theory is what you say you do and practice is what you do.

The Long Revolution, and After

In *Criticism and Ideology,* Eagleton declared that "Williams's work . . . tended to a dangerous conflation of productive modes, social relations, ethical, political and aesthetic ideologies, collapsing them into the empty anthropological abstraction of 'culture'. Such a collapsing not only abolished any hierarchy of actual priorities, reducing the social formation to a 'circular' Hegelian totality and striking political strategy dead at birth, but inevitably *over-subjectivises* that formation" (26). In light of Eagleton's subsequent rehabilitations of Williams as the great pioneer and theorist of cultural studies, however, it's tempting to read *Criticism and Ideology* as an instance of the sort of electrification of the rail lines to Paris of which Thompson complains: Althusser replaces Williams as vanguard theorist of the "new" New Left. It's also tempting to read it as an instance of the pseudo-politics among radical literary theorists about which Gerald Graff and Robert Scholes complain. Eagleton casts a sharp critical glance backward not only at Williams's "left-Leavisism," "residual populism," and "humanism," but at the culturalist and "reformist" tendencies of the old New Left as a whole. The distance he measures between himself and Williams is marked by 1968 and the failure of the old New Left to generate revolutionary social change in North America, Britain, or the rest of Europe. Yet the sharpening of Eagleton's own rhetorical weaponry and the connections he suggests between theoretical rigor and revolutionary practice don't reflect an increase in the chances for revolution in the seventies, but the reverse. Eagleton's stress on theory, like that of many other radical intellectuals over the last two decades, is itself a symptom of his remoteness from any adequate political practice: theory is what fills the vacuum left by the absent revolution.

But perhaps the revolution is never absent? Perhaps it is just different, slower, and most of the time (though not always) less apocalyptic and/or violent than Eagleton wishes it to be? It was just this sort of not always dramatic series of events or, rather, processes that Williams described in *The Long Revolution,* a book with which Eagleton in the 1970s had little patience, especially because of its "gradualist ideology" (Eagleton, *Criticism* 39). Eagleton's attack on Williams's early works would have been more persuasive if gradualism and revolution were alternatives that people could choose between just as they choose between brands of beer or cars. While Eagleton uses "gradualism," "revolution," and similar terms to refer to beliefs about how social change can best be effected, they can also refer to actual patterns of social change, the course of a now irrevocable history or of ongoing processes only partially amenable to conscious direction. And in *The Long Revolution* and his other works, Williams was more concerned with describing how social change has actually occurred and would probably occur in the future (see *Towards 2000*) than with being theoretically clairvoyant or politically correct.

If the point is to understand how societies actually change, then claiming that only one sort of change (revolution) counts while another sort (gradualism) doesn't is mere theoretical dogmatism. Against a related sort of dogmatism, Williams wrote: "It has been the gravest error of socialism, in revolt against class societies, to limit itself, so often, to the terms of its opponents: to propose a political and economic order, rather than a human order" (*Long* 131). Eagleton grew more generous toward Williams after *Criticism and Ideology:* in *The Function of Criticism,* he declares that "the single most important critic of post-war Britain has been Raymond Williams," that it is largely from his work that the cultural studies movement has arisen, and that, "while other materialist thinkers, including myself, diverted into structuralist Marxism, Williams sustained his historicist humanism only to find such theoreticians returning under changed political conditions to examine that case less cavalierly, if not to endorse it uncritically" (*Function* 109). This is refreshing, and can also serve as a thumbnail sketch of the history of cultural studies in Britain over the last two decades: the move away from empiricism to theory, and then a dialectical return, with gains (hopefully) from both. (In a recent discussion at Indiana University, John Fiske, editor of *Cultural Studies,* noted the same development, partly as a shift away from an emphasis on determining "structures" to one on indeterminate, "resistant practices.")

In *The Long Revolution,* Williams explored how the industrial and democratic revolutions of the last two centuries were related to a third, "cultural revolution." The cultural revolution had at least the potential of being liberating in a way that the merely political and economic revolutions, by themselves, could not be. Some of his propositions make liberation sound like the automatic result of the cultural revolution, an emphasis he himself later criticized (*Politics* 137–9). Thus the statement that "the process of communication is in fact the process of community" (55) is "reductionistic" and "idealist," as both Thompson and Eagleton pointed out. Williams sounds as though all we need to do to enter the utopia of "community" or of our shared "common life" together is talk to each other. But even the "we" deserves scrutiny: just who is this plurality that all of "us" supposedly belong to? If I happen to be black, working-class, female, oriental, gay, or gray, am I still part of "us"? (Who does Friday belong to? Robinson Crusoe?) Williams's "we" skates over differences just as he declares "masses" to do. And if "communication" is understood as referring to the new mass media, then Williams seems to be expressing a version of technological determinism qua utopianism like Marshall McLuhan's, whose theories Williams explicitly repudiates in *Television* (126–30): "we" are all being globally electrified and, whether we like it or not, "massified" in the gigantic web of telecommunications.

The difficulty arises from Williams's ambiguous way of using "communication" to refer both to actual practices and to an ideal potential or goal of transparent, democratic participation in the creation and exchange of meanings and values.

Much the same ambiguity hovers around definitions of "culture" (including his own), as he amply showed in *Culture and Society* (it is just the same logical snare that Eagleton fails to untangle, lambasting "gradualism" without distinguishing between historical record and ideal strategy or goal). But perhaps the ambiguity is unavoidable, an essential part of the history Williams records. He is aware that, as against any liberating or utopian outcome of "communication" or of the diffusion of (Arnoldian) "culture," powerful political and economic forces militate, including inauthentic forms of communication (such as "cynical," "corrupting," commercialized mass culture).

> We speak of a cultural revolution, and we must certainly see the aspiration to extend the active process of learning, with the skills of literacy and other advanced communication, to all people rather than to limited groups, as comparable in importance to the growth of democracy and the rise of scientific industry. This aspiration has been and is being resisted, sometimes openly, sometimes subtly, but as an aim it has been formally acknowledged, almost universally. Of course, this revolution is at a very early stage. Bare literacy is still unattained by hundreds of millions, while in the advanced countries the sense of possibility, in expanding education and in developing new means of communication, is being revised and extended. Here, as in democracy and industry, what we have done seems little compared with what we are certain to try to do. (*Long* 11)

If Williams in the early 1960s underestimated the forces resisting the cultural revolution, he did not underestimate the importance of working to achieve its emancipatory goals. And he saw his own cultural criticism as an active contribution to "our true common process" and progress toward "a participating democracy, in which all of us, as unique individuals, learn, communicate, and control. Any lesser, restrictive system is simply wasteful of our true resources" (*Long* 118).

Calling *The Long Revolution* "cultural history," Williams offered a number of theoretical or at least methodological observations, in a more self-conscious way than he had in *Culture and Society*. First, as with American Studies, there is his emphasis on holism or on culture as "a whole way of life" (*Long* 63). Eagleton accuses Williams of a "dangerous conflation" of distinctions which a more "scientific" or "structuralist" approach would avoid. This charge deserves comparison with Perry Anderson's contention in "Components of the National Culture" that what British intellectual life has lacked is a strong, critical conception of the "social totality"—the literary stress on culture is not strong enough. But Williams usually steers clear of a false unification of opposites in *either* of the directions indicated by Eagleton and Anderson: he is not so mushily unifying or undifferentiating as Eagleton claims, and he is less driven by the imperative of a theoretical totalization than either Eagleton or Anderson.

As Eagleton later acknowledged, Williams anticipated structuralist approaches by his emphases on patterns, relationships, and "structures of feeling." Williams declared that a keyword in cultural analysis "is pattern: it is with the discovery of patterns of a characteristic kind that any useful cultural analysis begins, and it is with the relationships between these patterns, which sometimes reveal unexpected identities and correspondences in hitherto separately considered activities, sometimes again reveal discontinuities of an unexpected kind, that general cultural analysis is concerned" (*Long* 63). Such a statement moves in the direction of functionalist sociology, but the task for Williams was not merely figuring out how all the parts of society worked together in a unified "pattern." It was also one of critique or evaluation, which the more positivistic kinds of sociology eschewed.

In evaluating "quality of life," the cultural analyst must be sympathetically receptive though also critical toward the attitudes and beliefs of those who live or lived in a particular place and time. Williams explored various terms that might allow both for a holistic overview and for the evaluation of a culture. In Erich Fromm, he found the idea of "social character," and in Ruth Benedict, the idea of "patterns of culture." These were suggestive and yet did not get at "the deep community that makes . . . communication possible" (*Long* 65). Whatever it was that people shared as members of the same society at the deepest, most rudimentary level, Williams called a "structure of feeling" (64–5), a concept which opened onto the terrain of imaginative representations or symbolic expressions of social life. And in this way also, by stressing emotion and imaginative creation, "structures of feeling" offered an interesting contrast with some other terms that later became central to culturalist work, particularly "ideology" and "hegemony." "Structure of feeling" was a kind of "structuralist" category (as was also Williams's "patterns"), but without rigid, mechanistic demarcations (compare Eagleton's chapter in *Criticism and Ideology* on "Categories for a Materialist Criticism").

> In one sense, [the] structure of feeling is the culture of a period: it is the particular living result of all the elements in the general organization. And it is in this respect that the arts of a period, taking these to include characteristic approaches and tones in argument, are of major importance. For here, if anywhere, this characteristic is likely to be expressed; often not consciously, but by the fact that here . . . the actual living sense, the deep community that makes the communication possible, is naturally drawn upon. (*Long* 64–5)

Williams added, however, that "structures of feeling" were not "possessed" equally or in the same ways by all members of a society. Nor by "structures of feeling" did he mean ideology, or the beliefs which legitimize particular institutions and social relations such as class or caste hierarchies. He was instead

attempting to get at that which, "in all actual communities," allowed communication to go on in the first place. "Language" did not capture this idea any more than "ideology," because people can live in vastly different communities and yet speak, say, Chinese or Swahili. Perhaps some paradoxical combination of solidarity *and* ideology is what "structure of feeling" finally means.

In the second part of *The Long Revolution,* Williams provided historical analyses of "particular forms of the whole [social] organization" which underlay the gradual strengthening and "growth" of the cultural revolution: schools, the evolutions of the reading public and the popular press, the rise of "Standard English," the "social history" of writers and "dramatic forms," and the question of realism in relation to contemporary fiction. For Williams, cultural analysis entailed assessing the "growths" or progress of these and other aspects of the cultural revolution. In other words, the task was critically to explore how the apparently, gradually liberating realm of culture related to the more deterministic realms of politics and economics. Criticism meant judging the "growth" of "our common process" or the lack of it, or assessing the "quality of life of a particular place and time" (63), as Williams did in his final chapter on the condition of "Britain in the 60s," in the mode of the "signs of the times" genre stretching back through Leavis and Arnold to J. S. Mill, Carlyle, and Coleridge. Williams's critical overview in this chapter of *The Long Revolution* is again worth comparing to Anderson's more sharply critical but also doctrinaire mapping of the social terrain in "Components of the National Culture." Anderson argues that British intellectuals lack an adequate theoretical conception of the social totality; Williams describes the social totality anyway. Anderson wishes for a theoretical perspective that will stimulate revolutionary socialism in Britain; Williams patiently assesses the "long revolution," insisting always that it will not be achieved automatically, that it must be continuously struggled for and won through the complex processes of cultural, political, and economic "growth." Williams's overview offers none of the electricity of structuralist and poststructuralist versions of theory, and is often open to the charge of vagueness. But given the choice between a questioning vagueness, aware of complexity, ambiguity, and the continuousness of debate, and the verbal guillotinings that sometimes pass for theory, Williams preferred vagueness: perhaps that was the price of his remarkable openness to history and diversity.

Yet both Williams's and Anderson's perspectives are clearly socialist. Williams affirmed, as he did more fully in *Communications* and *Towards 2000,* the need for rational, democratic planning and control in all areas of social life, including most notably those cultural areas—education, journalism, the mass media, the arts—which the ideologies of free enterprise and cynicism threatened wholly to colonize. "For my own part I am certain . . . that it is capitalism—a particular and temporary system of organizing the industrial process—which is in fact confusing us. Capitalism's version of society can only be the market, for its

purpose is profit in particular activities rather than any general conception of social use, and its concentration of ownership in sections of the community makes most common decisions, beyond those of the market, limited or impossible" (*Long* 327). And to this version of "marketing considerations," Williams opposed the central meanings of the cultural and democratic revolutions of the last two centuries: "The human energy of the long revolution springs from the conviction that men [sic] can direct their own lives, by breaking through the pressures and restrictions of older forms of society, and by discovering new common institutions" (375).

Given this picture of the "long revolution" and the forces resisting it, Williams also argued against the sorts of political complacency and theoretical pessimism that say either that the revolution is over or that it is an impossibility:

> I am told by friends in the United States that in effect the revolution is halted: that my sense of possibility in its continued creative energy is a generous but misleading aspiration, for they in America are in touch with the future, and it does not work—the extension of industry, democracy and communications leads only to what is called the massification of society. A different stance is then required: not that of the revolutionary but of the dissenter who though he cannot reverse the trends keeps an alternative vision alive. I hear this also in Britain, where the same patterns are evident, and it is true that in a large part of recent Western literature this is the significant response: the society is doomed, or in any event damned, but by passion or irony the individual or the group may preserve a human enclave. Meanwhile I am told by friends in the Soviet Union that the decisive battle of the revolution has been won in nearly half the world, and that the communist future is evident. I listen to this with respect, but I think they have quite as much still to do as we have, and that a feeling that the revolution is over can be quite as disabling as the feeling that in any case it is pointless. To suppose that the ways have all been discovered, and that therefore one can give a simple affiliation to a system, is as difficult, as I see it, as to perform the comparable act of ingratiation in Western societies: either the majority formula of complacency, or the minority announcement (tough, hard, realistic) that we are heroically damned. (*Long* 376)

These are arguments—for social democracy, for "community," for rational control over historical processes—that Williams repeated often throughout his career. And advancing these causes was, for him, the aim of cultural criticism and of all intellectual work that declared itself to be "humanizing" and truly "liberal" or liberating. The completion of the "long revolution" was, finally, the only true meaning culture could have.

The Centre for Contemporary Cultural Studies

In "Schools of English and Contemporary Society," his 1963 lecture inaugurating the Birmingham Centre, Hoggart declared that "work in Contemporary Cul-

tural Studies can be divided into three parts: one is, roughly, historical and philosophical; another is, again roughly, sociological; the third—which will be the most important—is the literary critical" (*Speaking* 2:255). This division of intellectual labor is similar to McDowell's and those of other early exponents of American Studies. The combination was to be the familiar one of literature plus history, or literature plus society. Hoggart went on to list concerns that he had stressed in *The Uses of Literacy,* particularly popular literature and journalism, advertising, the mass media, the schools, and issues of social class. He understood that these topics were more sociological than literary (at least, as these fields had been traditionally defined). What would seem odd and no doubt unpersuasive to a sociologist was Hoggart's insistence that all aspects of contemporary culture and society could be best approached from a "literary critical" standpoint. In insisting on the necessity for qualitative "criticism" and the centrality of literature to cultural studies, Hoggart acknowledged his indebtedness to F. R. Leavis's "culture and environment work" (2:255).

The Leavisite connection is worth emphasizing, because it has tended to disappear in more recent accounts of the history and methods of cultural studies. This is partly because, for some, Leavis's politics were wrong (the charge can be either "populist" or "elitist"), partly because of Leavis's blanket condemnations of "mass art," and partly because literary criticism and the category of literature itself quickly became peripheral in the work of the Centre. Thus the preface to *Culture, Media, Language,* an anthology written by members of the Birmingham Centre (CCCS), declares that "for a time, literary studies as such were not widely pursued" (9). By the end of the 1970s, however, "we have again been able to find a serious basis for this work." But the return of literature to the agenda of the Centre "breaks with the literary-critical tradition of a too text-bound practice, as well as with the text-context framework of the so-called 'sociology of literature', and relocates both in the analysis of literary formations and in literature as an institutional practice" (9).

Even more sharply, Janet Batsleer and the other co-authors of *Rewriting English* (all former students at the Birmingham Centre) claim that from the first there were "decidedly unsociable relations between cultural studies . . . and literary criticism, which had, in the writings of Richard Hoggart and Raymond Williams, been one of its progenitors. By the midseventies, cultural studies retained few of the affiliations or concerns of . . . *Culture and Society* or . . . *Uses of Literacy.*" Instead, in working through their less qualified commitment to Marxism "and, rather differently, [to] feminism," Batsleer and her colleagues began to assimilate and use theories "not by any means hospitable to the idea of literature, as that word would be understood in a university English department" (2–3). But they may be overstating the distance they have traveled from Hoggart and Williams. For one thing, the focus of their anthology is still "English studies" and therefore to a large extent also literature, although they see these as "ideologies and

discourses," which they analyze along with "their institutional locations and forms of power" (3). Among the targets of their critiques are educational practices which valorize both English literature and "Standard English," not only in England but in such former parts of the Empire as Nigeria and Jamaica.

Batsleer and her coauthors are thus in agreement with Colin MacCabe and the contributors to *Futures for English* about "broken English," as well as with Gayatri Spivak's recent definition (at the 1988 MLA convention) of cultural studies as the analysis of the "reproduction of banality in a postcolonial world." Beyond these issues looms the entire range of questions that the separate disciplines of sociology and political science supposedly address, though often "uncritically": social class, race, gender, the professions, the mass media, religion, law, government, imperialism.

But literature wasn't what Hoggart wished to install as the main subject of cultural studies. Instead, the Birmingham Centre, in his view, was to direct its energies toward the application of a Leavisite literary criticism to *all* aspects of culture and society. Hoggart declared "the directly literary critical approach" to be "essential" because the real issues in studying contemporary culture involved assessing "the quality of the imagination" revealed in all of its products, from advertising to abstract art. "Unless you know how these things work as art, even though sometimes as 'bad art', what you say about them will not cut deep" (*Speaking* 2:257). And this was true at all levels of cultural production, not just that usually associated with "bad art" (that is, Hoggart believed, especially with "mass art"). But could literary criticism really do all that Hoggart (and Leavis before him, and Arnold before him) expected of it? In what sense could it be "objective," if it was also to be (as it always was for Leavis) sharply evaluative and moralistic? How could all cultural production be reduced to the category of art? Could techniques for analyzing the rhetoric of a popular novel or the images of a film really also be used to analyze and evaluate institutions, economic developments, and patterns of social class and class formation? In short, Hoggart assumed that the best method of reading and evaluating the cultural or social text was literary criticism; his students and successors disagreed.

With literature dethroned, literary criticism seemed hardly up to the larger tasks Hoggart envisaged for it. But this was just one instance of how, as Stuart Hall declared, cultural studies stood in "awkward" relation to the traditional disciplines. Positivistic brands of sociology could not deal adequately with culture either, and the same was true of the more deterministic or positivisitic brands of Marxism. Anthropology offered a model for ethnographic "field work" or "participant observation," involving what anthropologist Clifford Geertz has called "thick description" and what other social scientists have called "qualitative" or "naturalistic" research. It also offered a model of research based on a conception of social totality (compare Benedict's "patterns of culture"), although this conception, focused on "primitive" societies, had too often been reductionistic, patroniz-

ing, and even imperialistic in tendency, while not at all critical of the "advanced" or "civilized" social formation that gave rise to it. The "contemporary culture" the Birmingham Centre proposed to study and evaluate was obviously different in many respects from, say, the Trobriand Islands culture Bronislaw Malinowski had studied. Whatever else cultural studies was going to be, it was not an easy match with any of the established disciplines; it was thus necessarily and from birth in a relation of critique to the maps of social and cultural knowledge presented by the university—to "their historical construction . . . their claims . . . their omissions, and particularly . . . the forms of their separation" (Green in Widdowson 88). Green's description merits emphasis, especially in regard to the crisis—or crises (two separate traumas?)—in the humanities and social sciences. One of the disabling aspects of academic work cultural studies aimed to overcome was the alienation of the disciplines from each other: knowledge should be made whole again; theorizing about culture in relation to society or "thinking the social totality" was a beginning.

Stuart Hall, who succeeded Hoggart as director of the Birmingham Centre, notes that one problem from the outset was to find ways out of traditional disciplinary boxes and into new practices for which neither literary criticism nor sociology would serve. Cultural studies wasn't a new discipline, but a "site" or subject to which the old disciplines could be applied in various new combinations and simultaneously criticized and remodeled. This was to be an important aspect of its focus on *contemporary* culture. That is, in emphasizing the contemporary it also undertook a self-scrutiny of educational institutions and cultural formations (such as universities, but also the primary schools, the intelligentsia, the mass media, and so forth—a list in which literature indeed has a place, but not necessarily a leading one). "Cultural Studies was an 'engaged' set of disciplines, addressing awkward but relevant issues about contemporary society and culture, often without benefit of that scholarly detachment or distance which the passage of time alone sometimes confers on other fields of study. The 'contemporary' . . . was, by definition, hot to handle. This tension (between what might loosely be called 'political' and intellectual concerns) has shaped Cultural Studies ever since" (Hall in CCCS, *Culture* 17). The critique of the disciplining of knowledge within the institutions of learning, moreover, mirrors the critique of "knowledge production" in the larger society, which creates and supports those institutions. Green offers a definition which fuses both the internal and the external "critical stance" of cultural studies: "the 'interrogation' of dominant practices, and particularly doubts about liberal-humanist and social-democratic orthodoxies and their various disciplinary supports" (88).

Cultural studies as practiced at the Birmingham Centre was thus a form of self-critical cultural politics. And because it very early acknowledged its political nature, partly through its "awkward" relations to the traditional disciplines (which usually fail to acknowledge their political natures), the question of "ideology"

came to the fore much sooner and more sharply than it has in the American Studies movement. Despite the devaluations of their work by current practitioners of cultural studies, Williams, Hoggart, and Thompson all recognized the relation (or perhaps identity) between culture and ideology. By focusing on social class both in their own experience and in the larger society, all three at least implicitly equated culture with ideology (though they tended to use the former rather than the latter term). The history of cultural studies at the Birmingham Centre might be written in terms of cultural criticism displacing literary criticism, and then of ideological critique displacing both of these. While such a narrative might suggest clear progress, the practical work of the Centre has often reverted to "culture" and sometimes to "literature" as central categories. Perhaps the literature-culture-ideology narrative involves not much more than a shift from less to more disillusioned and more politicized terminology. I will take a Thompsonian "poverty of theory" position by arguing that, while the Birmingham Centre has produced important, original results, its various attempts at theorization, exciting as these have sometimes been, have not moved much beyond what Williams, Hoggart, and Thompson originally offered.

In his 1976 survey of "the theoretical and practical achievements of the last ten years," Hall himself offers a history of British cultural studies as a sort of French dependency. This is undoubtedly the weakest version of the story. Hall sketches the achievements of the Birmingham Centre as a series of theoretical illuminations from abroad, beginning with a progressively radical or quasi-Marxist (but not clearly Marxist enough) tripartite Raymond Williams, through the importation of French structuralism (Barthes, Lévi-Strauss) and an older German Marxist tradition (Benjamin, Brecht), to an also tripartite but much more satisfactorily Marxist and vanguard Louis Althusser. According to Hall, the most advanced incarnation of Williams (that is, "Raymond Williams III") "can essentially be seen as an attempt to re-synthesize [his] earlier positions in the light of his continuing semi-silent dialogue with European Marxism" (Hall in Barker et al. 2). "Althusser III," on the other hand, is, Hall thinks, the full voice of what Williams left unspoken:

> Althusser III is concerned with the subject, not the Sartrean subject of free choice or the Cartesian subject of the ego, but the subject of ideology, the category of the subject as a formative category of ideological discourse. This owes a great deal of course to Lacan and the recent work of Kristeva, based on the Lacanian re-reading of Freud. It is a retransformation of the Althusserian paradigm by psycho-analysis whose major impact at the present time has been in film theory. (5)

Hall is perhaps thinking less of the work of the Birmingham Centre and more of *Screen* and "*Screen* theory," about which more later. The chief problem with his

account is that it focuses (after describing the tripartite Williams, with his truncated third act) entirely on French and German theory, and not at all on the actual work of the Birmingham Centre. This is a remarkable bit of modesty (if that is the case) on the part of the director of that Centre. It is also a remarkable example of the mesmerism of theory as against practice, because the "practical" part of Hall's title he simply neglects.

But the Birmingham Centre under Hall's direction was in fact producing a series of original, important works of "culturalist" analysis. And it seems clear that these works owe more to Williams, Hoggart, and Thompson than they do to Althusser or any other continental theorist. In a later, less theory-rapt account, Hall acknowledges *Culture and Society* and the other "founding texts" of cultural studies as breaking with "traditional, literary . . . definitions of culture, often elitist and bound up with narrow disciplinary practices (e.g., literary criticism), toward the much broader, 'anthropological' defintion." These works also subverted "the inert sense of 'period' which sustained the text/context distinction, moving the argument into the wider field of social practices and historical processes. It was difficult, at first, to give these breaks a precise location in any single disciplinary field. They appeared to be distinctive precisely in the ways in which they broke across and cut between the disciplinary empires. They were, for the moment, defined as 'sociological' in a loose sense—without, of course, being 'proper' sociology" (CCCS, *Culture* 20).

Perhaps "improper" sociology or "improper" literary criticism (or the merging of the two) can serve as a better description of cultural studies than anything more definite. This is partly because it sought to think the social totality not just in terms of given "positivities" and "facts," but also in terms of "counterfactuals"— the missing, the ungiven, the underrepresented, the stereotyped, the invisible. That is, it sought to hear Friday's language, the traces and silences of majorities, of all those "Others" who do not at first sight appear to be ourselves. If cultural studies has been an inherently political or politicized field, that is simply because politics means how "we" live together—or fail to live together—in "culture and society." And defining culture either as "ideology" or as "representation" opens onto the entire terrain of the political. To quote Jameson again, the political is "the absolute horizon of all reading and all interpretation" (*Political* 17).

The key problematic for British cultural studies from the beginning was social class and class consciousness. In a society dominated by the rich and powerful, how are "the masses" or the "vast majority" represented? Whose representations count? In Bourdieu's terminology, who controls "symbolic capital"? How does it happen that those who in fact constitute majorities—"the masses"—have also insistently been misrepresented as "minorities"? What role does literature play in such representations, in the representation of "the social"? Whose pictures hang on the walls, whose music gets played, whose news or journalism is the latest secular gospel? Can there be any definition of culture that transcends the politics

of representation? If the answer is no, then all culture, all representation, is political or ideological. From the first, therefore, work at the Birmingham Centre dealt with cultural representation as ideology. But even before the Centre was founded, Williams, Hoggart, and Thompson were working out the agenda of cultural studies, in part through their responses to the base/superstructure paradigm in Marxist theory.

Hall writes that "the problematic of Cultural Studies . . . became closely identified with the problem of the 'relative autonomy' of cultural practices. This was a radical break. It goes far beyond the impact of the 'structuralisms'—though they were instrumental in a major way in bringing this question to the fore. But, actually, the strongest thrust in 'structuralism' as a mode of thought is towards a radical diversity—the heterogeneity of discourses, the autonomization of instances, the effective dispersal of *any* unity or ensemble, even that of a 'relatively autonomous' one" (CCCS, *Culture* 28). This somewhat blurs the distinction between Althusserian structuralist Marxism and what Thompson and Williams had already said about the "relative autonomy" of culture. But it is nevertheless true that the tendency of cultural studies itself is "towards a radical diversity" and the recognition of "the heterogeneity of discourses" within social formations. As Williams never tired of stressing, culture is active and multiple; if it is imposed on people as ideology, it is also created by people as art and "lived experience"— and it can be understood, remade, reconstituted on freer, more democratic, and more communal ground.

For historians, the chief question posed by both *The Long Revolution* and *The Making of the English Working Class* concerns causation or, in Thompson's phrase, "human agency." Both Williams and Thompson were dissatisfied with the Marxist base/superstructure paradigm, which in its more dogmatic forms held that the base—the economic mode of production in a society—caused or determined the shapes taken by all manifestations of the cultural superstructure (laws, religion, the arts, etc.). Thompson offered an extended critique of the base/superstructure paradigm in *The Poverty of Theory* and elsewhere, and Williams presented his fullest critiques in *Marxism and Literature* and "Base and Superstructure in Marxist Cultural Theory" (*Problems* 31–63). In the less dogmatic forms of the paradigm (as in Marx himself), a certain reciprocity or interaction between base and superstructure is acknowledged—cultural forms are seen as having some "effectivity" in shaping a social totality and its history. According to Marx's famous dictum, "It is not the consciousness of men that determines their being, but, on the contrary, their social being that determines their consciousness" (*Marx-Engels* 4). Yet on various occasions Marx and Engels both indicated that the determination by the base of the forms of cultural superstructure is extraordinarily complex and indirect, as when, in the *Grundrisse,* Marx argued that the flourishing of philosophy and the arts in Periclean Athens could not be explained as a mere reflex of its slave economy. In criticizing the base/superstruc-

ture model, Thompson and Williams essentially agreed with Engels's letter to Joseph Bloch (September, 1890):

> According to the materialist conception of history, the *ultimately* determining element in history is the production and reproduction of real life. More than this neither Marx nor I have ever asserted. Hence if somebody twists this into saying that the economic element is the *only* determining one, he transforms that proposition into a meaningless, abstract, senseless phrase. The economic situation is the basis, but the various elements of the superstructure . . . also exercise their influence upon the course of the historical struggles and in many cases preponderate in determining their *form*. (*Marx-Engels* 760)

Versions of structuralism appear to reverse the base/superstructure equation: in them, fixed linguistic and mental structures determine everything else, from kinship patterns to postmodern fashions. As Williams observed in *The Sociology of Culture*, for structuralism "the basic cultural structures . . . 'evolving' entirely within their own forms, are either independent or relatively autonomous from other social history and practice, or are even its deep, generally determining forms. Encouraged by earlier neglect of . . . significant formal and structural evidence, this position comes to override all other kinds of knowledge and analysis, by the simple move of declaring [them], *a priori*, irrelevant. This may race the blood but it does not usually survive much actual inquiry" (143). In its more unqualified, deterministic variants, structuralism thus appears as the mirror opposite of the sort of mechanical Marxism which declares all cultural forms to be determined by the economic base. The problem of determination or historical causation is more complicated than either of these positions allows. Though Williams declared that "a Marxism without some concept of determination is in effect worthless" (*Marxism* 83), neither he nor Thompson were willing to settle for any theoretical formulation that left "human agency" and "creativity" out of the picture. The goal of historical materialism was, after all, human liberation; how could any theorization of "culture and society" be so contradictory as to deny human agency a role in making history in the present, and yet take liberation from deterministic forces as its goal? Althusser tried to solve these puzzles by his concepts of "overdetermination" (all aspects of the social totality interact as at least reciprocal causes) and "determination in the last instance" (the economic mode of production is the final but not the only determinant). But Thompson pointed out that Althusser was only repeating what Marx and Engels had already said, as in Engels's letter to Joseph Bloch.

So for Williams and Thompson the concept of culture emerges as that which occupies the space opened up between the determinisms of a reified or "idealistic" structuralism and an equally reified or "mechanistic" Marxism. "Culture" is another name for human agency, creativity, and freedom—or at least for the

potential for these, because it is the struggle for these (by no means anywhere completed) that Williams calls the "cultural revolution."

The task for *both* the liberal humanist who believes that the arts have (or *should* have, in the best of all possible worlds!) an emancipating influence at least on individuals, *and* the radical cultural critic like Williams, is to find ways to maximize the power of cultural forms over the economic base—that is, to maximize freedom and minimize blind necessity in all aspects of life. Their mutual aim is or ought to be completing the cultural or, as Williams also called it, the "long revolution." Of course there have been many *short* revolutions; Williams celebrates the gains made through these, recognizes that their work has been incomplete, but offers no version of the illusory Big Bang idea that a single great revolution just in the offing will bring a general liberation to all. No doubt this is, according to more "revolutionary" or doctrinaire radicalisms, a fading into "gradualist ideology," possibly even a reprehensible backsliding toward liberal humanism (though unrecognizable as such to many liberal humanists). Meanwhile, the crisis-haunted liberal humanist continues to imagine that the general progress of civilization has something to do with appreciating great art, unsullied by questions of politics and ideology. But the "long revolution" can only be accomplished through "the course of . . . historical struggles" and a more challenging cultural politics than is normally offered in Eng. Lit. 100.

3

From Althusser to Gramsci:
The Question of Ideology

From Literature to Culture

In *Marxism and Literature,* Williams writes that "in its modern form the concept of 'literature' did not emerge earlier than the eighteenth century and was not fully developed until the nineteenth century" (46). The development of literature as a category separate from, and according to romantic ideology superior to, all other forms of writing and discourse helped to give rise to new patterns of specialization and institutionalization, including today the institutionalization of literary criticism as an academic profession or discipline. Of course to note the historical origins of literature is already a challenge to its status as an absolute category having a timeless, transcendent role in human affairs. Discourse there has always been, and perhaps also special forms of discourse that we now identify as literature. The oral forms of myth and epic produced by preliterate cultures have been appropriated for the modern conception of literature, while other more recent forms of written discourse are excluded or sometimes only tolerated on the margins—journalism, scientific treatises, travelogues, film and television scripts, advertising, and so forth. Supposedly literature can be identified by certain inherent structural and esthetic properties—the "literariness" of the Russian Formalists (but see Pratt and also T. Bennett); other forms of discourse are supposedly primarily utilitarian, practical, or otherwise nonesthetic. Literature thus tends to be placed outside or above the sphere of practical affairs; the stress on formal esthetic properties moves it in the direction of art-for-art's-sake. At the same time, the professionalization of literary criticism—its academic "disciplining"—has separated it also from the realm of social practice (see Graff, *Professing*).

Others besides Williams have insisted upon the historicity of the category of literature. In *The Order of Things,* Foucault writes that from about 1800 forward, "literature becomes progressively more differentiated from the discourse of ideas, and encloses itself within a radical intransitivity; it becomes detached from all the values that were able to keep it in general circulation during the Classical age

. . . and becomes merely a manifestation of a language which has no other law than that of affirming—in opposition to all other forms of discourse—its own precipitous existence" (300). Similarly, according to Roland Barthes, not just the novel but literature as such is a "bourgeois" category whose importance increases from the eighteenth century forward. But "around 1850" (that is, after the failures of the European revolutions of 1848), "classical writing . . . disintegrated, and the whole of Literature, from Flaubert to the present day, became the problematics of language" (*Writing* 3). Moreover, literary modernism (and today, postmodernism) has from Flaubert on taken as its central theme "the disintegration of bourgeois consciousness" (Barthes, *Writing* 5). Realism, Naturalism, Symbolism, Decadence, Surrealism—these are main stages along the way, themselves deconstructive predecessors of the recent infiltration of the ranks of the literature professors by deconstruction.

The conditions that produce the seeming transcendence of literature as a category superior to or at least distinct from other forms of discourse are simultaneously empowering and disabling. They divide esthetic considerations from social reality (the beautiful is merely imaginary); they also help to create the "disciplines" of literature and language in the academic setting. The alienated forms in which literature is at once cut off from life and yet as "dream or menace" (Barthes, *Writing* 3) protests that separation take their central/marginal place in the educational establishment, though the element of protest is usually dismissed or at least disarmed and renamed at the doorway. By "element of protest," I mean, at the most abstract level, following Ernst Bloch, that all artworks are fundamentally utopian, that the forms of the beautiful carry within themselves *une promesse de bonheur,* and that they are therefore always at least implicitly critical of the forces of alienation that separate them from life. And to the extent that they are critical/utopian, they are also non- or counter-ideological. As Paul Ricoeur contends, the antithesis of ideology is not science or truth of some absolute sort, but "utopia," and utopia in turn must be understood as forms of expression and value—artworks prominent among them—which seek to reinstate the moral and esthetic claims to "the good life" repressed or excluded from reality by scarcity and the dominance of "instrumental reason." Yet literature and art, at least in what Fredric Jameson calls our present "fallen social state," are inevitably, inherently ideological as well as utopian (Jameson, *Political* 25). The main task of a socially relevant or "responsible" literary criticism (see Merod) would thus involve disentangling those moments, revealing their contradictions.

A characteristic modern form of the conflict between ideology and utopia is evident in the differences between the main tendencies of nineteenth-century literature, romanticism and realism. For nineteenth-century literary realism from Balzac to Gissing, the way to overcome the separation between literature and life was to represent life "realistically" and thus to downplay or reject the merely

literary. The realist novel in particular sought to efface the difference between itself and what it represented; unmediated, total reflection of the material realm was its impossible aim. In its extreme forms—Zola's "scientific" repudiation of the imagination, for example—realism was an assault on the very idea of literature, but one entailing the colonization by instrumental reason of the realm of esthetics. Romanticism for its part was equally an assault on "the real" and the cognitive appropriations of "life" through reason and science. But for those romantics and neoromantics (the Symbolists, the Decadents) who insisted on the value of imagination as opposed to merely material reality, the divorce from society, politics, and nonliterary categories of discourse led to the valorization of the "aesthetic dimension" in "art-for-art's-sake." Art separated from life seemed to relinquish its purchase both on social change and the utopian promise inherent in all forms of the beautiful.

The split between romanticism and realism adumbrates the even sharper dichotomy between high modernism and mass culture—"the great divide," as Andreas Huyssen calls it—in the first half of the twentieth century. Novelistic realism devolves into the forms of mass-market fiction and cinema on the one hand, and the "experimental," stream-of-consciousness novel on the other (Joyce, Woolf, Faulkner). Romanticism also devolves into the forms of mass-market "romance" (science fiction, detective stories, neo-Gothic eroticism) on the one hand, and expressionistic or surrealistic "fantasy" on the other (Kafka, Cortázar, Calvino). "When, at the end of the nineteenth century, the search for secular equivalents" to the older "magical content" of romanticism "seems exhausted, the characteristic indirection of a nascent modernism, from Kafka to Cortázar, circumscribes the place of the fantastic as a determinate, marked *absence* at the heart of the secular world" (Jameson, *Political* 134).

Modernist fantasy involves an obvious repudiation of the claims to referentiality in literary realism, even though it has nothing—Jameson's "marked absence"—to put in its place. Similarly, much literary theory today, especially deconstruction, also reflects "the distintegration of bourgeois consciousness" by, in part, continuing the assault on the realist premise of referentiality. Yet other theoretical tendencies, including several closely associated with cultural studies such as Marxist and feminist literary theory, depend on some version of referentiality. Because they are attempts to understand literature in relation to society, they are themselves forms of social "realism" or materialism. Marxist, feminist, and psychoanalytic approaches to the literary text insist on its connections to something external to itself, even while denying its claims to be an unmediated reflection of the real. One does not have to adhere exclusively to one side or the other in the recent theory wars to realize that *any* attempt to think literature in relation to something external to itself—history, culture, society, reality—undermines its status as an independent, free-standing category, while any attempt

to buttress that independence has the paradoxical effect of diminishing or denying its relevance to "real life."

The (temporary) disappearance of literature from the agenda of the British cultural studies movement is understandable for several reasons. The early participants in the Birmingham Centre were not all literary critics; Hoggart's notion of applying literary criticism to society—reading and evaluating it as "social text"—already marginalized literature, while to sociologists, historians, and political theorists, something more rigorous than Leavisite criticism was needed if cultural studies was going to develop as a coherent "field" or group of fields. In any event, the move beyond literature seems paradigmatic of all those theoretical tendencies which seek to operate as cultural or social criticism—to read the cultural as opposed to merely literary text—and which can be broadly labeled culturalist (even when they are structuralist or, paradoxically, deconstructionist).

Culturalism like structuralism perversely does just the opposite of what Wellek and Warren insisted upon in *The Theory of Literature*. Like all literary formalists, Wellek and Warren stressed the importance of an "intrinsic" approach to the text that would focus on its structures and internal coherence, as opposed to "extrinsic" approaches such as the Marxist, psychoanalytic, feminist, etc. But such an intrinsic approach works only if texts are self-contained, not if they are relational, dialogical, social, historical. Apart from certain forms of deconstruction, most versions of literary theory today insist that literary texts are invested with meanings from outside, from their various appropriations and uses by authors, readers, societies. For culturalism and structuralism alike, there is no inside-the-text; there are only forms of mediation and relation.

Perhaps the most promising directions in literary theory today are those suggested by Mikhail Bakhtin and his colleagues, rather than those suggested by de Saussure. "The contention," as Michael Holquist puts it, "is that meaning comes about *not* as the lonely product of an intention willed by a sovereign or transcendent ego. Nor is meaning ultimately *impossible* to achieve because of the arbitrary play of differences between signs." Rather, from the Bakhtinian or dialogical perspective, "I can mean what I say, but only *indirectly,* at a second remove, in words I take and give back to the community according to the protocols it establishes" (Holquist 164, 165). Meanings are dialectically or dialogically produced, at once conflictual and communal, individual and social. And one way of defining cultural studies is as the exploration of the social production and circulation of meanings—that is, of culture. Deconstruction meanwhile often seems to be only a ghostly inversion of the New Criticism: while insisting that "there is nothing outside the text," it often also insists that what the text contains is irredeemably illegible. The deconstructionist critic, as Holquist says, can do little more than point to "the perpetual elusiveness of meaning as it fades away in the phantom relay of the signifying chain" (165).

In order for literature to matter in the world, the very processes which caused its emergence as a separate, seemingly transcendent and nonutilitarian category must somehow be reversed or resisted. These processes include the institutional, disciplinary narrowings and specializings which, while they incorporate more and more bits of knowledge in fragmented and fragmenting ways—a sort of technicist *bricolage*—also make it increasingly difficult to construct a unified map of knowledge, let alone to overcome crisis-causing gaps between theory and practice. In his influential 1969 essay, "Components of the National Culture," Perry Anderson insisted on the central role of the concept of social totality in the formation of critical social knowledge. In Britain, he declared, only literature and anthropology offered weak versions of social totality, both centered on the idea of culture. Only in Marxist theory could one find a stronger, more effective concept of social totality that would unify the cognitive field in a rigorous manner. The adventures of the concept of social totality in Marxist theory have been well-told by Martin Jay. Today that concept is under attack by "postmodernist" theorists such as Jean-François Lyotard and Jean Baudrillard, who see all versions of social totality as relying on Hegelian or teleological "metanarratives" which are, they claim, no longer epistemologically defensible and which carry with them the taint of the (supposedly) failed Enlightenment project of the historical fulfillment of reason through modernization. But Anderson is surely right that *some* vision of history and of the social totality is necessary for there to be *any* form of social criticism or even social knowledge. Postmodern theorists simply substitute alternative—mostly negative and anarchistic—visions of history for Marxist and Hegelian ones (for instance, by proclaiming the failure of Enlightenment and modernity). As Peter Dews declares, however, "a wilful self-restriction of analysis to the fragmentary and the perspectival renders impossible any coherent understanding of our own historical and cultural situation" (Dews xiii).

The current debate over the cognitive status of "metanarratives" has the ironic effect (no matter which side one takes) of treating all forms of social knowledge as fictions. Marginalized or repressed in much radical cultural theory, literature nevertheless returns in assertions about the fundamentally narrative categories through which we apprehend the world (see, for instance, Hayden White). But literature—or, more accurately, literary categories—begins to take on the trappings of science in such formulations. The idea of the special, utopian significance of the "aesthetic dimension" gets lost in the traffic between literary and social science languages. Whether or not one agrees that only a Marxist version of social totality can produce effective oppositional criticism, the question of translating not just literary categories into social science discourse, but art itself—the forms of the beautiful—into social reality is clearly a *political* project, and one with far more significant radical implications than just reordering the disciplinary priorities of the university. According to Herbert Marcuse, the ultimate goal of oppositional cultural criticism is or ought to be the unification (or perhaps, *re*unification) of

art and labor, or in other words the activization of the utopian values now confined to the merely "literary" or merely "fictional" status of the "aesthetic dimension."

> Only through the subjectively unfolded richness of man's essential being is the richness of subjective *human* sensibility (a musical ear, an eye for beauty of form—in short, *senses* capable of human gratifications, senses confirming themselves as essential powers of *man*) either cultivated or brought into being. For not only the five senses but also the so-called mental senses—the practical senses (will, love, etc.)—in a word, *human* sense—the humanness of the senses—comes to be by virtue of its object, by virtue of *humanized* nature. The *forming* of the five senses is a labour of the entire history of the world down to the present. (*Marx-Engels* 88–89)

Nowhere does Marx sound more like a (Hegelian) liberal humanist than here, in his *Economic and Philosophical Manuscripts of 1844*. But for him the *completion* of "the forming of the five senses" could only occur through the revolutionary abolition of capitalism and private property. The dereification which would result would liberate both nature and human nature from the bondage of alienation and the illusions produced by that bondage (that is, the illusions of ideology). Among those illusions was the belief in the necessary, natural, timeless separation of art from labor or of beauty from everyday life. In this manner, instead of demystifying the literary as mere ideology, Marxism bestows on it (or rather, on the entire aesthetic dimension) a utopian significance undreamed of in the philosophies of most academic humanists and formalist literary scholars.

But "the formation of the five senses" is supposedly the goal of the humanities. If Marx was correct, that "formation" or cultivation of the senses would be possible, at least for the working class, "the masses," only through revolution. Meanwhile, under the reign of capital, the culture (art as well as education) so highly prized by the bourgeoisie "is, for the enormous majority, a mere training to act as a machine" (*Marx-Engels* 487). To demand the revolutionary overthrow of capitalism is, of course, another version of the insistence on the unification of theory and practice, and *some* version of such unification, as I have argued, is the only conceivable way of solving the ongoing "crisis of the humanities." In any event, through the various forms of their separation from life, literature and the other arts consciously or unconsciously reflect and reproduce crisis. Behind these contradictions of the modern division of labor, and especially the division of mental from physical labor, the literary critic in the university is doubly isolated—immured within the rules of her discipline and institution, and also immured within literature, which in its purest (art-for-art's-sake) form has by definition no "practical" value.

As most of the literary figures whom Williams analyzed in *Culture and Society* show, the chief attempt to solve the dilemma of an isolated literature and literary

criticism has been simply to *claim* for literature all of the practical powers that its isolation denies. In Shelley's formulation, poets are "the unacknowledged legislators of the world." In Arnold's, culture could be the cure for anarchy, even though, for John Ruskin and William Morris, the anarchy of modern life was the result of the *violent* sundering of art from labor, the beautiful from the everyday, caused by capitalism and industrialization. But Shelley and Arnold were right to the extent that even the most hermetic, "intransitive" forms of literature, as in the poetry of Rimbaud or Mallarmé, are criticisms of life because they illustrate the distance between the beautiful and the real. And even in its most complacently uncritical manifestations, just by "mirroring" the realities of bourgeois "middling-ness" or mediocrity (the non-spirit of *Biedermeier* realism), the realist novel could act as a form of social critique.

Implicitly in its forms of alienation and often explicitly in its themes and content, and despite its disabling separation from reality, literature has in fact functioned as an important form of social critique over the last two hundred years. Literary criticism over the same period has constantly crossed and recrossed the boundaries of the merely literary into the domain of culture and society. As Wolf Lepenies argues, relations between literature as social criticism and sociology as literary form were close throughout the nineteenth century. The connections remain vital to both literary and social science "disciplines"—perhaps most vital now, in their current, *disconnected* academic state of "specialization" and mutual exclusiveness. But whether one looks at Wordsworth's "Preface to the Lyrical Ballads" or Williams's *The Country and the City,* the most interesting literary criticism over the last two centuries has also been cultural or social criticism. As Williams notes, however, often the results of the movement from literature to culture have been reactionary: "It is in no way surprising that the specialized concept of 'literature', developed in precise forms of correspondence with a particular social class, a particular organization of learning, and the appropriate particular technology of print, should now be so often invoked in retrospective, nostalgic, or reactionary moods" Yet even in its most reactionary constructions, as in Thomas Carlyle's *Past and Present,* such literary/social criticism is "a form of opposition to what is correctly seen as a new phase of civilization," to industrialization and bourgeois values (*Marxism* 54).

Is literature therefore unreflected or unconscious ideology, "false conscious-ness," or is it rather always at least partially a form of social and ideological critique? As Eagleton writes in *Marxism and Literary Criticism:*

> Two extreme, opposite positions are possible here. One is that literature is *nothing but* ideology in a certain artistic form—that works of literature are just expressions of the ideologies of their time. They are prisoners of "false consciousness", unable to reach beyond it to arrive at the truth. It is a position characteristic of much "vulgar Marxist" criticism, which tends to see literary

works merely as reflections of dominant ideologies. As such, it is unable to explain . . . why so much literature actually *challenges* the ideological assumptions of its time. The opposite case seizes on the fact that so much literature challenges the ideology it confronts, and makes this part of the definition of literary art itself. (17)

However one chooses to answer the question of the relations between literature and ideology, Eagleton is surely right when, in *The Function of Criticism,* he declares both that "criticism today lacks all substantive social function" (7) and that "the role of the contemporary critic . . . is a *traditional* one" which is also political. In contrast to Williams, he locates "traditional" criticism in the eighteenth rather than in the nineteenth century. He does so, following Habermas, because he sees in the preindustrial eighteenth century a "public sphere" in which, he believes, the literary was not yet divided from the social. Despite the political themes of the first romantics, they were *unacknowledged* legislators. For Eagleton, as also for Williams, a central characteristic of the romantic cultural critics— Blake, Coleridge, Shelley, Carlyle—was their isolation, and hence their lack of any effective political influence, an isolation which in turn became one of their major themes. On the other hand, "just as the eighteenth-century bourgeois critic found a role in the cultural politics of the public sphere, so the contemporary socialist or feminist critic must be defined by an engagement in the cultural politics of late capitalism. Both strategies are equally remote from an isolated concern with the 'literary text' " (*Function* 123).

Despite what seems to me his exaggerated notion of the political influence of writers in the eighteenth century, I agree with Eagleton that a major task of both literary and social criticism today is or ought to be "to resist [the] dominance" of the mass media by helping to construct—or perhaps reconstruct—an "oppositional public sphere" through "re-connecting the symbolic to the political, engaging through both discourse and practice with the process by which repressed needs, interests and desires may assume the cultural forms which could weld them into a collective political force" (*Function* 123). But not just any "collective political force": of course not fascism or Stalinism, but also not Reaganism/ Thatcherism. Part of the difficulty with Eagleton's "revolutionary" criticism is his apparent assumption that the nature of the political influence which writers might exercise in an effective "counter-public sphere" will automatically be "revolutionary." But given more influence than they now have, would artists and intellectuals necessarily choose socialism or even democracy, let alone the utopian unification of art and labor? Eagleton tends to reduce politics to an apocalyptic revolution-or-nothing antithesis. But there are and will continue to be major differences and conflicts—degrees of effectiveness, insight, right and wrong, theoretical looseness or rigor, in oppositional criticism as in everything else.

Part of what Graff and Scholes are scornful about in regard to the "pseudo-

politics" of "radical" literary theorists (and perhaps academic intellectuals in general) is just this lack of definition about what "radicalism" and "politics" mean and can mean at the present time or any other. Yet definitions, and good ones, exist. In U.S. universities, useful, effective models of cultural politics are especially apparent among feminist scholars affiliated with various humanities and social science disciplines. In British universities, the cultural studies movement itself provides models for oppositional criticism both within and beyond their present academic settings. In any event, the "isolated concern with the 'literary text' " which Eagleton attacks has from the early nineteenth century forward been contested by poets, novelists, and "literary" critics operating as cultural and social critics. And the basic form of that contestation has always involved the move from literature to culture—reading the "cultural text" or, as Carlyle put it, the "signs of the times"—though this in turn entails the move, sooner or later, from a focus on culture to one on ideology.

From Culture to Ideology

We have already seen that, for the American Studies movement, while the idea of culture was present from the beginning, the question of ideology—including the possibility that all culture is inescapably ideological—has come to the fore only recently (Bercovitch and Jehlen). Various theorists and critics in the U.S. have pursued the question of ideology in relation to literature and the teaching of English from the sixties forward—an important collection of such work, *The Politics of Literature: Dissenting Essays on the Teaching of English,* first appeared in 1970 (Kampf and Lauter), and Richard Ohmann's equally important *English in America: A Radical View of the Profession* appeared in 1976. Ohmann for one points out that literary criticism in America, in a period when social scientists like Daniel Bell were announcing the "end of ideology," was ideological through and through:

> Here a general principle of ideology is helpful: a privileged social group will generalize its own interests so that they appear to be universal social goals ("What's good for General Motors . . ."). In America, in the fifties, the bourgeois intellectual needed assurance that his privileges were for the general good. For example, a critic and teacher of literature whose work is fun and respectable, but who sees little evidence that he is helping to ameliorate social ills, or indeed serving any but those destined to assume their own positions in the ruling class— a teacher in this dubious spot will welcome a system of ideas and values that tells him that politics and ideology are at an end, that a pluralistic society is best for all, that individual freedom is the proper social goal for rich and poor alike, and that the perfection of self can best be attained through humanistic intellectual endeavor. And this is what the New Criticism and its rival theories had to offer. The tacit ideology has its proper place in bourgeois culture; its main features are

practically inevitable, given the position of critics and teachers in . . . capitalist society. (*English* 86)

A sign of the triumph of precisely the New Critical ideology Ohmann is talking about has been the silencing of the question of ideology within its discourse. Until the last eight or nine years in North America, at least, theorists and critics who want to reopen the question of ideology have seemed relatively isolated and have apparently not had much impact on either literary criticism or the American Studies movement. In contrast, because of the connections of its founders to the working class and to various types and degrees of socialism, in the British cultural studies movement culture and ideology were identified almost from the beginning, and a main area of work in British cultural studies has been the development of theories of ideology.

As Williams realized, the idea of culture acts like a theoretical Pandora's box: once open, everything seems possible. In many definitions, culture is virtually identical with society. Attempts to identify literature with a realm of "high culture"—Arnold's "the best that has been thought and spoken," T. S. Eliot's literary "tradition"—have themselves proven endlessly debatable, a fact that has helped literary criticism and theory to proliferate in many contradictory directions. Anthropological definitions of culture as the realm of significations and symbols, supposedly distinct from the realm of material artefacts and practices, are themselves unclear and inherently unstable (Kroeber and Kluckhohn; Clifford). One of the lessons of Lévi-Strauss's structuralist anthropology was that material artefacts are always symbolic and that "practices" of all sorts necessarily also "signify." Thus all forms of labor in all societies involve communication and fit into symbolic hierarchies (though physical labor is usually located near the base of those hierarchies). But then culture as the realm of significations or symbolic representation comes to include everything, and useful analytical distinctions evaporate.

Insofar as structuralism breaks down the distinction between culture and society, it is possible to think of it as either a materialistic idealism or an idealistic materialism. Its theoretical power comes largely through the "linguistic turn" that has characterized recent social theory: from the structuralist perspective, society itself is language writ large, the "social text" somehow writing or producing all of the smaller versions of itself. At the same time, various leading structuralists saw no major contradiction between their position and Marxism: both Lévi-Strauss and Barthes, for example, claimed to be Marxists. But what happens to Marxism when the idea of economic causation is subtracted from it, or when something else—the "structural," based on a Saussurean linguistic model—is substituted for the economic? No wonder structuralism has seemed to E. P. Thompson a reinvention of philosophical idealism, with the ideal realm determining the material instead of vice-versa. Furthermore, the evolution from structural-

ism to poststructuralism or deconstruction has rendered the very question of social causation opaque. Despite occasional gestures by prominent deconstructors in the direction of Marxism (Derrida, for example: see Ryan xiv-xv, but also Eagleton, *Against,* 79–87), it's difficult not to think of deconstruction also as a sort of *negative* reinvention of idealism, in which the ideas (signifieds) are all that we know, but in which also the ideas make no sense because they bear no demonstrable relation to the phenomenal realm. Yet as Christopher Norris declares, while deconstruction "can be seen as suspending or subverting the most commonplace ideas of referential truth . . . this suspension is by no means incompatible with a strictly *materialist* approach to questions of language and representation" (Norris 142).

But the same defense can be offered for structuralism. It was a supposedly structuralist work—Barthes's *Mythologies* (1957)—which as much as any of the founding texts of British cultural studies made the question of ideology inescapable for anyone interested in cultural or even in merely literary criticism. Although Barthes quickly moved on to other positions (closer to deconstruction or poststructuralism), *Mythologies* performed several groundbreaking feats that have influenced cultural studies. He did not view myth as simply a matter of certain literary/religious texts or stories, as in the usual meaning of Greek or Hindu mythology. Instead, he defined myth as a "language" (11), and more specifically as "depoliticized speech" (143), and he treated it as a modern, extra-literary phenomenon, nearly synonymous with modern culture in general. The myths he analyzed ranged from professional wrestling matches and cinematic acting styles to toys, cars, and ads. Treating each myth as a "signifying system" or "second-order language" of "connotation" (constructed on top of a linguistic base of "denotation"), Barthes showed how each works to naturalize or conceal its social construction, and thereby also to universalize the values it expresses. Each myth was at once an instance of "the language of so-called mass culture" and an expression of "the essential enemy (the bourgeois norm)," disguising itself over and over again as the given, the natural, the classless, and the universal (9). Mythological representation was, Barthes contended, the process through which the bourgeoisie sought to "lose its name" by, in a sense, diffusing its name, its language, to all facets of history and social existence (140). This was Ohmann's "general principle of ideology" analytically extended to the entire field of modern capitalist culture.

> By spreading its representations over a whole catalogue of collective images . . . the bourgeoisie countenances the illusory lack of differentiation of the social classes. . . . The flight from the name "bourgeois" is not therefore an illusory, accidental, secondary, natural or insignificant phenomenon: it is the bourgeois ideology itself, the process through which the bourgeoisie transforms the reality of the world into an image of the world, History into Nature. And this image has a remarkable feature: it is upside down. (141)

Here Barthes invokes one of Marx's key metaphors for ideology, the "camera obscura" from *The German Ideology*, through which the world seems turned on its head, its actual relations reversed—culture appearing as nature, class representations as universal ones, and the inherently political as depoliticized.

Barthes offered the new science of "semiology" as the means for demythologizing the world. Semiology was to be the study of all forms of signification or meaning-making (compare Williams's definition of cultural materialism, *Writing* 210), and its chief role would be ideological critique or what Barthes called "semioclasm" (9). As a beginning, at least, Barthes drew from his analyses of mass cultural products a "rhetoric" involving such categories as "the inoculation" (through which "one immunizes the contents of the collective imagination by means of a small inoculation of acknowledged evil," a tactic Barthes also calls "operation margarine"), the "privatization of history," and "identification" (150–53). About the last rhetorical strategy, Barthes writes:

> The petit-bourgeois is a man unable to imagine the Other. If he comes face to face with him, he blinds himself, ignores and denies him, or else transforms him into himself. In the petit-bourgeois universe, all the experiences of confrontation are reverberating, any otherness is reduced to sameness. The spectacle or the tribunal, which are both places where the Other threatens to appear in full view, become mirrors. This is because the Other is a scandal which threatens his essence. (151)

"Identification," in other words, involves the assumption that "I" am the norm, and that everyone else is either like me or else so totally different as to be subhuman or monstrous—Crusoe dreading his footprint. The chief form taken by mythology/ideology for Barthes, as also for Marx, was simply the misrecognition of others as separate and at odds with ourselves—different in the senses of antagonistic and mistaken—and of the products of our own thoughts and labor as distant, foreign, also separate and beyond our shaping and control. Ideology, in short, turns both other people and our own creations into the threatening Other, Crusoe's nightmare.

Barthes is briefly mentioned in *On Ideology* (1978), a major anthology of work by members of the Birmingham Centre, as having produced "one of the few seminal treatments of the relationship between signification and ideology in what might be called the first phase of Semiotics" (CCCS, *On Ideology* 27). However, the dominant influence for the essayists in *On Ideology* was not Barthes, but Louis Althusser, who seemed to have welded Marxism together with structuralism into a much more rigorous science of demystification or ideological critique than Barthes's semiology. Before examining *On Ideology*, however, a brief account of the concept of ideology in Marx and Engels is in order.

The earliest meaning of "ideology" was the science of ideas envisaged by

Destutt de Tracy and other members of the Institut de France beginning in the 1790s, the aim of which was the production of objective knowledge about social life. In *The German Ideology* (1845–46) and elsewhere, Marx and Engels redefined the term to mean irrational or illusory thinking produced by class interest and the social formation. In doing so, they were influenced by two major traditions: Enlightenment rationalism, which treated the "false" worldviews of the past as superstitions imposed on the majority of people by Machiavellian rulers and "priestcraft" (Tom Paine summed these up as "force and fraud"); and Hegelian idealism, which treated history as a teleological succession of "false" or at least partial worldviews, the transient products of the World Spirit on its path towards self-unification.

In their simplest formulations, Marx and Engels follow the Enlightenment tradition by equating ideology with a "false consciousness" imposed on the majority by the rulers of a society. Thus Marx called religion "the opium of the people," a narcotic that substituted dreams of happiness in the hereafter for demands for social justice in the here-and-now. At the same time, Marx meant more by this than a simple imposition of false views by the rulers on the majority. Apart from the fact that he didn't use the phrase "false consciousness" himself (it was first used by Engels), he generally avoided absolutistic true/false dichotomies. Ideas can be partly "true" and yet also incomplete, distorted, or even presented in forms or via means of communication that are ideological. Also, religion was the *necessary* product of a social system based on injustice and suffering. To call for its abolition in the present, as Marx did, was not to claim that it could simply be replaced by science or truth—the abolition of religion would necessarily entail the abolition of social injustice. Religion was, in short, not consciously crafted by the ruling class and then injected into the minds of the majority; it was instead *produced* by specifiable, complex social conditions, related ultimately to the economic "mode of production." Changing consciousness and changing society had to be aspects of a single process of revolution.

Further, quite apart from the illusory realm of religion, Marx understood various other attitudes, beliefs, and assumptions about the workings of the social world to be ideological. The primary illusion or effect of ideology stemmed not from religion but from the feeling or belief that our thoughts are rational, self-chosen, "natural," and yet independent of material determinations. In other words, ideology begins when ideas appear to be severed from the social conditions which produce them, as literature in the nineteenth century appeared to be increasingly severed from experience. Yet "the phantoms formed in the human brain are . . . necessarily, sublimates of their material life-process. . . . Morality, religion, metaphysics, all the rest of ideology . . . thus no longer retain the semblance of independence. They have no history, no development; but men, developing their material production and their material intercourse, alter, along with this their real existence, their thinking and the products of their thinking.

Life is not determined by consciousness, but consciousness by life" (*Marx-Engels* 154–55). This famous passage from *The German Ideology,* however, still makes it sound as though, through the labor process, people actively shape their thinking to match their work. Instead, Marx and Engels go on to argue, for most people most of the time, ideology is unconscious, unwilled, something they do not choose. Though "the ideas of the ruling class are in every epoch the ruling ideas," and though the ruling class "has control . . . over the means of mental production," it is nevertheless the case that "the ruling ideas are nothing more than the ideal expression of the dominant material relationships, the dominant material relationships grasped as ideas" (*Marx-Engels* 172–73). Thus the "ruling ideas" are the "expression" not of individuals but of the lines of force and class positions within society, and hence no more consciously willed or chosen by the rulers than by the ruled.

No doubt the most difficult and, for current cultural studies, significant version of the concept of ideology in Marx is that of "commodity fetishism," which Marx elaborated toward the beginning of *Capital.* As W. J. T. Mitchell points out, commodity fetishism is in several respects a direct contrast to Marx's identification of ideology with ideas and systematically held (though irrational) beliefs like religion (Mitchell 162). Under the capitalist mode of production, commodity fetishism operates at a level that seems to underlie all forms of consciousness (whether "false" or not)—at the level of what Jameson calls the "political unconscious" in which values take shape. People's labor, for Marx the only true source of value, produces useful articles which, at least in the simplest pre-capitalist societies, can be traded without the mediation of money. In such face-to-face, communal patterns of exchange, labor is not lost sight of as the basis of value. But under capitalism money intervenes; it establishes a different kind of value— "exchange" as opposed to "use value," as Marx puts it—and it works to occlude the original source of value in labor. Now useful articles become commodities, which take on a life of their own apart from the labor process. "The mystical character of commodities does not originate . . . in their use-value" but only through exchange value (*Marx-Engels* 320). Instead of a relation between people measured by labor, what now obtains is a relation "between the products of their labour" abstracted from them—that is, a relation between things.

> There, the existence of the things *qua* commodities, and the value-relation between the products of labour which stamps them as commodities, have absolutely no connexion with their physical properties and with the material relations arising therefrom. There it is a definite social relation between men, that assumes, in their eyes, the fantastic form of a relation between things. In order, therefore, to find an analogy, we must have recourse to the mist-enveloped regions of the religious world. In that world the productions of the human brain appear as independent beings endowed with life, and entering into relation both with one

another and the human race. So it is in the world of commodities with the products of men's hands. This I call the Fetishism which attaches itself to the products of labour, so soon as they are produced as commodities, and which is therefore inseparable from the production of commodities. (*Marx-Engels* 321)

Commodity fetishism raises the question of the relations between articulated cultural, symbolic, linguistic "meanings" and unarticulated or unconscious assumptions or "values," both esthetic and economic. Under capitalism, Marx suggested, all forms of cultural expression tend toward the commodity form. Ideal esthetic "value" is transformed into material economic "value." Material "goods" in the world marketplace usurp the place of immaterial conceptions of the "good," including social visions of the "good life," now increasingly framed, isolated, and disempowered in works of art. But this commodified materialism is alienated and masquerades both as idealism and as a timeless, universal condition. Utopia becomes that consumer's paradise, the department store (today, the shopping mall). Mass or "mechanical reproduction," in Walter Benjamin's terms, leads to the substitution of a false "aura" (uniqueness, authenticity, originality, "value" in several esthetic senses) for the genuine "aura" of the elitist culture of the past.

While the industrialization of culture carries with it the promise of democratization, under the sign of capital it produces instead a reified, "mass," ersatz culture of consumer *kitsch* (see Haug and also Calinescu 225–62). For Marx, Robinson Crusoe on his island offered the perfect example of the production of value through labor, undistorted by exchange or money. Multiply Crusoe in a society that is genuinely communal, Marx thought, and value will continue to be directly related to labor—that is, it will continue to be "use value." Commodity fetishism only commenced with capitalism—a sort of savagery in the midst of civilization that was also, in a sense, the most advanced form of the ruthless forces of modernization driven by capital. Commodity fetishism wasn't yet Crusoe's malaise, and Marx did not mention Friday.

Marx's theories of ideology and commodity fetishism have been criticized from a number of perspectives, but they have nevertheless been powerfully influential on cultural studies. In all of the definitions that can be extracted from Marx and Engels, ideology decenters the individual "subject" from rational control over knowledge, beliefs, culture. All forms of ideological critique influenced by Marxism are thus also critiques of individualism, the main feature of what Barthes calls the "bourgeois norm." The fundamental, most difficult question raised by ideological critique, however, is epistemological. On what grounds does the critic propose to step outside ideology, to gain an Archimedean vantage point that is not also ideological? The ability to define and detect ideology of course implies that true consciousness is possible, while Marx's theory of revolu-

tion also implies that the dominion of ideology can be *generally* challenged and overthrown.

Whether the *general* demystification or awakening from the thralldom of ideology will come after some hypothetical revolution or is instead a precondition of revolution has been a major source of controversy in the Marxist tradition. For Marx and Engels, truth is identical with science which is in turn identical with historical materialism, and also with class consciousness and solidarity (as opposed to false consciousness, fragmentation, dispersion of interests, identification of the ruled with the rulers, etc.). So far from being the general category of *all* forms of knowledge and culture, ideology is the category of distorted half-knowledge and half- or complete illusion generated by class-divided societies and patterns of injustice. Yet Marx often writes as though, in a more general sense, *all* knowledge and culture are inherently ideological because they are always the products of economic forces. While thoughts, texts, and artworks seem to be the *independent* productions of individual thinkers, writers, and artists, and while they always present themselves as "free" in this sense, they are nevertheless also always at least *partly* determined (produced, caused, or merely limited?) by economic and social conditions which they fail to recognize or, at best, only incompletely acknowledge.

In his recent analysis of theories of ideology, Paul Ricoeur points out that they all share some version of what has been called "Mannheim's paradox" (after the German sociologist of knowledge, Karl Mannheim). "The paradox is the nonapplicability of the concept of ideology to itself. In other words, if everything that we say is bias, if everything we say represents interests that we do not know, how can we have a theory of ideology which is not itself ideological? The reflexivity of the concept of ideology on itself provides the paradox" (8). According to Ricoeur, there are only two solutions to the paradox. One is the claim to scientific objectivity, and the other is the consciousness of social alternatives derived from a utopian perspective. For Ricoeur, only the latter provides a genuine solution:

> the only way to get out of the circularity in which ideologies engulf us is to assume a utopia, declare it, and judge an ideology on this basis. Because the absolute onlooker is impossible, then it is someone within the process itself who takes the responsibility for judgment. . . . It is to the extent finally that the correlation ideology-utopia replaces the impossible correlation ideology-science that a certain solution to the problem of judgment may be found, a solution . . . itself congruent with the claim that no point of view exists outside the game. (xvi)

But Ricoeur's argument might be rounded off by asserting that the only basis on which social knowledge can claim the status of science involves the critical

"judgment from a utopia"—exactly the perspective of Brian Fay's "critical social science."

In the preface to *On Ideology*, Gregor McLennan offers a distinction between culture and ideology, but not because he sees the former as the domain of truth and the latter as that of falsehood. Rather, he thinks of culture as a broader category than ideology. "As part of a marxist problematic, a theory of ideology is both a centrally important area of study within the more general category of 'cultural studies', yet has a theoretical coherence which the latter manifestly lacks" (CCCS, On Ideology 6). But it could just as easily be assumed, as most of the contributors to the anthology appear to do, that culture and ideology are identical. After the preface, "ideology" absorbs most of the meanings of culture recorded by Williams in *Culture and Society* and elsewhere. This is true even in the essay most directly concerned with literature and art, Steve Burniston and Chris Weedon's "Ideology, Subjectivity and the Artistic Text" (199–229). They begin with the observation that, at least "at present" (mid-1970s), they think it impossible adequately to understand "the relationship between art, literature, and ideology" (199). This they attribute to "the inadequacies of Marxist theories of subjectivity" (199), though these inadequacies, they contend, have been partially overcome in the work of Louis Althusser and Jacques Lacan, as mediated by the Marxist/feminist semiotics of Julia Kristeva. Althusser, Lacan, and Kristeva supply the main thing missing from Barthes's *Mythologies*—the thesis that the individual "subject," the supposedly sovereign bourgeois ego, is a product of ideology, or in other words that ideology *speaks* the subject, even though the subject believes that he or she speaks freely and consciously. But the "reconciliation" of the two discourses of Marxism and psychoanalysis in Kristeva's esthetic theories Burniston and Weedon also find incomplete, because of her thin treatment of "the social formation" (199).

In Marxist theory, write Burniston and Weedon, the question of the relation of art to society has depended on "the initial status accorded to ideology. It has been seen variously as a form of false consciousness, imposed on the individual from above by the dominant class, as a consequence of a limited view of the whole, resulting from the individual's class position as a perceiving subject within the social formation, and—taking it to its furthest limits to date—as the result of the ideological nature of the perceiving subject *per se*, who is brought into being through his or her insertion into ideological signifying practices, which form the substance of lived experience, within ideological state apparatuses" (200). Marx and Engels are located mainly in the first two clauses of this catalogue; Althusser at the end ("the furthest limits to date"). At least at the time of *On Ideology*, British cultural studies was frequently echoing Althusser and Lacan. Besides the Birmingham Centre, *Screen*, the leading film journal in Britain, was from the early 1970s deeply influenced by Althusserian structuralist Marxism (on the French background to British film theory, see Harvey). Burniston and Weedon's

is just one of several essays in *On Ideology* which take Althusser's theory of ideology as "the furthest limits" of such thinking "to date."

Whether through the fierce counterattack of Thompson's *The Poverty of Theory* (1978) or the direct though not uncritical adoption of Althusser's ideas manifest in *On Ideology, Screen,* and elsewhere, Althusser has probably had more influence on British cultural studies than has any recent non-British thinker, with the exception of Antonio Gramsci. After examining Althusser's main ideas, therefore, I will turn to Gramsci's. This reverses their proper chronological order, of course: Gramsci, born in 1891, did much of his writing after his imprisonment by Mussolini in 1926; he died in 1937, shortly after being released from prison. Althusser, born in Algeria in 1918, wrote and published his major works in the 1960s and 1970s. But the two are in one sense contemporaries, because Gramsci's prison writings were not published even in Italian until the seventies. And Gramsci is in still another sense in advance of Althusser: after a period of Althusserianism in the 1970s and early 1980s, the British cultural studies movement has grown increasingly disenchanted with the scientism of Althusser's structuralism, while Gramsci remains an important influence. Perhaps this move away from Marxist structuralism parallels the move into poststructuralism marked especially by the emergence of deconstructive literary theory. In Britain, however, the most significant result hasn't been deconstruction, but culturalism, and in important ways E. P. Thompson and Raymond Williams were there all along.

Althusser and the
Interpellation of Subjects

Althusser takes up several of Gramsci's ideas, using them "more rigorously" in his own theory of ideology. Perhaps the rigor comes from Althusser's engagement with structuralism, or perhaps from the Stalinism Thompson accuses him of. But Althusser saw his work partly as a repudiation of Stalinism, even while he hued to an apparently orthodox line in the French Communist Party. Writing in *For Marx* of the misuse of the concept of "supersession" or dialectical *Aufhebung,* Althusser points out that a revolution in the economic base "does not *ipso facto* modify the existing superstructures and particularly the ideologies at one blow," but rather that these may survive and "reactivate" reactionary tendencies. This possibility, he says, helps "to explain how the proud and generous Russian people bore Stalin's crimes and repression with such resignation; how the Bolshevik Party could tolerate them; [and] how a Communist leader could have ordered them" (116). But while Althusser here distances himself from Stalinism, he is simultaneously concerned to distance himself from what he sees as humanist or Hegelian Marxism of the sort represented by Thompson. And the direction he takes is that of theoretical rigor, ambitious to produce "a rigorous conception of Marxist concepts, their implications and their development; a rigorous conception

and investigation of what appertains to them in particular, that is, what distinguishes them once and for all from their phantoms" (116). And there is one "phantom" in particular who needs to be exorcised, Althusser says, namely "the shade of Hegel." To exorcise both Stalinism and Hegelianism, "we need a little more light on Marx" (116).

Althusser's main project has been, therefore, the theoretical illumination of Marx's writings. He believes these have been systematically misread and distorted by both Stalinist and Hegelian quasi-Marxists (not to mention liberal humanists, who don't begin to understand them). The one sort of misreading produces the economistic or mechanical Marxism Gramsci also attacked. The other sort moves away from what is truly revolutionary in Marx's later writings, particularly in *Capital*, back through the early "nonscientific" writings in the direction of Hegel's anthropomorphic, historicist teleology. Althusser asserts that true Marxism is a "science"—historical materialism—and that his theoretical illuminations of Marx's texts will provide a sort of science of that science. And the key "problematic" of this Marxist science is that of ideology.

In *For Marx,* particularly in the essay "Contradiction and Overdetermination," Althusser turns as did Gramsci to the relation between economic mode of production (the "base" or "infrastructure") and the "superstructures" (political and legal institutions, schools, culture, religion, etc.). Citing Engels's letter to Joseph Bloch, he offers several ideas to describe and hopefully clarify what he sees as the complex, partly reciprocal interactions between the different "levels" of a "social formation," from economic base through the various superstructures. The chief of these ideas are those of "overdetermination" and of the determination "in the last instance" by the economic level. After quoting Engels, Althusser elaborates:

> Here, then, are the two ends of the chain: the economy is determinant, but *in the last instance,* Engels is prepared to say, in the long run, the run of History. But History "asserts itself" through the multiform world of the superstructures, from local tradition to international circumstance. Leaving aside the *theoretical solution* Engels proposes for the problem of the relation between determination *in the last instance*—the economic—and those determinations imposed by the superstructures—[e.g.,] national traditions and international events—it is sufficient to retain from him what should be called the *accumulation of effective determinations* (deriving from the superstructures and from special national and international circumstances) *on the determination in the last instance by the economic*. It seems to me that this clarifies the expression *overdetermined contradiction,* which I have put forward. . . . (112–13)

Althusser adopts the Freudian term "overdetermination" to describe the patterns of multiple interactions and reciprocal causations among the different "levels" in a social formation. These are the economic, the political, and the ideological.

There is no necessary symmetry to these interactions, no Euclidean axioms (except the "determination in the last instance by the economic") to predict their "uneven development." As in Freud's writings, "overdetermination" in Althusser leaves open the question of what exactly is being explained—and ultimately of whether *any* causal relationship between levels can be established. The idea of the "determination in the last instance by the economic" too neatly comes to the rescue, a *deus ex machina* seemingly preserving the explanatory power that Althusser himself has sapped by declaring all "instances," "moments," or "levels" of a "social formation" to be at least partial causes of all the others.

Jameson's account of Althusserian structuralism in *The Political Unconscious* (23–29) focuses upon Althusser's three-part hierarchy of historical causation: mechanical, expressive, and structural causality. In the third, supposedly highest or most potent form of historical explanation, history itself operates as "absent cause," forever beyond the horizon of the representable. But the reasoning here (and in Althusser) is circular: historical or social explanation via structural causality by this account must inevitably break down; the more powerful the explanatory model, the more it must be thwarted by that which it cannot represent—history as "absent cause." Perhaps the more serious difficulties in attempting to unite structuralism with Marxism, however, are those Thompson detected: first, that structuralism is fundamentally ahistorical or even anti-historical; second, that it allows no place for "human agency" or praxis; and third, that it is based on a set of metaphors that cannot themselves be taken at face value. As in other structuralist accounts, in Althusser the metaphors tend to be architectural—"structures," "base," "levels"—even while the attempt to capture the complex interactions among levels is dynamic rather than static, diachronic rather than synchronic ("instances," "moments"). As Jameson suggests, the problem of mediation—of how the different "levels" and "instances" interact—is crucial, but remains vague in the structuralist paradigm. Althusser's combination of terms seems ultimately more metaphoric than "rigorous" or "scientific": the underexplained relations between "levels" and "instances" or "moments" is precisely the difficulty, the gap between "empiricist" historical process and the "eternal" structures of the social formation which Althusser tries to close.

Later in *For Marx*, particularly in the essay "Marxism and Humanism," Althusser offers a number of propositions that help to flesh out his Marxist-structuralist model of ideology and the social formation. The most controversial of these are his claims that ideology is "an organic part of every social totality" *and* that it is possible to distinguish between ideology (untruth) and science (truth). The first proposition seems directly counter to what Marx and Engels usually suggest— namely, that in the revolutionary, communist society of the future, truth would prevail, the reign of ideology would be overthrown along with that of capital and private property. But Althusser insists that "historical materialism cannot conceive that even a communist society could ever do without ideology" (232). Of

course ideology under capitalism and ideology under communism will be different, but ideology is nevertheless an inescapable aspect of social life. "In a class society ideology is the relay whereby, and the element in which, the relation between men and their conditions of existence is settled to the profit of the ruling class. In a classless society ideology is the relay whereby, and the element in which, the relation between men and their conditions of existence is lived to the profit of all men" (235–6). Thus ideology "is not an aberration or a contingent excrescence of History: it is a structure essential to the historical life of societies. Further, only the existence and the recognition of its necessity enable us to act on ideology and transform ideology into an instrument of deliberate action on history" (232).

What enables us to "act on" ideology and "transform" it is "science." But the question immediately arises, since ideology is necessary, all-encompassing, and "eternal," how does "science" create any space for itself? This is the central question raised by Ricoeur in his *Lectures on Ideology and Utopia.* "Recognition" is a key term for Althusser—ideology is misrecognition—because it is through recognizing the workings of ideology that both science and revolutionary change become possible. For Althusser, Marx provides the central paradigm of "science." Althusser's reading of Marx sees him as moving from a humanistic, still Hegelian stage through an "epistemological break" to the fully achieved materialist "science" of *Capital* (*For Marx* 227). But because "science" is a form of both social and self-recognition, Freud is also important: just as individuals through the "science" of psychoanalysis can achieve a recognition of the workings of their unconscious psyches, so individuals through a Marxist "science" of ideology can achieve a recognition of the workings of what Jameson calls "the political unconscious." Indeed, says Althusser, "ideology has very little to do with 'consciousness', even supposing this term to have an unambiguous meaning. It is profoundly *unconscious,* even when it presents itself in a reflected form (as in pre-Marxist 'philosophy')" (*For Marx* 133). And again: "*ideology is eternal,* exactly like the unconscious" (*Lenin* 161).

At the same time, as in the case of dreams in Freudian theory, ideology is "a system of representations." And as with dreams, these representations do not emanate from a conscious self—they are not deliberately "authored" by freely choosing and acting individuals. Though often, as with Barthes's "mythologies," ideological representations give the feeling of conscious, rational control and choice on the part of individuals who reproduce, believe, and live within them, Althusser claims that they are never chosen. So far from seemingly "free" individuals' creating or authoring those representations, the representations instead create or author, as it were, the individuals who live within them.

> Ideology is indeed a system of representations, but in the majority of cases these
> representations have nothing to do with "consciousness": they are usually images

and occasionally concepts, but it is above all as *structures* that they impose on the vast majority of men, not via their "consciousness". They are perceived-accepted-suffered cultural objects and they act functionally on men via a process that escapes them. (*For Marx* 233)

If the source of ideological representations is not the "individual subject" in society, then what is that source? For Althusser, the answer is the social formation itself: it "authors" ideology and in doing so "authors" us as well. But at the same time, as Thompson declares in *The Poverty of Theory,* such a perspective threatens to liquidate any role for human agency in the making of class consciousness and history. As Jorge Larrain puts it in *The Concept of Ideology,* by totalizing the realm of mystification, Althusser's theory leaves no room for the idea of "revolutionary practice" central to Marx and Marxism:

> For Marx, the justification of the distortion of ideology lies in the fact that men cannot solve in their minds the contradictions they are unable to solve in practice. By putting forward the idea of a revolutionary practice capable of practically solving contradictions, Marx can conceive the fundament of a non-ideological consciousness. Althusser's theory of ideology, on the contrary, is the theory of the necessary domination of ideology. Ideology is a functional requirement of society, which constitutes subjects in their imaginary relations to their world as if their minds were just helpless and passive. Althusser's theory overlooks the very essence of the origin of ideology in class contradictions and thus cannot conceive a way out, other than resorting to the precarious solution of science. (163)

Althusser's conception of science as a form of recognition or demystification from ideology appears to be contradictory, because he has also declared ideology to be in some sense inescapable, part of the "eternal," necessary "structures" of every society. But as in psychoanalysis it is possible to know about the unconscious but not possible to abolish it, so it is with "the political unconscious" of ideology. The contradiction arises in part because Althusser's notion of "epistemological break" implies a complete antithesis between ideology and science: where one exists, the other cannot be. Such a notion overlooks the possibility that there may be degrees of recognition and misrecognition, or in other words that total ideology and total science, complete delusion or enlightenment, may both be impossibilities, though they may also be taken to represent the extreme ends of a spectrum, with most representations of reality—that is, most forms of culture—lying messily, massively, and inconveniently in between.

> So ideology is a matter of the *lived* relation between men and their world. This relation, that only appears as *"conscious"* on condition that it is *unconscious,* in the same way only seems to be simple on condition that it is complex, that it is not

> a simple relation but a relation between relations, a second degree relation. In ideology men do indeed express, not the relation between them and their conditions of existence, but *the way* they live the relation between them and their conditions of existence: this presupposes both a real relation and an *"imaginary"*, *"lived"* relation. Ideology, then, is the expression of the relation between men and their "world", that is, the (overdetermined) unity of the real relation and the imaginary relation between them and their real conditions of existence. In ideology the real relation is inevitably invested in the imaginary relation, a relation that *expresses* a *will* (conservative, conformist, reformist or revolutionary), a hope or a nostalgia, rather than describing a reality. (*For Marx* 233–4)

Thus "the 'lived' relation between men and the world, including History (in political action or inaction), passes through ideology, or better, *is ideology itself.*" Like the "textuality" of the deconstructionists, such a conception of ideology makes it all-encompassing, a category ultimately indistinguishable from the social totality itself.

These ideas Althusser took up again and elaborated in *Reading Capital,* written with Etienne Balibar. Perhaps the main theoretical advance here lies in the conception of "structural causality." In *On Ideology,* the authors of the essay primarily about Althusser explain:

> The main difficulty revolves around whether the concept *structural causality* . . . entails an important shift from the concepts of *overdetermination* and *structure* in *For Marx*. In the latter text, the term *structure* mostly designates the social formation, as in the conceptualisation of a *structure in dominance,* where no room for ambiguity is afforded. In *Reading Capital,* structural causality or *Darstellung* appears to be the same concept. And in one sense in which Althusser uses the notion, no problem of continuity arises; for it represents a rigorous re-examination of those mechanisms of the *economic* region the capital-ist mode of production . . . sometimes referred to by marxists as the relation between real relations and phenomenal forms. Althusser poses "Darstellung" as a means of analysing the real effectivity of seemingly 'surface' forms, such as wages, while retaining the notion that production (as opposed to exchange) is, so to speak, determinant in the last instance. The phenomenal forms/real relations couplet is, in Althusser's view, incapable of an adequate account of this double articulation, for it rests on a Hegelian notion which reduces given phenomena to the emenations of a supposedly problematic "essence." (80)

The first of Althusser's models of causality is the mechanistic, associated with Galilean and Newtonian science, according to which one physical object acts on another to produce an effect. This is the "billiard-ball model of cause and effect" which, Jameson points out, "has long been a familiar exhibit in the history of ideas and in particular in the history of science" (*Political* 25). While such an explanatory model works for a range of natural or physical phenomena, it by no

means works for all such phenomena (try to think of a cause-and-effect explanation for electricity, for example). And it seems especially simplistic when applied to human affairs, history, and culture. What is the "cause" of *War and Peace?* It's possible to answer "Tolstoy," but that is only the beginning of the difficulties.

A second, more complex form of causal explanation, "one conceived precisely in order to deal with the effectivity of a whole on its elements," is "the Leibnizian concept of *expression.*" This is the form of explanation dominant in Hegel, and therefore also in the early Marx. "But it presupposes in principle that the whole in question be reducible to an *inner essence,* of which the elements of the whole are then no more than the phenomenal forms of expression, the inner principle of the essence being present at each point in the whole, such that at each moment it is possible to write the immediately adequate equation: such and such an element (economic, political, legal, literary, religious, etc., in Hegel) = the inner essence of the whole" (*Reading* 186–89). If mechanistic causal explanation is reductive, so is expressive causal explanation, but in a different way. This is apparent, as Jameson points out, in regard to periodization in literary and intellectual history, according to which different eras in the "life" of a society or nation are treated as expressing some unified vision, myth, or worldview. Expressive causality is, for example, the principle form of explanation (or, as Althusser would have it, nonexplanation) practiced by the myth and symbol school of American Studies. Such approaches, says Jameson, "range from the various conceptions of the world-views or period styles of a given historical moment . . . all the way to contemporary structural or post-structural efforts at modeling the dominant episteme or sign-system of this or that historical period, as in Foucault, Deleuze-Guattari, Yurii Lotman, or the theorists of consumer society (most notably Jean Baudrillard)" (*Political* 26–7).

For Althusser, the way beyond these reductive models of causal explanation leads to "structural causality":

[This] can be entirely summed up in the concept of "Darstellung", the key epistemological concept of the whole Marxist theory of value, the concept whose object is precisely to designate the mode of *presence* of the structure in its *effects,* and therefore to designate structural causality itself The structure is not an essence outside the economic phenomena which comes and alters their aspect, forms and relations and which is effective on them as an absent cause, absent because it is outside them. The absence of the cause in the structure's "metonymic causality" on its effects is not the fault of the exteriority of the structure with respect to the economic phenomena; on the contrary, it is the very form of the interiority of the structure, as a structure, in its effects. This implies therefore that the effects are not outside the structure, are not a pre-existing object, element or space in which the structure arrives to imprint its mark: on the contrary, it implies that the structure is immanent in its effects . . . that the whole existence of the structure consists of its effects, in short, that the structure, which is merely

> a specific combination in its peculiar elements, is nothing outside its effects. (*Reading* 189)

Structural causality is, then, a way of thinking about the relations among parts and whole within a social totality, which avoids thinking of them in isolation from each other. In this respect, as Jameson recognizes, it bears comparison with hermeneutics and is essentially an interpretive theory according to which the significance of a given element can be understood in terms of its effects and relations within the larger system. Also, it is an attempt to explain complex social phenomena without anthropomorphizing them, as happens in "expressive causality," *and* without reducing them to the pattern of "mechanistic" cause-and-effect. At the same time, it gives the social totality, as Thompson complains, almost theological status. According to Jameson: "If therefore one wishes to characterize Althusser's Marxism as a structuralism, one must complete the characterization with the essential proviso that it is a structuralism for which only *one* structure exists: namely the mode of production itself, or the synchronic system of social relations as a whole. This is the sense in which this 'structure' is an absent cause, since it is nowhere empirically present as an element, it is not a part of the whole or one of the levels, but rather the entire system of *relationships* among those levels" (*Political* 36). But just how either an "absent cause" or an "entire system of relationships" can be grasped remains mysterious.

Particularly important as an influence on the British cultural studies movement has been Althusser's essay "Ideology and Ideological State Apparatuses," in *Lenin and Philosophy*. Its main theses are presented and debated several times over in *On Ideology*. Posing the question of "the reproduction of the conditions of production," Althusser notes that the answer lies chiefly in the "reproduction of submission to the ruling ideology for the workers, and a reproduction of the ability to manipulate the ruling ideology correctly for the agents of exploitation and repression, so that they, too, will provide for the domination of the ruling class 'in words' " (*Lenin* 132–33). Drawing on Gramsci's theory of "hegemony," Althusser points out that the reproduction of the forces and relations of production is largely the work of what he calls the "Ideological State Apparatuses" or "ISAs." These include churches, schools, the family, "the legal ISA," "the political ISA (the political system, including the different Parties)," trade unions, the communications media, and "the cultural ISA (Literature, the Arts, sports, etc.)" (143). Althusser locates all aspects of society under either the heading of "ISAs" or that of the "Repressive State Apparatus" or "RSA," by which he means those governmental institutions which exercise social control directly, through "violence," as opposed to indirectly, through ideology.

Among the various ISAs in modern societies, Althusser claims, the most important are the schools. "I believe that the ideological State apparatus which has been installed in the *dominant* position in mature capitalist social formations

as a result of a violent political and ideological class struggle against the old dominant ideological State apparatus [namely, the church], is the *educational ideological apparatus*" (152). Althusser leaves no doubt of the importance of schools in maintaining the "ideological subjection" that in turn permits "the reproduction of the skills of labour power" and, hence, the reproduction of the forces of production. "Children at school . . . learn the 'rules' of good behaviour, i.e. the attitude that should be observed by every agent in the division of labour, according to the job he is 'destined' for: rules of morality, civic and professional conscience, which actually means rules of respect for the socio-technical division of labour and utlimately the rules of the order established by class domination" (132). Obviously, there is here no room for liberal humanist claims about the humanizing effects of education.

Working in tandem with the various ISAs, at least in any modern social formation, is the RSA: the police, the prisons, the armed forces. Of course the RSA in a given society is legitimized and unified by ideology—there is an element of ideology in the RSA and an element of violence in the ISAs—but its mode of domination is nevertheless much more direct and coercive than that of the ISAs. The latter are, Althusser notes, plural rather than singular, highly diverse, and often functioning at apparent cross-purposes (as when schools teach Darwinian evolution while churches teach creationism—though this is my example, not Althusser's). Also, whereas the RSA "belongs entirely to the *public* domain, much the larger part of the Ideological State Apparatuses (in their apparent dispersion) belong partly, on the contrary, to the *private* domain. Churches, Parties, Trade Unions, families, some schools, most newspapers, cultural ventures, etc., etc., are private" (144).

Here and throughout, Althusser partly echoes what Gramsci had to say about the role of the institutions of "civil society" (as opposed to official government) in producing "hegemony," or forming the consensus that legitimates and unifies a society. But a key difference is that, for Gramsci, "civil society" can be a site of resistance or struggle against the state, whereas for Althusser *both* the ISAs *and* the RSA are "*state* apparatuses." Just as the "eternal" category of ideology seems to be all-encompassing and unchangeable for Althusser, despite his insistences upon "science" and "revolution," so too the state appears to be an all-encompassing category, leaving no room for resistance, freedom, rebellion. Nevertheless, Althusser cites Gramsci explicitly as authority for his claim that "the private domain" is not "free," but instead plays a major role in the ideological "reproduction of the forces of production" (144). Indeed, as does any ideological analysis which extends to schools, religion, the family, literature and the arts, Althusser's analysis renders the terms social and ideological virtually synonymous: there is no activity, no aspect of social life, which is not governed by ideology and in some sense also by the "state."

The apparently absolute determinism of Althusser's position becomes espe-

cially clear later in the essay, where he examines how the RSA and the ISAs act together on the "individual subject." Declaring that "ideology is a 'representation' of the imaginary relationship of individuals to their real conditions of existence" (162), Althusser advances a number of arguments that lead up to his main idea about the "constitution" of the "individual subject" by ideology. After asserting that ideology "has a material existence," he then goes on to explain that the ideas of any "individual subject" "are his material actions inserted into material practices governed by material rituals which are themselves defined by the material ideological apparatus from which derive the ideas of that subject" (169). He then asserts his "central thesis"—"Ideology interpellates individuals as subjects" (170)—which leads to an elaborate account of "the category of the subject," having as background the "philosophy of the subject" in Descartes, Kant, and Hegel. To simplify, the key question is whether or not humanity is "the subject" of history, society, and the cosmos. Are "we" the meaning, purpose, and end of history, and is that meaning in any case directly accessible to "our" reasoning or knowledge? Or does history have some other "subject" of which we are only the predicate, or does it have no "subject" whatsoever? And what, furthermore, is the relation between these grand notions of "the category of the subject" and the concrete, particular, innumerable "individual subjects"—our discrete "subjectivities"? According to the "Christian religious ideology," Althusser writes,

> God . . . defines himself as the Subject *par excellence,* he who is through himself and for himself ("I am that I am"), and he who interpellates his subject, the individual subjected to him by his very interpellation, i.e. the individual named Moses. And Moses, interpellated-called by his Name, having recognized that it "really" was he who was called by God, recognizes that he is a subject, a subject *of* God, a subject subjected to God, *a subject through the Subject and subjected to the Subject.* The proof: he obeys him, and makes his people obey God's Commandments. (179)

Althusser's play on "subject" (linguistically, as speaker, but also as main topic or what is spoken) and "subjectivity" (the mind's light, desires, etc., but also absolute captivity or thralldom through ideologically constructed consciousness) is partly, but only partly, ironic. The overarching "Subject" which interpellates or "hails" "individual subjects" just as God called Moses is of course not God for Althusser. Instead, the grand "Subject" interpellating all of us "subjects" and "subjecting" us to its purposeless will is Ideology. "As St. Paul admirably put it, it is in the 'Logos', meaning in ideology, that we 'live, move and have our being' " (171). No wonder that Thompson declares Althusser's Marxist structuralism to be a new theology—Althusser simply fills in the blanks left by the "death of God" with Ideology— even though behind *this* God, *this* ultimate Subject of history, there is no plan, will, or reason.

Gramsci and Hegemony

"Who has *really* attempted to follow up the explorations of Marx and Engels?" Althusser writes in *For Marx*; "I can only think of Gramsci" (114). Dissatisfied with the mechanical determinism many Marxists had read into the base/superstructure paradigm, Gramsci developed a more complex model of the interaction between economic base and culture or ideology. The key to this model is the idea of "the necessary reciprocity between structure and superstructure, a reciprocity which is nothing other than the real dialectical process" (*Prison* 366). As Engels had said, "the economic situation is the basis, but the various elements of the superstructure . . . also exercise their influence upon the course of historical struggles" (*Marx-Engels* 760). In line with this thought, Gramsci moved away from the notion of any simple correspondence or reflection between ideology and economic base: "The claim, presented as an essential postulate of historical materialism, that every fluctuation of politics and ideology can be presented and expounded as an immediate expression of the structure, must be contested in theory as primitive infantilism" (*Prison* 407).

Gramsci also rejected the tendency in Marxism to treat all ideology as false consciousness. There might be a positive as well as negative sense of the word "ideology." A distinction should at least be maintained between "historically organic ideologies" and ones that are disorganic, "arbitrary, rationalistic," and imposed on social groups and structures whose interests they violate.

> To the extent that ideologies are historically necessary they have a validity which is "psychological"; they "organise" human masses, and create the terrain on which men move, acquire consciousness of their position, struggle, etc. To the extent that they are arbitrary they only create individual "movements", polemics and so on (though even these are not completely useless, since they function like an error which by contrasting with truth, demonstrates it). (377)

Here and throughout the *Prison Notebooks* Gramsci moves away from the notion of ideology as false consciousness, toward a conception somewhat like Althusser's of ideology as a necessary aspect of all social formations. But unlike Althusser, Gramsci is not interested in making sharp theoretical distinctions between ideology and other sorts of social knowledge and social processes. Gramsci instead sees ideology as an inevitable part of the give-and-take of politics (that is, of living together), but not as a structuralist abstraction somehow separated from human intentions and practices, whereas for Althusser (despite structural causality) it stands outside and determines those intentions and practices. Further, ideology for Gramsci is never entirely illusory: it is effective because it works—because it fills particular needs, plays particular roles, and

tells particular though partial truths. Gramsci is in this way closer to pragmatism than to structuralism.

The central manifestation of ideology for Gramsci is neither religious illusion nor metaphysical idealism as in Marx, but "common sense." This is the primary form taken by the lived experience and the ideas of most people most of the time. Common sense is, says Gramsci, "the 'philosophy of non-philosophers', or in other words the conception of the world which is uncritically absorbed by the various social and cultural environments in which the moral individuality of the average [person] is developed" (*Prison* 419). Common sense is the ideological glue or cement that legitimizes and binds a social formation together by making its institutions and arrangements of power seem natural and wise. Here Gramsci anticipates what Barthes would say about how modern "mythologies" transform bourgeois values into universals, history into nature. At the same time, common sense "is not a single unique conception, identical in time and space" (419): it is instead multiple, conflicted, contradictory. And though deeply conservative in its effects, it is also "inconsequential"-seeming, "in conformity with the social and cultural position of those masses whose philosophy it is" (419). In this way, Gramsci declares, everyone is a philosopher or intellectual. But what then gives rise to "philosophies" superior to—of greater cognitive and critical value than—common sense? Gramsci's answer parallels Ricoeur's emphasis on "the judgment from a utopia." Common sense is challenged whenever the "hegemony" of a dominant class is contested. "At those times in history when a homogeneous social group is brought into being, there comes into being also, in opposition to common sense, a homogeneous—in other words coherent and systematic—philosophy" (419).

The new homogeneous social group or class, challenging and changing the social order, produces its "organic" philosophers or intellectuals whose role is the production of critical social knowledge (though all forms of social knowledge are also ideological). But again, in what sense can critical social knowledge be declared superior to or "truer" than other forms, including common sense? Partly to answer this question, which is, as Ricoeur stresses, central to *every* theory of ideology and of social knowledge, Gramsci resorts to a contrast between organic and disorganic or "traditional" intellectuals. As Quintin Hoare and Geoffrey Nowell Smith explain in the introduction to their translation of *Prison Notebooks:*

> In the first place there are the "traditional" professional intellectuals, literary, scientific, and so on, whose position in the interstices of society has a certain inter-class aura about it but derives ultimately from past and present class relations and conceals an attachment to various historical class formations. Secondly, there are the "organic" intellectuals, the thinking and organising element of a particular fundamental social class. These organic intellectuals are distinguished less by their profession, which may be any job characteristic of

their class, than by their function in directing the ideas and aspirations of the class to which they organically belong. (*Prison* 3)

According to this formulation, the "organic" intellectuals attached to the working class carry on the task of radical social critique and of educating "the masses." That education must have as its first goal the breaking down of the "hegemony" of the ruling class, and a main site of contestation will be the common sense of "the masses." Truth on this account is inescapably political and relative, a matter of class struggle and power relations within society. Nevertheless, "arbitrary" ideologies or ideological patterns reinforce common sense and rationalize the status quo, while "organic" ones demystify and liberate by anatomizing "hegemony" and pointing to alternative social possibilities.

For Marx and Engels, the problem of creating a revolutionary political force was partly educational, transforming false consciousness into objective knowledge of social conditions and class solidarity. The communist society of the future would be free of ideology; historical materialism itself was not just one more ideology, but a science—in a sense, the very science of ideas that Destutt de Tracy had dreamed of creating. Yet if ideology is universal—and, moreover, if "good" ideology or what Gramsci refers to as "good sense" is an "organic" part of its social formation—there can be no sharp or absolutistic dividing lines between what is ideological and what is not.

For Gramsci the key concept of "hegemony" helps him to analyze the complex nature of power, class hierarchies, and causation within society, as well as the social production and influence of ideas and culture. Because it is complex, multiple, contradictory, hegemony always carries within it the seeds of resistance and rebellion. It is at once, so to speak, hegemonic and counter-hegemonic, the balance at any given moment of history depending on the *relative* domination and subordination of the groups or classes within a society. Obviously, intellectuals as the chief creators, preservers, critics, and teachers of culture and ideology are also important agents in the construction and deconstruction of hegemonic social relations. They act as "experts in legitimation," and also as experts in delegitimation, particularly when they operate as "oppositional critics" who aim to produce liberating, counter-hegemonic knowledge.

Critical self-consciousness means, historically and politically, the creation of an *elite* of intellectuals. A human mass does not "distinguish" itself, does not become independent in its own right without, in the widest sense, organising itself; and there is no organisation without intellectuals, that is without organisers and leaders, in other words, without the theoretical aspect of the theory-practice nexus being distinguished concretely by the existence of a group of people "specialised" in conceptual and philosophical elaboration of ideas. But the process of creating intellectuals is long, difficult, full of contradictions, advances

and retreats, dispersals and regroupings, in which the loyalty of the masses is often sorely tried. (*Prison* 334)

"Hegemony" is a term which Gramsci uses in at least two ways: to mean domination or rule and to mean the process of consensus-formation through which rule is achieved by certain groups over others in society. Consensus is always a matter of degree, process, and "struggle": politics cannot be understood as a straightforward matter of a ruling class seizing power and then imposing its point of view or ideology on the classes it rules. Power in complex societies is always negotiated and shifting, and it is always relative to the class, group, and status positions of those who share it differentially, unequally. Thus the idea of hegemony is closer to Foucault's theme of the differential diffusion of power throughout all the interstices of the social formation than it is to Althusser's structuralism, which treats both the state and ideology as beyond the reach of human practice and, to a large extent, beyond consciousness. For Gramsci, in contrast, "hegemony presupposes that account be taken of the interests and the tendencies of the groups over which hegemony is to be exercised, and that a certain compromise equilibrium should be formed"—in other words, society and ideology alike involve complex processes of negotiation, in which both the dominant and the subordinate classes participate, though unequally (*Prison* 161).

For Gramsci as for Althusser, complex societies are divided into several levels or stages. Besides the economic mode of production, there are "two major superstructural 'levels.' " The first level is that of "civil society," which Gramsci describes as "the ensemble of organisms commonly called 'private.' " The second level is that of "political society" or "the State":

> These two levels correspond on the one hand to the function of "hegemony" which the dominant group exercises throughout society and on the other hand to that of "direct domination" or command exercised through the State and "juridical" government. The functions in question are precisely organisational and connective. The intellectuals are the dominant group's "deputies" exercising the subaltern functions of social hegemony and political government. (*Prison* 12)

The first level is the main site on which is produced "the 'spontaneous' consent given by the great masses of the population to the general direction imposed on social life by the dominant fundamental group; this consent is 'historically' caused by the prestige (and consequent confidence) which the dominant group enjoys because of its position and function in the world of production" (12). The second level is the main site of the exercise of "state coercive power which 'legally' enforces discipline on those groups who do not 'consent' either actively or passively. This apparatus is, however, constituted for the whole of society in

anticipation of moments of crisis of command and direction when spontaneous consent has failed" (12).

To these formulations can be added the idea of "historical blocs." What Gramsci means by this phrase seems close to what Althusser calls "social formations," or in other words the totality which emerges when the different "levels" are seen together. "Structures and superstructures form an 'historical bloc'. That is to say the complex, contradictory and discordant *ensemble* of the superstructures is the reflection of the *ensemble* of the social relations of production" (366). The question of mediation or how the levels interact within a historical bloc is better answered by "hegemony" than by Althusser's concept of "structural causality." In a sense, the latter idea explains nothing, because Althusser refuses or is unable to fill in its essentially circular framework with "empirical" evidence or with ideas that capture the "lived" complexity of political interactions. Without such evidence, it remains the lifeless abstraction Thompson accuses it of being, a static "orrery" or model of the "eternal" workings of the social formation.

"Hegemony" in contrast is anything but static, fixed, rule-bound. Yet as Williams explains in his essay "Base and Superstructure in Marxist Cultural Theory," "hegemony supposes the existence of something which is truly total, which is not merely secondary or superstructural, like the weak sense of ideology, but which is lived at such a depth, which saturates the society to such an extent, and which, as Gramsci put it, even constitutes the substance and limit of common sense for most people under its sway, that it corresponds to the reality of social experience very much more clearly than any notions derived from the formula of base and superstructure" (*Problems* 37). In *Marxism and Literature,* Williams contends that hegemony is a term superior to *both* culture and ideology in its explanatory power, largely because of its emphasis on the politics of experience and of "the whole lived social process as practically organized by specific and dominant meanings and values" (108–9).

> Hegemony is then not only the articulate upper level of 'ideology', nor are its forms of control only those ordinarily seen as 'manipulation' or 'indoctrination'. It is a whole body of practices and expectations, over the whole of living: our senses and assignments of energy, our shaping perceptions of ourselves and our world. It is a lived system of meanings and values—constitutive and constituting—which as they are experienced as practices appear as reciprocally confirming. It thus constitutes a sense of reality for most people in the society, a sense of absolute because experienced reality beyond which it is very difficult for most members of the society to move, in most areas of their lives. It is, that is to say, in the strongest sense a 'culture', but a culture which has also to be seen as the lived dominance and subordination of particular classes. (110)

Several terms in Williams's analysis contrast with Althusser's structuralism. The concepts of "practice" and of "lived experience" have little meaning in Althusser

except as forms of illusion or ideology. But both Gramsci and Williams insist on the active role people play in producing meanings, even when these are partially or wholly illusory, as well as on the patterns of domination and subordination within societies. In this manner, both Gramsci and Williams emphasize the significance of active practices—society and culture as processes—rather than static structures. Hegemonic social interactions are not "willed" or "rational" in the sense that an individual can be willful and rational, but they are nevertheless *political*—the multiple, conflicted "struggles" which shape what Williams calls "our common life together."

Though it is possible to think of the British cultural studies movement as having passed through an Althusserian phase in the mid-1970s, there was criticism of structuralist Marxism from the start, much of it not very different from Thompson's in *The Poverty of Theory*. Gramsci's influence has been more direct and longer-lasting, and it is easy to see why. As Stuart Hall puts it in the introduction to *Culture, Media, Language,* another anthology of work by the Birmingham Centre, "Gramsci massively corrects the ahistorical, highly abstract, formal and theoreticist level at which structuralist theories tend to operate. His thinking is always historically specific and 'conjunctural' " or relational (36). The notions of struggle and consensus-formation expressed by "hegemony" help to resolve the problem of determinacy in the direction of at least limited "agency" for individuals and subordinate groups: history for Gramsci as for Thompson and Williams remains open rather than closed, a process more than an "eternal" structure. And like "struggle" the idea of ideology as "common sense" also refuses the intellectual arrogance that views the vast majority of people as deluded zombies, the victims or creatures of ideology. As Chantal Mouffe points out, politics for Gramsci is not a "marche de dupes," nor is ideology "the mystified-mystifying justification of an already constituted class power." Rather, ideology is "the 'terrain on which men acquire consciousness of themselves', and hegemony cannot be reduced to a process of ideological domination" (Mouffe 196).

For these among other reasons, Gramsci's ideas continue to be a vital influence in cultural studies in Britain and elsewhere. Among U.S. historians of slavery and labor, for example, the concept of "hegemony" is now important albeit controversial. It has also been central to recent labor and feminist history in Britain, as well as to the increasing debates about race and empire there. And it has been of major importance in work dealing with the interactions between "youth subcultures" and the mass media. Arguing against those who have doubted that Gramsci's ideas, particularly hegemony, "can be wielded with any precision," American historian Jackson Lears declares: "Gramscian terms provide a theoretical vocabulary that acquires meaning only in specific contexts; the value of that vocabulary is that it highlights the relation between culture and power without reducing mental and emotional life to a mere epiphenomenon of economics or demography" ("Power" 137). Gramsci does not reduce culture to ideology,

but neither does he reduce ideology to culture. Instead, he thinks them together and dialectically, terms that are both appropriate to describe the always complex social processes through which people construct meanings, values, and their own subjectivities in history.

Ideology as Representation

There have been many influences on British cultural studies besides the theories of ideology of Marx and Engels, Althusser, and Gramsci. The entire range of "Western Marxism," from Lukács through Brecht, Benjamin, Adorno, and Sartre, to Italian theorists such as Galvano Della Volpe and Sebastian Timpanaro has been central. The western Marxist tradition reinforces the conception of cultural studies as a form of ideological critique. But other influences pull away from that conception. Falling somewhere between Marxism and a Durkheimian social semiotics, Pierre Bourdieu, with his concepts of "cultural capital," "the habitus," and "symbolic violence," has been only slightly less influential than have Althusser and Gramsci (Garnham and Williams). The structuralist semiotics of Lévi-Strauss and Barthes has offered methods of interpreting cultural "codes" such as film images and advertising at least partially freed from the more negative and absolutistic implications of ideological critique. The various strands of feminism have contributed powerfully to conceptions of cultural politics and subjectivity in ways that at least complicate theories of ideology which assert the causal primacy of social class. And Foucault's Nietzschean treatment of knowledge and "discursive practices" as forms of power also moves away from the concept of ideology, while retaining a radical-critical edge.

Foucault's criticisms of the concept of ideology and of theories dependent on that concept can serve as an example of the various forms of "poststructuralism" and "post-Marxism" (see Geras) that reject the Hegelian traces of "essentialism" and "historicism" in Marxist thinking. According to Foucault:

> The notion of ideology appears to me to be difficult to make use of, for three reasons. The first is that, like it or not, it always stands in virtual opposition to something else which is supposed to count as truth. Now I believe that the problem does not consist in drawing the line between that in a discourse which falls under the category of scientificity or truth, and that which comes under some other category, but in seeing historically how effects of truth are produced within discourses which in themselves are neither true nor false. The second drawback is that the concept of ideology refers, I think necessarily, to something of the order of a subject [that is, the rational, unified "subject" of history which, as Foucault is well-aware, is subverted by most definitions of ideology]. Thirdly, ideology stands in a secondary position relative to something which functions as its infrastructure, as its material, economic determinant, etc. For these three

reasons, I think that [ideology] is a notion that cannot be used without circumspection. (*Power* 118)

While Foucault's circumspection is reasonable, however, his solutions to the problems he sees in ideology seem less than adequate. At times, as in this passage, he speaks of "effects of truth . . . produced within discourses which in themselves are neither true nor false." But "effects of truth" might itself be a definition of ideology, which works by making people believe it is true—in other words, by producing "effects of truth." And to speak of "discourses which in themselves are neither true nor false" does not let Foucault off the hook about making judgments concerning the truth or falsity of discourses: knowing that they are "neither true nor false" is epistemologically just as problematic as knowing that they are either true or false. On most occasions, Foucault simply identifies truth with power, so that whatever "discursive practices" are operative or have power in a given society are true or constitute a "regime of truth." Thus there are no deeper or truer truths hidden beneath the surface forms of discourse *qua* power. But such a position, a sort of might-makes-right pragmatism, is just as contradictory as the first one and is obviously at odds with the radical political intention at least implicit in everything Foucault wrote. "It's not a matter of emancipating truth from every system of power (which would be a chimera, for truth is already power) but of detaching the power of truth from the forms of hegemony, social, economic and cultural, within which it operates at the present time. . . . The political question . . . is not error, illusion, alienated consciousness or ideology; it is truth itself. Hence the importance of Nietzsche" for whom the will to knowledge and the will to power were identical (*Power* 133). But how can truth, if it is identical with power, have any power "detached" from "the forms of hegemony" (that is, from the forms of power)? And how is "detaching" different from "emancipating?" Trying to avoid falling back into the pitfalls of ideological critique, Foucault adopts a radical skepticism that seems to offer no basis either for judging truth and falsity or for advocating any sort of political action. On the basis of this skepticism, there is no reason for Foucault to side with prisoners instead of wardens, with the insane instead of psychiatrists, or with witches instead of those who burn them. Yet Foucault obviously does take sides with the condemned, the weak, the persecuted against those powerful (therefore true?) voices which judge them. Perhaps it is possible to move away from the contradictions involved in both ideological critique and Foucauldian discourse analysis by coupling Gramsci's idea of hegemony with the related idea of representation. Representing the voiceless, the powerless, "the others" is how E. P. Thompson thinks of "history from below," and also how Edward Said defines "oppositional criticism." This is also the major thrust of Foucauldian "genealogy" or cultural history. Together with ideological critique, such "oppositional" or "counter-hegemonic" representation has been a main goal of most forms of cultural studies.

According to Said, "the critic is responsible to a degree for articulating those voices dominated, displaced, or silenced by the textuality of texts" (*World* 53). As in Foucault, discourse including "texts" means power: "Texts are a system of forces institutionalized by the reigning culture at some human cost to its various components." Said joins the ideas of textual power and voicing the voiceless with resistance to "monocentrism" and "ethnocentrism," so that the aim of oppositional or critical representation becomes dialogue and perhaps ultimately a democratically structured polyphony including all of "the others." This dialogue or polyphony, however, needs to be categorically distinguished from the liberal pluralism which merely reinforces the cultural and social inequalities of the status quo.

> . . . Most of all, criticism is worldly and in the world so long as it opposes monocentrism, a concept I understand as working in conjunction with ethnocentrism, which licenses a culture to cloak itself in the particular authority of certain values over others. Even for Arnold, this comes about as the result of a contest that gives culture a dominion that almost always hides its dark side: in this respect *Culture and Anarchy* and *The Birth of Tragedy* are not very far apart. (*World* 53)

Althusser defines ideology as "a system of representations" through which we live our *imaginary* relations with the social formation (ideology renders the *real* relations opaque). Because ideology is both unconscious *and* imaginary (that is, a fantasia which masks the real social conditions which produce us as subjects), he might better have defined it as a system of *mis*representations. Stressing the Lacanian features of Althusser's theory leads to a definition of ideology *as* the Imaginary (and therefore the unconscious), simultaneously identical with the most common forms of discourse and of *apparent* consciousness. Because ideology is totalistic for Althusser, the suggestion is that *all* forms of communication are misrepresentations, or in other words that there is no escape from false into true consciousness. According to Lacan, though the Imaginary and the Symbolic are developmental stages of the individual psyche, the Imaginary is not left behind, but is instead elaborated and "sublimated" in the Symbolic. But using any totalistic definition of ideology, its would-be critic paints her or himself into a corner. Althusser's insistence on the distinction between science and ideology seems arbitrary (how does science escape from being ideological?), and art for Althusser is incapable of the full self-recognition he attributes to science (though in "A Letter on Art," he treats art as a category that, like "science," at least partly escapes from ideological determinism (*Lenin* 221–27).

The concept of hegemony, on the other hand, involves the ideas of negotiation, consensus-formation, and *degrees* of truth and untruth, representation and misrepresentation. These ideas are *dialogical* in a way Althusser's are not (*both* his

theory of ideology *and* the totalistic version of ideology within that theory might be seen as examples of what Said calls "monocentrism"). As with Gramsci's attribution of *partial* reasonableness to "common sense," hegemony moves the definition of ideology away from the sharp dichotomies between truth and falsehood or illusion that many theorists rely on. It suggests that culture is a field of struggle in which the stakes are accurate, just, and direct representation by groups and individuals instead of misrepresentations by others. Better than "ideology," which is hard to pry loose from its negative connotations of illusion given it by Marx, "representation" is a term which makes room for the fact that there are degrees of justice and accuracy as well as of distortion and illusion in all forms of culture. Yet like "ideology," "representation" points to the *political* nature of all culture and discourse. This is not to suggest that "ideology" should be abandoned as a term without utility for cultural studies, but only that it is more useful when restricted to particular forms of *mis*representation than when it is treated totalistically, as that which, in common with "culture," envelopes us all from birth to death. The particular forms of *mis*representation or ideology can then be distinguished by comparison with alternative forms of more accurate or more truthful representation. The role of the cultural critic is to make such distinctions.

In Derrida's thinking "representation" is, of course, also totalistic, or all-pervasive and inescapable. "Representation becomes the most general category to determine the apprehension of whatever it is that is of concern . . . in any relation at all," he writes in "Sending: On Representation" (310). And he adds: "The great question, the generative question, thus becomes, for this epoch, that of the *value* of representation, of its truth or its adequacy to what it represents" (310). As Jonathan Arac points out, representation for Derrida is not *im*possible; instead, it is the *only* possibility, the sole form of consciousness, because absolute "presence" is impossible. In this sense, indeed, there is "nothing outside the text" or beyond the field of our representations. As with totalistic versions of ideology, representation conceived as consciousness as such makes critique difficult or impossible: starting from Derrida's position, there seems to be no way to distinguish more or less accurate representations from misrepresentations, truth from falsehood, reality from fiction. For Derrida, representation always makes a kind of falsehood inevitable: a representation claims to "present" or to "bring into presence" its referent, but can never do so; it is doomed always to be only the ghost or illusion of presence. But this is obviously a different sort of falsehood from the kind Althusser and most other theorists of ideology have in mind when they speak of illusion or distortion. For most western Marxists, ideology is a form of social dreaming or imagining on a Freudian or Lacanian model from which we may or may not be able to awake, but to which the possibility of waking up—the possibility of truth, therefore—adheres as part of its definition and as the moral/political imperative behind critique (we *should* wake up from the dream of ideology, even if we cannot). All theories of ideology make some sort of

distinction between imaginary and real relations, illusion and truth. For the deconstructionist, on the other hand, representation has no beginning or end; there are no cracks in its universal surface, no depths that it hides; we can never see beyond its horizon.

Of course "representation" has been attacked, along with "referentiality" and narrative realism or mimesis in fiction and cinema, as *both* impossible (a representation can never truly make present its object) *and* politically authoritarian or undemocratic (strange, given the numerous associations between linguistic and democratic representation; on these associations, see Pitkin). Catherine Belsey's *Critical Practice* is an example of such an attack, from an Althusserian perspective, on representation as mimetic realism; Terry Lovell's *Pictures of Reality* offers a good antidote to Belsey. An interesting recent variant of the rejection of representation occurs in Stephen Tyler's theory of "post-modern ethnography." According to Tyler:

> To represent means to have a kind of magical power over appearances, to be able to bring into presence what is absent, and that is why writing, the most powerful means of representation, was called "*grammarye,*" a magical act. The true historical significance of writing is that it has increased our capacity to create totalistic illusions with which to have power over things or over others as if they were things. The whole ideology of representational signification is an ideology of power. To break its spell we should have to attack writing, totalistic representational signification, and authorial authority (Tyler in Clifford and Marcus 131)

Tyler believes the struggle against representation which characterizes "post-modernity" to have been already partly won by Derrida, Walter Benjamin, Theodor Adorno, and others, in such a way that "post-modern ethnography builds its program not so much from their principles as from the rubble of their deconstruction" (131). This new ethnography will subvert the "graphy" part of its heritage, attacking representation and writing together by its insistence on the fragmentary, the "poetic" and "fictional" instead of the scientific, and on the participation of both observer and observed in "evocation" instead of "representation"—or rather on breaking down the entire distinction between observer/observed, subject and object.

Tyler and the other contributors to *Writing Culture: The Poetics and Politics of Ethnography* (Clifford and Marcus) are in understandable recoil from older versions of anthropology, directly or indirectly in the service of imperialism and cultural domination. But Tyler condemns *all* writing and representation (even as he writes and represents) in part by identifying them with the false forms of science or "scientism" that he rightly sees as aiming at the domination of both nature and "others" (with "others" here especially meaning nonwestern peoples).

In doing so, he follows Derrida into the blind alley within which deconstruction can only deconstruct itself. All representation becomes misrepresentation; there is no perspective either within or beyond ideology from which to understand it and criticize it.

Nevertheless, it is possible to think of representation as forming a range of specific practices and instances which can be *more or less* true or false, instead of *either* true *or* false. Its varying definitions start from the assumption that more or less truthful representation is possible; misrepresentation is of course equally possible. What emerges is a range or multiplicity of inherently ambiguous, always political possibilities, whereas most definitions of ideology imply a sharp break between falsehood (the ideological) and truth or science. Linguistic and political representation involve analogous ranges of possibility (see Pitkin). For Rousseau, according to Derrida, both writing and political representation entailed falls from the grace or innocence of absolute presence. In the case of writing, the fall was away from speech or face-to-face dialogue such that "alphabetic writing, representing a representer, supplement of a supplement, increases the *power* of representation" (*Of Grammatology* 295) and paradoxically also increases *mis*representation as the distance from "presence" increases. The representation or representative threatens the total usurpation of the place of that for which it presumably "stands." (It is easy from this to see how, in common with much modern anthropology, Tyler's "post-modern ethnography" looks back to Rousseau.) For similar reasons, Rousseau condemned all forms of political representation in favor of the direct, full assemblage and participation of all the people. "Praise of the 'assembled people' at the festival or at the political forum," writes Derrida, "is always a critique of representation. The legitimizing instance, in the city as in language—speech or writing—and in the arts, is the representer present in person: source of legitimacy and sacred origin" (*Of Grammatology* 296). Representation, whether political or linguistic, is for both Rousseau and Derrida a form of parasitism. The chief difference between them is that Rousseau thought it possible to escape from representation into pure presence—direct speech, the "assembled people"—whereas Derrida conceives of representation as only parasitic on further representations, in an infinitely regressive, circular, or playfully "free" pattern, depending on how you look at it.

The insight that representation is inescapable is logically parallel to the inescapability of ideology in its totalistic definitions (ideology is culture, whose creatures we are). But the word "representation" refers to an action as well as, in its most abstract, Derridean sense, a state of being (or rather, a condition of existence—we are never truly "present" even to ourselves, we are "always already" represented). Through language we represent ourselves, events, objects, and each other, and it is much easier to see how these discrete acts of representation—performances, speech acts, individual texts, etc.—can be scrutinized, judged in terms of truth or falsity, accuracy or inaccuracy than to understand how a totalistic

system of representation or ideological mystification functions when we ourselves are "subjected" to—the "subjects" or creatures of—that very system. A definition of ideology as misrepresentation approaches Habermas's conception of ideology as "distorted communication." As in earlier Frankfurt Institute attempts to distinguish "Critical Theory" or a philosophically valid sort of reason from the dominative or destructive "instrumental reason" embodied in industrial technology, Habermas elaborates a taxonomy of the forms of reason, based on speech-act theory and patterns of communicative interaction. The central problem is to understand how certain forms of communication or representation are rational (or partially rational) while other forms are irrational or partially irrational. For Habermas, as we shall see more fully later, the question of modernity is also one of the absorption or "colonizing" of all forms of rationality and knowledge by positivistic science or "scientism." In working out his theory of communicative reason, Habermas appears to valorize face-to-face communication in a Rousseauistic manner unacceptable to deconstructionists, who sense in all speech-act theory a veering away from the problematic of writing toward absolute presence. But Habermas merely begins with speech-acts (as do J. L. Austin, John Searle, and other speech-act theorists) because they are the simplest forms of communication and in some sense the basis for all other forms.

The cultural politics practiced by oppositional critics today—whether feminists, postmodern ethnographers, Marxists, Foucauldians, or some other variety—can be understood as the struggle for full representation and participation by those who have been under- and mis-represented in the schools, the curriculum, the artistic and literary canons, as well as in government, the economy, institutions of all sorts. No matter how divided on issues of theory feminists happen to be, most would agree that the central issue is one of full, just representation of women, which they obviously also equate with power. The same is true of the practitioners of Afro-American and various other ethnic studies and movements. And the target they are likely to aim at first is not the ideology or false consciousness of "those others," but the misrepresentation of others through the ideological practices of those with power.

4

Class, Gender, Race

Cultural Studies and the
Question of Representation

In the Marxist tradition, the concept of ideology helps to explain why certain dominated groups—most centrally the working class—seem to put up with their domination and to greater or lesser extent come to think of it as natural, inevitable, even just. But this approach is difficult to square with one which seeks to understand and appreciate on their own terms the beliefs and values of the dominated. In the first instance, working-class consciousness is false consciousness; in the second, it is true or at least truer than "arrogant" upper-class intellectuals, including many Marxists, have allowed. Williams, Hoggart, and Thompson treat working-class ideas, values, and culture not as ideological in the sense of false consciousness, but instead as valid within their own terms. The Gramscian concepts of common sense and hegemony clearly fit this approach better than the Althusserian thesis of the "interpellation of the subject" by "Ideology." And the Bakhtinian idea of the conflicted, "multiaccentual" or "heteroglossic" nature of all discourse is also more helpful in this regard than theories which view ideology as monolithic illusion.

In announcing the "death of the Author," Barthes argued, like Bakhtin, that "a text is not a line of words releasing a single 'theological' meaning (the 'message' of an Author-God) but a multi-dimensional space in which a variety of writings, none of them original, blend and clash" (*Image* 146). But Barthes's "semiology" (in common with later versions of semiotics) did not offer a theory of social causation that can explain how the polysemy of texts and meanings is limited and shaped by those social forces that, in *Mythologies* and elsewhere, Barthes simply identified with bourgeois ideology. If the monolithic version of ideology is misleading or simplistic, so is the idea of a limitless polysemy unshaped by such social factors as class and mode of production. The social incarnations or enactments of discourse—culture, in other words—seem always to fall messily in between the extremes of total imposition or control on the one

108

hand, and unbounded polysemy on the other. The space between these extremes is what cultural studies, in most of its variants, seeks to negotiate and map.

Like authoritarian theories of the text which impose uniform meanings on both authors and readers, in their most monolithic forms theories of ideology define it not only as false consciousness but as a false unity of the ruled with each other and with the rulers, a sort of solidarity against solidarity. Such an approach can be seen, for instance, in Marcuse's 1964 diagnosis of the "one-dimensional society," and in certain other radical versions of "mass society" theory (Brantlinger, *Bread* 222–48). In contrast, the hallmarks of Thompson's *The Making of the English Working Class* are a sense of the great diversity of radicalisms in the early Industrial Revolution and also Thompson's respect for those radicalisms. Again, as Thompson says in his preface, "I am seeking to rescue the poor stockinger, the Luddite cropper, the 'obsolete' handloom weaver . . . from the enormous condescension of posterity" (12). To this passage might be compared any number of preambles to more recent studies in labor history and politics, as for example this one from the opening of Patricia and Brendan Sexton's *Blue Collars and Hard Hats* (1971):

> We do not wish to glorify the individual working-class man. Yet as a class, workers possess a quiet strength, integrity, good sense and genuine individuality. It is regrettable that so few of our writers, dramatists, artists have ever seen fit to portray the workingman as more than a slob, menial, buffoon, racist. In a sense this core of our society—working-class culture—has almost never found expression in the formal arts or in the material that finds its way into academic classrooms. Occasionally the media will pick up a working-class type—most notably in the recent past the folk singer Johnny Cash—and find he is a crashing success, instantly and unexpectedly. But neither the media nor others who "express" American culture or peddle the arts learn much from such bright examples. Maybe soon we will begin to notice these people, their needs, and the political and economic organizations they have created. (23–24)

There are several points at stake in this Hoggart-like passage. The Sextons conceive of the central problem not as what transpires in the minds of workers, but as what transpires in the mass media and, Althusser's most powerful "ISA," the educational system. They are not concerned with how ideology has deflected the American worker from a true path of revolution or at least of radical resistance to the dominant culture, but with the lack of representational power of workers within that dominant culture, which either ignores them or misrepresents them through stereotyping practices.

Without a larger share in the power structure of society, workers by definition are not only those who are unable to sell anything except their labor, they are also those who are unable fully to represent themselves through the channels and institutions of the dominant culture. Marx made this point when he declared that

the "small peasants" of mid-nineteenth-century France are divided from each other and therefore "do not form a class":

> They are consequently incapable of enforcing their class interest in their own name, whether through a parliament or through a convention. They cannot represent themselves, they must be represented. Their representative must at the same time appear as their master, as an authority over them, as an unlimited governmental power that protects them against the other classes and sends them the rain and the sunshine from above. The political influence of the small peasants, therefore, finds its final expression in the executive power subordinating society to itself. (*Marx-Engels* 608)

In the inability of the small peasants of France to unite as a class and represent themselves, Marx saw the formula for dictatorship, or the form of political representation of the totally powerless by the totally powerful. Of course he also thought of the industrial proletariat as a direct contrast to the peasants: the workers were coalescing into a class, increasingly aware of their solidarity and power; they were creating organizations—protest movements, trade unions, political parties—to represent their interests; and they would one day represent themselves fully through revolution. The distance from Marx's vision of the industrial proletariat taking the cause of justice into their own hands and the Sextons' of a working class continually misrepresented by the seemingly all-powerful mass media is the central problematic of labor historians and theorists of ideology today. Yet as the Sextons note, even the American working class has created "political and economic organizations" which represent its interests, although then these organizations themselves are subject to the misrepresentations of the media.

The idea of misrepresentation here is clearly identical to one meaning of ideology, yet it has little to do with what the misrepresented think or believe about themselves or society. Ruling class ideology, as in the stereotyping of workers or blacks by the mass media, does not have to be believed by the ruled in order to be hegemonic. If as Foucault contends discourse is power, then those who can represent themselves and others through discourse are powerful; those who cannot are powerless. The power to represent oneself becomes of major importance; representation by others is, as Rousseau thought, likely to be misrepresentation and perhaps also, as Marx thought, the path to dictatorship. Viewed in this light, ideology is not a set of illusions which the rulers of a society convince the ruled to believe; it is instead the ensemble of discursive practices—that is, of representational practices—which both structure society and are structured by it in the complex ways Althusser, following Freud, calls "overdetermined." Habermas might add, striking a theme close to Foucault's of the discursive power of the modern academic and professional disciplines, that the chief form of ideology

today is not untruth but truth, or at least truth as determined by positivistic science, or in other words by the dominant patterns of "instrumental reason" and technological "rationalization," driven by capital. For Habermas, science is today the prime instance of the ideological not because it misrepresents its objects, but because it "colonizes," overrules, or excludes other forms of "cognitive" human interest—particularly those esthetic and moral forms that aim at beauty, freedom, community, and ecological sanity.

To the extent that workers or any other "subaltern group" come to believe the misrepresentations—stereotypes about themselves, for example—they are indeed victims of ideology in the sense of false consciousness. But it is still possible to distinguish between the misrepresentations of the dominated by the dominant culture and the forms of "anti-hegemonic" representations that constitute working-class and "subaltern" cultures. It is also possible to ask under what circumstances both the ruled and the rulers could be liberated from ideological misrepresentation. Foucault's answer seems to be that liberation from misrepresentation is never possible except through "micropolitical" instances of resistance and rebellion. His negative teleology or "genealogy" of the modern forms of discursive power suggests, moreover, that the patterns of domination in culture and society are getting stronger rather than weaker, and that there is little or nothing that we can do to change this trend. The traditional Marxist answer, on the other hand, has been when private wealth and the class divisions in capitalist society are abolished. In that revolutionary, utopian future, the forms of culture as of politics and economics will approximate the ideal of full, uncoerced self-representation in a community of equals. Or so Marx suggested when he defined communism as "the production of the form of intercourse itself"—that is, of community:

> Only in community [will each] individual [have] the means of cultivating his gifts in all directions; only in . . . community, therefore, is personal freedom possible. In the previous substitutes for . . . community, in the State, etc., personal freedom has existed only for the individuals who developed within the relationships of the ruling class, and only insofar as they were individuals of this class. The illusory community, in which individuals have up till now combined, always took on an independent existence in relation to them, and was at the same time, since it was the combination of one class over against another, not only a completely illusory community, but a new fetter as well. In . . . real community the individuals obtain their freedom in and through their association. (*Marx-Engels* 197)

Here, then, is one more definition of ideology from Marx: illusory community, illusory unity. In contrast, real community means, as Williams suggested, unrestricted, democratic "communication": "the process of communication is in fact the process of community" (*Long* 55). Habermas is thinking along similar lines

when he defines ideology as "distorted communication" (that is, as misrepresenta-
tion) while also contending that all speech-acts, all uses of language, carry implicit
within themselves the promise of "undistorted" or nonideological communication,
and hence point to the goal of free, direct, self-representation in democratic
community. That this goal seems unrealistic or impossible to achieve is no
argument against Marx, Williams, or Habermas: the fact that the goal of "undis-
torted" representation can always be struggled for, approximated, and won in at
least "micropolitical" ways lies at the core of *all* political theories which aim at
liberation. And insofar as representation and culture are synonymous, this idea
has given a powerful radical impetus to most versions of cultural studies.

As Said contends, understanding and working to change the ideological pro-
cesses of misrepresentation are the main tasks of the "oppositional critic." Most
accounts of the shift from literary to cultural criticism in both U.S. and British
universities stress analyzing and rectifying the dominant culture's misrepresenta-
tions of workers, women, Afro-Americans, and other "subaltern" groups. "Class,
gender, race come into definition, while the Humanities begin to look like a
granfalloon" (Ohmann, *Politics* 6). The forms of misrepresentation vary widely,
from the mass media stereotyping of workers which the Sextons analyze, to
racism, to the paucity of women writers in the literary canon. In explaining the
shift in American Studies from a mainly literary to an ideological focus, Myra
Jehlen says that the key factor has been "an increasing recognition that the political
categories of race, gender, and class enter into the formal making of American
literature such that they underlie not only its themes, not only its characters and
events, but its very language" (Bercovitch and Jehlen 1). Likewise, Jonathan
Arac notes "the deep concern with the mechanisms of representational power" as
a motivation for transforming literary into cultural studies and adds that "the
crucial contemporary agenda is elaborating the relations that join the nexus of
classroom, discipline, and profession to such political areas as those of gender,
race, and class, as well as nation" (Arac xxx). Those "political areas," as much
recent culturalist work has demonstrated, are constructed in and through the
ideological processes of representation and misrepresentation, domination and
subordination.

Labor History

With Hoggart, Williams, and Thompson as initiators, the British cultural
studies movement has from the start focused on working-class culture. Of course
class is a fundamental category for Marxist theory, which treats all forms of
social oppression as functions of the division of labor and class conflict. But
particularly for Hoggart and Williams, the question of working-class culture and
how it had been represented or misrepresented was also a directly autobiographical
one. Further, the work of the Marxist historians including Thompson, Eric

Hobsbawm, Christopher Hill, John Saville, and others has given labor history in Britain a greater centrality and cohesion than it has had in the U.S., where issues of class are complicated by American "exceptionalism" and by slavery, racism, and ethnic divisions.

The flourishing of labor history in Britain can be seen as a specific instance, though the most important one, of the development of social history from the late nineteenth-century forward. Along with *Past and Present,* the journal founded by the British Marxist historians group in 1952, the History Workshop at Ruskin College, Oxford, and its journal established in 1976 have been main sites for the publication of what Raphael Samuel calls "people's history." Oral history, a focus on "popular culture," and a stress on "lived experience" are attempts by historians such as Thompson, Samuel, Hobsbawm (*Primitive Rebels, Workers*) and Peter Burke (*Popular Culture in Early Modern Europe*) to let "the people" represent themselves in the shaping of the historical record. There are, Samuel points out, conservative versions of "people's history" in which politics, class, and class struggle are deemphasized in favor of family, church, and nation. As in the myth-and-symbol school of American Studies, a nationalist stress on the unity of "the people" overrides difference and dissent, and there is usually a strong element of nostalgia: "The characteristic location of right-wing people's history is in the 'organic' community of the past" (Samuel xxi). But the essays in Samuel's History Workshop anthology, *People's History and Socialist Theory,* are all written from a radical perspective much more typical of British social history since World War II. The emphasis on subjectivity or personal experience, moreover, brings Samuel's version of "people's history" well within the orbit of cultural studies:

> The main thrust of people's history in recent years has been towards the recovery of subjective experience. One might note, in oral history, the overwhelming interest in reconstituting the small details of everyday life; in local history, the shift from "places" to "faces", from topographical peculiarities to the quality of life; in labour history, the preoccupation with the more spontaneous forms of resistance. More generally one could note the enormous research industry which has gone into attempting to capture the voice of the past—the cadences of vernacular speech, the tell-tale turns of phrase which can be gleaned from court records or anonymous letters. As in hermeneutics, the major effort is to present historical issues as they appeared to the actors at the time; to personalise the workings of large historical forces; to draw on contemporary vocabularies; to identify the faces in the crowd. (Samuel xviii)

On the other hand, Samuel says, before the modern era of social history, the stress was upon "*impersonal* historical forces, located by some in climate and geography, by others in tools and technology, by yet others in biological neces-

sity" (xviii). And even before that, of course, nineteenth-century historiography stressed high politics, wars, the lives and deeds of the great.

In certain respects, British "people's history" has been influenced by the French *Annales* school, in which the concept of *mentalités* as collective consciousness (or, better, unconsciousness, close to ideology) and the interest in popular and "carnivalesque" forms of belief and behavior can be seen as materialist versions of cultural history (see Chartier; Burke; Stallybrass and White). As Harvey Kaye notes, however, a key difference has been the tendency of the *Annales* historians—Marc Bloch, Lucien Febvre, Fernand Braudel, and Emmanuel Le Roy Ladurie, among others—to downplay agency, consciousness, and discrete "events" in favor of a quasi-structuralist, deterministic emphasis on large-scale, long-term patterns of stability and change (223–26). From such a perspective, the concept of *mentalité* may be closer to the Althusserian conception of ideology than to the British conception of culture.

Much of the work produced by the Birmingham Centre can be understood as "people's history" in Samuel's sense. This is evident in the various anthologies produced by the Centre, including most obviously *Working-Class Culture* (Clarke et al., 1979), but also *Resistance through Rituals* (1976), *Policing the Crisis* (1979), *Making Histories* (1982), and *Unpopular Education* (1981). Two other anthologies of Centre work, *Women Take Issue: Aspects of Women's Subordination* (1978) and *The Empire Strikes Back: Race and Racism in 70s Britain* (1982), clearly also belong to this list; I will discuss both in some detail in the sections on gender and race.

The essays in *Working-Class Culture* all reflect the influence of Thompson and Hoggart. Yet the contributors place an immediate distance between themselves and Hoggart in particular, because of what they see as Hoggart's lack of theoretical and methodological rigor. Thus, in "Sociology, Cultural Studies, and the Post-War Working Class," Chas Critcher writes: "Take, for example, the problem of defining the 'working classes'. This is a theoretical problem; it is not resolvable within Hoggart's method. The nearest we get [in *The Uses of Literacy*] to a specific definition is a list of the kinds of places where working-class people live. A similar circularity runs through the whole book: the working classes are those who share working-class culture" (19). Also, Critcher notes, Hoggart's omission of any discussion of working-class politics and trade unionism makes for "serious deficiencies," although "there is much to appreciate as well" (19). Above all, there is Hoggart's respectful, detailed, semi-autobiographical account of many aspects of "working-class culture," seen "from below" instead of from the judgmental, paternalistic, or authoritarian perspective of the academic intellectual. If it is nostalgic, mourning a kind of golden age of working-class community before the invasion of the mass media, it is also appreciative of working-class customs, beliefs, and attitudes, which Hoggart treats not as ideologically warped but as reasonable within conditions of work, semi-poverty, and class subordination.

Hoggart avoids ideological critique by practicing a form of sympathetic, ethnographic representation. "Yet for all this the book is not to be dismissed as a historical hangover or as the debris of a less theoretical age. Hoggart revealed the paucity of what passed—then and now—for sociological method. His extension of analysis into the cultural, portraying class as an external and internal mode of definition, hastened the realization that 'embourgeoisement' was no accurate description of change but an attempt to impose an interpretation on much more ambiguous materials" (20).

Much the same can be said of the essays in *Working-Class Culture*. The anthology begins with Critcher's survey, followed by Richard Johnson's of the idea of culture in relation to labor history. Then come six essays focusing on aspects of working-class culture, ranging from 1790 down to the present and from directly political questions ("radical education," "imperialism," trade-unionism and the Labour Party) to questions of "leisure"—though the latter are also treated as political. "Leisure" here includes everything from workers' benefit clubs and reading rooms to modern professionalized football. The volume ends with two "theoretical" essays by Richard Johnson and John Clarke, but the stress is obviously less on theory than on culture, conceived as an immensely variegated, complex, constantly changing field of values, beliefs, and practices competing for hegemony within a social formation dominated by capitalism and industrialization.

In "Culture and the Historians," Johnson points out that "one feature of the older Marxist convictions about 'working-class consciousness' was the assumption of a degree of homogeneity, or at least a real or potential essence or core around which a whole culture was organized. Even more recent accounts of working-class culture tend to continue this search for some simple unity" or essence (62–63). These versions of "unity" can either be "dismissive," as when they represent working-class culture as falling completely under the sign of ideology, or "romanticized," as when they represent it marching onward toward solidarity and revolutionary class consciousness. In contrast, says Johnson, the essays by himself and his Birmingham colleagues "stress the heterogeneity or complexity of 'working-class culture', fragmented not only by geographical unevenness and parochialisms, but also by the social and sexual divisions of labour and by a whole series of divisions into spheres or sites of existence. The most important of these latter divisions is that which mainly distinguishes the social worlds of men and women: the division between the sphere of social production or 'work' on the one hand, and that of biological reproduction, private consumption and recreation . . . on the other" (62–63).

In "Three Problematics: Elements of a Theory of Working-Class Culture," Johnson underscores once again the idea of the "heterogeneity" of what happens in culture; as both Thompson and Williams often stressed, "experience" does not conform neatly to "theory." "It is an error, certainly in modern capitalist condi-

tions, to view working-class culture as 'all of a piece,' " says Johnson; "The degree of homogeneity (and of distinctiveness) is undoubtedly historically variable. It is probable that working-class culture from the 1880s to the 1930s was more homogeneous and distinct than in any period before or after. Yet, all notions of culture as coherent value systems tend to mislead; Gramsci's stress of the radical heterogeneity of (even) peasant culture is a better general guide" (235). And the Gramscian stress on the heterogeneity of culture is close, again, to Bakhtin's theory of the heteroglossic character of all discourse. Just so long as it doesn't tumble into the deconstructionist "abyss" of completely indeterminate "difference," heterogeneity *is* the social, an identity which stresses the influence of human agency or "freedom" in history. Culture is manifold, plural, messy, and not representable from a single point of view, whereas an emphasis even on overdetermined causation may reduce the multiplicity and contrariness of experience to the uniform, the one-dimensional, and the illusory. At the same time, however, heterogeneity paradoxically weakens that influence through a dispersion that moves away from the possibilities of class solidarity and revolution. "We have . . . noted many of the forms of internal difference," Johnson declares; these include differences of geography, "the social and sexual divisions of labour," age, political power or powerlessness, race, "unevenness" of "economic development," and so forth. Clearly, once difference instead of unity is stressed, it becomes very difficult to generalize, to make a single theory fit all cases, and, indeed, even to think in terms of "class" experience or culture at all. "It follows that there can be no simple or 'expressive' relation between economic classes and cultural forms, and that we should start any such analysis by looking for contradictions, taboos, displacements in a culture, as well as unities. This is one way of breaking from the bad 'romantic' side of cultural studies." Perhaps it should be added that it may also be one way of breaking from the "bad" theoretical side of cultural studies, especially the side which occasionally pretends to be "scientific" (235).

Still another way of breaking from the false unities promoted by both romanticism and theoreticism "is to recognize the gender-specific elements in any class culture and the ways in which the subordination of girls and women is reproduced, in part, within the culture itself" (235). Johnson here points to feminist work, including the essay by Pam Taylor in *Working-Class Culture* ("Daughters and Mothers—Maids and Mistresses: Domestic Service Between the Wars"), and also to the sort of work which came to be known at the Birmingham Centre as the exploration of "subcultures." The recognition of gender, ethnic, age, occupational, and geographical differences within working-class groups leads to the idea of subcultures. The idea captures heterogeneity in several respects—as subordination but also resistance to a hegemonic culture, and as a plural formulation. There is not one working-class culture, nor one unified or monolithic ideology blanketing consciousness; there are instead various competing subcul-

tures. The stress on subcultures is evident in many of the productions of the Birmingham Centre, and is now most readily identified with the work of Paul Willis and Dick Hebdige.

Before turning to Willis, Hebdige, and the idea of subcultures, however, I want to glance at parallel developments in labor history and the study of working-class culture in the U.S. The chief focal point for the British cultural studies movement has been working-class culture. This is partly because of the powerful formative influence of social class on British culture and society in general. More specifically, it is because the British working class, while it hasn't produced the revolution viewed by some Marxists as the alpha and omega of history, has achieved influential representation through trade unionism, more or less effective socialist movements, and the Labour Party (though these are now all in retreat from Thatcherism). The question of exceptionalism applied to the British scene has asked why there have been no revolutions on the model of the continental revolutions of 1848 or the Paris Commune of 1871 (see Kent; Anderson, *Arguments;* Williams, *Problems* 233–73). In contrast, the question of exceptionalism in relation to U.S. history has asked why there hasn't even been an effective political organization to represent the working class, on the model of the British Labour Party? This question goes back at least as far as Werner Sombart's 1906 collection of essays, *Why Is There No Socialism in the U.S.?* With or without revolution, the trade unions and the Labour Party, even when losing, are major players in British politics, and working-class culture has therefore presented itself as a visible, important subject of study. In the U.S., on the other hand, that subject is for many reasons harder to bring into focus—"the hidden injuries of class," as Richard Sennett and Jonathan Cobb argued in their important 1971 book of that title, are "hidden."

As Leo Marx declares, "The idea of 'American exceptionalism' derives from the marked difference between the critical reaction to the Great Transformation [Industrial Revolution] in western Europe and in the United States. By 1848 it had become apparent that in Europe the strongest opposition to industrial capitalism would come from the revolutionary socialist movement. In the United States, however, such a movement then had not and, indeed, never has developed comparable strength" (Marx in Bercovitch and Jehlen 46–7; see also Davis). Yet working-class culture is not so hidden in the U.S. as to prevent the flourishing of labor history in ways that often parallel British developments. Frequently American labor historians follow the leads provided by their British counterparts—Herbert Gutman, for instance, often acknowledged that his work was heavily indebted to both E. P. Thompson and Raymond Williams. According to Ira Berlin in his biographical introduction to Gutman's *Power and Culture:*

> Thompson's twin nemeses—smug liberalism and vulgar Marxism—were also
> Gutman's. . . . Thompson's understanding of class as the precipitate of common

experiences within a system of productive relations, and of class consciousness as the cultural articulation of those experiences, was also Gutman's. Gutman's repeated denial of any necessary connection between economic structure and behavior, his emphasis on experience, and his overarching commitment to empirical research were also Thompson's. Indeed, it was not so much the emphasis on culture that drew Gutman to Thompson as it was Thompson's explicit avowal, indeed his outright celebration, of human agency. (19; see also Abelove et al. 199).

For similar reasons, other labor historians in the U.S. and Canada have been drawn to the Gramscian idea of hegemony. This is evident in Jackson Lears, "The Concept of Cultural Hegemony: Problems and Possibilities" (*American Historical Review,* June, 1985) and in the flurry of responses to it, both pro and con (*Journal of American History,* June, 1988). But a Gramscian stress appeared earlier in the work on both "free" labor and slavery by Eugene Genovese and David Brion Davis. Also directly influenced by Thompson, Genovese's *Roll, Jordan, Roll: The World the Slaves Made* (1972) offers numerous parallels in its culturalist themes and methods to *The Making of the English Working Class.* To take just one example of how Genovese uses Gramsci, he explains the slaves' acceptance of white domination and paternalism as involving patterns of behavior that were also resistant to that domination, "within which they drew their own lines, asserted rights, and preserved their self-respect. . . . The slaves thereby provide an excellent illustration" of Gramsci's theories about "popular consciousness"—that is, the "contradictory" or "fragmented" consciousness Gramsci identified as "common sense" (Genovese 147).

> In Gramsci's terms, [the slaves] had to wage a prolonged, embittered struggle with themselves as well as with their oppressors to "feel their strength" and to become "conscious of their responsibility and their value." It was not that the slaves did not act like men. Rather, it was that they could not grasp their collective strength as a people and act like political men. The black struggle on that front, which has not yet been won, has paralleled that of every other oppressed people. (Genovese 149)

Just as Thompson celebrates the creativity, the humanity, and the many forms of resistance to domination developed by the nascent working class in Britain, so Genovese celebrates the creativity, humanity, and sheer courage of slaves and, since slavery, Afro-Americans in general. Rejecting "the essence of slavery by projecting their own rights and values as human beings" in religion, in rebellion, and even in their most "respectful" behaviors, the slaves developed their own powerful memories and utopian prospects of freedom, and their own complex system of defenses against domination. The creativity of the slaves laid the groundwork for the richness of Afro-American culture today.

Subcultures

In *Resistance through Rituals: Youth Subcultures in Post-war Britain,* members of the Birmingham Centre focused on a variety of social phenemona which in the late 1960s and early 1970s were labeled "*counter*cultural" and sometimes invested with great powers of at least proto-revolutionary rebellion (examples include Theodore Roszak's *The Making of a Counter Culture,* 1969, and Charles Reich's *The Greening of America,* 1970). But whereas discussions of countercultural movements in the sixties in North America usually identified them with middle-class, mostly white, mostly male college students (or drop-outs, ex-college students), the subcultures studied by the Birmingham Centre had their roots, at least, in working-class experience. And while these subcultures all expressed resistance to domination that might be construed as proto-revolutionary, they were also clearly subordinate to that which they resisted: "respectable" middle-class patterns of success in school and on the job; the images of society and of themselves projected by the mass media; and also their parents' own working-class values, beliefs, and practices.

The ethnographic studies in *Resistance through Rituals* focus on youth styles of dress and behavior codes in relation to popular music (the teddy boys, the mods, the skinheads, as well as the West Indian immigrant subculture associated with reggae music and Rastafarianism). The volume also includes studies of communes, of "the cultural meaning of drug use," and of girls in relation to male-dominated youth subcultures. And there are several theoretical essays on subcultures in relation to class, to generation and gender, to the mass media, and also on ethnography and its methodological corollaries, "naturalistic research" and "participant observation." At the outset, several of the contributors relate their studies to the idea of hegemony:

> Groups or classes which do not stand at the apex of power, nevertheless find ways of expressing and realising in their culture their subordinate position and experiences. In so far as there is more than one fundamental class in a society . . . [the] dominant culture represents itself as *the* [only] culture. It tries to define and contain all other cultures within its inclusive range. Its view of the world, unless challenged, will stand as the most natural, all-embracing, universal culture. (12)

As Barthes declared in *Mythologies,* in capitalist society bourgeois ideology has the paradoxical task of effacing its class basis—that is, of making that class basis (and bias) seem natural instead of political, universal instead of partial. But the wide variety of "mythologies" Barthes depicted—everything from "striptease" to "ornamental cookery"—has the effect of continual surprise, continual escape from the pall of universality and uniformity bourgeois ideology appears to cast

over culture. A similar pattern of domination and continual though limited escape from that domination emerges in *Resistance through Rituals*. Despite the universality of the dominant culture, "Other cultural configurations will not only be subordinate to this dominant order: they will enter into struggle with it, seek to modify, negotiate, resist or even overthrow its reign—its *hegemony*. The struggle between classes over material and social life thus always assumes the forms of a continuous struggle over the distribution of 'cultural power' " (*Resistance* 12). The authors then offer an important distinction between culture and ideology, although (as already noted) cultural studies frequently conflates these terms: "Dominant and subordinate classes will each have distinct cultures. But when one culture gains ascendancy over the other, and when the subordinate culture *experiences* itself in terms prescribed by the dominant culture, then the dominant culture has also become the basis of a dominant ideology" (12).

As the authors of *Resistance through Rituals* note, Phil Cohen's 1972 study of the working-class community in the London East End (also a product of the Birmingham Centre), offers an important theoretical model in which subcultural behavior or "style" emerges as an ideological solution to tensions and contradictions felt within the larger working-class "parent culture." According to Cohen, "The latent function of subculture is . . . to express and resolve, albeit 'magically', the contradictions which remain hidden or unresolved in the parent culture" (qtd. in *Resistance* 32). Cohen sees the succession of working-class youth subcultures generated in Britain since World War II—"mods, skinheads, crombies," etc.—as expressing the conflict in the parent culture between working-class "puritanism" and "the new ideology of consumption," and between the related idea of the supposed "embourgeoisement" of the working class and the objective fact that the majority of workers were not and could not be upwardly mobile. The youth subcultures, Cohen declared, "all represent in their different ways, an attempt to retrieve some of the socially cohesive elements destroyed in the parent culture, and to combine these with elements selected from other class fractions, symbolising one or other of the options confronting it" (qtd. in *Resistance* 32). In similar fashion, John Clarke argues that the subculture of the skinheads seeks the "magical recovery" of a lost or at least damaged working-class community: "the Skinhead style represents an attempt to re-create through the 'mob' the traditional working class community, as a substitution for the *real* decline of the latter" (99).

In general, the authors of *Resistance through Rituals* represent even the most "deviant," violent youth subcultures, and also the mass cultural forms through which they construct their specific styles (clothes, popular music), in a positive light—perhaps the moreso the more the subcultures seem resistant to the dominant culture. In "The Politics of Youth Culture," Paul Corrigan and Simon Frith declare that "any political judgment of youth culture must be based on treating it first as a *working class* culture, secondly as a cultural response to a *combination*

of institutions [and social forces], and thirdly as a response which is as creative as it is determined. Our own . . . judgment is that even if youth culture is not political in the sense of being part of a class-conscious struggle for State power, it nevertheless *does provide* a necessary pre-condition of such a struggle" (238). Thompson had written in similar terms about the numerous radicalisms that had entered into the "making of the English working class" in the early industrial period.

Against this relatively optimistic picture of subcultural resistance to domination, however, at least two of the contributors to the anthology offer a number of caveats. In part of their contribution headed, "Sociological Imperialism, Blind-Spots and Ecstasies," Geoffrey Pearson and John Twohig sharply criticize that sort of subcultural ethnography which sees in drug use and the adoption of mass-mediated styles elements of meaningful "creativity" and "resistance":

> The thesis of the social construction of even the most intimate aspects of personal experience reflects the fear (persistent among bourgeois intellectuals) that advanced industrial society overwhelms every nook and cranny of private life; and that modernity and the "massification" of society invade . . . the very possibility of human subjectivity.
>
> At the same time, ethnographic study provides intellectuals with a source of hopeful entertainment in the subjectless mass society. For, its own invasions of privacy (which it calls research) seem to re-construct and celebrate the microscopic detail of everyday life. In this way the popularity of ethnography does not only register a fear; it also offers a magical solution to the problem which is feared.
>
> Ethnography thus joins the mad scramble to rescue our threatened subjectivity. . . . It is ecstatic over the possibility that even the hidden depths of our lives are wellnormed and in good working order. But, if subjectivity and privacy are threatened, is ethnographic study the way to combat the threat? An apt remark by Colin Fletcher sums up the frail aesthetics of ethnography: "Qualitative research is . . . practised and developed in the interludes between wars. . . ." (125)

Since Pearson and Twohig's strictures are directed mainly against interpretations of drug use as politically meaningful, they seem to apply particularly to Paul Willis's contribution to *Resistance through Rituals,* on the "cultural meaning" of drugs in the "hippy" and "motorbike" subcultures. Willis's study, extracted from his doctoral thesis at the Birmingham Centre, reappeared in turn as part of his 1978 book *Profane Culture.* There, Willis presents ethnographic celebrations of the hippy and motorbike subcultures, treated as politically charged contestations of that dominant culture which views these and other subcultures only in terms of "deviance," "delinquency," and moral hysteria. At the same time, Willis defines ethnography in just the way Pearson and Twohig reject—as a method of

representing subjective experience rather than of submerging it in theories and statistics:

> At its best ethnography does something which theory and commentary cannot: it presents human experience without minimizing it, and without making it a passive reflex of social structure and social conditions. It reproduces the profane creativity of living cultures. It breaks the spell of theoretical symmetry: drily proposed contradictions and problems become uncertainty, activity, effort, failure and success. Ethnography shows subjectivity as an active moment in its own form of production—not as a whispered bourgeois apology for a belief in individual sensibility. (*Profane* 170)

Here and in his other works, Willis approximates Stephen Tyler's model of a "post-modern ethnography," whose goal is the task of celebrating human difference and creativity through "evocation" instead of authoritarian "representation" (see Tyler in Clifford and Marcus, 122–40). Just as Willis found much to praise in the "masculine" patterns of working-class "shop-floor culture" in industry (see his contribution to *Working-Class Culture,* pp. 185–98), so he finds much to admire in the violent, "outrageous" behavior of motorcycle gang members:

> The directness and irreverence of the motor-bike boys is also a challenge to institutional forms of politeness. Their spontaneity and lack of formality in social relations highlight the restrictions of a bureaucratic, neighbour-watching conformism. The roar of the motor-bike, or the menace of physical, masculine presence show how the learned lines of demarcation are social products, and, despite their restriction and enforced sacrifice of expression and autonomy, are no protection against the sword of those who do not respect their values. The piractical, often outrageous air of the bikeboys lives off, finds its meaning and clumsy grace from the ludicrous orderedness of the rest of us. They show just how easy it is to be a pirate when the rest of us wear grey. Our incorporated, bureaucratic, mindless existence is the air through which the motor-bike exhaust tears and crackles. (*Profane* 175)

Willis stresses "the definite cultural achievements of the hippies and bikeboys," which include, he believes, "real critical achievements—at least at the level of a cultural politics" (175). He means something similar when, in his essay on "shop-floor" values in *Working-Class Culture,* he declares: "In the machismo of manual work the will to finish a job, the will to really work—is posited as a masculine logic, and not as the logic of exploitation. . . . Masculinity is power in its own right, and if its immediate expression is the completion of work for another, then what of it? It has to be expressed somewhere because it is a quality of being. That is the destiny which a certain kind of self-esteem and dignity seems naturally to bring" (197). But this is politics only at the level of male individual

experience or subjectivity, as Willis recognizes. In relation to the hippy and motorcycle subcultures, Willis adds, in a move which brings him back in the direction of Pearson and Twohig's skepticism about ethnographic reconstructions of a subjectivity they see as irreparably atomized and colonized by capitalism and the mass media: "it is precisely in the larger arena of politics proper that these cultures met their final, tragic limits—limits which raise the whole question of the status and viability of cultural politics and of a struggle waged exclusively at the level of life-style" (*Profane* 175).

This formulation suggests that cultural politics—or, better, subcultural politics—is what falls to the lot of the powerless. Their means of self-representation remain at the "superstructural" level of culture, unable to affect the institutional level of politics, much less the "base" level of the economic "mode of production." A similar conclusion emerges even more dramatically from Willis's influential study of a group of teenagers in a Birmingham school, *Learning to Labour: How Working Class Kids Get Working Class Jobs* (1977). There also Willis proceeds ethnographically, as a participant-observer, to document through interviews and descriptions the cultural and social relations in and out of school of a group of "lads" from working-class homes. He shows how, through their very resistance to school authority, they unwittingly help to "reproduce the forces of production" through disqualifying themselves for middle-class jobs. School failure *is* a form of political resistance to the dominant culture, Willis contends, which nevertheless has the ironic effect of reinforcing that culture. Willis rejects "structuralist theories [particularly Althusser's] of reproduction [which] present the dominant ideology (under which culture is subsumed) as impenetrable. My view is more optimistic because there are deep disjunctions and desperate tensions within social and cultural reproduction. Social agents are not passive bearers of ideology, but active appropriators who reproduce existing structures only through struggle, contestation, and a partial penetration of those struggles" (175). On the other hand, just as the hippies and motorcyclists he studies in *Profane Culture* were unable to translate cultural forms of self-representation into truly political ones, so the "lads" in *Learning to Labour* choose paths of mainly cultural resistance to domination which lead to their school failures and land them in working-class jobs—where the system aims for them to be all along.

For the "lads," Willis writes, "the possibility of real upward mobility seems so remote as to be meaningless" (*Learning* 126). Yet the ideology of school dominates their efforts at ironic distancing and rebellion, in part by its ability to point to actual examples of upward mobility and to insist that this is the only path to self-improvement. "It is through a good number trying [and sometimes succeeding in moving upward] that the class structure is legitimated. The middle class enjoys its privileges not by virtue of inheritance or birth, but by virtue of an apparently proven greater competence and merit. The refusal to compete, implicit in counter-school culture, is in this sense a radical act: it refuses to

collude with its own educational suppression" (128). The "lads" define their group identity in opposition to other groups: the "ear 'oles" or school conformists and achievers; girls; ethnic minorities. Fighting becomes an honored, masculine form of resistance, but directed both against each other and against individuals from these other groups, and obviously powerless in reference to school or the larger society. "In contradictory and unintended ways the counter-school culture actually achieves for education one of its main though misrecognised objectives— the direction of a proportion of working-class kids 'voluntarily' to skilled, semi-skilled and unskilled manual work. Indeed far from helping to cause the present 'crisis' in education, the counter-school culture . . . has helped to prevent a real crisis. It's a process that produces a large degree of labor power" (178).

How could critically informed, oppositional teaching help to change the situation? In answering this question, Willis sounds very much like Paulo Freire in *Pedagogy of the Oppressed* and elsewhere. Like Willis's very book and like cultural studies in general, oppositional teaching within the schools can help "to expose not mystify cultural processes" (187):

> For the excluded and disaffected [Willis advises teachers], recognise the logic of their cultural forms: 1) recognise the strict meaninglessness and confusion of the present proliferation of worthless qualifications. 2) recognise the likely intrinsic boredom and meaninglessness of most unskilled and semiskilled work. 3) recognise the contradictions of a meritocratic society and educational system where the majority must lose but all are asked to join in some way in the same ideology. 4) recognise joblessness both as an enforced and a chosen option in relation to real opportunities available and to what working actually means. 5) use more collective practices, group discussions and projects to uncover and examine these cultural mappings of work. Promote real skills and discipline in the pursuit of a form of social self-analysis. (188)

Like *Profane Culture, Learning to Labour* offers a direct challenge to the liberal humanism which resorts to "high culture" and education in the Arnoldian sense for a panacea for all social problems. Schools in Willis's (as in Bourdieu's) view do not exist to humanize individuals and release them into a realm of cultivated leisure, but instead to reproduce the class system and the relations of economic production, much as in Althusser's account of schools as the most influential "ISA" in modern societies. But in contrast to Althusser, Willis focuses on the rebellious, creative capacities of the "lads," not on the impersonal, all-dominating workings of ideology. Willis agrees with Bourdieu that "it is probably cultural inertia which still makes us see education in terms of the ideology of the school as a liberating force and as a means of increasing social mobility, even when the indications tend to be that it is in fact one of the most effective means of perpetuating the existing social pattern, as it both provides an apparent

justification for social inequalities and gives recognition to the cultural heritage, that is, to a social gift treated as a natural one" (Bourdieu, "School" 110). Nevertheless, with respect to the culture workers construct for themselves on the shop floor, Willis writes:

> despite the subjective ravages, people do look for meaning, they do impose frameworks, they do seek enjoyment in activity, they do exercise their abilities. They repossess, symbolically and really, aspects of their experiences and capacities. They do, paradoxically, thread through the dead experience of work a living culture which isn't simply a reflex of defeat. This culture is not the human remains of a mechanical depredation, but a positive transformation of experience and a celebration of shared values in symbols, artefacts and objects. It allows people to recognize and even to develop themselves. For this working-class culture of work is not simply a foam padding, a rubber layer between humans and unpleasantness. It is an appropriation in its own right, an exercise of skill, a motion, an activity applied towards an end. (Willis in *Resistance* 188)

In *Subculture: The Meaning of Style,* Dick Hebdige echoes many of Willis's themes. At the same time, he points out that social science investigations of subcultures developed from the older tradition of urban exploration, stretching back to the nineteenth century. He also points to the work of the Chicago urban sociologists, including Frederick Thrasher's analysis of more than one-thousand street gangs in the 1920s and William Whyte's of the routines, customs, and values of a particular gang in *Street Corner Society* (1955). Hebdige's own study focuses on the appropriation of different "styles" of dress, behavior, and popular music forms by different elements of particularly working-class young people in Britain. The most "spectacular" of these have been the "punks"—and by "spectacular" Hebdige means not only glaringly threatening to bourgeois respectability but also self-consciously engaged in a complex interplay with the mass media. Through the rebellious behaviors of groups such as the Sex Pistols, the Rejects, and Clash, those who adopt the punk style do so in quite conscious opposition to the bourgeois values sanctified by the dominant culture. Yet they also do so, ironically, with the help and in the full glare of the dominant media of that dominant culture—the press, television and radio, the record industry, advertising.

Hebdige begins by citing Jean Genet's *Thief's Journal* in order to define style as a form of existential "Refusal." "I would like to think that this Refusal is worth making, that these gestures have a meaning, that the smiles and the sneers have some subversive value, even if, in the final analysis, they are, like Genet's gangster pin-ups, just the darker side of sets of regulations, just so much graffiti on a prison wall" (3). As also with Albert Camus and Jean-Paul Sartre, rebellion for Hebdige becomes a vital assertion of human freedom and creativity against

"regulations" and domination. The punks share rebelliousness, moreover, with other subcultures focused on forms of popular music—the mods, the parkers, the skinheads—and like these mainly white working-class groups, they owe much to West Indian reggae and the apocalyptic/revolutionary ideas expressed in Rastafarianism. As Hebdige explains, Rastas believe that Haile Selassie's coming to power in Ethiopia in 1930 signaled the beginning of the end of "Babylon"—that is, of white imperialism—and the liberation of the black races of the world (34). But this is only one of the forms in which reggae expresses oppositional values, which are "mediated through a range of rebel archetypes: the 'rude boy', the gunfighter, the trickster"—although, Hebdige is quick to add, these remain "firmly tied to the *particular* and [usually] celebrate the *individual* status of revolt" (37). Also, Rastafarian lyrics in reggae tend to be both offensive to white ears and "deliberately opaque," therefore "beneath the Master's comprehension" (64).

> This was a language capable of piercing the most respectfully inclined white ear, and the themes of Back to Africa and Ethiopianism, celebrated in reggae, made no concessions to the sensibilities of a white audience. Reggae's blackness was proscriptive. It was an alien essence, a foreign body which implicitly threatened mainstream British culture from within and as such it resonated with punk's adopted values—"anarchy", "surrender" and "decline"—

the "decline," that is, of Britain and the British Empire (64). With songs like the Sex Pistols' "Anarchy in the U.K.," punk rock took on the role of *épater le bourgeois* once associated with the bohemian artistic avant-garde. By committing "symbolic act[s] of treason" (64), they also took on something of the role of New Left student radicalism of the sixties. But what explains the emergence of the punk style in the first place?

As do Phil Cohen and Paul Willis, Hebdige attributes the phenomenon of rebellious youth subcultures to contradictions in economic conditions and (mainly) working-class experience. Hebdige sees the emergence of youth subcultures since World War II as part of a larger process of the "polarization" and fragmentation of "working-class community," coupled with the new power of electronic mass communications to mediate and, in complex ways, dominate the construction of class experience and "subjectivities." Despite confident assurances of both Labour and Conservative politicians "that Britain was now entering a new age of unlimited affluence and equal opportunity, that we 'never had it so good', class refused to disappear" (74). For working-class young people in particular, promises of affluence and upward mobility were contradicted by the realities of a closed, authoritarian system of schooling and by widespread unemployment, even while "the spending-power of working-class youth increased" and shifting patterns of consumption drew them into a mass market for

cultural goods that encouraged, in part, distance from their "parent culture" (74). An oppositional style like that of the punks, Hebdige believes, expresses these contradictions:

> . . . the punks were not only directly *responding* to increasing joblessness, changing moral standards, the rediscovery of poverty, the Depression, etc., they were *dramatizing* what had come to be called "Britain's decline" by constructing a language which was, in contrast to the prevailing rhetoric of the Rock Establishment, unmistakably relevant and down to earth. . . . The punks appropriated the rhetoric of crisis. . . . In the gloomy, apocalyptic ambience of the late 1970s—with massive unemployment, with the ominous violence of the Notting Hill Carnival, Grunwick, Lewisham and Ladywood—it was fitting that the punks should present themselves as "degenerates"; as signs of the highly publicized decay which perfectly represented the atrophied condition of Great Britain. (87)

In much recent cultural studies work—for example, studies of mass cultural forms by John Fiske, Iain Chambers, Janice Radway, and others—the old, Hoggart-and-Leavis pessimism about mass culture is qualified and at times almost reversed. Fiske, for instance, defines "popular culture" as all of the interpretive practices through which people make their own uncontrollable and "resistant" meanings from the uniform but nevertheless only imperfectly coercive "grid" of "mass culture." The mass media do not impose singular meanings on the multitude; instead, the multitude produce *their* meanings on the backs, as it were, of the mass media. Crusoe believes he is alone on the island, but there are footprints everywhere—this is one logical terminus of subculture theory, in some ways similar to Norman Holland's and Stanley Fish's "reader-response theory" and the idea of "interpretive communities" in U.S. literary criticism (for a representative sample, see Tompkins). But where do the footprints lead? As Meaghan Morris complains, "the thesis of cultural studies as Fiske and Chambers present it runs perilously close to this kind of formulation: people in modern mediatized societies are complex and contradictory, mass cultural texts are complex and contradictory, therefore people using them produce complex and contradictory culture. To add that this popular culture has critical and resistant elements is tautological" (Morris 19). And Judith Williamson registers much the same criticism when she writes that "left-wing academics are busy picking out strands of 'subversion' in every piece of pop culture from Street Style to Soap Opera" (Williamson 14).

Feminism and the
Politics of Representation

In a multivolume series called *The Left Academy,* the editors, Bertell Ollman and Edward Vernoff, declare that "a Marxist cultural revolution is taking place

today in American universities. More and more students and faculty are being introduced to Marx's interpretation of how capitalism works" (1:1). Journals such as *Telos, Social Text,* and *Praxis International,* and recent publishing events like Cary Nelson and Lawrence Grossberg's *Marxism and the Interpretation of Culture,* seem to bear out Ollman and Vernoff's thesis. But it remains to be seen what impact "university Marxism" will have on higher educational institutions, reforms, and classroom practices. Meanwhile, the term "revolution" seems at best wishful, especially given the current hegemony of neoconservatism; without a practical power base connecting academic Marxists with the working class, the "left academy" is, Ollman and Vernoff admit, marginalized even within the academy and virtually invisible to the general public. "Up to the present time, the progress of university Marxism has taken place in the absence of any corresponding political development in the working class" (1:3).

In contrast to Britain, where leftist intellectuals such as Williams and Thompson have had some impact not only within the university setting but also on public opinion and working-class politics, academic Marxists in the U.S. seem rather to prove Russell Jacoby's argument about the disappearance of "public intellectuals" since the 1950s. This is not a case, Jacoby contends, of a decline or absence of radicalism on the part of intellectuals. He agrees with Ollman and Vernoff that radical scholarship within the universities was never more flourishing than in the 1980s, but also that this flourishing state is "partly deceptive" (Jacoby 118). The "invasion and conquest" of the universities by leftist scholars starting in the sixties, much deplored by both neoconservatives and liberals, has left the "public sphere" almost deserted. But this looks more like a counterrevolution than a coup d'état of the wished-for variety. Jacoby believes that, confined to the proliferating though safe pigeon holes of the academic disciplines, North American intellectuals, at least those of radical persuasion, have ceased to influence public affairs.

To make his case, Jacoby downplays the influence of a number of prominent intellectuals who manage to be both academic and public. He ignores the powerful public roles played by some conservative and liberal intellectuals such as Henry Kissinger and John Kenneth Galbraith. But there are also a number of radical intellectuals with higher public visibility than Jacoby allows. I have in mind, for instance, Noam Chomsky, Michael Harrington, and Edward Said, to name just three who seem to me at least comparable in visibility and influence to C. Wright Mills, one of Jacoby's points of comparison. Also, Jacoby downplays work in two very important areas of higher education which involve strong ties between academic, often non-Marxist forms of radicalism and the public sphere: feminism and Afro-American studies. In the realm of culture, crisis occurs when an established system of representation is challenged by increasing numbers of people as *not* representing or as *mis*representing significant aspects of social experience. In the U.S. and Canada, while issues of class have seemed relatively "hidden,"

crises of representation concerning women, Afro-Americans, and various other ethnic "minorities" have been dramatic and persistent since the 1960s.

Whereas academic Marxism, at least in North America, seems to have lost its ties to the working class (assuming they once existed; see Eagleton, *Against* 49–64), academic feminism has a clear sense of a public beyond the academy which it both addresses and represents. Feminists from both the academy and the larger society joined forces in Washington, D.C. on April 8, 1989, in the largest single demonstration in support of women's rights ever held in the U.S. (even government estimates placed the turn-out at over 300,000). Along with the civil rights and anti-war movements of the sixties, the women's movement has been a major force for progressive social change—change which, as Fay notes in *Critical Social Science,* has as good a reason to be described as "revolutionary" as any tendency since World War II. "One of the lessons of the women's liberation movement is the inadequacy of any view of revolutionary social change that equates itself with the narrowly political. Marx should have been corrective enough of such a view, but given the actual course that so-called Marxist revolutions have historically taken, revolution has all too often been equated with the seizure of the governmental apparatus" (Fay 111). As both Marx and many feminists have understood, "changes in government can often follow changes in the other spheres of life" (Fay 111), and these changes are in turn dependent upon what feminists often call "consciousness raising." Fay declares that "the experience of the women's movement is . . . a strong one for those who wish to maintain that broad-based social change can occur in an educative fashion" (113).

"There's always been a woman's movement this century," according to Dale Spender; in one way she is right, but it is also true that the contemporary women's movement in both the U.S. and Britain emerged out of the same matrix of social forces and issues that shaped the New Left and civil rights movements of the sixties. In histories of modern feminism, various founding texts are cited, back to Mary Wollstonecraft's *Vindication of the Rights of Women* (1792). But these histories also point to declines in organized women's activism following the great suffrage victories in both Britain (1918) and the U.S. (1919). Simone de Beauvoir's *The Second Sex* (1949), with its fundamental question, "Why is woman the *Other?*" marked a renewal of interest in women's issues, which began once more to take the shape of organized political action in the 1960s. And the renewed activism of women, like that of Afro-Americans, ethnic "minorities," and the liberation struggles of imperialized peoples around the world, has continued through the neoconservative revival of the 1970s and 1980s, even while other forms of sixties radicalism have dissipated or turned "merely academic" (though there are now signs of renewed activism on many fronts—see Davis and Sprinker, *Reshaping the US Left*).

It's possible to speak of a feminist consensus that emerged in the sixties,

frequently in opposition to male-dominated radical movements. While this consensus seems now to have fractured, partly under the corrosive impact of new academic theories, its framework still provides both feminist scholarship and feminist politics with much of their impetus. As Catharine R. Stimpson notes, "In the late 1960s, feminists began to share a cultural consensus about the representation of women and gender"—a consensus empowering both feminist academic work and political practice in the larger society. But the consensus has unraveled in the eighties, partly through the emergence of liberals and even neoconservatives who call themselves feminists, and partly through the impact of feminist "postmodernism" or deconstruction, with its challenge to all previous theories of representation. Stimpson asks:

> If postmodernism has erased the humanistic picture of the coherent, individual self, what will justify an ethics of respect for the individual person? Without believing in totalities again, can we have communal ties other than a joy in opposition? (241; see also Snitow)

Taken to extremes, postmodernist or poststructuralist theory (Stimpson identifies the two) makes any political practice seem both tame and illogical, except for an anarchist practice whose revolutionary potential remains neatly contained by the narcissistic, specular mechanisms of the mass media and consumer capitalism. But besides liberalism and poststructuralism, other factors have divided the feminist consensus that emerged in the sixties, as the authors of *Rewriting English* note: "the 'women' of the women's liberation movement of the seventies were overwhelmingly white, middle-class and heterosexual. In recent years it has become necessary to . . . expand that definition . . . to include women who are working-class, black, of colour, Irish, lesbian" (Batsleer et al. 109). But far from diminishing the strength of the women's movement, these "fracture lines" seem to have bolstered it: feminists have been able to maintain a remarkable solidarity despite a diversification that now includes numerous partly conflicting theories and political positions.

Feminism since the 1960s has thus been characterized by a greater continuity (if perhaps not consensus) between theory and practice, the university and the larger society, than has been the case with Marxist literary theory, history, and social science. "Class" signifies the most basic category of oppression according to Marxist theory, which treats all forms of oppression as functions of the division of labor and class conflict. This view has, however, been challenged in a number of ways both by events and by many feminists. In *The Creation of Patriarchy*, Gerda Lerner, for example, contends that the class divisions of capitalist society originated in patriarchy and the enslavement of women, instead of the other way around. And patriarchy she traces back to the Neolithic period: "It was only after men had learned how to enslave the women of groups who could be defined as

strangers, that they learned how to enslave men of those groups and, later, subordinates from within their own societies" (Lerner 213).

Whether it is understood as the source of all other forms of social oppression or not, patriarchy is the central focus of feminist theory and practice. "England is under the rule of a patriarchy," declared Virginia Woolf in *A Room of One's Own* (33). And forty years later, in *Sexual Politics,* Kate Millett declared: "our society, like all other historical civilizations, is a patriarchy" (25). What exactly do Lerner, Woolf, and Millett mean by "patriarchy," and how does this concept articulate with other concepts of domination and subordination in society? In setting forth her "theory of sexual politics," Millett says that she found it particularly important to conceive of "power relationships" in a way different from "traditional formal politics." She therefore came to define those relationships "on grounds of personal contact and interaction between members of well-defined and coherent groups: races, castes, classes, and sexes. For it is precisely because certain groups have no representation in a number of recognized political structures that their position tends to be so stable, their oppression so continuous" (24). On the analogy particularly of racial oppression in North America, Millett proceeds to define patriarchy as a political system of domination and subordination rooted in misrepresentation:

> . . . a disinterested examination of our system of sexual relationship must point out that the situation between the sexes now, and throughout history, is a case of that phenomenon Max Weber defined as *herrschaft,* a relationship of dominance and subordinance. What goes largely unexamined . . . in our social order, is the birthright priority whereby males rule females. Through this system a most ingenious form of "interior colonization" has been achieved. It is one which tends moreover to be sturdier than any form of segregation, and more rigorous than class stratification, more uniform, certainly more enduring. However muted its present appearance may be, sexual dominion obtains nevertheless as perhaps the most pervasive ideology of our culture and provides its most fundamental concept of power. (Millett 24–5)

There are several points worth noting here. One is the stress Millett, in common with other feminists, places on the *personal* nature of the workings of patriarchy: "The personal is political." Richard Johnson's definition of cultural studies as the analysis of the social construction of "subjectivities," while derived mainly from Althusser's theory of the interpellation of "subjects" by ideology and from the study of working-class and youth "subcultures," is clearly also attuned to feminism as a political theory that insists on breaking down false conceptual divisions between self and society, private and public. Feminism recognizes that the "domestic sphere" is not an island apart from the (male-dominated) public realm of business and politics, but is itself politicized and shaped by economic forces.

The facts that women have historically been identified with the domestic or private instead of public sphere, with feelings instead of reason, with consumption instead of production, and with "nature" instead of "culture" (see Ortner) are all primary instances of the ideological misrepresentations which feminists seek to expose or deconstruct.

With her stress on ideological "internal colonization," Millett's definition of patriarchy anticipates Althusser's theory of the interpellation of subjects by ideology. "Internal colonization" connects patriarchy to all the other forms of oppression Millett has in mind, especially to racism and imperialism. In both the U.S. and Britain, from the nineteenth century forward there have been strong, complex ties between feminism and issues of racial oppression and liberation. Early feminists were often also ardent supporters of the abolition of the slave trade and of slavery—as Frederick Douglass, for one, recognized when he became an ardent advocate of women's rights. His abolitionist paper *The North Star* carried the slogan, "Right is of no sex" and he is commemorated at the site of "the first Women's Rights Convention in the World's History," held at Seneca Falls, New York, in 1848 (Foner 12, 14). "When I consider what was done for the slave by such women as Lucretia Mott, Lydia Maria Child, Elizabeth Cady Stanton, Maria W. Chapman, Lucy Stone, Abby Kelley Foster, Angelina Grimke, Elizabeth Chace and other noble women, I not only feel it a grateful duty, but a high privilege to give my voice and vote in favor of a larger sphere and broader liberty for the activities of women" (Douglass in Foner 132).

One further point worth stressing in Millett's definition is how she, in common with Lerner, sees patriarchy as a more fundamental form of oppression than either social class or race—one which historically precedes either of these. This last point involves, at least implicitly, a critique of Marxism. One of the most interesting, complex aspects of feminist work since the sixties has been its adjustments to—modifications and rejections of—other political, cultural, and psychological theories, most notably Marxism and psychoanalysis. In her essay "On Patriarchy," Veronica Beechey writes that Marxist feminists "do not believe that the subordination of women can be absolutely separated from the other forms of exploitation and oppression which exist in capitalist societies, for example, class exploitation and racism; yet they reject the ways in which orthodox Marxism and socialist organizations have marginalized women theoretically and within their practice and have regarded the oppression of women as simply a side-effect of class exploitation" (67). She goes on to indicate that, whether or not patriarchy is given some sort of theoretical priority over class, its construction in feminist theory produces a map of social reality that is at least multidimensional: the "motor of history" can no longer be understood as *merely* the "economic mode of production" as in classical Marxism; it must also be understood as the "family mode of production" or "reproduction," including most obviously sexual reproduction (Beechey 78). Althusser, Bourdieu, and other male theorists who have

recently complexified Marxism have had much to say about the "reproduction of the mode of production," but usually without considering the sexual connotations of "reproduction."

Some "revolutionary feminists" have sought to rewrite Marxism, substituting the ideas of "sex class" and "sexual revolution" for those of "economic class" and "the revolution of the proletariat." Probably the best-known of these rewritings of Marxism is Shulamith Firestone's *The Dialectic of Sex,* in which she argues that history has a biological as well as an economic dimension, and that Marx and Engels paid scant attention to the former. According to Firestone, oppression doesn't begin at the public site of economic production, the work place, but at the private one, the family. Therefore "unless revolution uproots the basic social organization, the biological family—the vinculum through which the psychology of power can always be smuggled—the tapeworm of exploitation can never be annihilated. We shall need a sexual revolution much larger than—inclusive of— a socialist one to truly eradicate all class systems" (Firestone 12).

Most feminists have been unwilling to follow Firestone in revising Marx and Engels and advocating the overthrow of the family as the prerequisite to the overthrow of the state and private property. Some of her critics see in Firestone's sexual revolutionism a completely impractical utopianism; others worry about the stress she places on biological factors as somehow more determining than economic and cultural ones in the shaping of history and society. Hester Eisenstein suggests that Firestone's emphasis on abolishing the "*biological* family" which chained women to the "domestic sphere" of child-bearing and child-rearing leads to the untenable notion that "to change society . . . it [is] sufficient to change biology" (Eisenstein 17). The stress on biology at the expense of the economic and cultural factors underlying patriarchy involves a form of essentialism which, despite the vehemence of Firestone's revolutionary rhetoric, renders political action and, indeed, historical materialism inconceivable. Eisenstein quotes Juliet Mitchell's similar critique of Firestone in *Woman's Estate:*

> To say [with Firestone] that sex dualism was the first oppression and that it underlies all oppression may be true, but it is a general, non-specific truth, it is simplistic materialism, no more. After all we can say there has always been a master class and a servant class, but it does matter *how* these function. . . ; there have always been classes, as there have always been sexes, [but] how do these operate within any given, specific society? Without such knowledge (historical materialism) we have not the means of overcoming them. (qtd. in Eisenstein 18)

For most radical feminists, whether or not they have tried to articulate their theories with Marxism, patriarchy is understood as a historical, cultural construc- tion rather than as power relations rooted in biological differences between the sexes. "Anatomy is destiny," to cite Freud's famous dictum, only up to a point:

as Jeffrey Weeks declares in *Sexuality and Its Discontents,* "Biology becomes meaningful through culture; the meaning of culture should not be searched for in biology" (117). Both feminists and gay rights theorists attempt to locate the threshold between nature and culture and, like Thomas Henry Huxley in *Evolution and Ethics,* to expand the domain of culture—which is also the domain of humanity's potential freedom from nature. The anatomical differences between male and female do not explain the great diversity of forms taken by "the sexual division of labor" throughout history. Even given its apparent primacy and universality, patriarchy is not a mere reflex of biological difference; it is at least as open to political transformation as are social class, racism, and imperialism. Perhaps most feminists would even agree that patriarchy is not one thing, one unchanging essence informing all sexual relations: it probably makes more sense to think in terms of patriarchies, just as it makes more sense to think in terms of cultures and ideologies instead of a single, totalistic Culture or Ideology.

This is one of the reasons why Rosalind Coward urges that the term patriarchy "should be treated with caution" (Coward 271). She points out that "the arrangement of the contemporary family retains few of the features of a classic patriarchal structure" (271). Changes in property and divorce laws have made fathers less than absolute rulers of families. Also, changes in conceptions of sexual identity have at least begun to decenter the seeming "naturalness" or inevitability of heterosexuality and the categories of male and female. And in many of its uses, "patriarchy" insufficiently allows for "the diffused workings of power in relation to sexuality" (272). According to Coward:

> . . . the term "patriarchal" describes a form of power which does not do justice to the complexity of the problem of sexual division and society. It limits what can be said in terms of the production and redefinition of sexual identities in a number of forms. It does not do justice to the subtle workings of discrimination. For the term "patriarchal" implies a model of power as interpersonal domination, a model where all men have forms of literal, legal and political power over all women. Yet many of the aspects of women's oppression are constructed diffusely, in representational practices, in forms of speech, in sexual practices. This oppression is not necessarily a result of the literal overpowering of a woman by a man. (272)

To revise the unitary model of power implicit in at least some uses of "patriarchy," Coward invokes Foucault, for whom "Power is exercised in our society not by the literal control of one group by another," but through discursive practices. In *The History of Sexuality,* Foucault demonstrates how "there is not one single sexuality enforced in our culture, but rather how discourses produce a series of sexual definitions" (Coward 283–4).

> Foucault . . . rejects the idea of the individual as substantive of instinct, need or behaviour. Instead, he is interested in the possibilities for individualisation in discourse, or subjection in discourse. As far as Foucault is concerned, it is the lure of the true [i.e., essentialist] sexual identity or disposition which constructs the possibilities of power within discourse. This is because the subject is produced by a discourse through recognising [his or her] identity within that discourse. (283)

In nineteenth-century documents, written during that same Victorian period which, according to many accounts, repressed public discussion of sexuality, Foucault unearths a vast proliferation of discourses—medical, psychiatric, moral, religious, educational, pornographic, etc.—*expressing,* defining, pluralizing, and at the same time thereby *controlling* sexuality. Boundaries drawn between the normal and abnormal, clean and unclean, legal and criminal were forms of the cultural diffusion and exercise of power, then as now. Coward explains: "Constantly defining and expanding categories of perversion and pleasure became the means by which the body and its activities were increasingly harnessed to social objectives through the connection between sexual pleasure, identity and their discursive definition" (284).

Whether or not they recognize the "discursive" complications Coward sees in patriarchy, radical feminists and gay rights theorists agree that "sexual identity" and the "sexual division of labor" are social or cultural constructions subject to human agency and political change. Anatomical difference does not mandate that women be subordinate to men, that they be bound to the "domestic sphere," that they be identified with feelings instead of reason or with nature instead of culture. While it may not make much sense to call for the abolition of the nuclear family as Firestone does, neither does it make sense to essentialize the nuclear family as an absolute, sacrosanct, unchangeable social relationship, much less one in which the man rules, the woman obeys. Nor does it make sense to treat heterosexuality as an absolute, sacrosanct norm, against which lesbianism and male homosexuality can only appear as "deviant," "abnormal," and somehow diseased.

" 'Desire' dances on the precipice between determinism and disruption" (Weeks 157). As more generally in cultural studies, in feminism and gay theory culture is understood as partly although not wholly transcending "determinism," whether biological or economic. At the same time, culture is not, as liberal humanists and neoconservatives would have it, a realm of freedom transcending the worldly realm of labor, politics, and ideology. On the contrary, patriarchy is first and foremost a cultural construction which, because it is *neither* biologically determined *nor* transcendentally ideal or pregiven, can be politically transformed. And the work of transformation feminists and gay rights activists undertake, in both the university and the larger society, focuses in exemplary ways both on institutional change and on the politics of cultural representation. In "Feminism

and the Definition of Cultural Politics," the British Marxist feminist Michèle Barrett declares:

> Cultural politics are crucially important to feminism because they involve struggles over *meaning*. The contemporary Women's Liberation Movement has, by and large, rejected the possibility that our oppression is caused by either naturally given sex differences or economic factors alone. We have asserted the importance of consciousness, ideology, imagery and symbolism for our battles. Definitions of femininity and masculinity, as well as the social meaning of family life and the sexual division of labour, are constructed on this ground. Feminism has politicized everyday life—culture in the anthropological sense of the lived practices of a society—to an unparalleled degree. Feminism has also politicized the various forms of artistic and imaginative expression that are more popularly known as culture, reassessing and transforming film, literature, art, the theatre and so on. (37)

Barrett does not mean, of course, that feminism has injected politics into cultural forms where before nothing was political: like cultural studies more generally, feminism raises to consciousness and analyzes a politics that is always already there—the "political unconscious" of "everyday life" and of those forms of artistic and cultural representation which, in perhaps more innocent, pre-1960s times, were seldom understood as having anything to do with politics.

Women Take Issue

According to Eisenstein, "Unlike its counterparts in Great Britain and elsewhere, much feminist theory in the United States during the 1970s did not focus upon the sexual division of labor, as it functioned in the workplace as well as the home, but instead analyzed the powerlessness of women chiefly in psychological terms" (142). Perhaps the stronger Marxist tradition in Britain has produced a fuller dialogue there between Marxism and feminism than in the U.S. This seems evident not only in the work of Marxist feminists such as Juliet Mitchell, Michèle Barrett, Rosalind Coward, and Sheila Rowbotham, but also in the essays in *Women Take Issue,* produced by the Birmingham Centre. Yet it seems also the case, as Germaine Greer notes in a recent issue of *TLS,* that Women's Studies courses and feminist theory are in a more flourishing condition in North America than in Britain. This is due partly, she believes, to the fact that the British universities are publicly funded, hence less "susceptible to undergraduate demand" (616). But it may also be the case that, because it has been less directly identifiable with other brands of political radicalism (particularly Marxism) than its British counterpart, North American feminism has had an easier time gaining at least a marginal place in the university in the form of Women's Studies departments and programs. To put this slightly differently, while radical feminists

often deplore the lack of a unified political stance in the women's movement, the very diversity of the movement may be one of its strengths. It would be easy enough for male-dominated institutions to exclude a feminism that was *merely* "revolutionary" or Marxist; but it is not so easy when feminism spans a wide political spectrum from the NOW and *Ms.* brands of liberalism to the separatism and revolutionism of a Mary Daly or Shulamith Firestone. Part of the secret of the (relative) success of feminism to date lies in the solidarity women have been able to achieve and express despite great differences of politics, race, and class.

There are many differences between the women's movements in North America and Britain, as the essays in *The New Women's Movement* demonstrate (see Dahlerup). Whatever the organizational differences between feminism in North America and in Britain, however, Eisenstein's account of the major theoretical difference seems accurate. North American feminists have been generally less quick and in some cases less willing to situate their work with reference to Marxism and questions of social class than have their British counterparts. To the psychological (and therefore individualistic) emphasis Eisenstein detects in North American feminism can be added a related emphasis upon literary criticism and theory. British feminism instead seems to have stronger roots than its North American counterpart in history and sociology. But these are at best only tendencies or emphases: once again, what is more apparent about feminism than its diversity is its solidarity around a central set of issues about social justice and representational or cultural authority for which "patriarchy" provides the clearest name.

A unified interest in both women's and class subordination characterizes all of the essays in *Women Take Issue*. Several of the contributors offer studies of female "subcultures," parallel to the work of Paul Willis and Dick Hebdige on male youth subcultures. At the beginning of "Working Class Girls and the Culture of Femininity," Angela McRobbie points out that her study of a Birmingham club for working-class girls "was prompted by a recognition that throughout a range of disciplines dealing broadly with youth . . . there was a whole missing dimension, namely girls. Adolescent girls tended to appear fleetingly, and often through the eyes of 'the lads' " in the ethnographic studies of Willis and others. In "family or community studies" like Hoggart's *Uses of Literacy,* moreover, girls were sometimes briefly discussed—but their very identification with family or community as opposed to work, politics, and the larger public sphere was in itself "a significant . . . indicator of where they were *assumed* to be rooted" (*Women* 96; see also McRobbie, "Settling Accounts with Subcultures"). Through her own ethnographic study, McRobbie seeks to answer two basic questions: "what are the determinations acting upon the girls, 'interpellating' . . . them as class subjects, and how do the effects of this positioning find expression at the level of a developing class cultural identity?" (100). Just as Willis in *Learning to Labour* describes an "anti-school culture" among the "lads," so McRobbie

finds a similar "anti-school culture" among the girls of the Mill Lane youth club—one partially resistant to the dominant culture, but whose very patterns of resistance lead to the reproduction of the social subordination of the girls. "Marriage, family life, fashion and beauty all contribute massively to this feminine anti-school culture and, in doing so, nicely illustrate the contradictions inherent in so-called oppositional activities" (104).

All of the essays in *Women Take Issue* deal in one way or another with "women's structural position within the 'production and reproduction of material life' " and with "how this is understood and represented politically and ideologically, and how women live their lives within and through these terms" (*Women* 23). Those essays that do not deal with girls' or women's subcultures focus either on theoretical issues or on representations of women in literature and the mass media. In " 'It Is Well Known that by Nature Women are Inclined to be Rather Personal,' " Charlotte Brunsdon examines the ways "the personal experience of the *recognition* of a common oppression has been a formative feature" of the British Women's Liberation Movement. At the same time, "one implication of finding the personal political is the recognition that the personal is political in a class society which defines it as apolitical" (31). In other words, to claim that the "domestic sphere" is just as much the domain of politics as the public sphere runs up against the ideological "common sense" which insists that the private and personal are "free" from politics. The difficulty for women is a double one: "To avoid interrogating the personal is to miss the specificity of women's oppression as lived, but to remain within this interrogation is to remain where our subordination places us" (31). The difficult task of feminism is *both* personal *and* political. Brunsdon finds in Juliet Mitchell's Marxist-feminist appropriations of psychoanalysis, in Sheila Rowbotham's feminist historical materialism, and in Henri Lefebvre's Marxist analysis of "everyday life" at least partial solutions to this difficulty. Brunsdon quotes Lefebvre: " 'the misery of *everyday life,* its tedious tasks, humiliations reflected in the lives of the working classes and especially of women, upon whom the conditions of everyday life bear heaviest' "—this is a theme that runs throughout *Women Take Issue*. It also connects with Johnson's definition of cultural studies as the analysis of the social construction of subjectivities, as well as with de Certeau's stress on "the practice of everyday life."

The other theoretical essays in *Women Take Issue* offer useful overviews of psychoanalysis and anthropology from an Althusserian-feminist perspective. For feminists, coming to terms with Freud has been at least as important as coming to terms with Marx. The major themes of psychoanalysis—sexuality, the family, and personal development—are obviously also major themes in feminist theory. As the authors of the essay on psychoanalysis in *Women Take Issue* point out, in *Psychoanalysis and Feminism* Juliet Mitchell shows that Freud's theories of sexuality and identity turn basically on cultural not biological factors. Mitchell "argues for a decisive break from concern with anatomy and biologism, and

points to Lacanian developments in psychoanalysis, as a theory of the cultural acquisition of sexual identity" (*Women* 121). But, they contend, Mitchell was not critical enough of "Lacan's explicit phallocentricism," which is just as patriarchal as Freud's male-centered categories of the Oedipus complex, penis envy, and female hysteria (121). At the same time, Mitchell also helped introduce British feminists to Althusserian concepts. And it is through the ideological construction of "sexed subjectivity," particularly as theorized by Julia Kristeva, that the contributors to *Women Take Issue* see a way forward from Mitchell's important work (*Women* 123).

If psychoanalysis has been a vital but contested terrain for feminism, so has anthropology. Various "anthropological" works, beginning at least with J. J. Bachofen's *Das Mutterrecht* (1861), have speculated that, at least in the very beginning (undecidably whenever), human society was matriarchal rather than patriarchal. In *Totem and Taboo* (1913), on the other hand, Freud drew on completely contrary anthropological ideas for his speculative version of the origin of human society in the oedipal rivalry of the sons against the ur-patriarch who, he contended, at first ruled the "primal horde." After the sons had banded together to murder and eat the ur-father and take possession of the women of the horde, their oedipal guilt continued to bond them and gradually produced rituals, laws, and religion—in short, the repressive "defense mechanisms" which in Freud's view constitute society. In the Marxist tradition, especially in Engels's *The Origin of the Family, Private Property and the State* (1884) which was directly influenced by Bachofen, but also in various presentations of the idea of "primitive communism," the Rousseauistic theme of an original society free from sexual as from other forms of domination has been influential (Maurice Bloch 7–15).

For feminists, the Bachofen-Engels line has had strong appeal, though it has been contested from a variety of angles, including the deconstructionist contention that all "origins" are fictive. In any event, anthropology is the main "discipline" which has explored kinship patterns and the social construction of sexual identities throughout the world. The work of many anthropologists, from Bronislaw Malinowski, through Margaret Mead and Claude Lévi-Strauss, down to the present, has shown the great diversity of the cultural patternings of sexuality, providing the strongest available evidence that relations between the sexes are culturally and not biologically "determined." Yet anthropology also shows, in the words of Sherry Ortner, that "women [are] subordinated to men in every known society. The search for a genuinely egalitarian, let alone matriarchal, culture has proved fruitless" (Ortner 70). After critically surveying these and other themes, the authors of the essay on anthropology in *Women Take Issue* contend that "relations of biological reproduction cannot be secured solely at the economic level, but require as a condition of their existence, the continual work of ideology. . . . [T]he subordination of women in the reproductive sphere requires the massive dissemination of specific forms of sexual ideology (myths of masculinity, of

motherhood, of maternal deprivation, of the primacy of heterosexual genital sex, etc.) in order to secure and maintain those relations of reproduction" (171).

The other essays in *Women Take Issue* deal directly with "specific forms of sexual ideology," in the British mass market magazine *Woman* and in Charlotte Brontë's novel *Shirley*. As part of the "anti-school culture" of her working-class girls, McRobbie emphasizes "their immersion in the ideology of romance" (98), and that phrase seems as good as any for viewing under the same rubric both an item of contemporary mass culture and an early Victorian (and presumably high cultural) novel. Issues of literary representation are uppermost in these essays and, as in much feminist literary and media criticism, the "romance" genre—which encompasses everything from the Gothic romances of Anne Radcliffe in the late eighteenth century to the latest televised soap operas—is theorized as one which runs the gamut from reinforcing patriarchy and women's oppression to helping to express, at least subliminally, women's unhappiness if not outright rebellion (see also Modleski, Radway). According to McRobbie: "The culture of adolescent working class girls can be seen as a response to the material limitations imposed on them as a result of their class position, but also as an index of, and response to their sexual oppression as women. They are both saved by and locked within the culture of femininity" (108). The "ideology of romance," in other words, is double-edged, ambiguous, although it may also be less explicitly politicized or expressive of resistance than, for example, the rebellious rock music and subcultural styles explored by Hebdige and Willis. In the hands of a great writer like Brontë, however, the more radical political implications in the romance genre rise to the surface.

Feminist Literary Theory

Is the romance genre a product of "patriarchy," a form of ideology imposed on women to help keep them in place, or is it also a site of resistance and at least potential rebellion? In *Rewriting English,* Janet Batsleer and her coauthors give the more positive interpretation to the "ideology of romance":

> Observing the extent to which reality appears turned upside-down in the conventions of romance fiction, we can register the presence of a powerful ideology which speaks to and resolves in imaginary form many of the most significant and fundamental aspects of women's subordination. That romance comforts women, affirms their value, offers to resolve in imagination conflicts that remain unresolved in reality, while at the same time reconciling them to a subordinate place in that reality, is not a matter for regret or for accusations of false consciousness. Women are not as simply suggestible and credulous as some Marxist and earlier feminist analysis has supposed, and are quite capable of recognizing a fairy-story when they see one. (Batsleer et al. 104)

Other feminist critics—Tania Modleski, for instance, in *Loving with a Vengeance*—agree at least in finding double messages in cultural forms directed at and, in many instances, created by women. According to Modleski, televised soap operas are not just commercialized rubbish which do no more than reinforce patriarchy; they also express utopian longings about family and community that should not be lightly dismissed: "For it is important to recognize that soap opera allays *real* anxieties, satisfies *real* needs and desires, even while it may distort them. The fantasy of community is not only a real desire (as opposed to the 'false' ones mass culture is always accused of trumping up), it is a salutary one. As feminists, we have a responsibility to devise ways of meeting these needs that are more creative, honest, and interesting than the ones mass culture has supplied" (Modleski 108–9). This is tantamount both to the point made by Gramsci and reiterated by Stuart Hall that ordinary people are not cultural "dupes" or "dopes" (see Hall, "Notes") as well as to the argument that even the most "primitive" or "escapist" forms of daydream or wishfulfillment culture serve a utopian function (see Ernst Bloch). As Hans Magnus Enzensberger says, even "consumption as spectacle is—in parody form—the anticipation of a utopian situation" (112).

All cultural forms express an "aesthetic dimension" which is always at least implicitly utopian. But such an argument comes close to discovering in the most fetishized cultural forms—advertisements, for example—the seeds of refusal or radical opposition to capitalism. The ideological function of the forms may be simply to swallow up those seeds, so that they don't grow into anything consciously political. Modleski is therefore right not to stop with the claim that utopian traces can be found in romances and soap operas; that seems obvious enough (but see Morris and also Williamson). The difficult part is, as she also rightly stresses, to envisage cultural forms that would bring those traces of utopian longing and critical opposition into the open and allow them to become politically empowering instead of marginalizing. This is one of the main positive tasks of feminist cultural criticism. Its negative task is clear enough: to oppose the forms of patriarchal exclusion and misrepresentation that have over and over again treated women, as Susan Gubar points out, as art objects, "texts," "blank pages" to be written upon by men, while denying them cultural authority and the chance to be authors and artists themselves (Gubar, " 'Blank Page' "). This is the literary version of historian Linda Gordon's definition of feminism as the "analysis of women's subordination for the purpose of figuring out how to change it" (qtd. in Eisenstein xii).

Feminist literary theory begins with basic issues of representation. Perhaps the most basic issue is quite simply the historical *absence* of women from what has appeared to be the cultural, literary, and artistic mainstream, as also from the "public sphere" and positions of political power. Much feminist literary criticism since the 1960s has been concerned with rediscovering, republishing, and "canonizing" neglected women writers (the works reprinted by Virago Press are exam-

ples). Such endeavors complement those by feminist historians to recover women's social and economic experience. Against neoconservative valorizations of a pre-existing canon of great books mostly by white, male authors, feminist critics can show numerous instances of literature by women which has been conveniently overlooked or actively suppressed by the male literary critics and scholars who have controlled the publishing houses, the journals, and the schools, and therefore also controlled canon-formation. Sometimes "patriarchy" or "sexism" renders women's writing invisible or unread in direct fashion. In *Mothers of the Novel*, Dale Spender notes that the standard, male accounts of the origins of the English novel—Ian Watt's *The Rise of the Novel,* for example—ignore the existence of a vast quantity of fiction by women. For Watt, the great originators of the modern novel were Defoe, Richardson, and Fielding. But Spender shows that there were literally hundreds of women novelists writing before 1800, languishing in the shadows cast by their male counterparts and by the male-dominated critical tradition. Of course such recovery work also raises questions about form and style. If to Watt and other male critics women novelists before Austen seem negligible, that may be partly because of the way they wrote and what they wrote about. Denied access to the public sphere, women poets have not produced epics. For much the same reason, their prose fictions have, with notable exceptions, tended toward the ideology of romance instead of the supposedly hard-headed realism often identified as both scientific and male.

Besides overlooking, ignoring, or perhaps just being unconscious of women's writing, subtler forms of oppression have been at work in literary and cultural fields. Dominated by male definitions of "greatness," literary history has produced a general devaluation of women's writing, even after such writing has begun to be published and to some degree publically celebrated. Without positive models of "great" literary achievement, would-be women writers have been, at least until recently, bereft of "history," as Elaine Showalter notes: "each generation of women writers has found itself, in a sense, without a history, forced to rediscover the past anew, forging again and again the consciousness of their sex. Given this perpetual disruption and also the self-hatred that has alienated women writers from a sense of collective identity, it does not seem possible to speak of a 'movement' " (*Literature* 11–12). Virginia Woolf said much the same through her myth of Shakespeare's sister in *A Room of One's Own,* a suicide because "a highly gifted girl who had tried to use her gift for poetry would have been . . . thwarted and hindered by other people [and] tortured and pulled asunder by her own contrary instincts" (51). Even when women have succeeded, against numerous constraints and disabilities that do not hamper men, in publishing poetry or plays or novels, what has happened to their literary productions has also been a story of thwarting and hindering.

As Sandra Gilbert and Susan Gubar point out in *The Madwoman in the Attic,* under patriarchy the male writer works on the analogy of the male God of the

Bible. Like the divine Logos, the secular literary word is male "authored" or "fathered," "penned" by a "phallocentric" ideology which elevates masculine authority and degrades or devalues the feminine. "For the female artist the essential process of self-definition is complicated by all those patriarchal definitions that intervene between herself and herself" (59). For women writers from Jane Austen down to Virginia Woolf and beyond, writing under patriarchal domination has meant overcoming or at least learning to live with an oppressive and often unconscious "anxiety of authorship" that has given their texts an especially double, "palimpsestic" quality, at one and the same time the source of "their distinctive female power" (59) and the product of their oppression. "Women from Jane Austen and Mary Shelley to Emily Brontë and Emily Dickinson produced literary works that are in some sense palimpsestic, works whose surface designs conceal or obscure deeper, less accessible (and less socially acceptable) levels of meaning. Thus these authors managed the difficult task of achieving true female literary authority by simultaneously conforming to and subverting patriarchal literary standards" (Gilbert and Gubar 73).

On the surface, the nineteenth-century woman writer, like her male counterpart, may have celebrated—and indeed herself may have imitated (despite authoring literary works)—Coventry Patmore's "angel in the house." In doing so, she also valorized the ideology of romance and of the unitary, bourgeois family (often the reward that comes at the end of the romance, as in *Jane Eyre:* "Reader, I married him"). But the omnipresent double of the angel, Gilbert and Gubar contend, is Bertha Mason, the "madwoman in the attic" from *Jane Eyre,* and her numerous analogues. Here the question of the ideology of romance returns with renewed force, because the "paradigmatic polarities of angel and monster" (76) represent the divided, "schizophrenic" response of women's writing to patriarchy. One might say, following Gilbert and Gubar, that there are simple romances, fairly straightforward examples of daydreaming or wishfulfillment as, say, in Barbara Cartland's "Harlequins," in which monstrosity and the heroine are not subliminally identified. And then there are more complex, more interesting romances, in which the angel and the monster are at least unconsciously parts of a single self or subjectivity. Gilbert and Gubar discover the female monster figure in all of the nineteenth-century novels and poetry they survey, and in all cases they interpret this figure as "in some sense the *author's* double, an image of her own anxiety and rage" (60).

A similar discovery of the inscription of "anxiety and rage" in nineteenth-century women's art and literature occurs in other feminist studies—for example, in Nina Auerbach's *The Woman and the Demon.* For Auerbach, the angel in the house herself was invested with a kind of demonism, a seemingly powerless power over the masculine realms of labor and politics which, though exercised "privately" instead of "publicly," was nonetheless effective. As in Foucault's recognition of the diffusion of power through all the "micropolitics" of society

and discourse, Auerbach suggests that patriarchy cannot be understood simplistically as the social condition in which men have all the power and women have none. This does not mean, however, that the forms of power are equal, let alone that men and women have been equal partners in the shaping of history and society through the ages.

But for some feminists, interpretations like Auerbach's and even like Gilbert and Gubar's too readily discover resistance in the forms of oppression. For those who find nothing but oppression in patriarchal society, some sort of radical break on the order of Firestone's "sexual revolution" seems necessary. For some radical feminists—Adrienne Rich and Mary Daly, for example—such a revolutionary break would entail a complete subversion of language as we know and use it—the overthrow of "phallocentric" discourse—and the replacement of that language and the "male-centered categorizations" it generates by a feminized discourse. According to Shoshana Felman, "the challenge facing the woman today is nothing less than to 'reinvent' language . . . to speak not only against, but outside of the specular phallogocentric structure, to establish a discourse the status of which would no longer be defined by the phallacy of masculine meaning" (qtd. in Showalter 191). Feminist criticism of even less radical varieties seeks to deconstruct or demystify "male-centered categorizations" and systems of representation which stereotype or exclude women and women's experience as inferior, negligible, not fully human. But after the negative work of deconstructing male-centered discourse, the next step is to examine the positive possibilities of a feminized discourse and literature. For both purposes, deconstructionist theory has probably been as useful to radical feminist critics as Marxism, which often itself, like Freudian and Lacanian psychoanalysis, seems tainted by patriarchal assumptions.

For deconstructionist feminists, criticism which begins from assumptions of the unity of the literary text and the authority of the individual author fails to escape from the most fundamental, oppressive categories of patriarchy. In her critique of *Madwoman in the Attic,* for example, Toril Moi argues that "phallocentric" esthetics is characterized by an authoritarian stress on the unity both of the literary text and of the author (and beyond these, also of the self of the individual reader). In the deconstructive theories of Derrida, Lacan, and the French feminists Julia Kristeva, Luce Irigaray, and Hélène Cixous, Moi finds a liberating emphasis on disunity, contradiction, and the play of "difference."

> . . . patriarchal thought models its criteria for what counts as "positive" values on the central assumption of the Phallus and the Logos as transcendental signifiers of Western culture. The implications of this are often astonishingly simplistic: anything conceived of as analogous to the so-called "positive" values of the Phallus counts as good, true or beautiful; anything that is *not* shaped on the pattern of the Phallus is defined as chaotic, fragmented, negative, or nonexistent. . . . Gilbert and Gubar's belief in unitary wholes plays directly into

the hands of such phallic aesthetic criteria. . . . To this extent, some Anglo-American feminism . . . is still labouring under the traditional patriarchal aesthetic values of New Criticism. (67)

But granting that phallocentric culture depends on the unity of the literary text and the authority of the author (at least when male), its opposite can't be merely disunity or difference stressed as a kind of negative virtue. As usually conceived in deconstructive theory, disunity and difference are themselves versions of the (merely) "chaotic." Perhaps this indeed makes them "feminine" as opposed to the "masculine" values of order and authority. But perhaps also disunity and difference are themselves the ideological reflections of patriarchy, the "chaos" which "phallocentrism" attributes to female genitality and to women in general.

Against an oppressive social order, it isn't sufficient to insist anarchistically on the liberating capacity of disorder; it's necessary instead to envisage and theorize an alternative social order (or, perhaps, plurality of social orders). This task deconstruction, which is not an alternative to Marxism, feminism, or other forms of radical political theory but a method of rhetorical analysis, cannot undertake. Nevertheless, it is along the trajectory of "difference" that the relations between feminism and deconstruction have been forged, as Terry Eagleton notes in *Literary Theory:*

> The women's movement rejected the narrowly economic focus of much classical Marxist thought, a focus which was clearly incapable of explaining the particular conditions of women as an oppressed social group, or of contributing significantly to their transformation. . . . Because sexism and gender roles are questions which engage the deepest personal dimensions of human life, a politics which was blind to the experience of the human subject was crippled from the outset. The movement from structuralism to post-structuralism was in part a response to these political demands. (148–9)

Eagleton goes on to point out that of "all the binary oppositions which post-structuralism sought to undo, the hierarchical opposition between men and women was perhaps the most virulent. Certainly it was the most perdurable: there was no time in history at which a good half of the human race had not been banished and subjected as a defective being" (149). He immediately adds, however, that "this staggering fact could not of course be put right by a new theoretical technique" (149)—and I would add, a technique which is primarily linguistic or rhetorical. As Michael Ryan and others have pointed out, deconstruction perhaps *implies* a social theory, but by itself is apolitical. The investment of radical political energy in deconstruction comes from elsewhere—from feminism, for example, which is today one of the most powerful sources of the politicization of deconstruction (rather than the other way around).

From the standpoint of reader response literary theory, the same text can have quite different meanings depending on the reader. From the standpoint of deconstructive theory, the supposedly unitary text "disseminates" contradictory meanings and hence again can have no single, determinate meaning (or, for that matter, political tendency or effect). From either standpoint, it is nonsensical to claim that one sort of text—the realist novel is the usual culprit—is authoritarian, while another sort—Gothic romances, science fiction, the French *nouveau roman,* postmodernist "metafiction," etc.—is liberating, or at least free of the traces of authoritarianism (and therefore also, presumably, of "authorship" or the unitary "author"). Similarly, the idea of the "duplicitous" or "palimpsestic" character of women's writings, as theorized by Gilbert and Gubar and restated by Showalter (204), is also insupportable to a deconstructive feminism which seeks something freer, more expansive in linguistic "play" and "difference" than doubleness offers. Beyond binary oppositions, deconstructive feminism seeks a utopian space in which all "differences" among individuals and groups will be honored as sources of strength and freedom, instead of as limitations or factors to be repressed or obliterated. As Eisenstein remarks, "feminist theory is utopian" (xiii), and this seems just as true of its deconstructive as of its other varieties. Nevertheless, while the deconstructive emphasis on difference also points to representation as the key issue for modern or postmodern literary practice, it does so from a position which disables it from engaging in what have been, for political purposes, the most influential forms of critical discourse. These have insisted on distinguishing accurate or truthful representations from misrepresentations, as well as on celebrating the sorts of "double" vision stressed by Gilbert and Gubar. Such forms of discourse have been too quickly dismissed by deconstructionists as entailing an impossible, self-contradictory realism, as when Moi attacks "disabling author-centred empiricism" (170). But the stress on difference, unsupported by reference to empirical reality, is merely circular, and is as easily cooptable by liberal pluralism as by any form of radical cultural politics.

Afro-American Influences

Just as Kate Millett writes about the "internal colonization" imposed on women by patriarchy, so Showalter offers an important analogy between the question of language as it arises in the struggle for women's liberation and as it arises in the struggle of "Third World" peoples against imperialism. Citing anthropologist Clifford Geertz, Showalter declares:

> From a political perspective, there are interesting parallels between the feminist problem of a women's language and the recurring "language issue" in the general history of decolonization. After a revolution, a new state must decide which language to make official: the language that is "psychologically immediate,"

that allows "the kind of force that speaking one's mother tongue permits"; or the language that "is an avenue to the wider community of modern culture," a community to whose movememts of thought only "foreign" languages can give access. The language issue in feminist criticism has emerged, in a sense, after our revolution, and it reveals the tensions in the women's movement between those who would stay outside the academic establishments and the institutions of criticism and those who would enter and even conquer them. (192)

Continuing with the colonization analogy, Showalter quotes Christiane Roche-fort's remark that " 'I consider women's literature as a specific category, not because of biology, but because it is, in a sense, the literature of the colonized' " (197). The key point both Rochefort and Showalter are making is that whatever is characteristic about women's language and literature is not due to anatomical but to cultural difference, the partially but not wholly determined result of women's "colonization" under patriarchy. Showalter therefore sees it as crucial to approach women's writing through "a theory based on a model of women's culture" (197). At the same time, she insists that there will be differences between an adequate theory of women's culture and "Marxist theories of cultural hegemony," in part because women are unified by their experience despite such obvious barriers as "class, race, nationality, and history" (197). Instead, "women's culture forms a collective experience within the cultural whole, an experience that binds women writers to each other over time and space" (197).

Showalter is agreeing here with Lerner's assertion that women's culture cannot be viewed as a "subculture" (Showalter 199). Certainly women's culture is not a "minority" one, although how it comes to seem so is one of the central questions about the cultural dynamics of patriarchy. Indeed one obvious characteristic women share with both the working class and racial "minorities" is that they are in actual fact a majority. Of course in certain communities and places around the world, men outnumber women, but the world population statistics tell another story. The same is true of the "nonwhite" or non-European races of the world: the populations of Asia and Africa together account for over 70% of the world's total. And, though definitions of "work" and "class" may shift the figures around, it is also true that men and women who "work"—that is, who perform physical labor for wages or to produce food from land they do not legally own—form the overwhelming majority of the world's population.

Given these basic facts, it becomes apparent why class, gender, and race are central topics for cultural studies, and also why they should be central topics for any vigorous humanities and social sciences curriculum. But how does it come about that these terms are perceived in the dominant culture as relevant to "minorities" instead of majorities? How has the map of the world become so distorted in, for example, traditional humanities fields that questions of class, gender, and race seem marginal, "special" topics for seminars and graduate

courses, perhaps, but not for the main agenda? These categories signify the *major* forms of division and difference between people. Understanding their historical, social construction, their complex interconnections, and their effects on "everyday life" and the formation of "subjectivities" is the chief aim of oppositional criticism. The role of cultural studies in higher education today may be precisely to prod the traditional disciplines into recognizing what they seem to have forgotten—that their subject-matter is or ought to be what divides and unites us as human beings, in the larger workings of society and culture, but also in "the practice of everyday life." Examining the role of social class in the teaching of English literature, H. Bruce Franklin concludes: "If we who study and teach literature wish that our profession survive, we must adjust our vision to a world in which most people are nonwhite, over half are female, the overwhelming majority are workers, and all live in a time of transformation so intense that it may constitute a metamorphosis" (Franklin in Baker and Fiedler 105).

"Majority studies" might be just as appropriate a label as "cultural studies" for the sort of politically committed teaching and research Franklin has in mind. Within the university setting in both North America and Britain, cultural studies is a main site from which the possible consolidation of the majority interests involved in the terms class, gender, and race has begun to be debated. And the fact that majorities have been marginalized, excluded, and historically perceived as minorities both within and outside schools and universities suggests that a central problem shared by the excluded is one of cultural representation. "This inability to find ourselves in existing culture as we experience ourselves is true of course for other groups besides women," writes feminist historian Sheila Rowbotham; she has in mind "the working class, black, national minorities within capitalism" (26). Insofar as oppression and exclusion are rooted in patterns of misrepresentation—that is, in ideology—a radical cultural politics is a necessary response from all these groups, suggesting in turn possibilities for solidarity and common struggle.

What patriarchy is to feminism and bourgeois or capitalist ideology to Marxism, racism and imperialism are to the world's nonwhite "minorities." The "colonizing" metaphor in feminist writing is thus not simply metaphoric. Empire, decolonization, and the immigration of West Indians, Asians, and Africans to Britain after World War II have led to the emergence of "race relations" as a central topic for cultural studies there, and of course that topic is at least equally central in North America. Starting with the Notting Hill and Nottingham riots of 1958, British cities have repeatedly experienced racial violence. Since 1967, the National Front has emerged as a neofascist movement, aiming at the expulsion of nonwhite "foreigners"; and Thatcherism like Reaganism has thrived ironically partly by situating itself as a voice of moderation against the extreme right, expressing its racial biases comparatively tactfully. These and related tendencies are the subjects of two studies by members of the Birmingham Centre—*Policing*

the Crisis (Hall et al., 1978) and *The Empire Strikes Back: Race and Racism in 70s Britain* (1982). In the former, Stuart Hall and his colleagues analyzed the "moral panic" aroused by the "mugging crisis" following the Handsworth "mugging" in November, 1972, and the ways the criminal and legal categories used to understand and control that "crisis" expressed the underlying ideology of white racism. In *The Empire Strikes Back,* Paul Gilroy and his colleagues continue that work, sharpening the criticism in part by indicting the British left for failing to acknowledge "the role of blacks and black struggles in the making and remaking of the working class" (7). All of the essays analyze the strengthening of white racism in relation to "the organic crisis of British capitalism" (9). Two, by Hazel Carby and Pratibha Parmar, also situate racism in relation to patriarchy. And all are critical of traditional sociological approaches to "race relations," which downplay class, ideology, and the "crisis of British capitalism"—Britain's economic and political decline, reflected in new domestic versions (not to mention the ongoing conflict in Northern Ireland) of the old imperial wars of conquest and expansion.

The connections between the oppression of women, of workers, and of the nonwhite races of the world were recognized in the last century by feminist abolitionists like Frederick Douglass (see Foner). In her account of early black feminist analyses of lynching, empire, and patriarchy, Carby analyzes the sophisticated understanding of "internal and external colonization" developed in Anna Julia Cooper's *A Voice from the South: By a Black Woman of the South* (1892), Ida B. Wells's *Southern Horrors: Lynch Law in All Its Phases* (1892) and *A Red Record . . . Lynchings in the U.S.* (1895), and the turn-of-the-century essays and fiction of Pauline Hopkins. Cooper believed that there were "masculine" and "feminine" tendencies in politics, and she saw the worst effects of unqualified or unfeminized masculinity in a will to dominate weaker races and individuals that manifested itself in slavery, racism, imperialism, and sexism. Wells's treatment of lynching as an instrument of white male racial domination and the symbolic rationalization of the rape of *black* women offers interesting parallels to recent feminist accounts of rape as an instrument of patriarchal power (see Susan Brownmiller's 1975 book *Against Our Will: Men, Women, and Rape* and the account in Eisenstein, pp. 27–34).

The connections between the racist oppression of Afro-Americans and the sexist oppression of women were especially apparent to black women intellectuals. In Cooper's words, "To be a woman of the Negro race in America, and to be able to grasp the deep significance of the possibilities of the crisis, is to have a heritage . . . unique in the ages" (qtd. in Carby 304). Cooper expresses a sort of painful privilege of consciousness, a deep-rooted awareness of oppression and of utopian longing that has often been a powerful source of cultural creativity, innovation, and potential liberation. It is also a primary source of historical understanding, without which history degenerates into the self-congratulatory

flag-wavings of the victorious, as Pauline Hopkins similarly understood: "all Negroes, whether Frenchmen, Spaniards, Americans or Africans [should] rediscover their history as one weapon in the struggle against oppression" (qtd. in Carby 310).

How many white male professors of American literature or history have heard of Cooper, Wells, and Hopkins? The trouble with E. D. Hirsch's idea of "cultural literacy" lies not so much with what it includes, but with what it leaves out, and the same is true with traditional notions of the literary "canon" or "great tradition." More to the point, as Hopkins realized, historical consciousness is itself a product of ideological struggle in which the powerful seek to tell their singular, self-congratulatory story and to repress or distort other stories. Just as a seemingly endless stream of British histories and school textbooks written between the 1830s and the 1950s treated the British Empire as the acme of historical progress, virtue, civilization, and freedom, so countless American histories and textbooks over the same period at least rationalized slavery and minimized the cultural and political achievements of Afro-Americans.

Historians of the black experience in America labor under a double indemnity. Not only do they struggle to recapture a past that has been all but obliterated by the dominant, white culture, they must also struggle to convince white colleagues and the academic powers-that-be that this repressed, nearly forgotten past is worth recapturing and teaching. Not to be represented, to be "invisible" people, that is the "blankness of darkness" in *white* culture against which Afro-American writers, artists, and intellectuals must continually struggle. Having just witnessed the shooting down of Brother Clifton by a white policeman, Ralph Ellison's Invisible Man wonders where the historian is who will record that crime? "The cop would be Clifton's historian, his judge, his witness, and his executioner, and I was the only brother in the watching crowd" (332). How often has this been the case, he muses, and "where were the historians today?"

> I stood there with the trains plunging in and out, throwing blue sparks. What did they ever think of us transitory ones? . . . birds of passage who were too obscure for learned classification, too silent for the most sensitive recorders of sound; of natures too ambiguous for the most ambiguous words, and too distant from the centers of historical decision to sign or even to applaud the signers of historical documents? We who write no novels, histories or other books. What about us, I thought. . . ? (*Invisible Man* 332)

Here again is the call for voicing the silenced or rendering visible the invisible heard in E. P. Thompson's social history, Sheila Rowbotham's feminism, and Edward Said's oppositional criticism. But it isn't just to fill in the blanks, correct the imbalances, or tell the stories of hitherto silent or invisible people that motivates a number of prominent historians to declare that Afro-American history

should have a *central* place in any humanities curriculum in the United States. Thus John Hope Franklin speaks of it as the "centerpiece" of American history which "provides . . . a very important context in which much, if not the whole, of the history of the United States can be taught and studied. It also provides an important context in which much of the history of the United States can be reexamined and rewritten" (Franklin in Hine 22). Even more emphatically, William Harris asserts that the humanities depend on history, and that both depend on recovering and understanding the full record of Afro-American experience: "I can think of no field that is more essential to the understanding of the history of the West than is Afro-American history" (Harris in Hine 140).

On one level, Franklin and Harris echo Ellison's assertion in *Shadow and Act* that "any viable theory of Negro American culture obligates us to fashion a more adequate theory of American culture as a whole" (*Shadow* 253). On another, as historians they insist that the practice of recovering and understanding the past is always a struggle against repression, forgetting, and misrepresentation. As a discipline and form of consciousness, history itself is in danger of failure, a kind of suicide by omission and distortion, if it forgets more than it remembers—above all, if it represses the stories of millions of "invisible" people, and then also represses the story of that repression. Afro-American history is crucial to American history as a whole, because only through understanding the Afro-American experience can the moral and political conscience vital to humanities teaching be sustained.

Franklin and Harris thus come close to expressing the thought that at the heart of Afro-American culture lies the conscience or "soul" that white America lacks. Concerning this notion, Ellison offers an important caveat. In his essay on *Intruder in the Dust,* Ellison notes that Faulkner's conception of the Negro as " 'the keeper of our consciences' " is an important advance over the stereotyped images of blacks in fiction and film before World War II, but he concludes: "Yet in the end, turning from art to life, we must even break with the definition of the Negro's role given us by Faulkner. For when it comes to conscience, we know that in this world each of us, black and white alike, must become the keeper of his own" (*Shadow* 274, 281). Ellison is right, of course; further, the idea of black Americans as the keepers of the conscience of white America may well seem restrictive and offensive to blacks. Yet it's worth comparing this idea with Marx's conception of the proletariat as the social class which alone bears the promise of ultimate social liberation. In the *Critique of Hegel's Philosophy of Right,* Marx asked where was there "a *real* possibility of emancipation in Germany?"

> *This is our reply.* A class must be formed which has *radical chains,* a class in civil society which is not a class of civil society, a class which is the dissolution of all classes, a sphere of society which has a universal character because its sufferings are universal, and which does not claim a *particular redress* because

the wrong which is done to it is not a *particular* wrong but *wrong in general*. There must be formed a sphere of society which claims no *traditional* status but only a human status, a sphere which is not opposed to particular consequences but is totally opposed to the assumptions of the German political system; a sphere, finally, which cannot emancipate itself without emancipating itself from all the other spheres of society, without, therefore, emancipating all these other spheres, which is, in short, a *total loss* of humanity and which can only redeem itself by a *total redemption of humanity*. This dissolution of society, as a particular class, is the *proletariat*. (*Marx-Engels* 64)

Just as Marx declares that the ultimate redemption of society depends on the fate of the proletariat, so the ultimate redemption of the U.S. may also depend on the emancipation of the slaves and the ultimate fulfillment of their descendants' long struggle for freedom and justice. As slaves, Afro-Americans formed a working class with even less power than the white working-class majority. One of the obvious (though not by itself sufficient) answers to the question of "American exceptionalism" is racism, which has kept white and black workers from achieving solidarity, and which has often deflected the energies and anger of the white working class away from the true sources of social injustice (see Davis).

Radical feminists may have another version of the class in "radical chains," as may also representatives of other ethnic, national, and "Third World" "minorities." Indiana University, for instance, houses a vigorous Jewish Studies program, with faculty who voice—in un- or anti-Marxist terms—exactly Marx's idea, only substituting Jews and Judaism for the industrial proletariat. In similar fashion, in *Orientalism* Edward Said inscribes all "oriental" victims of imperialism and western stereotyping (including, most urgently, the Palestinians) in the position of "class" in "radical chains." There is justice in all of these claims, for the simple reason that violence, oppression, and injustice have been central characteristics of history in both its capitalist and its pre-capitalist phases (as well as in most of the incarnations to date of socialism, in the Soviet Union, China, and eastern Europe).

But the paradox that only the oppressed can ultimately liberate and redeem their oppressors, central alike to Judaeo/Christian morality and to Marxism, seems especially relevant in the case of a group whose quite recent historical experience, in "the land of the free," has been that of slavery. And just as U.S. history must necessarily come back to this paradox again and again until it is resolved, so it seems true to say, with Ellison, that the vitality and uniqueness of *white* American culture are ultimately dependent on the Afro-American heritage. To these observations can be added Cornel West's argument, from "an Afro-American neo-Gramscian" perspective, that "the time has passed when the so-called race question . . . can be relegated to secondary or tertiary *theoretical* significance in [either] bourgeois or Marxist discourses. Instead, to take seriously

the multileveled oppression of African peoples is to raise crucial questions regarding the conditions for the possibility of the modern West, the nature of European conceptions of rationality, and even the limited character of Marxist formulations of counterhegemonic projects against multileveled oppression" (West 18).

Afro-American Literature and Literary Theory

In his introduction to *The Narrative of the Life of Frederick Douglass,* Houston Baker notes that the Unitarian minister, Theodore Parker, was one of many nineteenth-century American intellectuals who worried about the lack of originality in American literature, its dependence on European models. But Parker found originality in at least one sort of writing: " 'We have one series of literary productions that could be written by none but Americans, and only here: I mean the Lives of Fugitive Slaves. . . . all the original romance of America is in them, not in the white man's novels' " (qtd. in Douglass 12–13). Was Parker just being perversely hyperbolical, or is there an important truth in his observation? The standard (white) histories of American literature have not repeated Parker's claim. The chapter on the Civil War ("Literature and Conflict") in the third revised edition of Robert E. Spiller's *Literary History of the United States* (1963), to take just one quite standard example, discusses abolitionist writings by white authors including Parker and the inevitable Harriet Beecher Stowe, but mentions no writing by Afro-Americans (501–636). Paul Lawrence Dunbar is cited in a later chapter as "the first Negro American writer to learn the literary lessons of Joel Chandler Harris" and *Uncle Remus* (748), and Zora Neal Hurston figures as a "folklorist" more than a novelist (749). A list of Afro-American writers is offered still later in connection with 1930s Depression writing, and Richard Wright is briefly compared to James Farrell and Theodore Dreiser (1314–15).

Anyone who believes that literary or artistic "canons" of "great works" evolve magically, by some apolitical osmosis through which literary value is automatically and inevitably recognized, would do well to think about Parker's apparent exaggeration, and to compare what doesn't get said about Afro-American writing in *The Literary History of the United States* with almost any comparable volume published since the 1960s. This is not to say that the volumes since the sixties tell the full story, much less that they have accepted Parker's observation as the truth. The struggle for full literary representation by Afro-Americans has won some partial victories since 1963, but is far from over. The distance traveled and the distance still to travel can be roughly gauged by the fact that, while Afro-American Studies departments now exist at many universities, they are constantly embattled and marginalized. A better, sorrier gauge may be the upsurge of racism and racist violence on campuses throughout the U.S. (see, for example, Wiener). While the teaching of Afro-American literature and history goes on in Afro-

American programs (where these exist), it does not necessarily go on in departments of English, American Studies, and history.

For those who, like William Bennett, believe that teaching Afro-American literature is a frivolous distraction from teaching the established canon of great books, Parker's claim must seem ludicrous. Yet slave or ex-slave narratives *were* the most original, authentically "American" form of writing in the nineteenth century. A text like Douglass's *Narrative* may not have the *same* "literary" qualities as those valorized by formalist, white, male, academic criticism; its *different* literary qualities, however, are very much worth attending to. Like other slave narratives, beginning with Olaudah Equiano's (Gustavus Vassa's) *Life* in the eighteenth century, Douglass's can be read both as a heroic struggle for survival and freedom and as a text which reveals the very grounds of possibility for literature and "high culture" in a society claiming to be democratic while practicing slavery. Apart from the cruelties of slavery, the chief drama Douglass narrates is his own struggle for education and articulation. His path from illiteracy to literacy, from apparently total voicelessness or lack of representation to the status of influential public speaker, journalist, and advocate of women's rights as well as of abolition, is exemplary in many ways. The scholarly debates about the "authenticity" of his *Narrative* (and about that of other slave narratives)—about the degree to which, for example, Horace Greeley and other white abolitionists may have helped him compose it—have resolved little about its actual production, but do reveal a great deal about the power and covert racism of the scholarly discourses which define what is "authentic" and what is not, and therefore also what is "literature" and what is not. Much the same debate occurred around the reception of Phyllis Wheatley's poems in the eighteenth century—a debate in which some white "authorities" declared that Wheatley couldn't have written her poems herself (they must have been written by her mistress, or with the substantial help of her mistress). Thomas Jefferson, for one, simply transcended the debate about Wheatley's authorship by asserting that her poems were "below the dignity of criticism" (Baker, *Journey* 8–9).

The struggle for Afro-American literacy and literature (and all art forms) has been a struggle against the powerful, white voices, discourses, and disciplines that at first sought to deny the black writer the very instruments of writing, then later sought to deny to his or her writing either authenticity or the status of literature or both. Against such powerful cultural opposition, for blacks to speak up publicly or even more to write and publish their stories and ideas has necessarily involved them in struggles for representation which white, male, middle-class writers have not had to fight. Insofar as conservative, academic definitions of literature have succeeded in purging it and the other arts of any overt, immediately "relevant" politics, moreover, then they have so constructed the field that the writings of all "minorities," all oppressed groups, will seem nonliterary, "below the dignity of criticism."

Like other slave narratives, Douglass's is of course a piece of propaganda, written at the behest of abolitionists in the struggle against slavery. But this fact, instead of causing the exclusion of Douglass's *Narrative* from the canon, should instead raise the question of the extent to which all works of literature are propaganda. Certainly they are all "rhetoric," and the classical idea of rhetoric, focused on political oratory, aimed at persuasion. Is a work closer to being great literature when it masks or somehow sublimates its rhetorical, propagandistic designs upon its readers, or when it puts them up front? And is a work which tells us fundamental truths about our nation's past of more or less value than one which romanticizes, distorts, or represses that past? I am not suggesting that Douglass's *Narrative* should *displace* other great works of American literature—*Moby Dick* or *Walden,* for example—in the canon of established "classics." But it should certainly take its place alongside them. And the ideological nature of the entire category of "literature" should be deconstructed—not to be tossed on the trashpile of history, but to be better understood, opened to different experiences, values, ideas—in short, to include instead of exclude.

It is still possible in many universities for students to graduate with Ph.D.'s in English with only the slightest awareness that Afro-Americans have written works of literature worth reading, or that they wrote anything at all before this century. I read *Uncle Tom's Cabin* in college, but still had no idea that nineteenth-century Afro-Americans had often recorded their experiences in prose and verse. And of course *Uncle Tom's Cabin,* with all its sentimentalism, was itself treated as out of the main line of American literature—as too political, too propagandistic, too sentimental—just as it is now sometimes dismissively treated by Afro-American critics. Great literature, my own education taught me, is not about public life or politics; it is instead about the experiences, lives, values of private, usually "refined" individuals (lyric romantic poetry, portraits of the artist, remembrances of things past, etc.). How then does one begin to understand and value literature which ignores refinement, etiquette, and "taste" to tell the truth about a nation's past and to represent the struggles of majorities against slavery, sexism, poverty? But powerful forms of literary criticism and theory have arisen to forestall such questioning—by distinguishing sharply between esthetic value and truth (in the sense of descriptive accuracy, representativeness, etc.), and more recently by insisting on a strict divorce between text and referent, literature and reality.

The "romantic ideology" of literature—its supposed transcendence and yet also supposed critical nature—confronts the black writer, as also the feminist, the gay, the Native American, the "Third World" writer, with a dilemma. To have a chance at being perceived as artistically original and great appears to mean to avoid direct mimesis and social realism, and— in the wake of deconstruction— also to avoid historicism, "reference," "the political," and other assorted baggage labeled "western," "imperialist," and "Eurocentric." Yet to be truthful to oneself and one's heritage and to seek to use literature in the struggle against racism leads

in an obvious way to the forms of social realism, which as Lukács understood could in certain circumstances be "critical," and not simply reinforcements of the status quo. This dilemma shows up repeatedly in Afro-American literature and critical theory, as it does, with significant variations, in other "minority" literature and criticism. In the works of Robert Stepto, Henry Louis Gates, Jr., and other recent theorists influenced by deconstruction, the need for social realism is questioned along with the idea of "blackness" as "essence" or as a "transcendent signified" (Gates, *Black* 7). Such an approach rightly insists that racial difference (like social class and gender) is socially constructed, cultural not biological. Yet this insistence seems also to outrun social realism as a necessary form or perhaps phase of ideological and social critique. The emergence of a "black postmodernist fiction" (see Fox and also Werner) sharpens the debate, not only about blackness as "essence" or as culturally produced, but also about the possibility—and need for—mimetic representation. Perhaps "difference"—Stepto's "tribal literacy," for example, with its African and communal emphasis, as opposed to Eurocentric "literacy"—can be affirmed even as the socially critical dimension of realism continues to be recognized as esthetically and politically valid.

Writing about the critical uses to which both bourgeois and working-class writers have put fictional realism, Williams declared that "the diagnosis of 'real-ism' as a bourgeois form is cant" (qtd. in Lovell 66–7). Nevertheless, the stress on "difference" and the play of "margins" against "centers" in deconstructionist theory is powerfully appealing to radical cultural theorists. Gayatri Spivak, for one, is convinced that Derridean "grammatology" is indispensable not so much for "ideological demystification" as for revealing the limits of Eurocentric think-ing—the boundaries it cannot cross without ceasing to be "centric" ("Can" 291–94). Perhaps the solution lies in the possibility that a *critical* social realism or mimetic representation can be critical of the very sources of cultural and political authority that deconstruction also seeks to expose—namely, "the logocentric and a priori aspects" of those "hegemonic Western discourses that invoke universality, scientificity, and objectivity in order to hide cultural plurality, conceal the power-laden play of differences, and preserve hierarchical class, gender, [and] racial . . . relations" (West 18; see also Christian). Such a realism can be found, I think, in much Afro-American fiction and drama, from Toni Morrison's *Sula* and Alice Walker's *The Color Purple* back to Richard Wright's *Native Son* and beyond—back to "lives" like Douglass's, with its account of struggle for the most basic tools of literacy and therefore for fundamental rights to political and cultural representation.

As Baker notes, the question of authenticity has been central to Afro-American culture from the beginning. Until recently, from the perspective of the dominant white culture, black literacy and therefore literature were at best paradoxically surprising, at worst absurd or impossible except as "mimickry." From the perspec-tive of Afro-Americans themselves, authentic blackness has often seemed to exist

beyond the confines of the written word, in oral traditions, and also beyond the confines of America, in Africa. For both the black and the white literary critic, therefore, "the voice of the unwritten self, once it is subjected to the linguistic codes, literary conventions, and audience expectations of a literate population, is perhaps never again the authentic voice of black American slavery. It is, rather, the voice of a self transformed by an autobiographical act into a sharer in the general public discourse about slavery" (Baker, *Journey* 43).

Afro-American identity has thus been inevitably double, divided—both "African" and "American." The extremes have ranged from militant Black Nationalism (Marcus Garvey, Malcolm X) to various forms of assimilationism (integration as the goal of the civil rights movement) to right-wing "Uncle Tomism" (Blacks for Reagan and for Bush). But the common experience for black writers and intellectuals has been the torn, uncertain one of Ellison's Invisible Man or of Alice Walker's and Toni Morrison's heroines. Yet this very dividedness spans the world—is emblematic of the entire history of domination and resistance, imperialism and revolution—"modernization," standardization, and "world system" on the one hand and the search for "roots," "difference," and cultural identity on the other. These have been the general coordinates of majority human history from the (Eurocentric) Renaissance forward.

"Minority" Voices from "Other" Worlds

In *Nobody Knows My Name*, James Baldwin remarked that the gradual liberation of Africa from western imperialism after World War II and the gradual strengthening of Afro-American cultural identity went hand in hand. The civil rights movement in the U.S. and decolonization abroad were correlative developments:

> The power of the white world to control [nonwhite] identities was crumbling . . . Africa was on the stage of history. This could not but have an extraordinary effect on [Afro-Americans'] morale, for it meant that they were not merely the descendants of slaves in a white, Protestant, and puritan country: they were also related to kings and princes in an ancestral homeland, far away. And this has proved to be a great antidote to the poison of self-hatred. (81)

Earlier in the same volume, Baldwin records his experience at the 1956 Paris Conference of Negro-African Writers and Artists. The chief question for all of the participants was whether westernized blacks, the descendants of slaves, shared a cultural heritage or parts of one with Africans. Defining "culture" is difficult under any circumstances, Baldwin says, but "in the context of the conference, it was a question which was helplessly at the mercy of another one. And the second question was this: Is it possible to describe as a culture what may simply be, after

all, a history of oppression?" (28). The same question has been asked by and about other oppressed groups—workers, women, and imperialized peoples around the world. Catherine Stimpson, for instance, wonders whether feminists can "have communal ties other than a joy in opposition?" (241) What Afro-American writers like Baldwin and Richard Wright seemed to share with their African counterparts "was their precarious, their unutterably painful relation to the white world. What they held in common was the necessity to remake the world in their own image . . . and no longer be controlled by the vision of the world, and of themselves, held by other people. What, in sum, black men [sic] held in common was their ache to come into the world as men. And this ache united people who might otherwise have been divided as to what a man should be" (Baldwin 29).

As Frederick Douglass's *Narrative* makes clear, however, this very "ache" for full identity and therefore for full cultural representation has been the chief source of cultural creativity—or at least, of all culture that is growing, liberating, and not already entombed in traditions, canons, museums, and academic disciplines. It was just such an ache or desire that energized the romantic nationalisms of the late-eighteenth and nineteenth centuries (including the search for national identity that is a central theme of "classic American literature") and that continues to energize "Third World" rebellions against American and European neoimperialism today. The emancipatory cultural forces stirring and stirred up by these rebellions have so far been only dimly recognized by mostly white, mostly male academics in "the West." Either such academics can continue to ignore world developments and their own increasing isolation and impotence, or they can raise their horizon to the level of the world—to a fully human level. But to do the latter will entail "decolonizing" themselves in fundamental ways, including abandoning the privileged status they have accorded to the western literary tradition. To put it simply, there are other traditions, not equal, nor better or worse, higher or lower, but both human and different.

In British cultural studies, there is now a common recognition that the nineteenth-century establishment of English language and literature as school subjects and the imposition of these as social class and imperialist orthodoxies went hand-in-hand (see, for instance, Batsleer et al. 19–25). Analyzing nineteenth-century British educational policy in India, Gauri Viswanathan demonstrates that the English literature curriculum, with its Arnoldian aim of humanizing the student, was consolidated well before Arnold in the context of an imperialized India. Before Forster's Education Act of 1870, the Greek and Latin classics rather than texts in English were the chief literary fare in schools in Britain. But in the 1820s and 1830s in India, "British administrators discovered an ally in English literature to support them in maintaining control of the natives under the guise of liberal education." Unable to advocate the christianization of India (both because of the strength of Indian religious traditions and because of sectarian conflicts among themselves), the British found a substitute for religious texts in secular literary

texts written in English. The ideas and values in English literary works were, moreover, presented to Indian students "as objective, universal, and rational," in contrast to the supposed backwardness and irrationality of Indian texts and cultures (Viswanathan 95).

The imposition of English language and literature in the Indian context was an obvious ramification of imperialist domination, but what about the British "home" context? In "Broken English," MacCabe writes that the processes which produced "that monolith called English literature" as "an object of study involved the historical subjugation of Ireland, Wales and Scotland to England. I am a citizen of Great Britain but there is no such thing as British literature. There is, of course, English literature. And equally there is Scottish literature, Irish literature, Welsh literature. But in fact it is not equally at all" (MacCabe, *Futures* 10). The history of the spread of English (both the language and literature written in it) has largely been the history of imperialism "at home" as well as abroad. "If the members of the United Kingdom are all nominally British, it is instructive to recall that English as a language has been imposed, often by force, throughout the British Isles. And the peoples of those islands find that along with the imposed language they have acquired a literature to which their relationship is profoundly ambiguous—one need only think of Joyce or [Hugh] McDiarmid to realise exactly how ambiguous" (*Futures* 11).

MacCabe sketches a possible history of "a literature of decolonisation—from Joyce and Yeats to Rushdie and Lessing" (12). This would be a history of "a literature in broken English," but he also indicates that, for him, "breaking" is a positive not negative term, one which should be treated as a near-synonym for creativity in general: "The cultural monolith that was institutionalized in the study of English literature is now broken open as a contradictory set of cultural and historical moments—a past understood not as a tradition to be transmitted but a set of contradictions to be used" (12).

For MacCabe, a pioneering work of literature in "broken English" is *Finnegan's Wake*. MacCabe's description of Joyce as "very much the prototype of the postcolonial artist" (12), moreover, aligns the "broken English" argument with the definition of "minor literature" offered by Gilles Deleuze and Félix Guattari as writing "which a minority constructs within a major language" (Deleuze and Guattari 16). Deleuze and Guattari point to the Irish examples of Joyce and Samuel Beckett, but their main example of the production of "minor literature" by a "minority" author is Kafka. Minor literature, they argue, is marked by three characteristics: "the deterritorialization of language, the connection of the individual to a political immediacy, and the collective assemblage of enunciation" (18). By "deterritorialization" Deleuze and Guattari mean both geographical and cultural dislocation and alienation. Either the "minority," as with Afro-Americans, has been violently uprooted and must speak the language of the dominant majority, or as in both India and Ireland an imported language has been

imposed on majorities who, though practicing various degrees of resistance and linguistic nationalism, must still adopt the alien tongue. The result in minor literature is that the imposed language acts like a sort of "paper money," lacking authenticity—for highly original authors such as Kafka and Joyce, a counterfeit or at least surface language inspiring various creative breakages and deep subversions.

The ideas of alienation and subversion involved in deterritorialization point to the other two characteristics Deleuze and Guattari see in Kafka and Joyce: minor literatures are inevitably political, and they are also collective. Both of these characteristics, however, seem hardly to fit Kafka and Joyce, who distanced themselves in various ways from any active political commitments and any positive sense of collective identity with nation, religion, or culture. Thus, beginning with the theme of "paralysis" in *Dubliners,* Joyce's portrayals of both Catholicism and Irish nationalism are highly negative. And if *The Trial* and *The Castle* are read as either religious or political parables, the results are similarly negative. But Deleuze and Guattari insist that such readings are superficial, missing the deeper subversions at work in minor literatures—subversions operative first of all at the level of language:

> How many people today live in a language that is not their own? Or no longer, or not yet, even know their own and know poorly the major language that they are forced to serve? This is the problem of immigrants, and especially of their children, the problem of minorities, the problem of a minor literature, but also a problem for all of us: how to tear a minor literature away from its own language, allowing it to challenge the language and making it follow a sober revolutionary path? How to become a nomad and an immigrant and a gypsy in relation to one's own language? Kafka answers: steal the baby from its crib, walk the tightrope. (19)

A successful minor literature, Deleuze and Guattari suggest, will operate as revolutionary praxis for a cultural politics aiming at the overthrow of dominant forms of articulation, values, subjection, and subjectivity. Further, "there is nothing that is major or revolutionary except the minor" (26). In other words, minor literature and the discourses of minorities simply *are* the "majority," primary, perhaps only sources of artistic and cultural greatness. Here the justification for choosing seemingly "major," canonized, obviously Eurocentric writers as exemplars of minor literature becomes clear. Deleuze and Guattari want to show that the great texts of literary modernism—texts canonized and revered today in the humanities disciplines—belong to the category of minor literature, and that this minor or minority status was and is the very condition of their originality and greatness. But they also want to show that it is precisely the "minor" characteristics of Kafka's or Joyce's writings—deterritorialization, cul-

tural politics, "collective enunciation"—that are repressed in the canonization process.

Building on Deleuze and Guattari, David Lloyd reconstructs the career of James Clarence Mangan in relation to "the emergence of Irish cultural nationalism" and "minor literature." Lloyd argues that Mangan "anticipates Stephen Dedalus's castigation of Irish art as 'the cracked lookingglass of a servant' " and also "Dedalus's (and Joyce's own) disaffected refusal to affiliate with the nationalist cause" (209). But nationalism, Lloyd contends, is only the "specular opposite" of imperialism and leads, after decolonization, to the reproduction of "the forms of the bourgeois state" and thus to patterns of internal domination (which might be called "neoimperialist" or "late capitalist" subject-formation). Lloyd sees Mangan's own problematic affiliation with nationalism reflected in the "minor" status of his writings, marginalized yet still enclosed within the concentric circles of both empire and emerging nation-state. But "minor literature" even of Mangan's distinctly "minor," fragmentary, inconsistent sort acts, Lloyd contends, like a version of radical deconstruction, challenging the dominant modes "of subjectivity and of representation" (25). Further, Lloyd sees in his Irish examples the possibility that "the emergence of a Third World and post-colonial literature begins to constitute a literature of collectivity for which the canon as an institution and representation as a political and aesthetic norm would be irrelevant" (25).

But it is difficult to see how "representation" can ever be "irrelevant," though certain forms of it can be critiqued, rejected, superseded. "Minor literature" does not necessarily involve radical formal experimentation of the modernist sort, as in the novels of Joyce and Kafka, much less of the fragmentary, contradictory sort Mangan produced. On the contrary, in the works of nineteenth-century Irish novelists such as William Carleton and Samuel Lever, a critique of British domination goes forward through an often satiric social realism whose formal or representational properties seem quite standard and uninteresting (just as they do, for instance, in a novel like *Uncle Tom's Cabin*). The attack on representation as such by Lloyd and other poststructuralist critics seems too sweeping; what needs closer attention is the politics of specific forms and uses of representation.

In any event, in their introduction to the first of two issues of *Cultural Critique* devoted to "the nature and context of minority discourse," Lloyd and Abdul JanMohamed write that being "minor" "is not a question of essence (as the stereotypes of minorities in dominant ideology would want us to believe), but a question of position—a subject-position that can only be defined, in the final analysis, in 'political' terms, that is, in terms of the effects of economic exploitation, political disfranchisement, social manipulation, and ideological domination" (JanMohamed and Lloyd 11). Perhaps the only established academic disciplines relevant to the understanding of "minority" discourses and cultures (that is, ultimately "majority" discourses and cultures) are history and anthropology. The so-called "critical" disciplines—literary, musical, artistic—are so thoroughly

imbued with the "demarcating imperative" that they often seem, after all, to be not much more than repressive mechanisms entrenched in academic institutions (although, as Richard Ohmann says in *English and America*, "Better the MLA than the FBI" [252n]).

Questions about literary and artistic representation, moreover, are underwritten by prior questions about the very possibility of cultural articulation—the freedom and ability to say or write anything at all, or to represent oneself in the most basic (not just "minor") ways. Douglass's white masters tried to keep him from learning to read and write. The debate about whether it was wise (that is, politically safe) to teach the British working class to read and write extended well into the 1830s. "Shakespeare's sister," in Virginia Woolf's story, was foiled in various patriarchal ways from expressing herself, and committed suicide. And in "Can the Subaltern Speak?" Gayatri Spivak examines cases of Hindu widow-burning or *sati* in relation to the politics of representation. "Clearly, if you are poor, black, and female you get it in three ways," she declares (294). And if you are a Hindu widow confronting your own forced immolation, what then? "The subaltern cannot speak" (308), at least not through any official channels, though she may still discover various obscure, nonverbal modes of resistance. Silence and widow-burning, silence and genocide—such silence is a cultural construction, even more thoroughly a function of patterns of domination than the anti-hegemonic relation of "minor literature" to "canons" and "classics." At least, the authors of "minor literature" can speak.

The key to Deleuze and Guattari's theory of minor literature is the idea of subversion from within, the "deterritorialization" or "deconstruction" of "major" forms of cultural domination, articulation, and authority. Artistic creativity and originality spring from resistance, the "joys of opposition" (indeed, Deleuze and Guattari offer, as Réda Bensmaïa puts it in the introduction to their essay, a " 'joyous' reading of Kafka: a *Gaya Scienza* of Kafka's work" [xix]). A similar idea, related to social class hierarchies rather than to patterns of linguistic imperialism and resistance, emerges from Bakhtin's treatment of the "carnivalesque" in *Rabelais and His World* and elsewhere. Both concepts—minor literature and carnivalesque—offer versions of the paradox that "there is nothing . . . major . . . except the minor." Cultural creativity comes from below not above, from the worldly not the transcendent, from the invigorations of labor, sex, rebellion, and "lived experience," not the "higher" learnings and values of priests and academics.

> As opposed to the official feast, one might say that carnival celebrated temporary liberation from the prevailing truth and from the established order; it marked the suspension of all hierarchical rank, privileges, norms, and prohibitions. Carnival was the true feast of time, of becoming, change, and renewal. It was hostile to all that was immortalized and completed. (Bakhtin 10)

Bakhtin's analysis of the carnivalesque from medieval European peasant cultures (or subcultures) through *Gargantua and Pantagruel* has been highly influential in recent studies of working-class and "popular" cultures, as in Peter Stallybrass and Allon White's *The Politics and Poetics of Transgression*. Like carnival, the theory of the carnivalesque itself helps to subvert dominant patterns of thought and value. It offers a "joyous" approach to cultural hierarchies that deconstructs high/low paradigms of cultural and esthetic value. And it opens onto an analysis of the "bourgeois subject" in terms of repressions and negations, the "hysterical" dominant-class need to draw class and cultural boundaries, to differentiate and distance itself from that which is "low," worldly, bodily, popular, common.

> The division of the social into high and low, the polite and the vulgar, simultaneously maps out divisions between the civilized and the grotesque body, between author and hack, between social purity and social hybridization. These divisions . . . cut across the social formation . . . and the body, in such a way that subject identity cannot be considered independently of these domains. The bourgeois subject continuously defined and re-defined itself through the exclusion of what it marked out as "low"—as dirty, repulsive, noisy, contaminating. Yet that very act of exclusion was constitutive of its identity. The low was internalized under the sign of negation and disgust. (Stallybrass and White 191)

These class-based processes of division and exclusion—processes Pierre Bourdieu has also thoroughly anatomized under the sign of "taste" or "distinction"—are fundamental to all forms of cultural domination, from the legal restrictions that began to repress and deterritorialize fairs and carnivals toward the end of the middle ages to the hierarchical patternings of the academic disciplines. The "demarcating imperative" which shapes the "bourgeois subject" also shapes the literary and artistic canons. In relation to dominant cultures, minor literatures are themselves carnivalesque—they subvert from within and below the very patterns of domination, and in so doing tap hidden sources of creativity and freedom.

Meanwhile "difference"—the threat or promise of "the Other"—will continue to be the central organizing category for postmodernist cultural and literary theory. In one direction, ideas about "otherness" lead to theories of the complete incommensurability between cultures and also to complete relativism. In another, they lead to revelations of the universality of basic human needs, desires, and experiences—"human nature," a phrase that at least threatens to collapse historical struggles and differences into a bland, oblivious essentialism disguised as liberal pluralism. In their extreme forms, neither position can be sustained. Only through charting and understanding the ground between these positions—not as a set of authoritarian answers or knowledges, but as a questioning, a dialectic—can the humanities disciplines be genuinely human, engaged and engaging. As I have been arguing, cultural studies works to open sites or spaces where this dialectic can occur.

In the case of Afro-American culture, understanding its "difference" is not so easy as white scholars often assume. Yet it would be both absurd and self-defeating to claim that this "difference" is absolute, or to claim that whiteness and blackness are in some sense indeed polar opposites, or to claim that whites can't understand blacks and vice-versa. Such versions of "difference" fall prey to exactly the sorts of racist, binarist, essentialist thinking which all versions of cultural studies and poststructuralist theory struggle to subvert. As Baker declares:

> if black creativity is the result of a context—of webs of meaning—different in kind and degree from those conceived within the narrow attitudinal categories of white America, it seems possible that the semantic force of black creativity might escape the white critic altogether. And where black American works of literature and verbal art are involved, a case can certainly be made for the cultural specificity of meaning. (*Journey* 154)

Baker's own recommendation of an "anthropological" approach to Afro-American culture is, from this perspective, consistent with the "ethnographic" emphasis of much cultural studies work. Traditional "literary" categories are apt to falsify, to be limited by white privilege and prejudice (the "demarcating imperative") even when they seem to be emanating from a distant classical past or to be hypostatized as transcendent, esthetic universals. But in the realm of culture, as in that of history, there are no absolutes—only someone's culturally specific values masquerading as absolutes. Baker concludes:

> No analyst can understand the black literary text who is not conscious of the semantic levels of black culture. The journey to [this understanding] is by way of the whole discourse comprising black American culture. . . . Seeking to control, sum up, or categorize the black world in phrases drawn from their own peculiar cultural discourse, [white critics] have seldom learned how to converse with the natives of black American culture. In this sense, they have failed to enlarge the American universe of discourse. (163)

But that doesn't mean that blackness is timeless essence; it does mean that it is cultural, both different and human.

"How to converse with the natives" (remembering that we are all "natives") is also the fundamental question in the hermeneutical tradition: how to "come into the circle" in the right way, so as to achieve understanding. This is the central issue confronting all humanities and social science disciplines, although the ordinary meanings of "discipline" point to the authoritarian rather than dialogical, the hierarchical rather than democratic, the elitist rather than egalitarian, and the silencing and exclusionary rather than the questioning and inclusive. Those academics who do not understand Baker's idea of learning "to converse with the natives" have invested their cultural capital in what Paulo Freire calls the "bank-

ing" model of education: I teach, you learn; I know, you don't. At the conclusion of his essay, "The Politics of Silence: The Long March of the Indians," de Certeau quotes the remarks of Francisco Servin to the 1974 Congress of Indians held in Paraguay (*Heterologies* 231). It would be good to have some special punctuation to stress the dialogical nature of this requotation in the present text or, rather, context. At least I can place multiple quotation marks around Servin's statement, like exponential symbols in mathematics. De Certeau doesn't indicate in what language Servin spoke his minor discourse, but my guess would be Spanish. ' " 'We were once the masters of the earth, but since the gringos arrived we have become veritable pariahs We have the hope that the day will come when they realize that we are their roots and that we must grow together like a great tree with its branches and flowers.' " '

5

Mass Culture, Postmodernism, and Theories of Communication

Antirealisms and *Screen* Theory

While for many "minority" writers and artists, social realism—direct, accurate, mimetic representation—remains a formal value, cultural theory and practice of several varieties have challenged "representation" in general as being not just outmoded but the politically charged machinery of bourgeois subjectivity. According to one version of poststructuralist theory, no matter how critical in authorial intent realist fiction and art by their very forms are complicit with the hegemonic forces they may seem to criticize. Realist texts—Wright's *Native Son*, for example—may attack social injustice, but reinforce the structures of the real by treating them as inescapable, without alternative. Thus MacCabe, for example, contends that "the classic realist text . . . cannot deal with the real in its contradictions and that . . . it fixes the subject in a point of view from which everything becomes obvious" (MacCabe, *Theoretical* 44). What is true of the "classic realist text," moreover, is also true of the "classic" realist film: the structural similarities between the third-person omniscient narrators of many realist novels and camera focus and movement in realist cinema are apparent. With George Eliot's *Middlemarch* as illustration, MacCabe works out this parallel in terms of the distinction between "metalanguage"—the narrator's apparently objective voice—and "object language" such as dialogue, letters, and other forms of discourse reported by the metalanguage.

MacCabe is one of several theorists who dealt with the problem of realism in the British journal *Screen* in the 1970s (there are useful accounts in Easthope, Klinger, and also Harvey). In its pages emerged an increasingly sophisticated, forceful critique of "Quattrocento perspective" with its "monocular vision"—the stuff at once of Renaissance painting and of "classical Hollywood cinema." According to Stephen Heath, "The conception of the Quattrocento system is that of a scenographic space . . . set out as spectacle for the eye of the spectator. Eye and knowledge come together; subject, object and the distance of the steady observation that allows one to master the other" (Heath 30). The *illusion* of

mastery and of objective knowledge is one of the key elements in the *Screen* critique of realistic representation (whether in film, the novel, painting, or other media). The realistic narrative or image masks contradictions, including—and here the Althusserian influence on *Screen* is apparent—the contradiction between the *illusion* of the free, unified, rationally knowing bourgeois individual on the one hand, and the "interpellated," thoroughly "subjected" subject of ideology on the other. "What moves in film, finally, is the spectator, immobile in front of the screen. Film is the regulation of that movement, the individual as subject held in a shifting and placing of desire, energy, contradiction, in a perpetual retotalization of the imaginary" (Heath 53).

For MacCabe, Heath, and the other *Screen* theorists, the "cinematic apparatus" is a concentrated version of Althusser's Ideological State Apparatuses. Theirs is a sort of radicalized version of Frankfurt School concern with the massifying properties of mass culture: the very way we "see" the world is, according to this approach, ideological. Applying what Foucault has to say in *Discipline and Punish* about "panopticism" as fundamental to both bourgeois liberalism and the social sciences, one might say that cinema and its near relative television are both high-powered instruments of social control, "watching" (in the sense of "interpellating" or, to use the Lacanian term that crops up frequently in *Screen,* "suturing") spectators into certain attitudes, illusions, and "subject positions" even while those spectators believe they are freely "watching" the image-flows and patterns before them. *Screen* theory says, in effect, that the spectacle creates the spectator, and not vice-versa. Mass culture interpellates the masses, the ultimate commodity, as audiences of passive consumers.

Screen theory applies Althusser's concept of ideology to cinematic discourse in a way that emphasizes the Lacanian influence underlying that concept. A fusion of structuralist Marxism with Lacanian psychoanalysis is the basic formula at work in the writings of MacCabe, Heath, and Laura Mulvey, who gives the theory a powerful feminist dimension in her well-known essay, "Visual Pleasure and Narrative Cinema." Anthony Easthope explains:

> *Screen*'s analysis draws several implications from the Lacanian conception of subjectivity. One is that the subject does not exist outside or prior to discourse but is constituted as an effect within discourse through a particular stitching together or suturing of imaginary and symbolic. Another is that since there can be no signified without a signifier, there can be no imaginary coherence for the subject without an operation of the signifier in the symbolic to bring about that coherence. And a third is that a textual institution such as classic realism works to disavow the signifier, so producing a position of imaginary coherence in and for the reader by means of the various strategies through which the signifier is disclaimed. This corresponds to Althusser's understanding of ideology as producing submissive subjects, subjects who submit precisely in misrecognising their subordination as freedom. Much of subsequent work in *Screen* is devoted

to analysing these textual strategies in detail and to bringing the project into closer connection with the politics of feminism. . . . (Easthope 42)

In cinematic as in novelistic discourse, according to *Screen* theory, realism operates as a form of fetishism, corresponding to the commodification of the novel and of film. That which seems most opposed to illusion or the fantastic—namely, mimetic representation—is from this perspective all the more illusory and powerful because it masks as truth its fetishized condition. For the *Screen* theorists, the key point is that the structural properties of mimetic representation are a primary form of ideology and, indeed, through the concept of "suturing" these properties can be seen to be identical to bourgeois subjectivity itself (Harvey 34). There is no stance for the individual outside ideology (which in relation to cinema also means outside mass culture), in effect because the individual is the product of ideology.

But here *Screen* theory threatens to bypass older theories about the critical, demystifying potential of certain kinds of realism, as in Georg Lukács writings about the nineteenth-century novel (see Lovell). MacCabe says that "moments of subversion and strategies of subversion" are possible within "classic" realist texts (whether prose fiction or film), though he also thinks that such strategies cannot touch the deeper structural difficulties inherent in all versions of realism. These difficulties can be summed up as the naive positing of a knowing subject (author-reader) to whom "truth" or "reality" is accessible in an "objective," "rational," and therefore also absolutistic and "reactionary" way. According to MacCabe, a truly "revolutionary" artform can only arise from the rejection of the very category of the "subject," since "the sub-ject—that which underlies experience—is a production, very largely, of modern European philosophy from Descartes to its most sophisticated articulation in the philosophers of German Idealism" (52).

Of course to call the "subject" a "production . . . of . . . philosophy" attributes great power to the most theoretical forms of ideas ("philosophy"), a formulation MacCabe probably does not intend—rather, both the actual "subject" and its reflection or representation in philosophical texts from Descartes forward are "productions" of—to carry out the thread of causal logic left in this phrasing—a set of "material," historical, class relations, a "mode of production." Marx, MacCabe thinks, did not interrogate the category of the subject thoroughly enough, otherwise he might have realized that the subject is precisely that which bourgeois ideology—and philosophy—is most concerned to affirm and repro-duce. But *Screen* theory itself, as Easthope points out, represents a powerful merging of Marxism with poststructuralism, focused on the deconstruction of "the sovereignty of the individual" and therefore of bourgeois individualism (Easthope xiii). As "historical materialism," however, Marxism cannot be easily merged with those forms of poststructuralism which attack historicism and mi-

metic representation. The writings of Marx and Engels themselves often take the shape of documentary social realism, as in Engels's *Condition of the Working Class in England in 1844*. Engels's *Condition* is as "panoptical" as anything written by Jeremy Bentham or John Stuart Mill, yet its politics are obviously very different from theirs. And it uses the panoptical perspective—Engels's narrative persona as knowing subject, like the omniscient narrator of *Middlemarch*—to mount its "revolutionary" attack on capitalism and bourgeois ideology.

As Raymond Williams contended, "we must . . . distinguish between authentic naturalism and the more general movement of bourgeois physical representation" (*Sociology* 170). The same set of rhetorical, novelistic, or cinematic conventions can have "active and passive," critical and mystifying uses.

> . . . authentic naturalism was always a critical movement, in which the relations between men [sic] and their environments were not merely represented but actively explored. Indeed, though in its period it is quite evidently a bourgeois form, it is also, on its record, part of the critical and self-critical wing of the bourgeoisie. In Ibsen and Zola, early Strindberg and Chekhov, O'Casey and O'Neill, it accepted the deep convention of significant . . . relations between men and their living or working environments, but commonly as the literal staging of the radical questions: how do we, how can we, how should we live in this specifically tangible place and way of life? (Williams, *Sociology* 170).

Quoting Williams's remarks in his recent book *Acting in the Cinema* (200–1), James Naremore makes the same point in relation to such films as *On the Waterfront* (1954) and *Saturday Night and Sunday Morning* (1960): "the emphasis on naturalism preceded the talkies, growing at least partly out of a democratic, socially progressive impulse" (Naremore 48). And Naremore cites Brecht as pointing out that while "naturalistic representation . . . disguises the workings of ideology . . . certain kinds of naturalistic expression are important to a committed theatre" (49).

Brecht did not just advocate the famous *Verfremsdungs* or "alienation effect"; he advocated an "estranging" practice that was also a version of "realism," a way of getting at the truth about ideology and social injustice that couldn't be gained either from a passive sort of realism or from the forms of the purely fantastic. Among other things, Naremore has in mind Brecht's essay, "The Popular and the Realistic," which is worth quoting before going on to examine various threatened liquidations of "realism" and "the real" in postmodernist cultural theories. Brecht says, first of all, that "the words *Popularity* and *Realism* . . . are natural companions." The people need realism; the people are realistic; realistic forms of narrative are more apt to be popular than those based on more abstruse, difficult, rarefied esthetic theories. (It is difficult to imagine a genuinely popular film or novel based on *Screen* ideas about the formal characteristics of

revolutionary artforms, though the films of Jean-Luc Godard and other radical directors aim in that direction.) In any event, realism for Brecht would seem to be a category similar to Gramscian common sense—ideological, but with potential for critical enlightenment.

> It is in the interest of the people, the broad working masses, that literature should give them truthful representations of life; and truthful representations of life are in fact only of use to the broad working masses, the people; so that they have to be suggestive and intelligible to them, i.e. popular. None the less these conceptions need a thorough clean-up before being thrown into sentences where they will get smelted and put to use. . . . (Brecht 107)

Brecht interrogates conservative uses of both terms, both "popularity" and "realism," before offering his own radical definitions. With respect to realism, he points out that "reality alters; to represent it the means of representation must alter too" (110). And he also says that "history offers many widely varying examples" of "realist writing," which like industrial power "is likewise conditioned by the question of how, when and for what class it is made use of" (109). Again, the same esthetic conventions can have vastly different ideological uses and meanings.

> Our conception of *realism* needs to be broad and political, free from aesthetic restrictions and independent of convention. *Realist* means: laying bare society's causal network / showing up the dominant viewpoint as the viewpoint of the dominators / writing from the standpoint of the class which has prepared the broadest solutions for the most pressing problems afflicting human society / emphasizing the dynamics of development / concrete and so as to encourage abstraction. (Brecht 109)

Could it be that, within the framework of Brecht's definition, *Screen* theory and other forms of radical poststructuralism are themselves "realisms"? If one accepts the alignment of poststructuralism with historical materialism, the answer is yes. But there is little or nothing "popular" about poststructuralist *theory,* at least, while there is a danger that the turn to questions about *mass* culture (film, television, advertising) in recent theoretical discourse may only increase the distance between theorist and "the masses"—real people, "lived experience," "the practice of everyday life."

Death of the Modern

The death-of-the-subject theme in poststructuralism (e.g., in *Screen* theory) is merely negative unless what is substituted for the *individual* subject or "ego" is the *social* subject or "community," to use one of Williams's favorite keywords.

According to this theme, we have indeed entered a postmodern era in which "the subject" as (potentially) rational individual can no longer be affirmed either as axiomatic or as that from which all theory and knowledge emanate and to which these return according to individualistic author-reader, speaker-hearer, or teacher-student paradigms. But the difficult question then becomes whether reason, if not the exclusive property of individuals, is instead an attribute, function, or outcome of society or history. Given the irrational regressions society has experienced in this "modern," supposedly progressive century, such a question seems to entail a naive return to some version of Hegelian idealism, according to which history is ultimately rational and progress inevitable. But, if one assumes that knowledge and reason are in some sense possible (an assumption poststructuralisms obviously challenge), then it is also possible to ask how reason and knowledge are *socially* constituted? and to distinguish this question from the individualistic formulation: how does the isolated "ego" or "subject" arrive at "the truth"? To suggest that reason and knowledge *are* socially constituted is clearly very different from claiming that they are merely the illusions of individual desire, forever slipping away down "the phantom relay of the signifying chain" (Holquist 165).

Deconstructions of the supposedly rational "bourgeois subject" can lead either to anarchism (with two seemingly opposite poles of either celebration or nihilism), or to attempts to understand the complex, social constitution of reason—and therefore also to understand the at least potential fulfillment of what Habermas calls "the project of modernity" or Enlightenment. Around these two poles have now gathered the main lines of force of what—despite Habermas's conviction of the continuity of "modernism"—is now commonly called "postmodernist" cultural theory. As Albrecht Wellmer, Fred Dallmayer, and others besides Habermas have argued, the way beyond the contradiction between the supposedly rational, meaning-endowing individual and the dissolution of "the subject" (starting with Freud and Nietzsche and leading to structuralism and deconstruction) lies in "a communicative praxis, which, because it is constitutive of the life of linguistic meaning, cannot be reduced *either* to the expression of a *self-preserving or* of a *meaning constituting* subjectivity" (Wellmer 350). Nor can "the subject" be reduced to "the autonomy of discourse or of linguistic meaning" (Wellmer 350). Again, as with Bakhtin/Volosinov, both meaning and subjectivity are the productions neither of some transcendent absolute nor of individuals. Rather, these emanate from "communicative praxis"—in its simplest form, speech acts, which are always and irreducibly social relations.

"Social semiotics" would thus seem to be an appropriate label for that "science" which can most accurately explain the nature and production of the forms of knowledge (see Hodge and Kress, and compare Brenkman's "critical hermeneutics"). But this means that all knowledge is political—that is, ideological—which again raises the question of whether one ideological position can be "truer" than another, or whether all are inevitably "false." Ernst Bloch and Paul Ricoeur offer

the hopeful—that is, utopian—argument that ideology defends the status quo, whereas truth is always grounded upon or oriented toward a utopia. The extreme negative answers to this question, on the other hand, come from deconstruction and from some currently fashionable versions of postmodernist theory influenced by deconstruction, as for example in Jean-François Lyotard's argument that representational "metanarratives" are dead and that semiotics has now dissolved into a merely libidinal "energetics." Ihab Hassan sums up this position when he writes that postmodernity

> is an antinomian moment that assumes a vast unmaking in the Western mind— what Michel Foucault might call a postmodern *episteme*. I say 'unmaking' though other terms are now *de rigueur:* for instance, deconstruction, decentering, disappearance, dissemination, demystification, discontinuity, *difference,* dispersion, etc. Such terms express an ontological rejection of the traditional full subject, the *cogito* of western philosophy. They express, too, an epistemological obsession with fragments or fractures, and a corresponding ideological commitment to minorities in politics, sex and language. To think well, to feel well, to act well, to read well, according to this *episteme* of unmaking, is to refuse the tyranny of wholes; totalization in any human endeavour is potentially totalitarian. (Hassan 55–56)

Such a postmodernist position seems to lead to some version of radical anarchism (itself highly "energistic"), but it can just as easily be stripped of its avant-garde appearance to reveal a position according to which the "society of the spectacle" produced by "late capitalism" seems both right and inevitable. With a bit of skeptical examination, in other words, "postmodernism, as the dissolution of semiotics into 'energetics,' becomes indistinguishable from behaviourism"— a functionalist positivism that, no matter how radical it sounds, involves an implicit affirmation of the status quo (Wellmer 340). According to moderate versions of postmodernist theory, the religious, Hegelian, Marxist, historicist "metanarratives" which once seemed to sum up and explain all social experience must give way to relative, partial, "local" truths, perhaps best expressed in "fragments," "evocations," "minimalist" fictions, and Nietzschean aphorisms (though even these may seem suspiciously authoritarian). According to extreme versions, "the postmodern moment is a kind of explosion of the modern episteme, in which reason and its subject—as source of 'unity' and of the 'whole'—are blown to pieces" (Wellmer 338). Truth is now radically inaccessible rather than merely relative, and questions of the accuracy or inaccuracy of particular representations are beside the point, since representation as such is in ruins.

Perhaps the most influential proponent of the extreme postmodernist position is Jean Baudrillard, for whom modernity itself—starting with Marx or, even better, Adam Smith—is "the crisis of representation" and therefore also of both

meaning and value (Baudrillard, *Writings* 145). In his first essays, Baudrillard offered what appeared to be a semiological reversal of Marxist theory, with its emphases on production through labor and historical materialism. Like Althusser, Williams, and many other "western Marxists" today, Baudrillard rejects the economic base/cultural superstructures paradigm. For him, at least in the most developed forms of capitalism, the old political economy distinctions between "economy and signification" (or culture), production and consumption, "reality" and "simulation" have collapsed. "Ideology can no longer be understood as an infrastructural-superstructural relation between a material production (system and relations of production) and a production of signs (culture, etc.), which expresses and masks the contradictions at the 'base' " (*Writings* 76). Just as Marx accepted Feuerbach's critique of religion as "basically completed" and moved on to the critique of political economy, so Baudrillard asserts that this latter stage is now completed and must be superseded by an *Aufhebung* to "the level . . . of symbolic exchange and its theory" (*Writings* 116). Indeed, in the world of advanced capitalism or postmodern society, there is nothing but "symbolic exchange" or the endless circulation of signs—signs moreover which have lost all signifying capacity, all meaning in the traditional sense of the representation of the real.

For Baudrillard, "Reality itself [now] founders in hyperrealism, the meticulous reduplication of the real, preferably through another, reproductive medium, such as photography. From medium to medium, the real is volatilized, becoming an allegory of death" (145). Today reality is only that which can be represented or reproduced as reality, in the now global realm of "simulation." To put this idea slightly differently, representation today, especially through the mass media of film and television, no longer represents anything external to itself, but only "the hyperreal," which is unrepresentable:

> Hyperrealism is . . . beyond representation because it functions within the realm of simulation. There, the whirligig of representation goes mad, but with an implosive insanity which, far from being ex-centric, casts longing eyes at the center, toward its own repetition *en abîme*. (*Writings* 146)

Baudrillard takes the most "radical" conclusions of Derridean deconstruction—the shorthand version: representation of the real is impossible—and applies them to politics and economics, including Marxism. While, like many recent theorists, he seems to be moving beyond Marxism to something even more radical—perhaps a postMarxist, postmodernist libidinal anarchism or "energetics"—he begins from a thoroughgoing analysis of "commodity fetishism" as ideology, in which in a sense he carries to their logical conclusion themes already present in Marx. Thus as Baudrillard points out, Marx already understood the commodity as having a symbolic or representational aspect (exchange value). But Baudrillard claims that it has nothing but symbolic power because Marx's antithesis to

exchange value—use value, with its dual reflections of labor and objective "needs"—is merely the dream of a pre-linguistic origin that has always haunted western metaphysics. So Baudrillard points out that Marx uncritically accepts much of the Crusoe "myth," which is "the bourgeois avatar of the myth of terrestrial paradise" (*Writings* 74). In *The Political Economy of the Sign,* moreover, Baudrillard asks: "But if Crusoe's relations to his labor and his wealth are so 'clear,' as Marx insists, what on earth has Friday got to do with this set-up?" (*Writings* 75). Jennifer Wicke asks a similar question of Baudrillard, however, in her brilliant analysis of what Baudrillard ignores or represses—especially the actual labor that produces the machinery that produces the illusions of hyperreality (see Wicke).

Baudrillard argues that production is no longer based on labor and consumption is no longer based on needs—at least not in their unexamined state as still offered by much Marxist as well as bourgeois economic theory. "Today consumption— if this term has a meaning other than that given it by vulgar economics—defines precisely *the stage where the commodity is immediately produced as a sign, as sign value, and where signs (culture) are produced as commodities*" (*Writings* 80). Just as Lacan says that "the unconscious is structured like a language," so Baudrillard says that the economy is structured like a language. "It is because *the structure of the sign is at the very heart of the commodity form* that the commodity can take on, immediately, the effect of signification: not epiphenomenally, in excess of itself, as 'message' or connotation, but because its very form establishes it as a total *medium*, as a *system of communication* administering all social exchange" (*Writings* 79). Ideology, culture, representation are here all absorbed into the "total medium" of communication of the commodity. From such a position, it is an easy step to the assertion that *all* communication, *all* culture in postmodern society is mass cultural "simulation," and that behind or beneath the uniformly commodified appearances of billboards, television screens, shopping malls, Disneyland and Hollywood there is no longer (if there ever was) any hidden reality. "Today, reality itself is hyperrealistic" (*Writings* 170), and the world outside Disneyland is even less real (though the very phrase "less real" is necessarily illogical by this logic) than the "simulated," "infantile" world inside: "Disneyland is presented as imaginary in order to make us believe that the rest is real" (*Writings* 172).

Baudrillard's world of hyperreality and "simulacra" is the illusory future and the future-as-illusion described in Stanislaw Lem's *Futurological Congress,* in which the hero is plunged into a psychedelic dystopia (presented at first, as in many dystopias, as utopia), in which it seems impossible any longer to distinguish between appearance and reality, hallucination and truth, superstructure and base. The "crisis of representation" breaks down such supposedly simplistic binary oppositions. Out of the rubble of all past traditions based on such oppositions ("western metaphysics," "high" as opposed to "mass" culture, "realism" and

"representation," etc.), rise the gleaming façades of the postmodern cityscape, characterized by a new, frightening-euphoric "depthlessness" or "superficiality," in the face of which "critical distance" and therefore critique collapse. Against the models of "depth" interpretation and "the hermeneutics of suspicion"— Marxism, Freudianism, Nietzschean deconstruction itself—that have both characterized intellectual modernism and caused its continuous crisis, postmodernism offers only "a new kind of flatness or depthlessness, a new kind of superficiality in the most literal sense—perhaps the supreme formal feature of all" versions of postmodernism, including the versions of poststructuralist theory (Baudrillard's prominent among them) which seem to be simultaneously forms of critique and celebration (Jameson, "Postmodernism" 60).

Given Baudrillard's central thesis of the collapse of representation and therefore of access to "the real," postmodernist theory itself cannot be distinguished from one more "simulation": theory itself becomes just another commodity, an effect— or side-effect—of the ceaseless circulation of signs without referents, superstructural "effects" without base, that constitutes both mass culture and the life (assuming that they/we still have any) of "the masses." As Jameson puts it in his influential essay on postmodernism, "what is today called contemporary theory— or better still, theoretical discourse—is also . . . itself very precisely a postmodernist phenomenon" (61). Baudrillard seems to follow the same trajectory as his mentor, Marshall McLuhan, from critic of commercialized mass culture to one of its celebrants and high priests, even though he can also be seen as offering a pessimistic inversion of McLuhanism (see Kellner). In any event, as Jameson contends, it would be "inconsistent to defend the truth" of the "theoretical insights" of Baudrillard and similar postmodernists "in a situation in which the very concept of 'truth' itself is part of the metaphysical baggage" they are seeking "to abandon." Nevertheless, "the poststructuralist critique of the hermeneutic, of . . . the depth model" of cultural and historical interpretation, "is useful . . . as a very significant symptom of the very postmodernist culture which is our subject here" ("Postmodernism" 61).

Jameson's own analysis of postmodernism does not lead him to abandon the older forms of Marxist and Freudian explanation—historicism, "the depth model"—but instead to relate the crisis of representation to "the cultural logic of late capitalism" in a manner obviously different from Baudrillard's. Critique as historical analysis maintains its position for Jameson as the necessary other or outside of the postmodern circulation of signs. In a situation which Andreas Huyssen describes as characterized especially by the collapse of the older "modernist" dichotomy between "high" and "mass" culture, Jameson seeks to salvage at least history and Marxist/Freudian theory from the ruins. As an absolute minimum, he thinks, some version of the " 'semi-autonomy' of the cultural sphere"—some esthetic/critical "distance"—must be defended against the destructive force of "late capitalism," threatening the complete reification of all

forms of culture—the ultimate triumph of commodity fetishism through mindless consumerism and the death of the once rational or at least potentially rational subject.

> No theory of cultural politics current on the Left today has been able to do without one notion or another of a certain minimal aesthetic distance, of the possibility of the positioning of the cultural act outside the massive Being of capital, which then serves as an Archimedean point from which to assault this last. What the burden of our preceding demonstration suggests, however, is that distance in general (including "critical distance" in particular) has very precisely been abolished in the new space of postmodernism. (Jameson, "Postmodernism" 87)

Against this ultimate cooptation of theory—the idea of poststructuralist "critique," whether Derridean or Baudrillardian, as itself finally not critique at all but "simulacrum," the latest hot commodity on the theory market—Jameson at the end of his essay offers a tentative "model of political culture appropriate to our own situation" based on the notion of the "cognitive mapping" of urban "hyperspace." Drawing on Kevin Lynch's work on urban topography, Jameson argues that "disalienation" in the postmodern as in the "traditional city" might involve a "practical reconquest of a sense of place" through the "construction or reconstruction of an articulated ensemble which can be retained in memory and which the individual subject can map and remap" (89). But it is difficult to see how this notion of "cognitive mapping" is any different from other forms of social representation and "knowing one's place," both in the sense of ideology and in the sense of rational critique. Jameson claims that a "cognitive map is not exactly mimetic," yet he also hesitates to claim that it completely escapes from the poststructuralist attacks on "the ideology of representation."

Jameson seems to want to have it both ways—both to retain the old "depth model" involved in the very notion of "truth" through representation and rational critique, and to acknowledge the force of the poststructuralist assault on reason and representation. His "cognitive mapping" solution seems only to substitute a set of spatial metaphors for older ideas of reason and representation drawn from Marxism and psychoanalysis. His solution, in short, is not nearly so strong as his diagnosis. "Cognitive mapping" emerges as just another name for rational, critical knowledge, which Jameson has all along been insisting (if only implicitly, through his own strongly rational and historicist practice) *can* represent what he claims is today *un*representable, namely the "multinational" capitalist "world system" which has produced postmodernism and the crisis of representation. But once the full force of Jameson's underlying, axiomatic terms—reason, history, critical representation—is readmitted to the debate about postmodernism, then it seems likely that a new theory of knowledge, based on "communication" and the

"dialogical"—that is, on the social coordinates of all knowledge and ideology—may open more fully the mystified and mystifying terrain of postmodernism to the very sort of "cognitive mapping" Jameson strives to achieve. In short, "cognitive mapping" is at best only a metaphor for a postmodern theory of communication that would make a critical cultural politics viable, at once deconstructive *and* reconstructive.

The New Subject (or Subject of the New): Mass Culture

Despite its "postmodern" currency or fashionability, Baudrillard's theory of simulations and the hyperreal echoes some older themes in relation to mass society and culture. For one thing, it offers a revamped version of the technological determinism in McLuhan, according to which the most important actors (or causes) now on the stage of history are the communications media. Baudrillard opposes McLuhan's optimism but also Hans Magnus Enzensberger's attempt from a Marxist point of view to see in the mass media at least the potential for a future democratic enlightenment. "What characterizes the mass media," Baudrillard declares, "is that they are opposed to mediation, intransitive, that they fabricate noncommunication—if one accepts the definition of communication as an exchange, as the reciprocal space of speech and response, and thus of *responsibility*" (*Writings* 207). Furthermore, Baudrillard sees "the masses" (along with the supposedly whole, rational, individual "subject") as merely a function of the media, what the media themselves produce—in one familiar version, as audiences to sell to advertisers.

There can be no politics focused on the masses—no goal of general demystification and liberation—if the masses are seen as one more fetishized commodity, the ultimate "simulation" produced by the media. Baudrillard's *In the Shadow of the Silent Majorities* defines the masses as "the end of the social," the "black box of every referential, of every uncaptured meaning, of impossible history, of untraceable systems of representation" (*Shadow* 6).

> . . . the masses function as a gigantic black hole which inexorably inflects, bends and distorts all energy and light radiation approaching it: an implosive sphere, in which the curvature of spaces accelerates, in which all dimensions curve back on themselves and "involve" to the point of annihilation, leaving in their stead only a sphere of potential engulfment. (*Shadow* 9)

Here the masses, as "the abyss of meaning," have not even the active albeit destructive capacity attributed to them in traditionally pessimistic and usually profoundly anti-democratic theories of mass society. In *The Revolt of the Masses*, for example, José Ortega y Gasset granted the masses a genuinely active role in

history, even though that role (he thought) could only be destructive (for a survey of such theories, see Brantlinger, *Bread and Circuses*).

This is not to say that Baudrillard is opposed to "the masses" in the same elitist way as Ortega (or, before him, Nietzsche). He considers himself and the rest of us inevitably to belong to the masses. But he also insists that the masses mean the end of history, the end of representation, the end of culture, even more thoroughly and hopelessly than Ortega thought them/us to be: for Baudrillard, the only escape from the false nirvana of consumer society lies in the death instinct. Yet Baudrillard is never without an ironic glimmer of hope: a sort of salvation of the masses is present already in their "silence," their refusal of "meaning." Against the various theorists, whether conservative, liberal, or Marxist, who have insisted on some version of high culture or enlightenment as a means of saving the masses—and history—from the abyss of meaninglessness and, perhaps, ultimate annihilation, Baudrillard declares that "the masses scandalously resist this imperative of rational communication. They are given meaning: they want spectacle" (*Shadow* 10).

There are two ways to take Baudrillard's definition of the masses as the refusal of meaning. On the one hand, one can interpret it as the poststructuralist extension of earlier "revolt of the masses" theories like Ortega's. On the other, cheering from the sidelines or the grandstand, one can interpret it as itself an (ironic?) affirmation of the "democratic" status quo, capitalism triumphant, in which football is as valid—or invalid, there is no longer any way to tell—as any version of high cultural meaning or value, just as Jeremy Bentham said that pushpin was as valuable as poetry if both gave the same pleasure. Baudrillard is capable of writing, Ortega-like, that "the mass is dumb like beasts, and its silence is equal to the silence of beasts" (*Shadow* 28). But he reinvests a clearly positive significance in the masses when he constructs their "silence" as "resistance":

> The emergence of silent majorities must be located within the entire cycle of historical resistance to the social. Resistance to work of course, but also resistance to medicine, resistance to shooling, resistance to security, resistance to information. Official history only records the uninterrupted progress of the social, relegating to the obscurity reserved for former cultures, as barbarous relics, everything not coinciding with this glorious advent. In fact, contrary to what one might believe (that the social has definitely won, that its movement is irreversible, that consensus *upon* the social is total), resistance to the social in all its forms has progressed *even more rapidly than the social*. (*Shadow* 41)

Whatever one thinks of such an argument, it at least has the virtue of capturing the contrary positions into which most contemporary theories of mass culture arrange themselves. At one pole, the mass media and mass culture are conceived as "monologic" and anti-democratic, "interpellating" the masses in the strong

sense intended by Althusser: the "subject" becomes the product (or even the mere identity-effect) of the "apparatus." According to some versions, mass culture, at least in its commodified, "late capitalist" form, is monolithically ideological, Althusser's "Ideology" triumphant, now itself seen as the sole agent or "Subject" of history. According to others, mass culture is at best only incompletely ideological—it operates instead more like a sieve than like a machinist's mold or stamp-press: "all systems leak," as the linguist Edward Sapir once wrote, and through the system or perhaps a-system (anarchy) of mass culture leak all possible meanings and values. Mass culture is thus conceived not as a monolith enforcing what Baudrillard calls "hyperconformity," but (at most) as a set of limits within which all sorts of "resistances" are not only possible but ironically inevitable.

Much recent work on the mass media and mass culture seems to move contradictorily in both directions. Treatments of MTV, for example, see it as exemplifying, in extreme fashion, the postmodernist conflict between resistance and ideology, nonconformity and commodification, the avant-garde fragmentation of "the subject" and its ultimate "suturing" into the interstices of late capitalism (see Grossberg, for instance). On the one hand, the monolithic brainwashing of Ideology; on the other, continuous, albeit "micropolitical" forms of resistance. These tendencies lead at times to attempts to distinguish between "mass" and "popular" culture, as when John Fiske argues that mass culture is the basically ideological, commercialized fare offered by the mass media, while popular culture is the various, resistant "meanings" or "poaching" raids people make on that culture, constructing their own values and interpretations out of what is, finally, more sieve-like than monolithic (see Fiske, *Television*). According to this distinction between the mass and the popular, similar in its logic to reader response theory in literary criticism, the mass media and the other "disciplinary" institutions which make up the realm of the "social" (Althusser's RSA and ISAs) try to but cannot wholly capture or control the sense or nonsense people make out of their commodified and therefore semi-incoherent messages.

In the British tradition, the Althusserian moment, with its assertion of the complete determination of "the subject" by "Ideology," perhaps reached its apogee in *Screen* theory. But the cultural studies movement as a whole is even more thoroughly indebted to Williams, Thompson, and Hoggart, with their claims that the "popular" is never completely under the control of the "mass" institutions of capitalist society. If one position can be accused (as Thompson accuses Althusser) of Stalinism, the other can be accused of populism or even of liberal pluralism, somewhat radicalized. The conflict between these positions is visible, for example, in the work of Stuart Hall, as in his essays "Encoding/Decoding" and "Notes toward Deconstructing the 'Popular.' " Hall wants both to acknowledge the power of the mass media to shape and enforce ideology, and the power of "the people" to resist ideology. The same difficulty is evident in Thompson's *Making of the English Working Class* and in the "subcultures" work of the

Birmingham Centre. Thus Dick Hebdige's *Subculture* offers rock music "styles" both as forms of resistance or "refusal" and as forms of at least semi-ideological commercialization.

But perhaps these contradictions are after all "real"—that is, perhaps the theories (including Baudrillard's) which capture these contradictions offer significant expressions of the historical and social contradictions we are now experiencing. While it seems to make little sense to valorize either the "popular" or the "silence of majorities" as a realm of rebellion which is not only capable of resisting Ideology but of ultimately overthrowing it, it also seems to make little sense to construct the category of mass culture as a "black hole" or "abyss" against which all resistance is impossible (much less, as in Baudrillard, as the very category of resistance). The potential either for progress (even in a utopian, revolutionary sense) or for regression (even in the worst, totalitarian sense) is everywhere present and now hangs in the balance, in part in relation to what sense and use we make of the mass media (which in the last analysis, *we* "the masses" make).

In "Constituents of a Theory of the Media," Enzensberger writes that "with a single great exception, that of Walter Benjamin, Marxists have not understood the consciousness industry and have been aware only of its bourgeois-capitalist darkside and not of its socialist possibilities." Among recent theorists, perhaps Williams and Habermas come closest to countering Enzensberger's criticism. Both reject treatments of communications and the mass media as merely the superstructural spin-offs of modern capitalism, or even as merely the generators of that ideology which serves to mask exploitation by hiding production behind a highly inequitable system of consumption. Rather, Williams and Habermas find in the idea of communication itself an emancipatory *potential,* but without the simplistic optimism associated with McLuhan's technological determinism. The history of technologies and institutions of communication is for both first and foremost a history of the major economic and political struggles of modern times. But that history also opens up at least local sites of utopian possibility and occasional fulfillment. In "Means of Communication as Means of Production," Williams writes: "It is in this perspective that we can reasonably and practically achieve Marx's sense of communism as 'the production of the very form of communication,' in which, with the ending of the division of labour within the mode of production of communication itself, individuals would speak '*as* individuals,' as integral human beings" (*Problems* 57).

Here Williams assimilates communication to a productionist model of history in a way that Habermas seeks to move beyond with his "theory of communicative action." The point cannot be that communication suddenly emerges historically to usurp the place of capitalism or any other economic mode of production. Communication can better be conceived, following Habermas, as the basis for a new paradigm of knowledge that will overcome the aporias in the "philosophy

of the subject" extending from Descartes down to Derrida (see Dallmayer). The various philosophies that hypostatize a knowing subject, incarnation of Descartes's lonely cogito, along with its "alienated" world of objects to scrutinize, know, and scientifically master, include those forms of Marxism rooted in nine-teenth-century political economy and scientism. What they, too, reject or bypass as starting point or "ground" is the possibility and, indeed, historically continuous partial actualization of "communicative reason," or the ever-present prospect of achieving "mutual understanding" through language. Within the framework of communicative reason, Habermas contends, truth- and validity-claims different from the scientific analysis and mastery of objects emerge as the very core of social experience, and on their basis it may be possible radically to reshape or revolutionize that experience.

Habermas's evolving theory of communication offers, I believe, a better model for cultural studies than Althusserianism has proved to be—this, despite the fact that Habermas and his Frankfurt School predecessors have often been dismissively treated by British writers. Just as Williams, Thompson, and Hoggart were produc-ing their seminal books, Habermas was starting his career with *Strukturwandel der Öffentlichkeit* (1962) and *Theory and Practice* (1963). These works ask many of the same questions and offer some of the same answers to be found in Williams and in theoretical analyses in the pages of *New Left Review*. It seems symptomatic of British tendencies, however, that Perry Anderson, one of the editors of the *Review*, should make amends for not even mentioning Habermas in *Considera-tions on Western Marxism* (1976) by caricaturing his ideas in *In the Tracks of Historical Materialism* (1983). In the latter book, Anderson notes the similarity between "the characteristic coordinates of Habermas's thought" and French struc-turalism, but makes him out to be a facile optimist in contrast to the essential demonism of French poststructuralism. Where "structuralism and post-structural-ism developed a kind of diabolism of language, Habermas has unruffledly pro-duced an angelism" (*Tracks* 64). Habermas's theory of communicative action involves a kind of "benign providentialism," according to Anderson, based upon a utopian potential in all language use.

> In France when, as Derrida put it, "language invaded the universal problematic" . . . it strafed meaning, over-ran truth, outflanked ethics and politics, and wiped out history. In Germany, on the contrary, in Habermas's work language restores order to history, supplies the salve of consensus to society, assures the founda-tions of morality, anneals the elements of democracy, and is congenitally dis-posed against straying from the truth. (*Tracks* 64)

Anderson might more fairly have said that while Habermas offers no guarantees any more than does Derrida, the theory of communicative action is different from deconstruction in that it seeks to salvage the possibilities of truth, ethics, politics,

and history from the mounting poststructuralist ruins. So does Anderson's version of historical materialism. In any event, it will be interesting to see how Anderson reacts to the more sympathetic renderings of Habermas's work by Peter Dews, Michael Pusey, and others, and to Habermas's own encounters with French poststructuralism in *The Philosophical Discourse of Modernity*. Also, Eagleton has now moved beyond Althusserianism both to offer his currently positive assessment of Williams and to explain Williams's weaknesses in Habermasian terms, as due to the crucial absence in Britain of "a counterpublic sphere" within which Williams's work might have been more directly influential on the course of British politics (Eagleton, *Function* 108–15).

Toward Communicative Reason

Because Habermas stresses communication as central to his emancipatory project, like Williams he is open to the charge that he idealizes the social realm. But emphasizing communication is not much different from emphasizing language use as in structuralism and deconstruction, except that communication brings the question of politics to the fore: language use *for what?* Habermas himself asks "whether the concepts of communicative action and of the transcending force of universalistic validity claims do not reestablish an idealism that is incompatible with the naturalistic insights of historical materialism" (*Philosophical* 321). By insisting on the primacy for all forms of sociality of speech acts and on the possibility of achieving mutual understanding which they always entail, Habermas seems to regress from the Critical Theory of his predecessors (and, of course, from Anderson's version of historical materialism) to a form of liberal democratic theory similar to John Stuart Mill's emphasis on rational "discussion" in *On Liberty*. But, as Ben Agger declares, "It is a misreading of Habermas to suppose that he restricts emancipatory projects to the realm of talk":

> He suggests, rather, that domination has to be reconceptualized (since Marx and the evolution of advanced captialism) as involving not only economic deprivation but also all distortions of what Marx . . . called the "relations of production." Habermas tries to reenergize the silenced proletariat by appealing to its innate (but currently distorted) competence in self-determining thought and action. Thus his communication theory of society implies counterhegemonic strategies that attempt to uncover and organize our potential for mastering our productive infrastructure. . . . (Agger 6)

Nevertheless, the theory of communicative action might fairly be described, as Eagleton does, as a theoretical hunt for that translucent, rational, fully emancipated "public sphere" that is a central ideal of all modern democratic theory, and that, as Habermas recognizes, has in a variety of ways been *partially* realized in

various social formations in the past and present. It was partly the eclipse of a rational public sphere that the Frankfurt Institute theorists diagnosed in terms of "the dialectic of enlightenment." Habermas would in any case agree with Williams that

> If man is essentially a learning, creating and communicating being, the only social organization adequate to his nature is a participating democracy, in which all of us, as unique individuals, learn, communicate and control. Any lesser, restrictive system is simply wasteful of our true resources; in wasting individuals, by shutting them out from effective participation, it is damaging our true common process. (Williams, *Long* 118)

Both Habermas and Williams, in common with structuralists and semioticians, insist that all *material* social practices are language-dependent, which is a quite different starting point from Platonic ideas, the Cartesian cogito, the Hegelian World Spirit, or even a McLuhanesque media mystique. Further, as Habermas demonstrates repeatedly, *communication* is also a quite different starting point from the abstractions of language that appear in linguistically oriented theories from Saussure to Derrida. The Saussurean line abstracts language from history and, in some instances, treats it as "final cause" at least in relation to culture. Habermas like Williams is closer to the position of the Bakhtin circle, for whom language is "the lost middle term between the abstract entities, 'subject' and 'object', on which the propositions of idealism and orthodox materialism are erected . . . language is . . . a dynamic and articulated social *presence* in the world" (Williams, *Marxism* 37–38). As Pusey puts it, "the distinctive feature of Habermas's work is that processes of knowing and understanding are grounded, not in philosophically dubious notions of a transcendental ego, but rather in the patterns of ordinary language usage that we share in everyday communicative interaction" (Pusey 23).

In contrast to the historical and political understanding of language offered by Bakhtin and Volosinov, poststructuralism or deconstruction, as Habermas argues, falls into linguistic nihilism because it does not move beyond the same "logocentric" categories it deconstructs. No matter how "radical" its intentions, deconstruction cannot clear away the rubble of metaphysics its analyses pile up in order to open a space for an understanding of the social/political—as opposed to theological/metaphysical—construction of meanings. It seems strange to find a historical materialist like Anderson suggesting that Derridean deconstruction is ultimately more radical (because "demonic") than Habermas's painstaking elaboration of a historical materialist paradigm of "communicative reason." Derrida shows how all expression through language is "decentered" from the start, but, Habermas contends, "communicative reason is expressed in a decentered understanding of the world" (*Philosophical* 315). According to Habermas:

The critique of the Western emphasis on logos inspired by Nietzsche proceeds in a destructive manner. It demonstrates that the embodied, speaking and acting subject is not master in its own house; it draws from this the conclusion that the subject positing itself in knowledge is in fact dependent upon something prior, anonymous, and transsubjective—be it the dispensation of Being, the accident of structure-formation, or the generative power of some discourse formation. [But the] hope awakened by such post-Nietzschean analyses has constantly the same quality of expectant indeterminacy. Once the defenses of subject-centered reason are razed, the logos, which for so long had held together an interiority protected by power, hollow within and regressive without, will collapse into itself. It has to be delivered over to its other, whatever that may be. (*Philosophical* 311)

Such at least are the results of deconstructive analyses, including Derrida's and Foucault's. But "a different, less dramatic, but step-by-step testable critique of the Western emphasis on logos starts from an attack on the abstractions surrounding logos itself, as free of language, as universalist, and as disembodied. It conceives of intersubjective understanding as the telos inscribed into communication in ordinary language, and of the logocentrism of Western thought, heightened by the philosophy of consciousness, as a systematic *foreshortening* and *distortion* of a potential always already operative in the communicative practice of everyday life, but only selectively exploited" (*Philosophical* 311). Derridean deconstruction remains just as trapped in the paradigm of the knowing subject deconstructing its (necessarily linguistic) objects as its structuralist predecessors. Similarly, Foucauldian genealogical analysis mimics the very scientism it seeks to criticize and escape. Neither Derrida nor Foucault move toward a new paradigm of knowledge that would begin to conceptualize the dialogical or social construction of meanings. It is precisely this task that Habermas sets for the "theory of communicative action."

The point is not, as Anderson appears to believe, merely to affirm an emancipatory or utopian tendency in "the communicative practice of everyday life" (*Philosophical* 311). On the contrary, all manifestations of such practice have been, Habermas recognizes, systematically "colonized" and distorted by the very forms of logocentrism and power/knowledge/discipline Derrida and Foucault deconstruct. But they do not deconstruct their own deconstructions, to find within them the truth- and validity-claims inherent in every speech act. Foucault, for example, "did indeed provide an illuminating critique of the entanglement of the human sciences in the philosophy of the subject: These sciences try to escape from the aporetic tangles of contradictory self-thematization by a subject seeking to know itself, but in doing so they become all the more deeply ensnared in the self-reifications of scientism" (*Philosophical* 295). So, as Habermas shows, does Foucault, just as in similar fashion Heidegger and Derrida remain bound to the metaphysical categories and the paradigm of "a subject seeking to know itself" that they simultaneously deconstruct.

In *Culture and Society,* Williams wrote the classic account of British intellec-
tual responses to the industrial and democratic revolutions that ushered in the
modern age. As the Frankfurt School problematic of the dialectic of enlightenment
suggests, the fate of "modernity" is identical to the success or failure of the social
embodiments of reason through industrialization and democratization. Most ver-
sions of "postmodernist" theory announce the failure of the Enlightenment project
of social rationalization, and do so at times even more pessimistically or at least
categorically than did Horkheimer and Adorno in *The Dialectic of Enlightenment.*
Against such pessimistic and nihilistic claims, Habermas has argued that "the
project of modernity" cannot and should not be rejected, despite the failures and
catastrophes that it has caused. In taking this unfashionable line in defense of the
project (as opposed to the results so far) of modernity, Habermas assumes a
position similar to Williams's in *The Long Revolution* and elsewhere. To the
industrial and democratic revolutions most closely identified with modernism,
Williams added a third, "cultural revolution," by which he meant primarily the
development of mass literacy, of public education, and of the mass media. Of
course the cultural revolution is in complex ways the product of industrialization
and democratization, but Williams believed that it is gradually gaining the upper
hand. "We are used to descriptions of our whole common life in political and
economic terms," he declared. That is, the dual revolutions in politics and
economics seem to determine everything else in modern social experience, as
base to superstructure. But into this apparently deterministic picture enters the
cultural revolution, through which communication becomes increasingly a major
factor in social change. "The emphasis on communications asserts . . . that
[people] and societies are not confined to relationships of power, property,
and production. Their relationships, in describing, learning, persuading and
exchanging experiences"—that is, their "communicative" relationships—"are
. . . equally fundamental" (*Communications* 18).

Here Williams seems to land in just the sort of facile optimism that Anderson
accuses Habermas of expressing, and that Williams himself accuses McLuhan of
expressing. But the point is neither to affirm that communication is an automati-
cally rational activity that will eventually cure history of all its obvious ailments
nor to assume, as do many poststructuralist postmodernists, that communication
and history are both inevitably irrational and headed for the abyss (or already in
it). The problem is essentially the same for every critic who wishes to use the
tools of reason to indict the irrationality of society: the promise of a future,
authentic social rationality must be affirmed, or else the criticism seems point-
less—a Jeremiad minus Jeremiah's hope of salvation. Again, as Ricoeur con-
tends, the escape from ideology can come only through a utopian orientation, not
through scientism. But neither Williams nor Habermas asserts the automatic
primacy of reason in the shaping of history and society; both begin instead from
a clear recognition of processes of *irrationalization* (reification and alienation,

ideology, power struggles and processes of exploitation and domination, Weberian social rationalization that has imprisoned us all in the "iron cage" of modernity).

Yet even the most negative stress on, for example, ideology still suggests that what people think is always an important force in history, even though what people think may be largely false or deluded. Such a stress also of course implies that the forms of rationality or true consciousness *can* be recognized and set over against irrationality (the theorist practicing ideological critique inevitably positions her or himself as rational). Moreover, it makes little sense to claim, as Eagleton did in "scientifically" attacking Williams in *Criticism and Ideology,* that "the creation of new values" *can only* come about through "revolutionary rupture" (*Criticism* 27). Such a claim renders it impossible either to predict or to prepare for any revolutionary rupture, so long as the vast majority remain ideologically spellbound. The future must instead turn, for better or worse, on what Habermas calls the "organization of enlightenment" or what Williams called the "cultural revolution"—that is, on the communicative practices that bind societies together, and that also offer the only hope of changing them in progressive instead of regressive directions. Only the most reductive versions of ideology theory—*both* those associated with mechanistic base/superstructure dichotomies *and* those that abolish such dichotomies to posit ideology as the supreme and only "Subject" of history—offer models in which two terms suffice to describe human consciousness: ideology on one side; the generalization of truth, reason, or "science" on the other, with the semicolon standing for some hypothetical revolutionary break which may never get translated into practice. Most poststructuralisms are similarly dichotomous without recognizing it, only now by claiming the erasure of the truth side of the dichotomy (but how can they claim to know the truth if the truth is inaccessible?). From the deconstructive perspective, all that remains is our ultimate entrapment in ideologies of power or in the illusions of truth endlessly generated by our always decentered and decentering Babel of languages.

Aware that history does not usually operate in apocalyptic either/or terms, Williams presented the complex, conflict-ridden, volatile keywords of art, culture, and communication—along with many others—in part as an elaborate rejection of any sharp, absolutistic ideology/truth dichotomy. Perhaps "truth" is always both messier and more resilient than theory makes it out to be. Instead of the production of totally new values through "revolutionary rupture," Williams's cultural history presents us with the "long revolution," that series of complex social struggles and partial breakthroughs associated with industrialization and democratization and summed up by the idea of modernism. In this manner, Williams's mainly historical accounts of modernization—in *Culture and Society, The Long Revolution, The Country and the City,* and elsewhere—parallel Habermas's mainly theoretical analyses of "the philosophical discourse of modernity."

For Habermas as for Baudrillard, ideology is less a matter of false conscious-

ness, or of the irrational contents of deluded minds, than of the formal structures of communication—structures which contain, control, and also disseminate *both* truth *and* falsehood. In a sense, Habermas suggests, truth today comes in the guise of ideology, because in its most influential forms it comes in the guise of science. In his accounts of the ways positivistic "instrumental reason" has colonized and marginalized other forms of reason, including most prominently those associated with morality and those associated with esthetic judgment, Habermas is in essential agreement with Foucault's genealogies of the modern "human sciences" and "disciplines."

Following the Weberian paradigm of modernization as social rationalization, Habermas writes:

> [Weber] characterized cultural modernity as the separation of the substantive reason expressed in religion and metaphysics into three autonomous spheres. They are: science, morality, and art. These came to be differentiated because the unified world-views of religion and metaphysics fell apart. Since the 18th century, the problems inherited from these older world-views could be arranged . . . under specific aspects of validity: truth, normative rightness, authenticity and beauty. . . . Scientific discourse, theories of morality, jurisprudence, and the production and criticism of art could in turn be institutionalized. Each domain of culture could be made to correspond to cultural professions in which problems could be dealt with as the concern of social experts. . . . As a result, the distance grows between the culture of the experts and that of the larger public. . . . With cultural rationalization of this sort, the threat increases that the life-world, whose traditional substance has already been devalued, will become more and more impoverished. ("Modernity" 9)

In the eighteenth century, according to Habermas, Enlightenment philosophers like Condorcet believed that "objective science, universal morality and law, and autonomous art" would develop harmoniously all the faculties of human nature, enriching "everyday life" and steering civilization toward perfection. "The arts and sciences would promote not only the control of natural forces but also understanding of the world and self, moral progress, the justice of institutions and even the happiness of human beings" ("Modernity" 9). But the "dialectic of enlightenment" has led, in the twentieth century, to catastrophe instead of utopia.

The choices, according to Habermas, are two: either the abandonment of "modernity and its project as a lost cause" ("Modernity" 12), or the recognition that, while the hopes of the Enlightenment philosophers have not been fulfilled, the task of any radical theory and practice must be to understand why and to continue to struggle to fulfill them. Even if one believes, with Fredric Jameson, that we have passed out of the period of cultural modernism into that of postmodernism, the task for radical theory and practice remains unchanged. And for Habermas, the chief task for radical theory is to understand how "a reified

everyday praxis can be cured . . . by creating unconstrained interaction of the cognitive with the moral-practical and the aesthetic-expressive elements" that the culture of "the experts" has separated into professions and disciplines beyond the grasp of the vast majority ("Modernity" 11–12).

> From this perspective, both cognitive-instrumental mastery of an objectivated nature (and society) and narcissistically overinflated autonomy (in the sense of purposively rational self-assertion) are derivative moments that have been rendered independent from the communicative structures of the lifeworld, that is, from the intersubjectivity of relationships of mutual understanding and relationships of reciprocal recognition. Subject-centered reason is the *product of division and usurpation,* indeed of a social process in the course of which a subordinated moment assumes the place of the whole, without having the power to assimilate the structure of the whole. Horkheimer and Adorno have, like Foucault, described this process of a self-overburdening and self-reifying subjectivity as a world-historical process. (*Philosophical* 315)

So, too, from their very different perspectives, have Baudrillard and other theorists of the emergence of postmodernity from the death of the modern. In most instances of postmodernist cultural theory, there has been at least some recognition of what Habermas sees as the ultimate irony in our situation, that "the communicative potential of reason has been simultaneously developed and distorted in the course of capitalist modernization" (*Philosophical* 315). Instead of abandoning "the project of modernity" in its entirety, critical theory must identify those aspects of social rationalization that are genuinely progressive and find ways of separating them off from irrational and destructive aspects. Jameson says much the same when he writes:

> The topic of the lesson is . . . the historical development of capitalism itself and the deployment of a specifically bourgeois culture. In a well-known passage, Marx powerfully urges us to do the impossible, namely to think this development positively *and* negatively all at once; to achieve, in other words, a type of thinking that would be capable of grasping the demonstrably baleful features of capitalism along with its extraordinary and liberating dynamism simultaneously, within a single thought. . . . We are, somehow, to lift our minds to a point at which it is possible to understand that capitalism is at one and the same time the best thing that has ever happened to the human race, and the worst. The lapse from this austere dialectical imperative into the more comfortable stance of the taking of moral positions is inveterate and all too human: still, the urgency of the subject demands that we make [the] effort to think the cultural evolution of late capitalism dialectically, as catastrophe and progress all together. ("Postmodernism" 86)

For those theories and theorists who fail to recognize either the "communicative potential of reason" or the *partially* progressive, liberating force of "capitalist modernization," both the complexity and the irony of our current historical situation are apt to be missed. The development of modern productive forces—capitalism, industrialization, science—has involved the increasing "rationalization" and "disciplinary" domination of society. From the perspective of those who (more or less) control the productive forces, modernization appears completely rational, identical with progress, freedom, and truth. Their "ruling class ideology," moreover, is difficult to evade, despite the catastrophes this century has already experienced and is likely to experience in the near future (the worst-case scenario is, of course, nuclear holocaust, the reductio ad absurdum of all visions of progress through science and industry). Because of this, it seems to me, theories that completely reject "the project of modernity" are at least necessary and hopefully useful as forms of ideological critique. But they nevertheless fall into the category of "the taking of moral positions" that Jameson has in mind as undialectical, and are therefore usually little more than mirror-opposites or doubles of the ideological positions they seek to subvert. Again, as Jameson points out, much contemporary "theoretical discourse . . . [is] itself very precisely a postmodernist phenomenon," and thus television and deconstructive literary theory fit into the same "logic of late capitalism" ("Postmodernism" 61).

The "Critical Theory" of Horkheimer and Adorno aimed to explain how enlightenment has been dialectically transformed in the modern world into "positivism" or the reified "instrumental reason" behind the technological domination of people and nature. Habermas elaborates on their basic distinction between the humanistic, critical reason embodied in the philosophical tradition and what he calls, echoing Weber, *Zweckrationalität* or "goal-oriented rationality," in part by seeking to distinguish between types of rationalization and their embodiments in institutions and forms of social interaction. Foucault again offers some obvious similarities. "Goal-oriented rationality" has been a source of genuine social progress—it is basic to all the sciences—but it has simultaneously been a chief cause of reification and oppression.

On the level of the theory of action, [Weber] depicted the global process of rationalization as a tendency toward replacing communal social action [*Gemeinschaftshandeln*] with rationally regulated action [*Gesellschaftshandeln*]. But only if we differentiate *Gesellschaftshandeln* into action oriented to reaching understanding and action oriented to success can we conceive the communicative rationalization of everyday action and the formation of subsystems of purpose-rational economic and administrative action as *complementary* developments. Both reflect . . . the institutional embodiment of rationality complexes; but in other respects they are *counteracting* tendencies. (*Theory of Communicative Action* 341)

In other words, even within such thoroughly "rationalized" institutions as, for example, the academic "disciplines," it is possible, and indeed necessary, to distinguish modes of communication that, to use Bakhtin's terms, are "dialogical" ("oriented to reaching understanding") from those that are "monological" ("oriented to success"). Within the humanities disciplines themselves, it seems clear that many "professional" patterns and pressures are today far more oriented to *Zweckrationalität* than to anything that could still plausibly be described as "humanistic" in the older sense of humane or in the newer (or at least today increasingly prevalent) sense of dialogical. The theory of communicative action, writes Pusey, "is not offered as a drug for perpetual adolescents who yearn for intimations of utopia, but rather as a hard body of theory that can enter the university and rationally ground successful challenges to the stubbornly resistant false science embedded in the research agendas and curricula of modern economics, philosophy, history, sociology, psychology, anthropology, politics, the humanities, and all the multi-disciplinary and applied fields such as education, urban planning, etc. A tall order indeed!" (Pusey 35–36). Within the university setting, this is precisely the "counter-disciplinary" agenda of the cultural studies movement.

The key point is that, under modern conditions of industrial and bureaucratic rationalization, instrumental reason has tended to absorb or colonize forms of "communicative action" whose chief aim ought to be "achieving understanding." Technocratic thought and action come to seem the only legitimate types of thinking and acting. Whenever they don't pay, communal, democratic, self-reflective, esthetic, emancipatory modes of thought and action get shoved to the periphery. Habermas's theory of communicative action aims in part to explain— or re-explain in terms of communication—the "dialectic of enlightenment," the modern tendency to submerge all other forms of rationality (the moral, the esthetic) in *Zweckrationalität*. His theory also aims to provide new analytical tools for prying open social institutions and practices in the present, analyzing the ways in which they are based on "distorted communication" or ideology, and suggesting ways of reforming these in the light of models of "undistorted" or democratic communication. "For the structure of distorted communication is not ultimate; it has its basis in the logic of undistorted language communication" (Habermas, *Theory and Practice* 17).

The generalization of undistorted discourse—assuming it can always be at least approached on the individual level—would be the ultimate source of dereified social experience, or the reunification of subject and object in a harmonized social totality. Such a teleological, "metanarrative" goal is, of course, itself under attack by those postmodernists such as Lyotard, Baudrillard, and Derrida who see in it the very form of that dominative or authoritarian calculus of rationality that, ironically enough, Habermas himself is attacking. But in contrast to the poststructuralist assault on reason as such, Habermas

insists that the forms of reason—scientific, moralistic/normative, and esthetic—are valid within the limits of their own communicative rules, but that the central flaw in "the project of modernity" has been the totalitarian aggrandizement of scientific rationality. Further, he insists that reason in any of its forms is inseparable from communication—that is, from language. This means that meanings and values are socially constructed, but also that within the social framework of communicative practices reason and truth as forms of noncoercive consensus or "mutual agreement" are always at least potentially achievable. Obviously, such a position is at odds with the deconstructionist argument that, because language is the basis for all knowledge, and because language is inherently metaphoric and can ultimately only represent itself in an endless tautological circle, truth is inaccessible.

Habermas does not assume that "the project of modernity" can be completed in any sharply revolutionary, utopian sense. But it is, like Williams's "cultural revolution," the main thing on the historical and political agenda, toward which we must strive. Instead of a utopian totality in the future, Habermas holds forth the undoubtedly more ambiguous, but also more realistic, prospect of partial and gradual areas of emancipation, of doing what can be done with the tools at hand toward deconstructing the reified social formations now constructed from the materials of positivistic "scientism" and "distorted communication." These reified social formations include the academic disciplines as now constituted on the basis of the fragmentation and reification of consciousness, from one perspective the splintered reflection of the individual "subject" itself (see Herron 24–32). Habermas's immediate political goals may sound tame in contrast to the apocalyptic revolutionism often associated with Marxism, and the same is true of Williams's democratic socialism. But the general goal is universal enlightenment and liberation. The contributors to John Forester's recent anthology, *Critical Theory and Public Life,* show the range of the possible practical applications of Habermas's ideas, from classroom teaching strategies (Dieter Misgeld) to the "critical evaluation of public policy" (Frank Fischer), and from unraveling the distorted communications in news media (Daniel Hallin) to furthering decolonization (John O'Neill). David Held's description of the emancipatory aims of Habermasian Critical Theory, moreover, could just as easily describe Williams's "cultural materialism": "Habermas conceives of his project as an attempt to develop a theory of society with a practical intention: the self-emancipation of people from domination. Through an assessment of the self-formative processes of the human species, Habermas's critical theory aims to further the self-understanding of social groups capable of transforming society" (Held 250). Clearly, this description would also fit most versions of cultural studies, including Richard Johnson's assertion that "our project is to abstract, describe and reconstitute in concrete studies the social forms through which human beings 'live,' become conscious, [and] sustain themselves subjectively" (Johnson 45), with the goal of

at least local emancipations from the structures of economic, political, and cultural domination.

Toward an Ordinary Utopia

The dialogical model of the "ideal speech situation," Socratic in its invocation of the rational pursuit of truth through a free, equal, ideally transparent exchange of meanings, provides Habermas's theory with both its analytical center and its utopian energy. Yet Habermas insists that his theory is more pragmatic than utopian:

> To be sure, the concept of communicative rationality does contain a utopian perspective; in the structures of undamaged intersubjectivity can be found a necessary condition for individuals reaching an understanding among themselves without coercion, as well as for the identity of an individual coming to understanding with himself or herself without force. However, this perspective comprises *only* formal determinations of the communicative infrastructure of *possible* forms of life and life-histories; it does not extend to the concrete shape of an exemplary life-form or a paradigmatic life-history. Actual forms of life and actual life-histories are embedded in unique traditions. Agnes Heller is right to insist that communication free of domination can count as a necessary condition for the 'good life' but can by no means replace the historical articulation of a felicitous form of life. (Habermas in Held and Thompson, 227–28)

Habermas is here responding, in part, to Heller's remark that in reading his works "one gets the impression that the good life consists solely of rational communication" (Held and Thompson 22). The point on which he agrees is that his *theory* does indeed need to be fleshed out with a *history*—both an actual "historical articulation" and an historical account of that articulation, and both involving "actual forms of life and actual life-histories . . . embedded in unique traditions."

If history (in both senses) requires theory to be rendered meaningful, theory equally and obviously requires history. But an historical analysis corresponding to the theory of communicative action would necessarily be different from the forms of historicism that Habermas identifies with positivism, or the scientistic reification of the past. It should for one thing be a history attuned to *alternative* social and political possibilities, and it should also be a history of actual and potential "communicative practices." According to Williams, "A theoretical emphasis on the means of communication as means of production, within a complex of general social-productive forces, should allow and encourage new approaches to the history of the means of communication themselves. This *history* is, as yet, relatively little developed" (*Problems* 53). Several of Williams's own works— *The Long Revolution, Communications, Television: Technology and Cultural*

Form, and *Towards 2000*—offer versions of such a history, as do many of the studies of the Birmingham Centre (see especially the essays in *Culture, Media, Language*).

For any history stressing culture and communications, settled facticity should be unsettled, stirred up, understood as the reified sediment of complex social processes which were and are far from closed. "Walter Benjamin called the 'empathy with the victor' one of the signs of historicism," writes Habermas, sounding like E. P. Thompson; "When, in the spirit of Benjamin, Gustav Heine-mann called for the adoption of the perspective of the defeated, the unsuccessful rebels and revolutionaries, he had to put up with the rejoinder . . . that this orientation toward the ideals of his own past was merely a 'fixation of immaturity' " (Habermas in Bernstein 91–92). On the contrary, Habermas sug-gests, the immaturity lies on the other side, on the part of a history that treats human affairs as determined or predetermined by nonhuman forces (including "victors" and "great men," seen as the agents of "Nature" or "Providence" or sheer "Will-to-Power"), plotted out as a linear, seemingly progressive narrative with few or no branches, spirals, or reversions, with no subplots, without even the shadows of doubts—history as the parade of the victors and their "facts."

"Cultural history," with its echo of Dilthey's "cultural sciences" based on a *Verstehen* or hermeneutic understanding that might be partially translated as humanistic empathy for all sides, including even the victors, is perhaps the best name for the sort of history Thompson, Williams, and Habermas all have in mind (see Brenkman 25–56, and also Chartier). In his brief allusion to Dilthey at the start of *The Sociology of Culture,* Williams writes that "the method of '*verstehen*' could be quite insufficiently explanatory, or could fall back for explanation on a (theoretically circular) 'informing spirit,' " an idealism he wishes to avoid through "cultural materialism" (*Sociology* 16). But without fully confronting the theoreti-cal issues surrounding the hermeneutic tradition of the cultural sciences, including anthropology and the sociology of knowledge, Williams's "cultural materialism" threatens to dissolve into an endlessly shifting lexicon of keywords, without focus except in traditional radical invocations of democratic community and equality. Habermas in contrast *begins* with the problem of grounding hermeneutic or interpretive knowledge, in part rejecting the tradition that extends from Dilthey down to Hans-Georg Gadamer in a "continuing effort to find a critical vantage point outside the hermeneutic circle" (Martin Jay in Bernstein 102). Yet this "outside" remains crucially *inside* for Habermas, within the framework of that sort of rational discourse which ideally allows two or more people to exchange valid, trustworthy messages and thus to "achieve understanding."

For both Habermas and Williams, art or the "aesthetic dimension" is a central category, but not as a reservoir of radical will nor as a privileged refuge of utopian possibilities. Williams's critique of the high cultural elitists from Arnold through Leavis is similar to Habermas's reservations about the privileged status accorded

to art by Adorno and Marcuse. Benjamin's thesis concerning the destruction of cultural "aura" under the impact of modern techniques of mass, "mechanical reproduction" leads to a split both in his thinking and that of the other Frankfurt School theorists. On the one hand, Benjamin recognizes the emancipatory *potential*, at least, in the industrialization of art (that is, in the transformation of "auratic," elitist art-forms into the forms of mass culture). Yet on the other, Benjamin seems deeply pessimistic about the industrialization of culture, sometimes willing to credit only "auratic" art-forms with an intrinsic, liberating power. The "decline of [auratic] storytelling," for example, has been paralleled by—in some sense, caused by—the rise of the modern press with its mass dissemination of essentially trivialized, fragmented bits of "information" (Benjamin 88). "Historically, the various modes of communication have competed with one another. The replacement of the older narration by information, of information by sensation, reflects the increasing atrophy of experience" under capitalism (Benjamin 158). Similarly, in writing about Baudelaire's response to photography, Benjamin seems to agree that "there was something profoundly unnerving and terrifying about daguerrotypy," and even that it is an art-form reflective of " 'the stupidity of the broad masses' " (Benjamin 186).

Baudelaire is an early exemplar of the sharp separation between bohemian, defensive, elitist (even when radical in intent) *l'art pour l'art* modernism on the one hand, and "bourgeois" or capitalist, industrialized mass culture on the other. Today postmodernism is often defined as involving the collapse of the distinction between high and mass culture, pointing to the question of whether any genuinely emancipatory or even socially progressive energy can be found *either* in modernist "high" art *or* in mass culture. According to Huyssen, in the postmodern era mass culture ceases to be "the threatening other of modernism," essentially because the forms of high culture are now themselves thoroughly industrialized and commodified (Huyssen 28). "It is in Benjamin's work in the 1930s that the hidden dialectic between avantgarde art and the utopian hope for an emancipatory mass culture can be grasped alive for the last time. After World War II, at the latest, discussions about the avant-garde congealed into the reified two-track system of high vs. low, elite vs. popular, which itself is the historical expression of the avantgarde's failure and of continued bourgeois domination" (Huyssen 14).

Huyssen sees the avant-garde not as synonymous with high modernist elitism but as seeking in a variety of ways, including alliances with the mass media, to pull down the barriers separating art from everyday life. From this perspective, postmodernism could almost be defined as the triumph of the avant-garde, effacing the last vestiges of "the great divide" between high and mass culture. Certainly instead of barriers, all sorts of bridges now exist between high and mass culture—assuming that the distinction still has any meaning. As long ago as 1969, Susan Sontag declared that "the distinction between 'high' and 'low' (or 'mass' or 'popular') culture is based partly on an evaluation of the difference between

unique and mass-produced objects," but that "in the light of contemporary practice in the arts, this distinction appears extremely shallow. . . . The exploration of the impersonal (and trans-personal) in contemporary art is the new classicism" (Sontag 297–98).

One version of the apparent postmodernist erosion of the distinction between high and mass culture is that the "critical" dimension associated with high culture has now been completely absorbed, colonized, and annulled by mass culture. Mass culture becomes synonymous with wall-to-wall ideology, with the "panoptical" machinery of the mass media—cameras, copiers, computers, and so forth—imprisoning or interpellating us all through its disciplinary gaze. Another, obviously less pessimistic version is that mass culture acts only as a kind of sieve or grid, through and against which the innumerable "resistant" interpretations and meaning-producing practices of "the people" are enacted. De Certeau's idea of reading as "poaching," echoed by John Fiske, and the "subcultural" studies of Dick Hebdige, Paul Willis, and Simon Frith are examples of this approach, as are also the studies of the interpretive practices of the "mass audience" in "reading" television and film by Ien Ang, Grossberg, and others.

In several of his early essays, Habermas echoes the pessimistic themes of his Frankfurt School predecessors in regard to the mass media, though without offering a version of Adorno's and Marcuse's stress on the utopian nature of the "aesthetic dimension." In *Toward a Rational Society,* Habermas expresses Marcuse's theme of "the absorption of contradiction" by "the all-pervasive system of mass media" (32). The chief difficulty in mounting any resistance to the status quo is that "the young grow up far from the sphere of production and encounter reality only through the filter of consumer orientations and mass media" (*Toward* 33). In *Legitimation Crisis,* Habermas finds in "scientism, post-auratic art, and universalistic morality" the "components of cultural tradition dominant today," none of them capable, in their disunited, commodified, mass-mediated forms, of supporting a radical "repoliticization of the public sphere" (84). Although "modern art is the shell in which . . . the counterculture was prepared," even "radicalized art" takes on ambivalent meanings. Modernist, avant-garde art "infiltrates the ensemble of use values only when it surrenders its autonomous status. It can just as easily signify the degeneration of art into propagandistic mass art or into commercialized mass art as, on the other hand, transform itself into a subversive counterculture" (*Legitimation* 86).

Nevertheless, in later works Habermas also criticizes Adorno's sweeping condemnations of the "culture industry," because "an analysis that starts from the commodity form assimilates the new means of mass communication to the medium of exchange value, even though the structural similarities do not extend this far" (*Theory of Communicative Action* 371). The same could be said, of course, about Baudrillard's sweeping inclusion of all bourgeois or capitalist forms of communication under the sign of the commodity. Reification and ideology do

indeed characterize the messages of the commercialized mass media. But, Habermas contends, "whereas the medium of money *replaces* understanding in language as a mechanism for coordinating action, the media of mass communication remain dependent on achieving understanding in language" (371–2). Adorno apprehended only the technological/economic machinery of the mass media, failing to take into account their linguistic or "discursive" nature. "Adorno adopted a culture-critical perspective that made him sceptical—and rightly so— of Benjamin's somewhat precipitous hopes for the emancipatory power of mass culture—at that time chiefly film. On the other hand [Adorno] had no clear concept of the thoroughly ambivalent character of social control exercised through the mass media" (371).

For both Williams and Habermas, art or high culture is no more radical or liberating in and of itself than is commodified mass culture. Both high and mass culture are "thoroughly ambivalent" in character—both are complexly shaped, but not wholly determined, by ideology and ideological institutions (Althusser's ISAs), even while they both generate promises of enlightenment and liberation. For Habermas, these promises are grounded in the very nature of language, which is rooted in testable truth- and validity-claims and which must point toward the achievement of "mutual understanding" in order to function at all. The task of cultural analysis from such a perspective becomes twofold: analyzing the instruments and institutions of communication (from speech acts to mass media) to reveal the complex ways both distorted and undistorted meanings are generated by and intertwined within them, and reconstructing the histories of those instruments and institutions to reveal how they have taken their present shapes and to suggest alternative paths of use and development.

Habermas's critics argue—as might Williams's—that such an approach is too simplistically rational, offering only the mirage of translucent, "undistorted communication" as the basis of all that follows. It is obviously problematic to suppose that perfectly "undistorted communication" can ever be experienced, even in the most intimate forms of dialogue. As Dominick LaCapra points out, Habermas's typical dichotomies—distorted/undistorted, dialogic/monologic, rational/irrational—oversimplify the inevitably slippery nature of language. Given that slipperiness (the main theme, of course, of deconstruction), what can be made of Habermas's attempt to locate within language itself a stay against the eternal falsifications of language, much less the magical, emancipatory key to unlock reified social institutions and achieve "universal consensus"? Similarly, according to Lyotard, the "condition of knowledge" in the "postmodern world" (or perhaps in any world?) cannot be understood in terms of a straightforward consensus model of rational discourse. Rather, the separate sciences and disciplines all follow the "locally" valid rules of "language games" whose objects are endlessly centrifugal and thus better described in terms of a sort of ongoing discord and anarchy than in terms of consensus-formation.

But of course the "rules" of "language games" and "disciplines" *are* based on consensus. Besides, Habermas does not conceive of consensus as a sort of forced unification through the totalitarian erasure of difference, but as by definition entailing the constructive working out of differences. The histories of the disciplines and sciences themselves offer paradigms, although partial and partially distorted ones, of consensus-formation through communicative reason. Williams's and Thompson's versions of cultural history also offer paradigms, obviously even more useful for cultural studies. Both Williams and Thompson conceive of culture and communication as consensual processes—hegemonic struggles for and against domination—rather than as logocentric instruments for the discovery of absolute, final truths. Williams finds in Gramsci's theory of hegemony a more powerful model for these processes than in other sorts of ideological critique, partly because hegemony involves consensus-formation and partly because it recognizes that "common sense" also makes sense—that is, that the opinions and voices of "the people" matter, even when they are ideologically dominated and distorted. As Gramsci defines it, hegemony entails a deformation of—but simultaneously a potential for—democratic communication, education, and choice. From such a vantage point, cultural criticism can begin to show how the illusion of choice is maintained, and how lines of force in society can be transformed into authentic modes of participatory decision-making.

Whether or not it is now giving way to postmodernism, the modernist division between elitist, auratic culture on the one hand and a debased, commercialized mass culture on the other can be seen as a structural defense against the use of the mass media for liberating purposes—purposes which would be *neither* auratic (following the old line of liberal humanism) *nor* commercial-propagandistic, but dialogical, consensual, and progressive, moving us toward a democratic world community. Habermas's theory of communicative action and Williams's cultural materialism at least shadow forth what such a dialogical culture and society might look like; both aim to nurture and begin to enact the forms of that culture and society now, despite the limitations of "postmodern" social reality.

Just as Benjamin found democratic or anti-elitist—and therefore potentially constructive—*tendencies,* at least, in anti-auratic, mass cultural art-forms and techniques such as photography and cinema, so Williams insists that "masses" of people—meaning all of us—have benefited in significantly liberating ways from the development of mass communications, even though the full potential of these new techniques has scarcely been tapped. Commercialization and monopolistic, elitist control are retarding factors, but not the techniques themselves. In contrast, the defense of elitist cultural formations as in *l'art pour l'art* modernisms can, as Benjamin suspected, easily support fascist political alternatives. Art and culture, science and the forms of social rationalization—enlightenment, in short—must ultimately be made available to all. If the sharing of art and also of the power of "discursive will-formation" and "communicative action" often

summed up by the term "culture" is only gradually, erratically, sometimes painfully being achieved through the "long revolution," it is nonetheless, for both Williams and Habermas, our most hopeful prospect. The inclusion of "the masses" in the *schöner Schein* of a "common culture" must continue to be the goal of cultural workers; an authentically democratic mass culture uniting people through recognition of and respect for differences, for "otherness," is the aim, not the enemy. Today the footprints in the sand are everywhere; there is no escaping the conclusion that they are ours.

Works Cited

Abelove, Henry, et al., eds., *Visions of History* (New York: Pantheon Books, 1983).

Adorno, Theodor W., *Negative Dialectics* (New York: Continuum, 1973).

——, *Prisms* (Cambridge, MA: MIT Press, 1983).

Agger, Ben, "The Dialectic of Deindustrialization: An Essay on Advanced Capitalism," in Forester, ed., *Critical Theory and Public Life*, 3–21.

Althusser, Louis, *For Marx* (New York: Pantheon Books, 1969).

——, *Lenin and Philosophy and Other Essays* (New York: Monthly Review Press, 1971).

Althusser, Louis, and Etienne Balibar, *Reading Capital* (London: New Left Books, 1970).

Anderson, Perry, *Arguments within English Marxism* (London: New Left Books, 1980).

——, "Components of the National Culture," in *Student Power*, ed. Alexander Cockburn and Robin Blackburn (Harmondsworth: Penguin, 1969).

——, *In the Tracks of Historical Materialism* (Chicago: University of Chicago Press, 1984).

Angus, Ian, and Sut Jhally, eds., *Cultural Politics in Contemporary America* (London: Routledge, 1989).

Arac, Jonathan, ed., *Postmodernism and Politics* (Minneapolis: University of Minnesota Press, 1986).

Baker, Houston A., Jr., *The Journey Back: Issues in Black Literature and Criticism* (Chicago: University of Chicago Press, 1980).

Baker, Houston A., Jr., and Leslie A. Fiedler, eds., *English Literature: Opening up the Canon* (Baltimore: Johns Hopkins University Press, 1981).

Bakhtin, Mikhail, *Rabelais and His World* (Bloomington: Indiana University Press, 1984).

Baldwin, James, *Nobody Knows My Name: More Notes of a Native Son* (New York: Dial Press, 1961).

Barker, Francis, et al., eds., *Literature, Society and the Sociology of Literature* (Colchester: University of Essex, 1977).

Barrett, Michèle, "Feminism and the Definition of Cultural Politics," in Rosalind Brunt and Caroline Rowan, eds., *Feminism, Culture and Politics* (London: Lawrence and Wishart, 1982), 37–58.

Barrett, Michèle, Philip Corrigan, Annette Kuhn, and Janet Wolff, eds., *Ideology and Cultural Production* (New York: St. Martin's, 1979).

Barthes, Roland, *Image-Music-Text* (New York: Hill and Wang, 1977).

——, *Mythologies* (New York: Hill and Wang, 1972).

——, *Writing Degree Zero, and Elements of Semiology* (Boston: Beacon Press, 1970).

Batsleer, Janet, Tony Davies, Rebecca O'Rourke, and Chris Weedon, *Rewriting English: Cultural Politics of Gender and Class* (London: Methuen, 1985).

Baudrillard, Jean, *In the Shadow of the Silent Majorities . . . or the End of the Social* (New York: Semiotext(e), 1983).

————, *Selected Writings*, ed. Mark Poster (Stanford: Stanford University Press, 1988).

————, *Simulations* (New York: Semiotext(e), 1983).

Beechey, Veronica, "On Patriarchy," *Feminist Review* 3 (1979), 66–82.

Belsey, Catherine, *Critical Practice* (London: Methuen, 1980).

Benjamin, Walter, *Illuminations* (New York: Schocken, 1969).

Bennett, Tony, *Formalism and Marxism* (London: Methuen, 1979).

Bennett, William, "To Reclaim a Legacy," *Chronicle of Higher Education* 29:14 (Nov. 28, 1984), 16–21.

Bercovitch, Sacvan, "The Problem of Ideology in American Literary History," *Critical Inquiry* 12:4 (Summer, 1986), 630–53.

Bercovitch, Sacvan, and Myra Jehlen, eds., *Ideology and Classic American Literature* (Cambridge: Cambridge University Press, 1986).

Bernstein, Richard J., ed., *Habermas and Modernity* (Cambridge, MA: MIT Press, 1985).

Bloch, Ernst, *The Utopian Function of Art and Literature: Selected Essays* (Cambridge, MA: MIT Press, 1988).

Bloch, Maurice, *Marxism and Anthropology* (Oxford: Oxford University Press, 1985).

Bourdieu, Pierre, *Distinction: A Social Critique of the Judgment of Taste* (Cambridge, MA: Harvard University Press, 1984).

————, *Outline of a Theory of Practice* (Cambridge: Cambridge University Press, 1977).

————, "The School as a Conservative Force: Scholastic and Cultural Inequalities," in Roger Dale, Geoff Esland, and Madeleine MacDonald, eds., *Schooling and Capitalism: A Sociological Reader* (London: Routledge and Kegan Paul, 1976), 110–17.

Brantlinger, Patrick, *Bread and Circuses: Theories of Mass Culture as Social Decay* (Ithaca: Cornell University Press, 1983).

————, *Rule of Darkness: British Literature and Imperialism 1830–1914* (Ithaca: Cornell University Press, 1988).

Brecht, Bertolt, *Brecht on Theatre*, ed. John Willett (New York: Hill and Wang, 1964).

Brenkman, John, *Culture and Domination* (Ithaca: Cornell University Press, 1987).

Burke, Peter, *Popular Culture in Early Modern Europe* (New York: Harper and Row, 1978).

Cain, William E., *The Crisis in Criticism: Theory, Literature, and Reform in English Studies* (Baltimore: Johns Hopkins University Press, 1984).

————, ed., *Philosophical Approaches to Literature* (Lewisburg: Bucknell University Press, 1983).

Calhoun, Craig, *The Question of Class Struggle: Social Foundations of Popular Radicalism during the Industrial Revolution* (Chicago: University of Chicago Press, 1982).

Calinescu, Matei, *Five Faces of Modernity: Modernism, Avant-Garde, Decadence, Kitsch, Postmodernism* (Durham: Duke University Press, 1987).

Carby, Hazel V., " 'On the Threshold of Woman's Era': Lynching, Empire, and Sexuality in Black Feminist Theory," in Gates, ed., *"Race," Writing, and Difference*, 301–16.

CCCS (Centre for Contemporary Cultural Studies), *Culture, Media, Language* (London: Hutchinson, 1980).

————, *The Empire Strikes Back: Race and Racism in 70s Britain* (London: Hutchinson, 1982).

————, *Making Histories: Studies in History-Writing and Politics* (London: Hutchinson, 1982).

————, *On Ideology* (London: Hutchinson, 1978).

————, *Resistance through Rituals: Youth Subcultures in Post-War Britain* (London: Hutchinson, 1976).

————, *Unpopular Education: Schooling and Social Democracy in England since 1944* (London: Hutchinson, 1981).

————, *Women Take Issue: Aspects of Women's Subordination* (London: Hutchinson, 1978).

Certeau, Michel de, *The Practice of Everyday Life* (Berkeley: University of California Press, 1984).

————, *Heterologies: Discourse on the Other* (Minneapolis: University of Minnesota Press, 1986).

Chartier, Roger, *Cultural History* (Ithaca: Cornell University Press, 1988).

Christian, Barbara, "The Race for Theory," *Cultural Critique* 6 (Spring, 1987), 51–63.

Clarke, John, Chas Critcher, and Richard Johnson, eds., *Working-Class Culture* (New York: St. Martin's, 1980).

Clifford, James, *The Predicament of Culture: Twentieth-Century Ethnography, Literature, and Art* (Cambridge, MA: Harvard University Press, 1988).

Clifford, James, and George Marcus, eds., *Writing Culture: The Poetics and Politics of Ethnography* (Berkeley: University of California Press, 1986).

Coward, Rosalind, *Patriarchal Precedents: Sexuality and Social Relations* (London: Routledge and Kegan Paul, 1983).

Dahlerup, Drude, ed., *The New Women's Movement: Feminism and Political Power in Europe and the USA* (London: Sage Publications, 1986).

Dallmayer, Fred, *Twilight of Subjectivity: Contributions to a Post-Individualist Theory of Politics* (Amherst: University of Massachusetts Press, 1981).

Davis, Mike, "Why the U.S. Working Class is Different," *New Left Review* 123 (September/October, 1980), 3–44.

Davis, Mike, and Michael Sprinker, eds., *Reshaping the US Left: Popular Struggles in the 1980s* (London: Verso, 1988).

Defoe, Daniel, *Robinson Crusoe* (New York: Penguin, 1982).

Deleuze, Gilles, and Félix Guattari, *Kafka: Toward a Minor Literature* (Minneapolis: University of Minnesota Press, 1986).

De Man, Paul, *Blindness and Insight: Essays in the Rhetoric of Contemporary Criticism* (New York: Oxford University Press, 1971).

Derrida, Jacques, "But, beyond . . . ," in Gates, ed., *"Race," Writing, and Difference*, 354–69.

————, "Like the Sound of the Sea Deep within a Shell: Paul de Man's War," *Critical Inquiry* 14:3 (Spring, 1988), 590–652.

————, *Of Grammatology* (Baltimore: Johns Hopkins University Press, 1976).

————, "The Principle of Reason: The University in the Eyes of its Pupils," *Diacritics* 13:3 (Fall, 1983), 3–20.

————, "Racism's Last Word," in Gates, ed., *"Race," Writing, and Difference*, 329–38.

————, "Sending: On Representation," *Social Research* 49:2 (Summer, 1982), 294–326.

Dews, Peter, *Logics of Disintegration: Post-Structuralist Thought and the Claims of Critical Theory* (London: Verso, 1987).

Douglass, Frederick, *Narrative of the Life of Frederick Douglass, an American Slave, written by Himself*, intro. by Houston A. Baker, Jr. (New York: Penguin Books, 1982).

Eagleton, Terry, *Against the Grain: Essays 1975–1985* (London: Verso, 1986).

————, *Criticism and Ideology: A Study in Marxist Literary Theory* (London: Verso Books, 1978).

————, "Foreword," in Daniel Cottom, *Social Figures: George Eliot, Social History, and Literary Representation* (Minneapolis: University of Minnesota Press, 1987).

————, *The Function of Criticism: From the Spectator to Post-Structuralism* (London: Verso Books, 1984).

————, *Literary Theory: An Introduction* (Minneapolis: University of Minnesota Press, 1983).

————, *Marxism and Literary Criticism* (Berkeley: University of California Press, 1976).

————, "Resources for a Journey of Hope: The Significance of Raymond Williams," *New Left Review* 168 (March/April, 1988), 3–11.

Easthope, Anthony, *British Post-Structuralism* (London: Routledge, 1988).

Eisenstein, Hester, *Contemporary Feminist Thought* (Boston: G. K. Hall, 1983).

Ellison, Ralph, *Invisible Man* (New York: Vintage Books, 1972).

————, *Shadow and Act* (New York: Random House, 1964).

Enzensberger, Hans Magnus, *The Consciousness Industry: On Literature, Politics and the Media* (New York: Seabury, 1974).

Fay, Brian, *Critical Social Science* (Ithaca: Cornell University Press, 1987).

Firestone, Shulamith, *The Dialectic of Sex* (London: The Women's Press, 1979).

Fiske, John, *Television Culture* (New York: Methuen, 1987).

Foner, Philip S., ed., *Frederick Douglass on Women's Rights* (Westport, CT: Greenwood Press, 1976).

Forester, John, ed., *Critical Theory and Public Life* (Cambridge, MA: MIT Press, 1987).

Foucault, Michel, *Discipline and Punish: The Birth of the Prison* (New York: Vintage Books, 1979).

————, *The History of Sexuality*, vol. I (New York: Vintage Books, 1980).

————, *Language, Counter-Memory, Practice* (Ithaca: Cornell University Press, 1977).

————, *Power/Knowledge: Selected Interviews and Other Writings 1972–1977* (New York: Pantheon Books, 1980).

————, *The Order of Things: An Archaeology of the Human Sciences* (New York: Vintage Books, 1973).

Fox, Robert Elliot, *Conscientious Sorcerers: The Black Postmodernist Fiction of LeRoi Jones/Amiri Baraka, Ishmael Reed, and Samuel R. Delany* (Westport, CT: Greenwood Press, 1987).

Franklin, John Hope, "Afro-American History: State of the Art," *Journal of American History* 75:1 (June, 1988), 162–73.

Gagnier, Regenia, "Social Atoms: Working-Class Autobiography, Subjectivity, and Gender," *Victorian Studies* 30:3 (Spring, 1987), 335–63.

Gallagher, Catherine, *The Industrial Reformation of English Fiction: Social Discourse and Narrative Form 1832–1867* (Chicago: University of Chicago Press, 1985).

Garnham, Nicholas, and Raymond Williams, "Pierre Bourdieu and the Sociology of Culture: An Introduction," *Media, Culture and Society* 2 (1980), 209–223.

Gates, Henry Louis, Jr., ed., *Black Literature and Literary Theory* (New York: Methuen, 1984).

————, ed., *"Race," Writing, and Difference* (Chicago: University of Chicago Press, 1986).

Genovese, Eugene, *Roll, Jordan, Roll: The World the Slaves Made* (New York: Pantheon Books, 1972).

Geras, Norman, "Post-Marxism?" *New Left Review* 163 (May/June, 1987), 40–82.

Gilbert, Sandra, and Susan Gubar, *The Madwoman in the Attic* (New Haven: Yale University Press, 1979).

Giroux, Henry, David Shumway, Paul Smith, and James Sosnoski, "The Need for Cultural Studies: Resisting Intellectuals and Oppositional Public Spheres," *Dalhousie Review* 64 (1985), 472–86.

Goodheart, Eugene, *Culture and the Radical Conscience* (Cambridge, MA: Harvard University Press, 1973).

————, *The Failure of Criticism* (Cambridge, MA: Harvard University Press, 1978).

Graff, Gerald, "American Criticism Left and Right," in Bercovitch and Jehlen, eds., *Ideology and Classic American Literature*, 91–121.

————, *Professing Literature: An Institutional History* (Chicago: University of Chicago Press, 1987).

Graff, Gerald, and Reginald Gibbons, eds., *Criticism in the University* (Evanston: Northwestern University Press, 1985).

Gramsci, Antonio, *Prison Notebooks* (London: Lawrence and Wishart; New York: International Publishers, 1971).

Green, Martin, *Dreams of Adventure, Deeds of Empire* (New York: Basic Books, 1979).

Greer, Germaine, "The Proper Study of Womankind," *TLS* (June 3–9, 1988), 616, 629.

Grossberg, Lawrence, "MTV: Swinging on the (Postmodern) Star," in Angus and Jhally, eds., *Cultural Politics in Contemporary America*, 254–68.

Gubar, Susan, " 'The Blank Page' and the Issues of Female Creativity," *Critical Inquiry* (Winter, 1981), 243–63.

Gutman, Herbert, *Power and Culture: Essays on the American Working Class,* ed. Ira Berlin (New York: Pantheon Books, 1987).

Habermas, Jürgen, *Knowledge and Human Interests* (Boston: Beacon Press, 1971).

———, *Legitimation Crisis* (Boston: Beacon Press, 1975).

———, "Modernity—An Incomplete Project," in Hal Foster, ed., *The Anti-Aesthetic: Essays on Postmodern Culture* (Port Townsend, WA: Bay Press, 1983), 3–15.

———, *The Philosophical Discourse of Modernity* (Cambridge, MA: MIT Press, 1987).

———, *Theory and Practice* (Boston: Beacon Press, 1974).

———, *Theory of Communicative Action,* vol. I (Boston: Beacon Press, 1974).

———, *Toward a Rational Society: Student Protest, Science and Politics* (Boston: Beacon Press, 1970).

Hall, Stuart, "Encoding/Decoding," in CCCS, *Culture, Media, Language,* 128–33.

———, "Notes on Deconstructing 'the Popular,' " in Samuel, ed., *People's History and Socialist Theory,* 227–40.

Hall, Stuart, Chas Critcher, Tony Jefferson, John Clarke, and Brian Roberts, eds., *Policing the Crisis: Mugging, the State, and Law and Order* (New York: Holmes and Meier, 1978).

Harvey, Sylvia, *May '68 and Film Culture* (London: British Film Institute, 1978).

Hassan, Ihab, "The Critic as Innovator: The Tutzing Statement in X Frames," *Amerikastudien* 22:1 (1977), 47–63.

Haug, Wolfgang, *Critique of Commodity Aesthetics: Appearance, Sexuality, and Advertising in Capitalist Society* (Minneapolis: University of Minnesota Press, 1986).

Heath, Stephen, *Questions of Cinema* (Bloomington: Indiana University Press, 1981).

Hebdige, Dick, *Subculture: The Meaning of Style* (London: Methuen, 1979).

Held, David, *Introduction to Critical Theory: Horkheimer to Habermas* (Berkeley: University of California Press, 1980).

Held, David, and John B. Thompson, eds., *Habermas: Critical Debates* (Cambridge, MA: MIT Press, 1982).

Herron, Jerry, *Universities and the Myth of Cultural Decline* (Detroit: Wayne State University Press, 1988).

Hine, Darlene Clark, ed., *The State of Afro-American History: Past, Present, and Future* (Baton Rouge: Louisiana State University Press, 1986).

Hodge, Robert, and Gunther Kress, *Social Semiotics* (Ithaca: Cornell University Press, 1988).

Hoggart, Richard, *Speaking to Each Other,* 2 vols. (London: Chatto and Windus, 1970).

———, *The Uses of Literacy: Changing Patterns in English Mass Culture* (Boston: Beacon Press, 1961).

Hohendahl, Peter Uwe, *The Institution of Criticism* (Ithaca: Cornell University Press, 1982).

Holquist, Michael, "The Politics of Representation," in Stephen Greenblatt, ed., *Allegory and Representation* (Baltimore: Johns Hopkins University Press, 1981), 163–83.

Hughes, H. Stuart, *History as Art and as Science* (New York: Harper and Row, 1964).

Huyssen, Andreas, *After the Great Divide: Modernism, Mass Culture, Postmodernism* (Bloomington: Indiana University Press, 1986).

Jacoby, Russell, *The Last Intellectuals: American Culture in the Age of Academe* (New York: Basic Books, 1987).

Jameson, Fredric, *The Political Unconscious: Narrative as a Socially Symbolic Act* (Ithaca: Cornell University Press, 1981).

———, "Postmodernism, or the Cultural Logic of Late Capitalism," *New Left Review* 146 (July/August, 1984), 53–92.

JanMohamed, Abdul, and David Lloyd, "Introduction: Toward a Theory of Minority Discourse," *Cultural Critique* 6 (Spring, 1987), 5–12.

Jay, Martin, *Marxism and Totality* (Berkeley: University of California Press, 1984).

Jehlen, Myra, "Introduction: Beyond Transcendence," in Bercovitch and Jehlen, eds., *Ideology and Classic American Literature*, 1–18.

Johnson, Richard, "What Is Cultural Studies Anyway?" *Social Text* 6:1 (1987), 38–80.

Kampf, Louis, and Paul Lauter, eds., *The Politics of Literature: Dissenting Essays on the Teaching of English* (New York: Random House, 1970).

Kateb, George, *Utopia and Its Enemies* (New York: Schocken, 1972).

Kaye, Harvey J., *The British Marxist Historians: An Introductory Analysis* (London: Polity Press, 1984).

Keating, Peter, ed., *Into Unknown England 1866–1913: Selections from the Social Explorers* (Manchester: Manchester University Press, 1976).

Kellner, Douglas, "Baudrillard, Semiurgy and Death," *Theory, Culture & Society* 4 (1987), 125–46.

Kent, Christopher, "Presence and Absence: History, Theory, and the Working Class," *Victorian Studies* 29:3 (Spring, 1986), 437–62.

Kerber, Linda K., "Separate Spheres, Female Worlds, Woman's Place: The Rhetoric of Women's History," *Journal of American History* 75:1 (June, 1988), 9–39.

Klinger, Barbara, "In Retrospect: Film Studies Today," *The Yale Journal of Criticism* 2:1 (Fall, 1988), 129–51.

Kogan, David, and Maurice Kogan, *The Attack on Higher Education* (London: Kogan Page, 1983).

Kroeber, Alfred, and Clyde Kluckhohn, *Culture: A Critical Review of Concepts* (New York: Vintage Books, 1963).

Krupnick, Mark, *Lionel Trilling and the Fate of Cultural Criticism* (Evanston: Northwestern University Press, 1986).

Kwiat, Joseph J., and Mary C. Turpie, *Studies in American Culture: Dominant Ideas and Images* (Minneapolis: University of Minnesota Press, 1960).

LaCapra, Dominick, "Habermas and the Grounding of Critical Theory," in *Rethinking Intellectual History: Texts Contexts Language* (Ithaca: Cornell University Press, 1983), 145–83.

Larrain, Jorge, *The Concept of Ideology* (Athens: The University of Georgia Press, 1979).

Lears, T. J. Jackson, "The Concept of Cultural Hegemony: Problems and Possibilities," *The American Historical Review* 90:3 (June, 1985), 567–93.

———, "Power, Culture, and Memory," *The Journal of American History* 75:1 (June, 1988), 137–40.

Lentricchia, Frank, *After the New Criticism* (Chicago: University of Chicago Press, 1980).

———, *Criticism and Social Change* (University of Chicago Press, 1983).

Lepenies, Wolf, *Between Literature and Science: The Rise of Sociology* (Cambridge: Cambridge University Press, 1988).

Lerner, Gerda, *The Creation of Patriarchy* (New York: Oxford University Press, 1986).

Livant, Bill, "The Imperial Cannibal," in Angus and Jhally, eds., *Cultural Politics in Contemporary America*, 26–36.

Lloyd, David, *Nationalism and Minor Literature: James Clarence Mangan and the Emergence of Irish Cultural Nationalism* (Berkeley: University of California Press, 1987).

Lovell, Terry, *Pictures of Reality: Aesthetics, Politics, Pleasure* (London: British Film Institute, 1980).

Lyotard, Jean-François, *The Postmodern Condition: A Report on Knowledge* (Minneapolis: University of Minnesota Press, 1984).

MacCabe, Colin, ed., *Futures for English* (Manchester: Manchester University Press, 1988).

———, *Theoretical Essays: Film, Linguistics, Literature* (Manchester: Manchester University Press, 1985).

McDowell, Tremaine, *American Studies* (Minneapolis: University of Minnesota Press, 1948).

McGann, Jerome J., *The Romantic Ideology: A Critical Investigation* (Chicago: University of Chicago Press, 1983).

McLennan, Gregor, "E. P. Thompson and the Discipline of Historical Context," in CCCS, *Making Histories: Studies in History-Writing and Politics* (London: Hutchinson, 1982), 96–130.

McRobbie, Angela, "Settling Accounts with Subcultures," *Screen Education* 34 (1980), 37–49.

Marcus, George, and Michael M. J. Fischer, *Anthropology as Cultural Critique: An Experimental Moment in the Human Sciences* (Chicago: University of Chicago Press, 1986).

Marcuse, Herbert, *The Aesthetic Dimension: Toward a Critique of Marxist Aesthetics* (Boston: Beacon Press, 1978).

Marx, Karl, and Friedrich Engels, *The Marx-Engels Reader,* ed. Robert C. Tucker, 2nd ed. (New York: W. W. Norton, 1978).

Megill, Allan, *Prophets of Extremity: Nietzsche, Heidegger, Foucault, Derrida* (Berkeley: University of California Press, 1985).

Merod, Jim, *The Political Responsibility of the Critic* (Ithaca: Cornell University Press, 1987).

Merquior, J. G., *From Prague to Paris: A Critique of Structuralist and Post-Structuralist Thought* (London: Verso, 1986).

Millett, Kate, *Sexual Politics* (Garden City, NY: Doubleday, 1970).

Mitchell, W. J. T., *Iconology: Image, Text, Ideology* (Chicago: University of Chicago Press, 1986).

Modleski, Tania, *Loving with a Vengeance: Mass-Produced Fantasies for Women* (New York and London: Methuen, 1984).

Moi, Toril, *Sexual/Textual Politics: Feminist Literary Theory* (London: Methuen, 1985).

Mooney, Carolyn J., "Conservative Scholars Call for a Movement to 'Reclaim' Academy," *The Chronicle of Higher Education* 35:13 (Nov. 23, 1988), 1, 11.

Morris, Meaghan, "Banality in Cultural Studies," *Discourse* 10:2 (Spring/Summer, 1988), 3–29.

Mouffe, Chantal, ed., *Gramsci and Marxist Theory* (London: Routledge and Kegan Paul, 1979).

Naremore, James, *Acting in the Cinema* (Berkeley: University of California Press, 1988).

Nelson, Cary, and Lawrence Grossberg, eds., *Marxism and the Interpretation of Culture* (Urbana: University of Illinois Press, 1988).

Norris, Christopher, *Derrida* (Cambridge, MA: Harvard University Press, 1987).

Ohmann, Richard, *English in America: A Radical View of the Profession* (New York: Oxford University Press, 1976).

———, *Politics of Letters* (Middletown, CT: Wesleyan University Press, 1987).

Ollman, Bertell, and Edward Vernoff, eds., *The Left Academy,* vol. 1 (New York: McGraw-Hill, 1982).

Ortner, Sherry, "Is Female to Male as Nature is to Culture?" in Michele Zimbalist Rosaldo and Louise Lamphere, eds., *Women, Culture, and Society* (Stanford: Stanford University Press, 1974), 67–87.

Pitkin, Hanna Fenichel, *The Concept of Representation* (Berkeley: University of California Press, 1967).

Plumb, J. H., ed., *Crisis in the Humanities* (Harmondsworth: Penguin Books, 1964).

Pratt, Mary Louise, *Toward a Speech-Act Theory of Literary Discourse* (Bloomington: Indiana University Press, 1977).

Punter, David, ed., *Introduction to Contemporary Cultural Studies* (London: Longman, 1986).

Pusey, Michael, *Jürgen Habermas* (London: Tavistock, 1987).

Radway, Janice, *Reading the Romance: Women, Patriarchy, and Popular Literature* (Chapel Hill: University of North Carolina Press, 1984).

Ricoeur, Paul, *Lectures on Ideology and Utopia* (New York: Columbia University Press, 1986).

Robbins, Bruce, "The Politics of Theory," *Social Text* 88 (Winter, 1987), 3–18.

Rowbotham, Sheila, *Dreams and Dilemmas: Collected Writings* (London: Virago, 1983).

Ryan, Michael, *Marxism and Deconstruction: A Critical Articulation* (Baltimore: Johns Hopkins University Press, 1982).

Said, Edward, *Orientalism* (New York: Vintage Books, 1979).

——, *The World, the Text, and the Critic* (Cambridge, MA: Harvard University Press, 1983).

Samuel, Raphael, ed., *People's History and Socialist Theory* (London: Routledge and Kegan Paul, 1981).

Sayres, Sohnya, et al., eds., *The 60s without Apology* (Minneapolis: University of Minnesota Press, 1984).

Scholes, Robert, "Deconstruction and Communication," *Critical Inquiry* 14:2 (Winter, 1988), 278–95.

——, *Textual Power: Literary Theory and the Teaching of English* (New Haven: Yale University Press, 1985).

SDS (Students for a Democratic Society), "The Port Huron Statement," reprinted in *Socialist Review* 93–94 (May–August, 1987), 106–40.

Sexton, Patricia, and Brendan Sexton, *Blue Collars and Hard Hats* (New York: Random House, 1971).

Showalter, Elaine, "Feminist Criticism in the Wilderness," *Critical Inquiry* (Winter, 1981), 179–205.

——, *A Literature of Their Own: British Women Novelists from Brontë to Lessing* (Princeton: Princeton University Press, 1976).

Sinfield, Alan, ed., *Society and Literature, 1945–1970* (New York: Holmes and Meier, 1983).

Snitow, Ann, "Pages from a Gender Diary: Basic Divisions in Feminism," *Dissent* (Spring, 1989), 205–24.

Sontag, Susan, *Against Interpretation* (New York: Dell, 1969).

Spender, Dale, *For the Record: The Making and Meaning of Feminist Knowledge* (London: The Women's Press, 1985).

——, *There's Always Been a Women's Movement This Century* (London: Pandora Press, 1983).

Spiller, Robert, et al., eds., *Literary History of the United States* (New York: Macmillan, 1963).

Spivak, Gayatri Chakravorty, "Can the Subaltern Speak?" in Nelson and Grossberg, eds., *Marxism and the Interpretation of Culture*, 271–313.

——, *In Other Worlds: Essays in Cultural Politics* (New York and London: Methuen, 1987).

Sprinker, Michael, *Imaginary Relations: Aesthetics and Ideology in the Theory of Historical Materialism* (London: Verso, 1987).

Stallybrass, Peter, and Allon White, *The Politics and Poetics of Transgression* (Ithaca: Cornell University Press, 1986).

Steiner, George, *In Bluebeard's Castle: Some Notes towards the Redefinition of Culture* (New Haven: Yale University Press, 1971).

Stimpson, Catharine R., "Nancy Reagan Wears a Hat: Feminism and Its Cultural Consensus," *Critical Inquiry* 14:2 (Winter, 1988), 223–43.

Sutherland, John, "The Politics of English Studies," in Jerome McGann, ed., *Historical Studies and Literary Criticism* (Madison: University of Wisconsin Press, 1984), 126–40.

Sykes, Richard E., "American Studies and the Concept of Culture: A Theory and Method," *American Quarterly* (Summer, 1963), 253–70.

Tate, Cecil F., *The Search for a Method in American Studies* (Minneapolis: University of Minnesota Press, 1973).

Thompson, E. P., "The Long Revolution," *New Left Review* 9 and 10 (May/June, July/August 1961), 24–33, 34–39.

——, *The Making of the English Working Class* (New York: Vintage, 1963).

——, *The Poverty of Theory* (New York: Monthly Review Press, 1978).

Tompkins, Jane P., ed., *Reader-Response Criticism from Formalism to Post-Structuralism* (Baltimore: Johns Hopkins University Press, 1980).

Trachtenberg, Alan, "Comments on Evan Watkins' 'Cultural Criticism and Literary Intellectuals,'" *Works and Days* 3:1 (1985), 33–37.

Veblen, Thorstein, *The Higher Learning in America* (New York: B. W. Huebsch, 1918).

Viswanathan, Gauri, "Currying Favor: The Beginnings of English Literary Study in British India," *Social Text* 19/20 (Fall, 1988), 85–104.

Wald, Alan M., *The New York Intellectuals: The Rise and Decline of the Anti-Stalinist Left from the 1930s to the 1980s* (Chapel Hill: University of North Carolina Press, 1987).

Watkins, Evan, "Cultural Criticism and Literary Intellectuals," *Works and Days* 3:1 (1985), 11–31.

Weeks, Jeffrey, *Sexuality and Its Discontents* (London: Routledge and Kegan Paul, 1985).

Wellek, René, and Austin Warren, *The Theory of Literature* (New York: Harcourt, Brace, 1955).

Wellmer, Albrecht, "On the Dialectic of Modernism and Postmodernism," *Praxis International* 4:4 (January, 1985), 337–62.

Werner, Craig, "Recent Books on Modern Black Fiction: An Essay-Review," *Modern Fiction Studies* 34:1 (Spring, 1988), 125–35.

West, Cornel, "Marxist Theory and the Specificity of Afro-American Oppression," in Nelson and Grossberg, eds., *Marxism and the Interpretation of Culture*, 17–27.

White, Hayden, *Tropics of Discourse: Essays in Cultural Criticism* (Baltimore: Johns Hopkins University Press, 1978).

Wicke, Jennifer, "Postmodernism: The Perfume of Information," *Yale Journal of Criticism* 1:2 (Winter, 1987), 146–60.

Widdowson, Peter, ed., *Re-Reading English* (London: Methuen, 1982).

Wiener, Jon, "Reagan's Children: Race Hatred on Campus," *The Nation* (Feb. 27, 1989), 260–64.

Williams, Raymond, *Communications* (Harmondsworth: Penguin, 1962).

———, *Culture and Society, 1780–1950* (1958; New York: Harper and Row, 1966).

———, "Fiction and the Writing Public: *The Uses of Literacy*," *Essays in Criticism* 7 (1957), 422–28.

———, *Keywords: A Vocabulary of Culture and Society*, 2nd ed. (New York: Oxford University Press, 1983).

———, *The Long Revolution* (Harmondsworth: Penguin Books, 1965).

———, *Marxism and Literature* (Oxford: Oxford University Press, 1977).

———, *Politics and Letters: Interviews with New Left Review* (London: Verso Books, 1979).

———, *Problems in Materialism and Culture* (London: Verso Books, 1982).

———, "The Road from Vitebsk: The Uses of Cultural Theory," *New Left Review* 158 (July/August, 1986), 19–31.

———, *The Sociology of Culture* (New York: Schocken Books, 1982 [British title: *Culture*]).

———, *Towards 2000* (London: Chatto and Windus, 1983).

———, *Writing in Society* (London: Verso, 1984).

Williamson, Judith, "The Problems of Being *Popular*," *New Socialist* (September, 1986), 14–15.

Willis, Paul, *Learning to Labour: How Working Class Kids Get Working Class Jobs* (New York: Columbia University Press, 1977).

———, *Profane Culture* (London: Routledge and Kegan Paul, 1978).

Wolff, Michael, "Victorian Study: An Interdisciplinary Essay," *Victorian Studies* 8:1 (September, 1964), 59–70.

Woolf, Virginia, *A Room of One's Own* (New York: Harcourt Brace Jovanovich, 1957).

Index

209

210

Lynch, Kevin, 176
Lyotard, Jean-François, 72, 172, 190, 196

MacCabe, Colin, 34, 36, 61, 159, 166–168
McDiarmid, Hugh, 159
McDowell, Tremaine, 27–29, 31, 60
McGann, Jerome, 29, 40
McLennan, George, 84
McLuhan, Marshall, 55, 175, 177, 180, 183, 185
McRobbie, Angela, 137–138, 140
Malinowski, Bronislaw, 62, 139
Mallarmé, Stéphane, 13, 74
Malcolm X, 157
Mangan, James Clarence, 161
Mannheim, Karl, 83
Marcus, George, 105, 122
Marcuse, Herbert, 6, 9, 19, 72–73, 109, 194, 195
Marx, Karl (see also Marxism), 1, 7–8, 18, 19, 30,
 65–66, 73, 79–84, 86–91, 96–97, 101, 104, 109–
 112, 128–129, 133, 138, 151, 152, 169, 172, 174,
 175
Marx, Leo, 32, 117
Marxism, 11, 15, 16, 22–23, 25, 26, 30, 35–38, 42–
 43, 47–53, 55–59, 61, 63–67, 70–107, 108, 111,
 112–113, 117, 127–130, 132, 133, 136, 138, 144–
 145, 147, 151–153, 167–169, 172–176, 180–181,
 186, 191 (see also Engels, Friedrich; Frankfurt
 Institute; Marx, Karl; New Left)
Mass culture (mass media), 44, 46–48, 55–56, 58,
 61, 68, 70, 78–79, 84, 92, 101, 105, 109–110,
 119–127, 130, 140–141, 143, 162–163, 166–198
Materialism, 16, 36, 66, 70, 77, 79, 82, 83, 86,
 138, 167–168, 181–182 (cultural, historical; see
 also Marxism)
Matthiessen, F. O., 30
Mayhew, Henry, 45
Mead, Margaret, 139
Medvedev, P. M., 42
Megill, Allan, 13–14
Merod, Jim, 23
Merquior, J. G., 12
Mill, John Stuart, 14, 58, 169, 182
Miller, J. Hillis, 18, 19
Millett, Kate, 131–132, 146
Mills, C. Wright, 30, 128
Minnesota (University of), 27–29
Minor literature, 159–162
Misgeld, Dieter, 191
Mitchell, Juliet, 133, 136, 138–139
Mitchell, W. J. T., 81
Modern Language Association (MLA), 14, 40, 48,
 61, 162
Modleski, Tania, 140–141
Moi, Toril, 144–146
Morris, Meaghan, 127, 141
Morris, William, 41, 50–51, 53, 74
Morrison, Toni, 156, 157
Mott, Lucretia, 132
Mouffe, Chantal, 100
Mulvey, Laura, 167
Mussolini, Benvenuto, 85

Naremore, James, 169–170
Nazism, 18 (see also Fascism)
Nelson, Cary, 128
New Criticism, 14–15, 27, 30, 32, 71, 76–77, 145
New Historicism (see also Cultural history), 41
New Left, 5, 9, 10, 23, 35, 37, 54, 129

New Left Review, 37, 47, 51, 53, 181
Nietzsche, Friedrich, 13–14, 101, 102, 103, 171,
 172, 175, 184
Nigeria, 61
Norris, Christopher, 78
Northern Ireland, 149

Ohmann, Richard, 76–77, 78, 162
Ollman, Bertell, 127–128
Ortega y Gassett, José, 177–178
Ortner, Sherry, 139
Orwell, George, 41
Owenism, 49
Oxford University, 113

Paine, Tom, 80
Paraguay, 165
Paris Commune, 117
Parker, Theodore, 153–154
Parmar, Pratibha, 149
Past and Present, 113
Patmore, Coventry, 143
Patriarchy, 131–134, 140–145, 147, 149
Pearce, Roy Harvey, 29
Pearson, Geoffrey, 121, 123
Phenomenology, 25
Pitkin, Hanna, 105, 106
Plumb, J. H., 35–37
Postmodernism, 16, 17, 24–25, 72, 105–106, 130,
 146, 156, 163, 166–198 (see also Baudrillard,
 Jean; Lyotard, Jean-François; Poststructuralism)
Poststructuralism, 12–21, 25, 78, 85, 91, 101, 130,
 145, 161, 166–198 (see also Deconstruction; De
 Man, Paul; Derrida, Jacques; Postmodernism)
Pragmatism, 96, 102
Pratt, Mary Louise, 15
Praxis International, 128
Psychoanalysis (see also Freud, Sigmund; Lacan,
 Jacques), 11, 15, 63, 70, 71, 77–89, 138–139,
 176
Pusey, Michael, 182, 183, 190

Racism, 5, 43, 103, 112, 113, 118, 131–132, 134,
 148–165
Radcliffe, Anne, 140
Radway, Janice, 127, 140
Reader-response theory, 15, 127
Reagan, Ronald (Reaganism), 3–4, 8, 11, 75, 148,
 157
Realism (see Representation)
Redfield, Robert, 29
Reich, Charles, 119
Representation, 64–65, 77, 78, 88, 89, 94, 101–107,
 108–112, 127–136, 141, 144, 146, 148, 153, 155–
 156, 159–162, 166–170, 172–179, 182–198
Rich, Adrienne, 144
Richards, I. A., 41
Richardson, Samuel, 142
Ricoeur, Paul, 69, 83–84, 88, 96, 171–172, 185
Rimbaud, Arthur, 74
Robbins, Bruce, 10
Rochefort, Christiane, 147
Rock music, 119–127 (see also Mass culture)
"Romantic ideology," 29, 40, 41, 69–70, 74–76,
 140–143, 155
Roszak, Theodore, 119
Rousseau, Jean-Jacques, 106–107, 110
Rowbotham, Sheila, 136, 138, 148, 150

211

Rushdie, Salman, 159
Ruskin, John, 41, 74
Ryan, Michael, 26, 78, 145

Said, Edward, 24, 30, 33, 102, 103, 112, 128, 150, 152
Samuel, Raphael, 113–114
Sapir, Edward, 179
Sartre, Jean Paul, 101, 125
Saussure, Ferdinand de, 16, 42, 71, 77
Saville, John, 113
Scholes, Robert, 17–22, 75
Screen, 63, 84, 166–170, 179
Scrutiny, 44
Searle, John, 107
Semiotics (semiology), 25, 79, 84, 101, 171–173
Sennett, Richard, 117
Servin, Francisco, 165
Sexton, Brendan, 109–110, 112
Sexton, Patricia, 109–110, 112
Sexuality (*see also* Feminism; Gay rights; Patriarchy), 133–135, 138–140
Shelley, Percy Bysshe, 40, 74, 75
Showalter, Elaine, 142, 144, 146–147
Sixties (1960s), 3–11, 31, 32, 35, 76, 129, 130, 136
Slavery, 30, 32, 118, 132, 149, 152–155, 157
Smith, Adam, 1, 172
Smith, Geoffrey Nowell, 96
Smith, Henry Nash, 29, 32–33
Social class, 27, 33, 43, 44–50, 52, 55, 59–63, 108–127, 130, 132, 134, 148, 149, 151–152, 161–163, 168–170
Social sciences, 3, 7, 11, 45, 57, 61, 64, 71, 76, 83–84, 114–115, 119–127, 130, 137, 149, 164–165, 190, 193 (*see also* Anthropology)
Social Text, 128
Sociology (*see* Social sciences)
Sombart, Werner, 117
Sontag, Susan, 194–195
Soviet Union, 59, 85, 152
Spender, Dale, 129, 142
Spiller, Robert E., 153
Spivak, Gayatri Chakravorty, 156, 162
Sprinker, Michael, 129
Stalinism, 51–52, 75, 85–86, 179
Stallybrass, Peter, 163
Stanton, Elizabeth Cady, 132
Steiner, George, 8–10
Stepto, Robert, 156
Stimpson, Catharine R., 130, 158
Stone, Lucy, 132
Stowe, Harriet Beecher, 153, 155, 161
Strauss, David, 13
Structuralism, 10, 11, 56, 57, 63, 66, 71, 77, 85, 87, 91–92, 99–100, 101, 145
Students for a Democratic Society (SDS), 5, 9
Subcultures, 100, 116, 117, 119–127, 137–138, 147, 179–180
Sutherland, John, 35
Sykes, Richard, 28

Tate, Cecil, 29
Tawney, R. H., 41
Taylor, Pam, 116
Television (*see* Mass Culture)
Telos, 128
Thatcher, Margaret (Thatcherism), 3–4, 11, 35, 39, 75, 117, 148

Thompson, Denys, 44
Thompson, Dorothy, 50
Thompson, E. P., 35, 37–38, 48–53, 54, 55, 63, 64–66, 77, 85, 87, 92, 94, 100, 102, 108–109, 112–113, 115, 117–118, 121, 128, 150, 179–180, 181, 193, 197
Thoreau, Henry David, 30
Thrasher, Frederick, 125
Timpanaro, Sebastian, 101
Tolstoy, Leo, 91
Trachtenberg, Alan, 23–24
Tracy, Destutt de, 80, 97
Twohig, John, 121, 123
Tyler, Stephen, 105–106, 122
Tylor, Edward Burnett, 42–43

Veblen, Thorstein, 4
Vernoff, Edward, 127–128
Victorian Studies, 31–32
Vietnam War, 5, 31, 32, 129
Viswanathan, Gauri, 158–159
Volosinov, V. N., 42, 171, 183
Volpe, Galvano Della, 101

Wald, Alan, 30
Walker, Alice, 156, 157
Warren, Austin, 15, 71
Watkins, Evan, 23
Watt, Ian, 142
Weber, Max, 131, 185–186, 189
Weedon, Chris, 84–85
Weeks, Jeffrey, 134, 135
Wellek, René, 15, 71
Wellmer, Abrecht, 171–172
Wells, Ida B., 149–150
West, Cornel, 152–153, 156
West Indies, 126, 148
Wheatley, Phyllis, 154
White, Allon, 163
White, Hayden, 72
Whitman, Walt, 28, 30
Whyte, William, 125
Wicke, Jennifer, 174
Widdowson, Peter, 34, 36
Wilde, Oscar, 41
Williams, Raymond, 17, 21, 26, 34–49, 54–59, 63–67, 73–75, 79, 85, 99–100, 101, 108, 111–112, 115, 117, 128, 156, 169, 170, 173, 180–186, 191–198
Williams, William Appleman, 30
Williamson, Judith, 127, 141
Willis, Paul, 117, 121–126, 137–138, 140, 195
Wilson, Edmund, 30
Wittgenstein, Ludwig, 37
Wolff, Michael, 32
Wollstonecraft, Mary, 129
Women's Studies (*see also* Feminism), 4–5, 24, 26–27, 127–150
Woolf, Virginia, 70, 131, 142, 162
Wordsworth, William, 40, 74
Working class (*see* Social class)
World War I, 35
World War II, 32, 35, 113, 126, 129, 151, 194
Wright, Richard, 153, 156, 166

Yeats, William Butler, 159

Zola, Émile, 70, 169

212

ABP-7940